THE ART OF TAKING A WALK

THE ART OF TAKING A WALK

FLANERIE, LITERATURE, AND FILM

IN WEIMAR CULTURE

Anke Gleber

PRINCETON UNIVERSITY PRESS PRINCETON, NEW JERSEY

Library of Congress Cataloging-in-Publication Data
Gleber, Anke, 1957–
The art of taking a walk : flanerie, literature, and film in
Weimar culture / Anke Gleber.
p. cm.
Includes bibliographical references and index.
ISBN 0-691-01222-9 (alk. paper).
ISBN 0-691-00238-X (pbk. : alk. paper)
1. Flaneurs in art. 2. Flaneurs in literature. 3. Arts, German.
4. Arts, Modern—20th century—Germany. I. Title.
NX650.F52G64 1999
700'.453—dc21 98-26420 CIP

This book has been composed in Times Roman

Princeton University Press books are printed
on acid-free paper and meet the guidelines for
permanence and durability of the Committee on
Production Guidelines for Book Longevity
of the Council on Library Resources

http://pup.princeton.edu

Printed in the United States of America

1 3 5 7 9 10 8 6 4 2

(pbk.)
1 3 5 7 9 10 8 6 4 2

Contents

Preface

In this book, I wish to delineate a history of perception and representation in modernity by analyzing one of its significant modes of observation, that of "flanerie." A comparative and interdisciplinary study in intellectual and cultural history, this project traces what Franz Hessel once called "the art of taking a walk" through the cities and spaces of modernity. The mode of flanerie can be considered a pivotal expression and disposition of its times as well as the means whereby, from early industrial modernity on, the literature and film of flanerie defined themselves. Flanerie was in fact coincidental with what was perhaps the most accelerated capitalist development in modern history, one that resulted in the emergence of various new dispositions, rapid urbanization and industrialization, and an increased influence of the visual upon our experience of reality. It is connected to such contemporary issues as the interpretation of images, visual literacy, power and public space, the female gaze, and the cultural definition of identity.

In its attempt to demonstrate this mode as a prevalent disposition of modernity, this study establishes the "flaneur" as an important, yet underappreciated, presence in literature, film, and culture. It seeks to revise and expand approaches to modernity, perception, and representation formulated by critics and theorists such as Georg Simmel, Walter Benjamin, and Siegfried Kracauer in their efforts to define a visual epistemology of the city and its exteriority. It argues that the flaneur, as a product of modernity, experiences city streets as interiors, its traffic and commodities as images of reflection. In addition, the study sketches the European cultural context that produced the German variant of the flaneur, reconstructing the history of this privileged mode in the modern perception of exteriority. Following the lead of the recent work by Dana Brand, Susan Buck-Morss, and David Frisby, I will rehistorize the flaneur by trying to clarify the important cultural and visual connections between writings and representations of the Weimar period and the central literary, philosophical, sociological, political, historical, and cultural texts or movements of this period. Despite the recent interest in the cultural and theoretical dimension of this figure in cultural studies—which can be seen in works by sociologists such as Keith Tester; art historians such as Maud Lavin; and theorists of film such as Giuliana Bruno, Miriam Hansen, and Anne Friedberg—the origins of the flaneur in Benjamin's theories and in his *Denkbilder* have not been traced to their initial rhetorical formulations in German literature and Weimar culture. The project thus contributes to a broader understanding of the specific cultural context within which this figure emerged, and thereby helps redefine our conception of the intersections among modernity, vision, and public spaces.

Working to follow as closely as possible the many diverse traces of this cultural phenomenon, I have tried to develop an ambulatory form of presentation that seeks to adjust its own trajectories in accordance with the phenomena it seeks to investigate. Within the movement of this process, I suggest above all the extent to which the writings of flanerie may be read as both symptomatic and critical of the prevailing cultural rhetorics through which the discourses of this period reflected on their own relation to the exteriors and interiors of flanerie. Flanerie can be said to involve a mode of sensory experience that is bound to the processes of distraction but which works to overcome this alienation through intense visual perception. In these early Weimar texts, the flaneur appears in various forms, often in relation to other figures of modernity, such as the collector, the historian, or the spectator. As a city stroller, the flaneur is at once a dreamer, a historian, and a modern artist, someone who transforms his observations into texts and images. In trying to read the flaneur's relation to these other figures, I wish to suggest not only that he participates in these other realms, but also that he becomes visible as a figure only in his relation to all of these facets of modernity. Even so, the flaneur continues to define himself in terms of his insistence on the process of walking and writing that characterizes his subjectivity. Flanerie embraces both surrealistic and impressionistic sensibilities, the intoxication with images as icons of modern mythology, and an increased attention to the light and textures of big city environments. Ultimately, flanerie gives way to a perceptual inner monologue, a visual stream-of-consciousness that is translated into writing and images.

The first part traces a "Theory of Literary Flanerie" and explores the state of "The City of Modernity" by reading the development of this modern consciousness from its nineteenth-century beginnings. Focusing primarily on texts by Heinrich Heine and E.T.A. Hoffmann from Berlin as well as by Ludwig Börne from Paris, I argue that the changes in the material and technological basis of reality gave a new epistemological status to the activity of seeing and walking in the emerging city of modernity. The third chapter of this part, "Passages of Flanerie," is a reading of some of the theoretical, philosophical, and feuilletonistic understandings of this phenomenon in early twentieth-century German thought and theory. Paris inspires Benjamin's theory of flanerie in such seminal texts as *Charles Baudelaire. A Lyric Poet in the Era of High Capitalism; Paris, the Capital of the Nineteenth Century;* and the fragmentary perceptions of the *Paris Arcades.* Similarly, the flanerie of authors in Berlin illuminates the everyday reality of the Weimar Republic as much as it forms the conceptual background of numerous theories and perceptions of metropolitan sociology by Siegfried Kracauer, Ernst Bloch, Georg Simmel, and other representatives of Weimar literature, arts, and theory. Finally, I emphasize the multitude of forms that Paris, the original city of flanerie, brings forth as a variety of perceptions within this new disposition. In the impressionistic observations of Edouard Dujardin's *Les Lauriers sont coupés,* the flaneur appears as a dandy

whose subtle perceptions in Paris cafés and streets inspired James Joyce to pursue his invention of the "stream-of-consciousness" mode of writing. Dujardin's interior monologue on seeing as an activity of reading as well as writing emerges in this study as the immediate precursor to this approach to literature and experience. With the increasing urbanization in modernity, Parisian flanerie becomes a surrealist intoxication with city streets, as manifested in Louis Aragon's *Le Paysan de Paris*. Aragon's perceptions and perambulations in the labyrinths of the Parisian arcades provide both a critique of and fascination with commodity capitalism.

Within this context, part 2, "Hessel in Berlin," focuses on the writings of Franz Hessel, a representative Berlin flaneur as well as an influential friend of Walter Benjamin. Hessel is one of the last representatives of the metropolitan, intellectual bohemian characteristic of the European culture of early modernity. He frequented the circles of Franziska von Reventlow in Munich as well as the artists' cafés in Paris, where he befriended the author Jean-Pierre Roché. As his constant companion, Hessel has become widely known as the real-life model for the "Jules" character of *Jules et Jim*, Roché's fictitious representation of their friendship, rendered memorable by Francois Truffaut's cinematic adaptation. In Berlin, Hessel is known as the editor of a major publishing house, an author in his own right, and a close and sensitive observer of the popular and intellectual culture of the Weimar Republic whose work provides access to the intellectual history of Weimar Germany. As one of Benjamin's closest friends, he represents an important and so far largely unacknowledged influence upon the work of this Weimar theoretician. Hessel himself emerges as the author of an early semiotic "theory of flanerie," one that he literally defines in terms of a "reading [of] the street" [*Lektüre der Straße*]. This unique mode for the reception of reality perceives passersby, streets, and fleeting impressions as the transitory signs of modernity. Hessel's feuilletonistic images of the 1920s, collected in his 1929 collection *Spazieren in Berlin* (reprinted as *Ein Flaneur in Berlin*), scrutinize history, stories, and views of a crucial public sphere between the wars. His perceptions anticipate Benjamin's aesthetics of the "image of reflection" [*Denkbild*], and offer a new perspective of the capital of the Weimar Republic in terms of the visual phenomena of its public and exterior existence. Hessel's essays illustrate a unique theory within the tradition of flanerie, one both pertinent to and perceptible in the German literature of his time. These texts provide new models for a veritable reading of reality in which faces, streets, and scenes become semiotic extensions of modernity, texts that demand close and sympathetic interpretation.

Part 3, "Flanerie and Film," seeks to expand Hessel's characteristic aesthetics into a comprehensive phenomenology of the flaneuristic gaze, an aesthetics of the everyday that can serve to open up new approaches to a theory of film. I suggest that the flaneur in motion in the urban exteriority captures the moving images of city streets, acting in this way like the camera of silent cinema,

which functions as another pronounced obsession of the contemporaries of early Weimar cinema and of an omnipresent public "film-debate" [*Kino-Debatte*]. In this part I argue that the flaneur, in the process of strolling, sets out to perceive everyday life as a three-dimensional screen whose images he projects immediately into his unique form of literature. Flanerie deciphers the modern world as a complex text, in an aesthetics redolent of many aesthetic constructions of modernity, not least of Kracauer's seminal *Theory of Film* as the "redemption of physical reality." A camera, a kino-eye, an author as director, the flaneur shapes reality into an ongoing film; he acts as a spectator-turned-reader-turned-writer. In tracing this process, I suggest that the dream state of flanerie has much in common with filmic reception and its hypnosis, reverie, and hunger for experience [*Erfahrungshunger*], suggesting that we can observe a renaissance of flanerie and its sensibilities in West German literature since the 1970s, that is, since the so-called New Subjectivity. Through the optic of flanerie, New Subjectivity can be seen as a move toward radical exteriority.

Another pivotal moment within the history of flanerie forms a final, yet crucial focus of this book which I explore and expand in my fourth part: the search for traces of a "female flanerie" within Weimar culture and female writing. In juxtaposing texts and films that reflected and shaped the public imagination, such as Walter Ruttmann's *Berlin, the Symphony of the City*, with contemporary urban texts by Weimar women, such as Irmgard Keun, a writer obsessed with cities and lights, and Charlotte Wolff, an early feminist psychoanalyst in Berlin, I suggest the role in which the phenomenon of female flanerie may serve as a significant movement of emancipation, a move that hopes to assert female subjectivity in the public realm and to make possible a liberated gaze that in turn would allow women to become the subjects of their own perception.

In working to revise our understanding of the relation not only among the writers of Weimar Germany, the Frankfurt School, and the theoretical issues of early twentieth-century culture, but also among literature, film, history, and politics in wider spatial contexts, I have hoped to write a book that might be of interest to scholars and students—both inside and outside the fields of modern European literature, film, and cultural studies—who are engaged in a reconsideration of the ways in which literary texts may reflect or shape the multiple arenas of what we call "public space."

Acknowledgments

MY THANKS goes above all to my editor at Princeton University Press, Mary Murrell, who has accompanied this long walk from its beginning with an amazing sense of friendship and solidarity. I would like to express my special thanks to J. Dudley Andrew, an always inspiring reader and teacher as well as the generous host of a symposium on the "Image in Dispute." I also want to thank the participants of that seminar, in particular Sabine Hake, Carol Vance, and Sally Shafto, for their perceptive eyes and comments.

I am grateful to the many inspired and insightful students who have attended my courses on German cinema and Weimar culture at Princeton, among them Alicia Dwyer, Chi Yoon Chung, and Anne B. Paas. I would also like to thank my colleague Walter Hinderer for facilitating this work with his unfailing support and generosity. Thanks is due to Eduardo Cadava for helping to edit the final version of the English text, while at the same time doing everything in his power to prevent the completion of this project altogether. I am very much indebted to the care and stylistic grace that Talia Bloch has taken with this manuscript over the better part of two summers.

For many gestures of kindness and words of encouragement offered during the passage of this text toward completion, I would like to express a strong sense of gratitude to my always supportive friends and colleagues: Veronica Alvarez, Katharina von Ankum, Ken Calhoon, Catherine Cucinella, Kevin Childress, Craig Decker, Jörg Drews, Lisa Dunkley, Gerald Fernandez, Anne-Lise François, Donald R. Froyd, Alexander Gelley, Nancy Kaiser, Alice Kuzniar, Charles E. Lambert, Brent Peterson, Eric Rentschler, Ellen Risholm, Stephan K. Schindler, Jörg Schweinitz, Robert B. Shandley, Jiro Tanaka, Claudia Wollenweber, and Carlos Zamudio.

This book commemorates the many talented and wonderful women, among them Sarah Buss, Dorothea Dietrich, Anne Garreta, Wahneema Lubiano, and Ruth Klüger, who have wasted altogether too much time of their lives on a small town in New Jersey. It is dedicated to Carlos Antonio Briz, for everything that is possible and for everything that he is.

Abbreviations

AM Hessel, *Alter Mann*
B Dronke, *Berlin*
CS Raabe, *Die Chronik der Sperlingsgasse*
DH Hoffmann, *Das öde Haus*
EG Hessel, *Ermunterung zum Genuß*
FB Hessel, *Ein Flaneur in Berlin*
G Keun, *Gilgi—Eine von uns*
H Wolff, *Hindsight*
HB Hessel, *Heimliches Berlin*
KG Hessel, *Der Kramladen des Glücks*
KM Keun, *Das kunstseidene Mädchen*
LH Hessel, "Letzte Heimkehr"
M Simmel, "The Metropolis and Mental Life"
MD Hessel, *Marlene Dietrich*
OM Kracauer, *Das Ornament der Masse*
PM Biro, *Profane Mythology*
PR Hessel, *Pariser Romanze*
T Hessel, "Tagebuchnotizen" (from *Juni*)
TF Kracauer, *Theory of Film*
TM Hessel, "Des deutschen Buches . . . Tändel-Markt"
VE Hoffmann, *Des Vetters Eckfenster*

Note: All translations are by Anke Gleber, unless otherwise indicated.

Part One

LITERATURE, CULTURE, THEORY

Walking Texts: Toward a Theory of Literary Flanerie

> Have you ever reflected on everything contained in
> the term "flanerie," this most enchanting word
> which is revered by the poets . . . ? Going on infinite
> investigations through the streets and promenades;
> drifting along, with your nose in the wind, with both
> hands in your pockets, and with an umbrella under
> your arm, as befits any open-minded spirit; walking
> along, with serendipity, without pondering where to
> and without urging to hurry . . . stopping in front of
> stores to regard their images, at street corners to
> read their signs, by the *bouquinistes'* stands to touch
> their old books . . . giving yourself over, captivated
> and enraptured, with all your senses and all your
> mind, to the spectacle.
> (*Victor Fournel*, Ce qu'on voit dans les rues de Paris)

WRITING of Paris, the city that Walter Benjamin would call the capital of the nineteenth century, Victor Fournel here approximates his own experience and understanding of urban modernity.[1] One of the earliest writers and theorists of flanerie, Fournel defined it as a new state of existence that inscribes a significant phenomenon of modernity into the intellectual and literary perspective of its times.[2] The flaneur's mode of perception and his vision of exterior reality soon became manifest in a large number of literary and, later, filmic texts that followed the itinerary evoked here by one of its first practitioners. In "infinite investigations" through the inexhaustible realms and nuances of this new reality, these authors left their bourgeois interiors in order to encounter their materials of observation in a new sphere of public exteriors—jogging their creativity by traversing the "streets and promenades" of the city, and coming across imaginary spaces at every turn. "Drifting along" with the modern crowds, these authors and their texts attentively described the ways in which the flaneur's literary dreams gradually take material shape. At the same time, they slowly pursue their own trajectories, considering reality with their own careful gaze.

Both expressing and exemplifying this flanerie, these authors-as-flaneurs approach the realities of their modern times in entirely open ways, "regard-[ing]" the images they see in the streets with a renewed sense of amazement, gazing at the surroundings and books they find open before them as if for the first time, reading reality as a series of textual documents, images that ask to be approached and appreciated with care and respect. These walking writers enter the public sphere in order to "read" the texts of modernity within the continuum of their strolls, within the kaleidoscopic continuity offered at every street corner. As a modern author, the flaneur regards these new images as texts in their own right. With "all of [their] senses" and "all of [their] minds," these flaneurs abandon themselves to the spectacle of the new reality appearing before them in the unfolding spaces of modernity. Flanerie assumes the sense of a contemporary disposition that becomes a privileged way of recording the exterior world and phenomena of its times. This innovative access to the world is reflected in the enthusiasm and fascination with which Fournel, as only one representative among many modern authors, begins to perceive these images and scenes as writings of the street, at once embracing the literary and visual sensitivities evoked by the figure of the flaneur.

If Fournel's early flaneuristic visions suggest that flanerie is a word "revered by the poets," the phenomenon of flanerie has long been overlooked in the history of modern perception offered by the chroniclers of literary and cultural history. It therefore remains to be seen how the various impulses of flanerie, as a privileged mode of perceiving modernity and its many reali-ties, have always already been present in various forms in both literary and cinematic culture. That flanerie has been conspicuously absent from his-tories of perception and literature means that these histories need to be ap-proached in new ways as a largely uncharted territory.[3] The primary cue for these excursions can be taken from the eyewitnesses of early flanerie: "I would quite like to begin tracing the theory of flanerie here; the distinguishing factor between this one and any other theory, however, is the fact that it does not, or moreover, that it cannot exist at all. Flanerie, this amiable science . . . lives by what cannot be foreseen and by its immediate freedom of will."[4] The pre-sumed incongruities to which Fournel reacted in his formulation of flanerie as a movement of impressionable impulses provide the point of departure for my investigation.

The aim of this investigation is to pursue those very imperceptible, yet sig-nificant traces of a cultural history and aesthetics of modernity that are captured through the eyes of the flaneur. Tracing the movement of this paradigmatically modern figure, I will suggest that the flaneur is the precursor of a particular form of inquiry that seeks to read the history of culture from its public spaces.[5] This is why the point of departure for approaching the visual phenomena of flanerie within the spaces of literature and the images of modernity is decisive. Following Fournel, we can delineate not only certain preferred routes of inves-

tigation but also the more confined, one-way streets that we will want to avoid: "I might . . . begin to enumerate all the great names, all the beautiful works, the useful achievements and precious discoveries which flanerie is rightly entitled to claim its own. . . . However, this would only be a pleading that follows by the rules. How heavy-handed and absurd an enterprise! I would much rather approach this matter in a much more facile way. The topic will not lose its pertinence, and the reader may even gain as many insights in this process as the author will. So let me therefore . . . convey to you the observations of a flaneur by way of flanerie itself."[6]

The phenomenon of flanerie, I suggest, can only be approached by the very ways of the flaneur, that is to say, by looking at the texts of flanerie with an eye toward how they have inscribed themselves in the literature of modernity. Part 1 therefore reads texts that represent some of the possible stations on a historical tour aimed at following the path of flanerie from the beginnings of the nineteenth century through what we call modern culture. This part follows the outlines of tenuous yet prevailing connections that link the traces of flanerie to certain contours of cultural history. Taking its first steps, this excursion will return to a few precursors of flanerie in nineteenth-century literature, and situate these early urban dwellers within their specific time frame, that is, in relation to the industrial revolution and the ensuing evolution of cityscapes, urban constellations, and conditions of perception that surround them.

I will explore the foundations of a modern age that give rise to a movement that reaches well into the twentieth century. The visual phenomena of modernity and their related manifestations will be revisited in the specific social, material, and theoretical shapes that they take in the metropolitan sphere of the Weimar Republic, returning to a Berlin that is only beginning to become the pivotal urban center of early twentieth-century German culture. The return to this lost history of flanerie will be helped by the writings of such seminal thinkers as Georg Simmel, Siegfried Kracauer, Walter Benjamin, and of many other city dwellers, on the relation between flanerie and modernity. These writers view flanerie as a visible mode of writing, as an aesthetics of reflection in, through, and of images—as *Denkbilder*.[7] For them, flanerie names a mode of thinking that gives shape to the unique theoretical and aesthetic approaches that Weimar thought and literature take in modernity. Significant predecessors to these writers of flanerie will be found by taking a closer look at the writings of Edouard Dujardin, a writer who exemplifies this modern urban approach with his texts about Paris, Benjamin's proclaimed "capital of the nineteenth century." As evidence of an impressionistic disposition, Dujardin illustrates some of the characteristic frames of vision and mind that have come to be regarded as constitutive of flanerie as a mode of perception and representation.

Within this extended lineage of modernity, the works of Franz Hessel hold a privileged position. His writings can be understood as the personal and literary

companion pieces to the major theoretical constants in Benjamin's oeuvre. The latter's declaration of a "return of the flaneur" is based primarily on a reading of the urban and literary texts that his friend Hessel made accessible and disclosed to him. The too often neglected relations of Hessel's writings to Benjamin's theories lend renewed emphasis to the work of an author who moved at the center of cultural life in Berlin, surrounded by a circle of friends whose visions and debates helped shape important theoretical constructions of Weimar's intellectual modernity. A consideration of Hessel's long overlooked, decidedly marginal, yet hardly insignificant work substantiates my claim about the essential relation of flanerie to the literature of modernity in general and to Weimar culture in particular. As the course of the inquiry will show, flanerie is very closely related to other constructions of cultural modernity. Linked to the movements and images that belong to the processes of tourism, photography, and psychoanalysis, it ultimately charts an aesthetics of modernity that reveals its affinities to the medium of the cinema and its reception of exterior reality.

The flaneur personifies a perspective that links many of these phenomena of modernity, serving above all as a visual medium of perception and subjectivity in human form. He represents a disposition that is closely affiliated with the gaze of the camera, renders the sensitivity of a director who records his own vision, and repeats the spectatorship of a moviegoer who perceives the images of reality as an ongoing film of modernity. It should be said that this film of modernity includes women as well. This is why, in tracing the aspects and affinities of this disposition, we will follow this pivotal phenomenon of flanerie into an all but uncharted terrain in German culture, the "missing" phenomenon of female flanerie. Considering the seminal yet hidden contributions that modernist women brought to Weimar culture and thought, figures that appear as female pedestrians in *Berlin, the Symphony of the City* as well as in the writings of Weimar women authors such as Irmgard Keun and Charlotte Wolff, this exploration of cultural and visual phenomena will conclude by linking this significant absence to the eventual appearance of a "female flaneur."[8]

PARIS, OR THE RISE OF FLANERIE

The beginnings of flanerie can be found long before the twentieth-century reflections of Benjamin, and even before the era of Baudelaire's nineteenth-century urban poetry. If flanerie predates many of its assumed origins, however, its consequences also move beyond the literature of early modernity into that of a certain postmodernity, transcending the efforts to record flanerie by way of written texts, and moving toward a flanerie that informs other media and new forms of "writing" by way of images. The very beginnings of this

movement are nevertheless initiated by an intensive experience of new shocks in urban realities. For most German writers of the early nineteenth century, the pursuit of such novel experiences inevitably involves a journey to cities, and not just to any city but to Paris, the most advanced and pronouncedly modern city in Europe.[9] The very first texts of flanerie in German literature therefore often come in the shape of travel writing and urban letters from abroad.

One of the earliest traces of an art of flanerie in German literature can be found in the letters that Heinrich von Kleist wrote from his sojourns and excursions to Paris, and later to Berlin. These texts represent notes of a flanerie quasi *de negativo*, recorded by a disturbed and shocked observer who became a city traveller almost against his will. For the most part, Kleist deplores the effects of modernity, of a mobility that disturbs the travelling leisure of horse coaches and strolls in the countryside that he so often treasured and praised. He prefers to seek out sites that provide sweeping views of the city from above. Embedded in its landscape, the city becomes a cultural sign enshrined in nature. From the height of this removed perspective in May 1801, Kleist describes the sight of Dresden in its environs as an auratic work of art: "It lay there like a painting by Claude Lorrain beneath my feet . . . it seemed to me embroidered like a landscape onto a tapestry."[10] Although he still privileges static forms of art and a perception that is derived from the spaces and textures of eighteenth-century culture—paintings, tapestries, landscapes—his sensitivity favors a process of walking that functions more as an introspective stroll than as a walking reflection of his time in its contemporary images.[11] As Kleist suggests to Wilhelmine von Zenge, the recipient of one of his letters written in the early months of the year 1800: "If tomorrow you will not decline a stroll, I could find out from you what you judge and think about this step."[12] This process of walking moves decidedly within the confines and traditions of an eighteenth-century bourgeois society that expects to find its Enlightenment views reflected by the textures of the world. The members of this society set out on their expeditions in order to further civilized discourse, rather than to experience the changing and evolving life of their cities and times.[13] From this perspective, Kleist finds little pleasure in dwelling on the energy of the emerging metropolises of his times. In the fall of 1800, he considers Berlin to be merely a limited distraction for the traveller in transit: "For a short time, Berlin may please, for a long one not, not me."[14] More than a year later, the disenchanted Kleist continues his verdict against the cities of modernity, this time against the Paris which presents an undisputed attraction for his contemporaries. He declares even the capital of the nineteenth century to be devoid of stimuli that might resonate in his mind and interests: "Furthermore, Paris does not captivate me through anything at all."[15] While these statements formulate one of the last, if lasting, manifestations of a sensitivity that is decidedly indebted to an eighteenth-century experience, Kleist's letters already crossed paths with those of an avant-garde of German travellers who deliberately

sought out the city of lights in order to further and renew the illumination of their own times.

With this next generation of travelling writers came a wave of reporting from Paris by authors who moved quickly to capture and appreciate the more recent, often conflicting, and decidedly confusing stimuli of urban life with all of their newly liberated senses. Around the time of the July Revolution in 1830, these expatriate Germans began to understand the shifting signs of the city as indicators of political change and democratic possibilities in the liberal capital of their century. From the early nineteenth century on, their visual observations, working as a screen for cultural considerations, became an important and formative aspect of their journalistic writings. These sensitivities were partly evasive, since their literary production in Germany had been scrutinized and stifled by severe censoring measures in the wake of the *Karlsbader Beschlüsse* in 1819. As a direct reaction to such restrictive prescriptions, their emphasis on the phenomena of public surfaces and exterior realities may have involved a subversive intent. Scrutinizing even the most minute details of their society, they produced observations that were charged with political significance, even if they seemed initiated by or packaged in the guise of an interest in the marginal, the mundane, or the merely contemporary. In this way, a form of writing that emphasizes the visual focus of literature arose specifically from the authors of a liberal opposition, in response to the restoration and oppression of the first half of the nineteenth century. Evidence of the resistance that characterized this literary contingent, a generation of expatriate Germans at once political and cultural "flaneurs and chiffonniers,"[16] includes the writings of authors such as Heinrich Heine, Ludwig Börne, and early journalists in Paris. In 1835, the writer Ludolf Wienbarg called on his contemporaries to persist in their orientation toward the contemporary life of their times—"*Haltet euch an das Leben*"[17]—while Karl Gutzkow specifically called on his fellow authors to record the "images of the present," a revolutionary call aimed at reminding the public and audience of its "closest interests."[18]

The necessity for this participation in the public sphere was particularly realized by those foreign correspondents who reported on the new visual signs to be found everywhere, with a new sense of awe and amazement from the liberal capital of the latest revolutions. Defining themselves as writers and reporters, they consistently referred to each other as latent flaneurs in an unknown sphere. One of these journalists, Maximilian Donndorf, of the *Augsburger Allgemeine Zeitung*, was described above all as a "ragpicker on the news market,"[19] his colleague Heine addressing him as a "three-star chiffonnier" in the realm of the city and its drifting pieces of information. Benjamin would soon link this figure of the ragpicker or chiffonnier to that of the flaneur, a figure who scavenges for sights, who collects a plenitude of observations and subsists largely on his status as a public witness. The primacy of vision is evident here in the title of another writer's views on the ongoing revolutions in the French capital,

Johann Heinrich Schnitzler's self-declared *Extensive Report of an Eye Witness on the Last Events of the French Revolution*.[20] His documents, presumably from an observer of the new sites of change, satisfied an increasing hunger for the actualities and experiences of the time, for reports from a new political sphere in the streets. Another correspondent appears to follow similar impulses in declaring his intention to present his travels as a compendium of pictures from a different and diverse society, to describe in detail the housing conditions of Paris, and to render an illustrative signature of the daily conditions of another population in the spaces in which it lived. This francophile traveller and recorder—an observer with a particular interest in the nuances of the everyday and a physiognomic eye for the furnishings and architectural structures, for the interiors and exteriors of the daily life of a culture—has been known by a name that is nearly programmatic for this movement, Richard Otto *Spazier*. He and his contemporary precursors in flanerie delineated the close affinities that this sensitivity shares with the emerging modes of journalism and with its minute reporting of contemporary details. The frames that these authors chose for their journalistic work served to legitimize their dual pursuits: a productive practice of social research and an aesthetics that engages an entire palette of visual observations in the exterior reality of urban modernity.

One of the most prominent among these German flaneurs is Ludwig Börne, a liberal author who returned with his own, amply illustrative *Schilderungen aus Paris* (Depictions from Paris) in 1822. The text of this "Parisian reporter" approaches the city and its displays with the eyes of both a collector and a witness. Viewing the city from the angle of a politically and culturally oriented flanerie in a newly defined urban space, Börne arrives in the city as a flaneur, and he proceeds to write as one.[21] The self-proclaimed resident of Paris describes the strolls that he takes through his adopted city in great detail, scanning his surroundings street by street, scene by scene, sign by sign, shop by shop, window by window, and doing so with the freshness of a foreigner's first gaze. The text that he assembles from this kaleidoscope of impressions reflects the very obsessions that characterize an emerging flanerie: while the traveller encounters descriptions of tourist attractions such as Versailles, the Louvre, and the Tuileries, the flaneur balances them with equal care and attention for the nuances of the city. His collection of the details of gossip, statements, and facts forms a kind of journalistic *recherche* in the street.[22] While this professional move constitutes an important step toward the legitimization of the flaneur's idle strolling, as Benjamin will later register, Börne's early strolls also ascribe a larger textual significance to the art of taking a walk. The individual sections of Börne's *Schilderungen aus Paris* can in fact be read as an expository catalogue of the wide range of experiences that flaneurs will undergo again and again through the coming century. Enumerating the many diverse sites and phenomena of the city, his catalogue of experience is a precedent for the phenomenological and material terms of Benjamin's *Passagen-Werk*. Börne mem-

orizes his Paris according to such key terms and scenes as "The Stores," "The Place Grêve," "The Reading Cabinets," "The Street Notices [*Anschlagzettel*]," "The Industry Exhibition in the Louvre"; indeed, his survey of urban sensations is almost endless. Börne's effort to orient the multitudes of the modern city in spatial terms at the same time reveals an emerging visual predilection that works to form a critical perspective on these very phenomena. As the following passage suggests, this perspective involves the effort to register the new relations between economy and the display of its commodities: "This time, I will only mention a few of the sensory means which the commodity merchants use . . . to attract the shoppers [*Kauflustigen*]. It is a matter of a minute, of a step, to let the forces of attraction come into play. . . . One's eyes are being abducted as if with violence, one has to look up and stand still, until the gaze returns."[23] Börne's reflections on the new means of public presentation available to advertising already extend their focus toward the both violent and forceful political implications that the shocks of these commercial media of the street exert on the quiet stroller in their attempt to convert him into an active shopper. The image of an "abducted" [*entführt*] gaze returns in Heine's writings with his observations on the "blinded" [*geblendet*] gaze of the consumer.[24] These writers were among the first to register their fascination with, as well as their reservations about, the realities of modern capitalism, whose phenomena change their shapes and structures as rapidly as the conditions they seek to adapt. With their early focus on new techniques of advertising, their explicit reflection on the beginnings of capitalism in its surface phenomena, Heine and Börne became representatives of a flanerie that turns toward the critical scrutiny of the images in their respective realities. They interpreted these images as documents of a modern society in the process of formation, and sought to reflect as many of the features of these images as they can capture in their illustrative texts. Turning toward the streets and its images, Börne arrived at an aesthetics that perceives the realities of the street as a text that always already formulates itself: "Paris is to be called an unfolded book, wandering through its streets means *reading*. In this instructive [*lehrreich*] and delightful [*ergötzlich*] work, illustrated in such plenitude with images true to nature [*naturtreu*], I browse every day for several hours."[25]

Significantly, Börne declared this mode of flanerie to be an "art" of new realities, arguing that these presumably unstructured and mundane processes coincide precisely with the classical definition of the functions of art: to be useful and pleasurable. This one glance at an art negotiating new realities, articulated in terms of visual perception, reveals the larger poetics of Börne's and Heine's texts of the city, texts that formulated an art of "seeing as reading" that would reach its epitome in Benjamin's fragmentary maxim that "perception is reading."[26] These underlying textual dispositions of modernity suggest a textual model for the concept and perception of reality, a reality that since the early years of the nineteenth century had increasingly reinvented itself as

a surface of reading with its quasi-fictional attention to commodities and commercial aspects, traffic scenes, and other images of a civilization in the street. This expanding text of exterior reality, the city with its multiple stimuli, its multiplying shocks and signs, shapes the accompanying means and media that register and render these multiple and multiplying images. These new optics begin to formulate forms of visual discourse that are flexible and sensitive enough to approach these new spheres and to continue changing with them.

As a "reading" of the street, flanerie represents the primary principle of a larger poetics that Börne's text of the city reveals. Beyond the "far-reaching lack of structure"[27] that critics have seen in his seemingly aimless approach to the work of description, enumeration, and classification, Börne demonstrates an awareness of the theoretical implications of his new metaphor of the text. His understanding of modernity as a book of consecutive pages through which one can "browse" [blättern]—a text that is experienced in passing as a series of contingent images—displays this diversity as a visual experience that literally evokes the images of the protofilmic Blätterbücher that Benjamin sees as the precursors to early cinema.[28] Börne's aesthetic metaphor of the "book of the street" therefore reaches far into the next century, viewing streets, films, and other visual phenomena as extended definitions of the text. The "textual metaphor" of which Börne's approach speaks—an approach in which the city and its streets figure as texts of reality in their own right—unfolds its program as a way of walking that names a process of reading, thereby anticipating in great detail the approaches to flanerie that some of the most pronounced flaneurs will replicate in twentieth-century Berlin.[29]

Subsequent journalistic accounts of the capital of the nineteenth century can be found in many of Börne's, Heine's, and Spazier's writings, contributing to an entire genre of city texts and travel reports that proliferate between 1830 and 1850. These texts and reports constitute an emerging genre that represents the literary and aesthetic equivalent to an age of increasing industrialization. They enter the literary market as local accounts of the city and provide informed guidance to its ever-expanding possibilities. A form of "survival manual," these texts will accompany the city's inhabitants through new and unknown, therefore uncanny and largely threatening spaces. These so-called "physiologies" aim at opening the eyes of a populace in order to heighten its perception of the shifting contours of the city at a time when its many locales threaten to become distant and increasingly foreign territories.[30] This need to refamiliarize oneself with the aspects of a changing, redefined, and ever more fragmented environment is apparent in fractured titles such as Paris la nuit, Paris à table, Paris dans l'eau, all of which suggest the new definition of the modern urban sphere to which Benjamin will return in his search for the prehistory of modernity's textual formations. At the same time, these urban eyewitness reports also reflect an immediate fascination with the technical innova-

tions that are changing perception and expanding the city for all time. These walking physiologists are particularly attracted to the spectacle of new forms of lighting. Their sense of excitement, illuminating the sense of space at work within their physiologies, can be read in texts such as *Paris en Gaz*, or *Paris bei Sonnenschein und Lampenlicht* (Parts by Sunshine and Lamplight). The lights of the city appear particularly new and exhilarating to one female flaneur by the—nearly "utopian"—name of Emma von *Niendorf*, a woman who revels in her new-found freedoms with exceptional candor, and whose early account of female flanerie, *Aus dem heutigen Paris* (Out of Recent Paris, 1854), is obsessed with phenomena of light and illumination. While all of these authors collect their observations of the city as they stroll its streets, they still seek to contain the "subjectivity" of their experience within the measure of presumed "objectivity" required by the conventions of the travel guide and his genre.

SCOPOPHILIA IN BERLIN

A similar sensitivity toward the conditions of observation and perception was already evident in certain narrative forms in the capital of an evolving modern Germany. E.T.A. Hoffmann was one of the first writers in Berlin who combined the traveller's tableaux of the city with the mystery provided by the physiologists. Exploring the figures of his imagination within the multifold attractions that the streets present to him, he guides his reader to the point of sensory confusion and intellectual disturbance. While Hoffmann's work is often considered to be of a presumably bygone, Romantic age, his texts are riddled with the flaneurs of early modernity, who enter his writings in their very real, material, and contemporary spaces. These figures search out the secrets and mysteries inherent in the limits of an expanding civilization of the everyday. They explore the mystery and miracle of the modern city rather than retreat to any romanticized sense of nature. The protagonist of Hoffmann's tale *Das öde Haus* (The Deserted House) undergoes these processes in exemplary ways.[31] Exposed to an uncanny place located in the very midst of the main promenade of modern Berlin, Unter den Linden, this urban character explicitly professes his "old inclination often to walk alone through the streets, and to delight in every copper engraving on display, every attached notice, or to look at the figures that encountered me, even to posit some of their horoscopes in my mind" (*DH*, 45). Hoffmann's narrator speaks from a position that is also inhabited by the obsessions of flanerie, by a declared desire to "read" the faces of passersby and to decipher the mysteries of his age from the images of store fronts, façades, and street signs. Taking its point of departure from the close observation of an urban haunt beset by unknown mysteries, the title's promise of a deserted location on an otherwise busy street unfolds according to the visual logic of an action that never moves too far from its stationary

focus. This view from a bench on one of the prominent promenades of modern Berlin indeed assumes the intensity of a camera's long take, allowing the extended scrutiny of Unter den Linden, a boulevard that is favored by well-to-do flaneurs and, as the narrator observes, "a public privileged by status or wealth to enjoy the more sumptuous pleasures of life." As a narrating observer, he does not participate in this particular society, but instead works to discern one of its more somber constructions and foreboding abodes. Taking a view that transcends its romantic mysticism, the main action of the text really focuses on a visual obsession that emanates from the façades and transactions surrounding the house under observation. The narrator goes so far as to comment explicitly on his increasing visual fixation, suggesting that he is beset by a virtual "case of staring addiction" [*Starrsucht*] (*DH*, 58). As the character increasingly falls under the spell of these spatial mysteries, he literally can no longer (re)move his gaze from the mirror that reflects the objects of modernity's visual desire.

This intense scopophilia also provides the point of departure for Hoffmann's tale of *Des Vetters Eckfenster* (The Cousin's Corner-Window), a story that introduces what is at first glance the paradoxical variant of a stationary flaneur, a figure who gazes on the scenes of a Berlin marketplace from the height of his corner window. A kind of "cousin" to the flaneur, he presents himself as a transfixed voyeur who compensates with the swiftness of his eyes for what he has lost in the use of his feet. At first a lesser cousin—superficially the personification of an anti-flaneur—Hoffmann ascribes to this persona all of the dispositions that would belong to the city-flaneur. Only his view from the corner window of his narrow confines, looking out "upon the complete panorama of this grandiose place" (*VE*, 598), can release him from a prevailing sense of melancholy. While Hoffmann's tale has often been regarded as primarily a sequence of romantic sketches and scurrilous types, the succession of images in this narrative of perception unfolds as a programmatic introduction to flanerie, as a declared initiation into "the principles of the art of looking."[32]

The narrator presents himself as a character who is until now inexperienced in the pursuit of aimless scopophilia. As he notes in one of his first responses: "Such a sight . . . might easily cause a minor intoxication in excitable persons which might not be dissimilar from the deliria of approaching dreams" (*VE*, 599). As early as 1822, Hoffmann's text anticipates the delirious trance-like quality of the city, which Benjamin will name the "shock" of the streets, the very reverie of urban experience that will move Baudelaire to experience the city as a dream-scape of subjective *féeries*. While Hoffmann's "cousin" initiates the narrator into ever more refined forms of the "art of looking," he explicitly declares this process of seeing to be his aesthetic project: "The fixation of the gaze engenders clearer viewings." This view remains within the tradition of physiology as the characters watch what they call "outstanding physiognomies" from their window and interpret them with an eye toward their "skilled

physiognomics." Their close attention moves from the movement of a passing woman to the circumstances that might be shrouding the "exotic figure" cast by a man in an "outmoded suit." Throughout the text, they try to imagine suitable narratives for the pedestrians, whom they envision as characters or types in their own plots—"I call this person . . . the furious housewife" (*VE*, 601), one of them notes. Such early conversations on the literary implications of public perception already suggest, in the wording of Benjamin, the "flaneur's phantasmagoria: the reading of professions, backgrounds, and characters from faces." Such a reading may also unfold as an interpretive sketch that shifts the contours of the figure in focus, as can be seen in the following example: "So I recreated the disgusting, cynical German drawing master in an instant into a comfortable, French pastry baker, and I believe that his exterior, his entire demeanor follows suit just fine" (*VE*, 612). Hoffmann "recreates" his text as a collage of perception, arranging and rearranging his impressions into a sequence of oscillating images, superimpositions that observe the principles of seeing and give primacy to the visual domain. Initiating an even younger character into the reading of physiognomy and the interpretation of passersby by way of their appearance, Hoffmann's "cousin" suggests that this process of perception is predicated on an understanding of the privileged moment of seeing, an *Augenblick* that names the moment of insight in which he perceives external appearance to be a "true representation of life's eternal change."[33] This formulation makes apparent how a slight shift in focus can redirect physiological descriptions of the city from an imaginary narrative of observation to the observant record of an exterior public, and on toward a critical reflection of the public sphere and its cultural and social conditions.

One example of such an application of the principles of physiology on the political and social conditions of public life in Berlin can be found in a "socialist *Reportage*"[34] by Ernst Dronke. Entitled *Berlin* (1846), this extended study of city life focuses on the political aspects of Prussian society: government structures and parties, the role of the proletariat, the police state, and the judicial system. Dronke's focus on the political structure is framed by observations from the public sphere and, in particular, by two chapters that dwell significantly on the spaces of flanerie under the headings "In the Streets" and "Public Life." This early text on Berlin follows the lines of city tableaux generally associated with Paris while at the same time pursuing its own course as one of the first documents of flanerie in Berlin. Dronke opens his text with a space that will later become significant for filmic approaches to Berlin: the tracks of the newest medium of transportation in modernity, the railroads. In one particularly futuristic take, Dronke's reporter even raises his gaze to look upon the spread of urbanity in a panoramic, fictitious "bird's-eye perspective" (*B*, 6), high above the big city. Prefiguring the moves of urban symphonies with their tracking and aerial shots, these instances of observation reconcile the

foundations of flanerie in the nineteenth century with new codes of vision yet to come.[35] Like his contemporaries in Paris, Dronke remains convinced that "physiognomy is the mirror of the soul" (*B*, 11). He not only reads the stories of passersby from their faces but also the very appearance of the city as a text from which to read a history in the streets.[36] Critically and attentively "reading" the background and prospects of passing pedestrians while he emphasizes the didactic purposes of his intense scrutiny, Dronke asserts: "It is instructive for the calm observer to stroll the *trottoirs* [sidewalks] and study the physiognomies." With one foot in a passing age of Enlightenment, this reference to a literature of *prodesse et delectare* tends to characterize the flaneur's stand throughout the nineteenth century and into the Weimar Republic.

Dronke proceeds primarily to describe the marginal existences of city life: the characteristic figures of Berlin's corner-idlers [*Eckensteher*], students walking with streetwalkers on sidewalks, privileged "idle strollers" [*Müßiggänger*] in the streets by day, or the even more leisurely "late night-birds" [*späte Nachtvögel*] (*B*, 10) under the cover of darkness.[37] Evoking a topos that is to become a constant in comments on the dynamics of life in Berlin, Dronke casts a piercing eye on this leisure society of metropolitan flaneurs: "Berlin is full of people who only live here in pursuit of their own pleasure [*vergnügungshalber*]."[38] If Dronke views Berlin as a scene of diverse cultures, it is in part because of the availability of a site in which both an observation of others and a presentation of the self can occur. "The sidewalks are as if ready-made for the purpose of strolling" (*B*, 43), he comments on the material conditions for the art of taking a walk. These conditions are reinforced for Dronke because Berlin also provides "a variety of excellent institutions serving the pleasure of the leisure class"—restaurants, pubs, and cafés all serve as windows of observation over a public street life that is increasingly defined by the visual phenomena of modernity: "The *affiches* [large posters] that one sees attached at all street corners and public places, offer the news to the public in the most screaming and most resounding expressions. In immense letters that one can discern and read from hundred steps away, they shine over the distance."[39]

These early forms of advertising translate Börne's textual metaphor into highly concrete texts with a very distinct, economically circumscribed function. The project of "reading" the city as an unfolding book becomes an ever-present factor in all daily walks of life and one that can no longer be overlooked. Commercial posters transmit the first signs of a semiotics of the street that calls attention to itself as a visual "language" in its own right, a language whose paradoxical appeal is explicitly highlighted by Dronke's rhetoric: "Thus it *screams* its messages from whatever corner, even from the trees on the promenades, in its *mute* and gigantic letters."[40] The shocks of modernity unfold into a scream in the street, a call for attention that can be "overheard," so to speak, in visual terms.[41] Its resonant appeal becomes visible again in Dronke's nearly

speechless attempt to mimic the spellbinding effects of the city's stimuli: "It is—it is—it is—Yes, it is so many things, it is the big city. Therein consists the entire secret of the great attraction which life in this city holds for everyone and everywhere. Life in a big city is always stimulating, if only because it is multidimensional [*vielseitig*] and multifaceted" (*B*, 13). This formulation prefigures in stunning detail some of the observations on urban anonymity and its psychosocial dynamics that Georg Simmel will describe over fifty years later as a process of differentiation in his seminal essay on "The Metropolis and Mental Life." Before the bourgeois intellectual would redeem the differentiated sociological qualities of this "intellectual" life [*Geistesleben*] of the city from the reactionary critiques of modern civilization, the socialist flaneur Dronke already displayed a large measure of appreciation for the new pluralities of the metropolis unfolding before his eyes.

MODERNITY'S CITIES

Contemporary scenarios of the big city were experienced in Paris and increasingly in Berlin, giving vision and voice to an ever-multiplying number of literary formulations for the city's attractions and mysteries and to a modern genre that encompassed a wide range of European cities. In particular, the writings of Edgar Allan Poe and Charles Baudelaire became visible influences on German literary and theoretical thought. Benjamin included them in his writings on the "heroes of the modern age," writings which trace the flaneur in literature as a poetic successor to the physiologist in the city. Poe's stories of the inquisitive detective conjure the secrets of the anonymous masses and take their course on the infinite streets of modern cities. The very titles of these tales bear witness to the altered nature of experience in the city, ranging from "The Man in the Crowd" to "The Murders in the Rue Morgue." "The crowd" and "the street" name the formative sites where modernity is constructed and its secrets wait to be investigated, to become illuminated by a sense of simultaneous curiosity, wonder, and terror. As Poe's tales describe activities that are commonly ascribed to the detective, they also focus on what Benjamin calls the x-ray image of both prototypes of the detective story and patterns of modernity that figure in the process of flanerie: the pursuer, the crowd, the stranger. Strolling and observing, the flaneur is therefore a kind of detective of the streets who, by his association with the suspicious circumstances of the public sphere, comes to be regarded as a conspicuous presence in the crowd himself. The detective approaches the secrets of the city from a double, and often ambivalent, perspective that circumscribes the flaneur's existence as well: moving in the streets as an active, observing camera, he becomes a screen on which he projects himself as an observed medium of modernity.

We should add here that for many of these male authors—whether they be flaneurs, voyeurs, or detectives—the visual pursuit of the evasive and conflicting aspects of the city becomes personified above all in the figure of the woman who passes in the street. The *Augenblick* takes on the face of an attraction that is embodied in the momentary *passante*, a focal image for the transitoriness of a street life that Benjamin reads in the writings of Charles Baudelaire as a paradigm of modern experience and perception. Baudelaire's sonnet "A une passante" (1857) introduces an important literary manifestation of this evasive experience, an experience that produces a shock in the city crowd that is both sensory and sensuous in every sense of the word.[42] The passing moment of perception and desire evaporates in a sense of retrospective melancholy that leaves an indelible trace of memory, which in turn enables a transitory illumination, an epiphany of the everyday in the street. Baudelaire expresses similar epiphanies in a cycle of poems that is dedicated to this fleeting mode of urban perception. His *Tableaux parisiens* present the city as a veritable landscape of vision, a *paysage* of modernity. He is one of the first modern authors to crystallize the aesthetic qualities of the "chaos des vivantes cités," that is, to awaken the city as a character in its own right: "Paris, en se frottant les yeux,"[43] he writes. As Poe's narrative mysteries cast a certain light and attention on the urban atmosphere, Baudelaire's poetic evocations view the dusk of the cities as a suggestive and suspicious veil, with light providing an "ami du criminel," acting "comme un complice." Night and twilight provide the appropriate circumstances for a series of suspicious elements, including the drifting strollers and flaneurs of modernity.

Above all, Baudelaire conveys a sense of the city as a site of dreams and poetic trance that is encapsulated in the "dream-sleep" that Benjamin will associate with his Paris, "the capital of the nineteenth century." For Baudelaire, his contemporary city already appears as a "cité pleine des rêves, où le spectre en plein jour raccroche le passant." Born from all the unforeseeable secrets and shocks that surround his senses, the kaleidoscopic city leaves whoever observes its poetics startled and stimulated, "blessé par le mystère et l'absurdité." The poet, as Baudelaire defines him(self), surrenders his sensitivity to an avalanche of impressions that include images of absurdity and surreality. He experiences himself with all of his senses as an "architecte de mes féeries," a builder of dreams who assembles all of the phenomena of reality into a constitutive metaphor of modernity—"tout pour moi devient allégorie." Literature becomes a medium that enables the transformation of his melancholy by projecting it upon his perceptions of modernity. This expansion of literary space in turn lets us view even the seeming banalities of modernity as poetic matter: the everyday vocabulary of the street life, even its very "fracas roulait des omnibus," becomes poetry. Slices of life in the city, these banalities become images that are flexible and expansive enough to incorporate the objects of the city's new experiences. Surrounded by the dawn of modernity, Baudelaire sees its poetry

rising to the occasion like a sun that comes to illuminate all of its phenomena alike: the poet of the everyday, like the sun every day, "descend dans les villes. Il ennoblit le sort des choses les plus viles."

This profane illumination in the medium of urban poetics casts its light on the many aspects and cultures of modernity. In the same year when "A une passante" first appeared as a text in the spaces of modernity, yet another poetic trace of urban life emerged, one that may not be as far removed from Baude-laire's experience of the city as a traditional historiography of literature would have it.[44] While Wilhelm Raabe's *Die Chronik der Sperlingsgasse* (The Chronicles of Sparrow Lane, 1857) has been considered part of a realist poetics very different from Baudelaire's modern images, this "chronicle" of a "lane" also views the city as an unfolding fiction. Like the literature of flanerie, Raabe's text experiences the modern environs as one would a text, contemplating the city's structures as a "picture book" (*CS*, 5) of fleeting images. Raabe's writing seeks to reflect these images "in a colorful sequence," to transmit in his textual experience the "ever changing, ever new pictures of this great picture book called 'world' " (*CS*, 6). Joining authors of flanerie who in the long run would prove to be more innovative modernists, Raabe fragments his world and its views from the closed continuum of a central narrative perspective into a kalei-doscope of singular images, which refract the whole of the novel into a shifting "chronicle" of constellations and descriptions made up of these very images.[45] Raabe's narrator insists on the decided novelty of his narrative choice, as he declares, "I am not writing a novel" (*CS*, 8). Previous notions of traditional plot begin to give way here to a rendering of images in their own right in the course of being perceived. The street as it is takes precedence over the construction of other story lines. The very spatiality of the modern city gives form to the narrative and structure of his book. Indeed, as Volker Klotz has observed, the main stimulants of the action are the book's localities.[46] Dis-playing these sites as important stations of a "plot" that is redefined in terms of walks through the city, Raabe's text prefigures the visual experience of many later modern flaneurs and matches the aesthetics of even their most spatially inspired texts.[47]

Raabe chooses "a street that tells its own chronicle" as the point of departure for his narrative. This shift of focus necessarily changes its narrator into a reader who is called on to decipher the city's streets and façades, forms that after Börne's Paris can be understood as an "unfolded book" of modernity. For Raabe's protagonists, the city presents this public text as an "invaluable stage of the life of the world," a performance and presentation of figures, shadows, and attractions within the process of their perception. Despite the decided limi-tations involved in approaching the relatively sedate Berlin of the 1880s as a future metropolis—and especially before the turn-of-the-century's increasing construction and population—Raabe's close look at the public life of one street

helps him transcend the very microcosm of this "Sperlingsgasse."[48] This hidden "lane" in fact provides an avenue of flight for the everyday imagination of his time, a minute model of modern street life that "is populous and vivacious enough to drive someone prone to nervous headaches crazy and into the insane asylum." The very sensitivity to the shocks of the street that Benjamin will declare as symptomatic of modern experience is already present in this text. Registering the dizzying quality of life in the street, Raabe records what has been a distinct presence in the literature of flanerie since Hoffmann's "cousin." Even though he still balances his multiple impressions via a form that maintains the illusion of an idyllic locale, the city also appears as an already fragmented and increasingly ambiguous "dream-and picture book" (*CS*, 12). Announcing an addiction—albeit a moderate one—to the dreams induced by these images, Raabe proves himself to be yet another precursor of a literature of flanerie—albeit a sedentary and still limited one.

The art of taking a walk becomes further differentiated as modernity takes its course and the twentieth century approaches. It increasingly influences the works of a variety of modern authors, among them Edouard Dujardin in the Paris of the 1880s, and Franz Hessel in Berlin before World War I and during the Weimar Republic. Dujardin's *Les Lauriers sont coupés* closely follows the path sketched out by Raabe's tranquil reflections on the city and does so in a leisurely style projected upon the grander scene of the dandy in Paris.[49] Though his protagonist promenades through a considerably more metropolitan space and does not limit himself to the life of a single street, he still prefers to dwell on the aesthetic and sensory impressions that he encounters amidst the bustling city life. With his techniques for bringing together his inner monologue and exterior perception, Dujardin helped to shape the trajectory of modern narratives. His mental experiments and visual inquiries in fact anticipated a modernist aesthetics that we often associate with James Joyce.[50] In its subject matter, however, Dujardin's text continues to reflect the exterior images that for him envelop the secret attractions of the city: the shadows of trees projected on street walls, nuances of color patterning urban façades, and circles of illumination cast by the light of gas lanterns. These images often beckon the narrator into the narrow side alleys of the city. Visual signs of the transition into modern reality, they at the same time preserve their origins in a calmer and more contemplative era.

Pursuing an ever-expanding history of flanerie along its many distinct stations throughout the twentieth century, I will focus particularly on the writings and walkings of Benjamin's friend Franz Hessel, from the time of World War I to the final years of the Weimar Republic, from Berlin to Paris via Munich, and back to Berlin in the posthumously published writings of a flaneur's exile in Paris.[51] In his novel trilogy, he understands the unfolding metropolises of his century as specific places in time that are populated by a public and culture

particularly receptive to its images. The Munich of his student years and home of the Schwabing *bohème* is experienced as a treasure chest of sensual sensations, a veritable *Kramladen des Glücks* (Junk Store of Happiness). The privilege of Munich is transferred to his *Pariser Romanze* (Paris Romance) and, in the course of the Weimar Republic, these modes of perceiving the city lead to an extended exploration of the mysteries of its capital, *Heimliches Berlin* (Secret Berlin). This site of secrets is revealed, according to Hessel, by looking at its transient scenes and illuminated boulevards, by sudden perspectives into side streets and oblique insights into the public sphere. Among the multitude of contemporary texts seeking to capture the experience of the city in a time of transit and transition, motion and movement, Alfred Döblin's grand epos of the city, *Berlin Alexanderplatz*, is perhaps the most prominent, although it stands in close proximity to a lesser-known, but similarly grandiose and shockingly surrealist vision of the city, Paul Gurk's *Berlin. The Novel of the City*. Gurk's novel conjures an expansive metropolitan view that includes signs of a rare German surrealism in literature. In its daring textual design and construction, this oeuvre of Berlin approximates the visual excesses of Louis Aragon's text on the Paris arcades, *Le Paysan de Paris*. Aragon's and Gurk's manic monuments to their respective cities explore these urban "landscapes" in ways that evoke locations of absurd and astounding images, avenues of wonder and bewilderment that allow the horizon of flanerie to expand to the margins of surrealism.

Sharing the time of these novel images of modernity, the space of the street assumes the status of a pivotal cultural location for contemporary theoretical thought and philosophical reflection. In the year after Hessel directed our attention to a secret Berlin, Benjamin turned the spatial locations of the city into the autobiographical stations of philosophical passages in his assembly of texts called *Einbahnstraße* (One-Way Street, 1928). Benjamin will go on to unfold an early history of flanerie by reading its many cultural and historical, psychological and philosophical aspects in his "The Paris of the Second Empire in Baudelaire," a series of readings in cultural theory and philosophy that he assembled from the numerous fragments and quotations collected in the nineteenth-century public sphere of the *Paris Arcades*. In the year following his *Einbahnstraße*, Benjamin discovered a distinct "return of the flaneur" in Hessel's collection of sketches on the scenes and streets of the city, entitled *Spazieren in Berlin*, and in so doing, declared the reappearance of this important type as characteristic of his time. As a modern sensibility, flanerie is not limited to any particular series of written texts. The image of the street in fact functions as a formative figure of thought in contemporary reflections of modern culture such as the *Kino-Debatte*, a series of extended Weimar debates around the cinema as its newest medium of vision.[52] Nevertheless, Hessel, the author around whom this study is primarily organized, was among the first to take

the decisive steps toward an aesthetic theory of flanerie in his feuilletonistic reflection *Von der schwierigen Kunst spazieren zu gehen* (On the Difficult Art of Taking a Walk). One hundred years after Börne introduced the topos of "reading the street," Hessel's walkings and writings of the city revisited this trope in his pursuit of the cultural and material foundations of modernity.

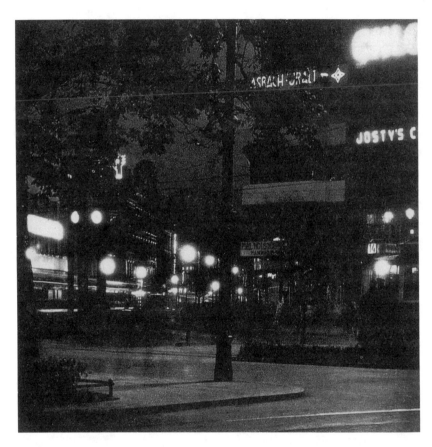

Mario von Bucovich, "Potsdamer Platz" (Potsdam Square). Courtesy of
Marquand Library.

The City of Modernity: Shifting
Perspectives, Urban Transitions

THE RISE of flanerie follows on the heels of the emergence of the city as a territory meant to be traversed. The primary importance of urban space to this movement requires that we consider a number of crucial steps in the innovation and modernity of this new setting.[1] The city of modernity comes with its own specific innovations of environs, living conditions, and human inhabitants. Within this vast and increasingly complex conglomerate of people and styles, we can differentiate certain characteristic social types—among them, the particularly rarified and aestheticized, style-conscious and visually-obsessed types of the dandy, the snob, and the flaneur.[2] The figure of the flaneur shares an aesthetic articulation with the dandy and the snob; yet he emerges not from the stylization of his own appearance but rather from the seemingly disinterested, yet highly visually invested perception of the styles of others. The city and its many modern realities are both the catalyst and the representation of an innovative inventory of images, a spectacle of new phenomena and unseen sensations. This visual dynamics allows us to see the emergence of the flaneur as a direct function of the multiple differentiations that the exterior surfaces of modern cities reflect.

Georg Simmel's treatise "The Metropolis and Mental Life" (1903), one of the first studies to approach the city in order to scrutinize its new living conditions, can be read as a text that classifies this type of modernity.[3] In addition to the value of its sociological observations, Simmel's text touches closely on some of the premises and rhetoric of flanerie.[4] Characterizing life in the city in terms of its evolution after the turn of the century, Simmel chooses not to condemn these changes. Rather, he understands the city's development in terms of the following eminent factors: first, the fundamentally new quality of life that results from new technologies and forms of industrialization; and second, the material and intellectual innovations that, changing these living conditions, thereby condition the development of humans subjected to them. As Simmel explains, "The psychological foundation upon which the metropolitan individuality is erected, is the *intensification* of emotional life [*Nervenleben*] due to the swift and continuous shift of external and internal *stimuli*."[5] Locating the fundamental, quantitative and qualitative difference between modern cities and previous forms of human organization in a psychological shift of perception, Simmel traces this shift back to the quickly multiplying phenomena to be

discerned. This process of nervous, or sensory, intensification brings humans to define themselves increasingly as visual sensitivities subjected to an array of unforeseeable exterior stimuli within their environment and culture. Simmel defines this new metropolitan existence as an *Unterschiedswesen* that is both uniquely capable of and susceptible to the perceiving of difference, a creature "whose existence is dependent on differences." The very increase of stimuli refashions previous responses to the world into a form of perception that is now asked to take in and process the expanding mass of modern stimuli. The "rapid telescoping of changing images" that characterizes modernity therefore has a significant effect upon what Simmel calls the mental life [*Geistesleben*] of his times:

> To the extent that the metropolis creates these psychological conditions—with every crossing of the street, with the tempo and multiplicity of economic, occupational, and social life—it creates in the sensory foundations of mental life, and in the degree of awareness necessitated by our organization as creatures dependent on differences, a deep contrast with the slower, more habitual, more smoothly flowing rhythm of the sensory-mental phase of small town and rural existence. (*M*, 325)

His definition of the changing conditions of modernity puts its emphasis on factors that are constitutive of and derived from an aesthetics and perception of the city. Faced with an enormous number of rapidly changing images, the inhabitant of modernity experiences the visual domain as a primary factor in the quality of his urban life. With every walk across the street, public space is realized as the central location wherein a perception of its phenomena must be situated. Simmel suggests that these images are provided by the streets. As the primary source of images, streets name the site of an ever increasing, mutually reinforcing kaleidoscope of the city. This dynamics multiplies the expanding visual aspects of modern reality as they begin to manifest themselves not only in advertisements, billboards, posters, placards, store signs, shop fronts, and display windows but also in the multitude of commodity forms and shapes, fashions and architectures that the city offers in its sights and its traffic.

Some of the first documents to describe this new impact of the streets and their sensory stimuli include Heinrich von Kleist's letters from Paris, a city which he encounters as the most rapidly expanding metropolis of his times. On July 29, 1801, in the meandering syntax of a single sentence—that is to say, in one extended breath of perception—Kleist writes in one of his travel letters about Paris:

> Ever so often, I am walking through the streets, my eyes wide open, and I see—lots of ludicrous, even more abominable things, and eventually something beautiful. I walk through the long, crooked, narrow . . . streets redolent with the smells of a thousand disgusting fumes, along the narrow but high houses . . . almost as if to

multiply the location. I twist myself through heaps of humans, screaming, running, panting, pushing each other, hitting, and turning around without complaining, I look at someone, he looks back . . . and we will both have forgotten about each other before we turn the corner.[6]

In its own particular mode of disenchantment, this letter offers an—inverted—document of early flanerie. Kleist is exposed to this fast and surface-oriented mode of perception, even as he resists being drawn into it. Yet even the introverted German poet who feels violated by the overwhelming exteriority of shocks in the city will traverse this new reality "with [his] eyes wide open." Even he perceives—almost against his will—the ever increasing plurality of sensory impressions that his eyes and body experience in the social kaleidoscope of the passing crowd. The modern tendency to "multiply the location," as Kleist puts it, will return in Simmel's theory of the city as a location that engages in this "intensification" of sensory life [Nervenleben]. By adding ever newer stimuli, and expanding them even further through the extended means of technological amplification—print, electricity, and rapid transit, for example—this quantitive increase results in a distinct and innovative quality of sensation. In Simmel's view, this increase of sensory stimuli affects the psychological constitutions that receive them. It stimulates them to react and to analyze, effecting what he terms "the essentially intellectualist character of the mental life of the metropolis." This "blasé attitude" (M, 329) results from a defense against the myriad of stimuli received, a reaction that assumes a protective stance against an imposing overload of facts and contacts.[7] This intellectualized response also reflects the increasingly wider differentiation and greater sophistication of stimuli as they are received and recorded, a process that unfolds in ever more variant and extravagant styles of urban fashions and modes of interaction, habits, attires, and lifestyles.

Simmel claims that these urban dispositions in the city's mental life may correspond to three distinct types of "social characters" [Sozialcharaktere] in modernity: a mode of eccentricity and sophistication that can be aligned with the dandy's exterior habits, a stance of blasé urbanity that characterizes the attitudes of the snob, and an approach that registers the sensory traces of perception and belongs to the flaneur, whose intellectual approach to modernity distinguishes him from the sophistication and urbanity of the first two types. The materials of observation that are encountered in the process of flanerie participate, according to Simmel, in all levels of the city's existence. The flaneur engages in a spectacle of dandyism that expands his field of vision with an increasing sense of differentiation. On the other hand, the very selectivity, freely roaming leisure, and overall lack of purpose that characterize his gaze—one not bound by economic direction—reflect a certain "indifference" that borders on what Simmel calls "blasé." While these traits indicate his pivotal modern disposition, the flaneur can also be defined as an outsider, a resistant

reader of his own modernity, a mere observer who does not accept the period's declared sense of functionalization and "objectivity" of purpose, what Simmel describes as a "purely matter-of-fact attitude in the treatment of persons and things" (*M*, 326). The flaneur's attention to details and images keeps him from the state of indifference "to all things personal [*alles Individuelle*]" that Simmel sees as another constitutive sign of modernity. His openness to the perception of stimuli and associations leads to the high degree of sensitization that defines his project. With all of his being, he refuses to participate in a modern system of productivity and rational labor that orients itself according to the values of usefulness and marketability. As Benjamin notes: "The flaneur's leisure is a demonstration against the division of labor."[8] If the flaneur views the general system of labor from the safety of a certain distance, the "work" of his flanerie is organized not along lines of clear rationality, but according to a spontaneous, unmitigated, and seemingly unsystematic turn of attention toward the surface phenomena of the exterior world.

The flaneur does not participate in the dominant processes of the market, "which reduces all quality and individuality to a purely quantitative level" (*M*, 326). He resists these modern developments with his drifting and shifting, deliberately nonjudgmental and noncalculatory existence.[9] He proceeds to redeem the very materiality and quality of the objects and moments of modernity through a process of walking that comes with an intense concentration of attentiveness. By orienting himself toward all the details of his perception, on the other hand, the flaneur also participates in the very "precision" that Simmel defines as yet another characteristic of city existence. Its "exact punctuality" (*M*, 328), however, is defied by the flaneur. Viewing time as a continuum for his unmeasured drifting, he uses his time deliberately and generously. A kind of ambiguous kaleidoscope that brings together an obsessive attention to detail with a distinct defiance of modern exactitude, the flaneur works to resist some of the constrictions of capitalist modernity. The ambivalence of his perception and the errancy of his movement redefine the characteristic mode of modernity which, according to Simmel, consists in the "exclusion of those irrational, instinctive, sovereign human traits and impulses which originally seek to determine the form of life from within instead of receiving it from the outside in a general, schematically precise form" (*M*, 328ff). Flanerie is characterized by its very receptive disposition, a mode of embracing rather than of excluding external impulses. Refusing to go along with given interpretations of the impressions that he receives, the flaneur insists on the free range of a subjective gaze that leads him to an unprecedented experience of unforeseeable phenomena. Privileging perception and freedom of movement, he defines a site and perspective of resistance that perseveres in the anonymous presence of modernity.

Still the flaneur can be associated with what Simmel understands as the "blasé" character of modern man. He does not, however, condemn the "imper-

sonality" of modern life as a deplorable deviation from a more personalized past but rather perceives it as an inevitable "consequence of those rapidly shifting stimulations of the nerves" (*M*, 329) that the individual encounters in its modern environs. This impersonality, he suggests, appears primarily as a protective reaction, one that is aimed at decreasing the vulnerability and susceptibility of modern man to the proliferation of objects and phenomena. The differentiated character of Simmel's approach to this stance of resistance comes into relief when contrasted with the first experiences of his contemporaries, who begin to encounter these emerging "metropolitan" developments. One of the earliest reactions against such an experience of the city in German literature is again provided by Kleist's letters from Paris. On July 18, 1801, he notes the new social dynamics that accompany this shift in human interactions, this seeming increase in indifference:

> In the city men are too scheming . . . to be true. Actors, that is what they are. . . . Coldly one passes the other; one winds one's way in the streets through a heap of people who are nothing but indifferent to their own kin; before one has grasped an appearance, it is already surpassed by ten others . . . one exchanges kind greetings, but here the heart is of no use whatsoever.[10]

Kleist comes to the city as an early visitor only to leave its modern realms in a state of alienation. Alienated by the multiplicities of "appearance," he rejects them on the grounds of their volatility and anonymity.[11] On the other hand, the flaneur seems capable of negotiating these extremes with a degree of indifference that characterizes his modus operandi. Seeking an equilibrium—albeit one of equal curiosity—amongst all of the stimuli he encounters in the present, the flaneur mediates between Kleist's sensitivity toward the shocks of modernity and Simmel's view that indifference forms a main catalyst for its social life. He arrives on the scene as a spectator who displays an equal interest in all the phenomena of exterior reality. This "sameness" of approach, however, does not manifest itself as an "indifference" toward the differences of these phenomena, but rather as a rigorously consistent form of attention. With his highly differentiated visual perspective, the flaneur does not share the typical disposition of his time if this disposition is defined as the "essence of the blasé attitude [in its] indifference toward the *distinctions* between things."[12] On the contrary, while the flaneur equally regards everything as a sign, his eclectic, open attitude does not collapse into a mitigation of his attention. Instead, it resists this contemporary tendency in favor of an acute sharpening of his overall sense of attentiveness.[13] Insisting on his own vision, the flaneur resists the prevailing modern disposition that Simmel finds in the merely transitory and aim-oriented pedestrian of the crowd. Moreover, the flaneur also participates in what Simmel views as the most significant aspect of intellectual city life: a shift away from perceiving modernity as an immense, incalculable, and unforeseeable multitude—one that leads to a merely negative dissolution

of previous "values" and orientations—in favor of a new stance of specialization and differentiation in all expressions of modern life. "At this point the quantitative aspects of life are transformed qualitatively,"[14] Simmel suggests, and it is here that the flaneur's awareness comes into being in accordance, and in confrontation, with the prevailing principles of modern life. The demand for a division of labor and leisure "that forces the individual to a kind of specialized accomplishment in which he cannot be so readily exterminated by the other,"[15] also encourages the inhabitants of modernity to adopt "the strangest eccentricities . . . specifically metropolitan extravagances of self-differentiation, of caprice, of fastidiousness, the meaning of which is no longer to be found in the content of such activity itself but rather in its being a form of 'being different'—of making oneself noticeable."[16]

These phenomena can be traced in the specifically modern sensations of the street, a site for the display of extremes in fashion, behavior, attire, and atmosphere that come together to create a new field of attractions for the flaneur. The very differentiation of these fields and their images provides the vast visual materials of his extended perception. Like the dandy's appearance, the flaneur's very perspective forms a distinct expression of modern specialization, a type that engages exclusively in the perception or production of the street's living, moving images.[17] Previous structures of experience, according to Simmel, offered very little in terms of surprise, less material to experience, and therefore neither encouraged nor required a chronicler of daily images. The atmosphere of modernity that gives rise to the flaneur comes into being by a paradox of interrelated, yet contradictory phenomena: the very anonymity and frantic rationality of the city produces one of its most subjective, decidedly slow, and antifunctional perspectives. Simmel already indicates the possibility of such shifts in point of view: "For many types of persons these are still the only means of saving for oneself, through the attention gained from others, some sort of self-esteem and the sense of filling a position" (*M*, 336). Responding to the cultural conditions of modern realities, the flaneur and the dandy form versions of an ultimate, if in many ways opposite, stylization of the self. The increase in the tempo of, and overall exposure to, these passing images both accelerates and facilitates the shock-like quality of the flaneur's epiphanies. The momentary quality of an *Augenblick* or, as Simmel would have it, "the brevity and rarity of meetings which are allotted to each individual" (*M*, 336ff.), increases the intensity of these fractured moments. Their differentiation multiplies further with the rising numbers of noticeable and noteworthy stimuli, the encounters with more stylish and stylized passersby. As Simmel notes, the modern intellect can "attempt to appear to-the-point, clear-cut, and individual with extraordinarily greater frequency" (*M*, 337) in his brief metropolitan contacts than in the quiet, small, provincial communities whose contacts, even over extended periods of time, do not produce the high profile necessary to stand out amongst the anonymity of the metropolitan crowd. This

modern "striving for the most individual forms of personal existence" appears in "forms of individualism that are nourished by the quantitative relationships of the metropolis, i.e., individual independence and the elaboration of personal peculiarities . . . with reference to their historical position" (*M*, 338). The rise of an individual with a new sense of independence and heightened awareness of his mobility corresponds to the rise of the flaneur, whose spaces of perception and movement in the city characterize his singularity.

These shared concerns and terrains suggest that Simmel's study on the modern metropolis views the flaneur and the factors that define his existence as one of the characteristic manifestations of the age. The flaneur represents a perspective on modernity that is particularly partial to the visual registration of its multiple phenomena. A medium embodied in a human sensitivity, he specializes in the perception and formulation of the city's heterogenous mental life. In his approach to the modern metropolis, Simmel defines modernity as an age of indifference, of reservation and specialization; the ostensible limitations of these positions at the same time stimulate an increase in seemingly reserved forms of perception. While the city reduces the previous forms of access to small-scale, small-space organizations of life, it also, through an abundance of anonymous, shocking phenomena, provokes new forms of response. The increasing number of visual objects "to be seen" calls for a quantitative shift in the media that come to register these objects by way of the distinct differentiation and sensitization of human dispositions. In a related text, "Exkurs über die Soziologie der Sinne" (Excursus on a Sociology of the Senses),[18] Simmel alludes to this process in his reference to the living conditions of modern cities. He focuses on the many different ways in which "the inner-sociological nature of city life [finds] expression in the language of space."[19] Beyond any specific localized structure, the city's dynamics are determined by the defining spatial conditions of modernity. Human survival in modern traffic becomes a matter of the mere inches that may separate automobiles and railroads from pedestrian paths. The gaze that is directed toward other participants in the scene of traffic—participants who are either driving or driven, running or walking—becomes the focal point that structures all the angles and aspects of life in the street. A virtual arsenal of visual signs competes for the attention of passengers, pedestrians, and passersby: the street's signals serve as miniaturized icons for the level of modern rationality that governs the public sphere, with traffic lights that display red, yellow, and green flashes of ordering stimuli, significant markers on the surface of the streets that regulate moving vehicles and reserve crossings for passing pedestrians.

Faced with this very new terrain of complex and conflicting stimuli, more than ever the eye becomes the prevailing medium of attention and orientation. It not only imparts a sense of spatial perception but it also determines the life of the city via the sheer multiplication of what can now be seen. This quantitative increase in perceptible moments in fact enhances the very quality of percep-

tion. The proliferation of visual phenomena is variously affected by the developments of modernity emerging from the conditions that determine its traffic: as Simmel explains, never "before the formation of buses, trains, and streetcars, were [humans] able or obliged to look at each other for minutes or hours without talking to each other."[20] Public transportation encourages the increased use and observation of the visual as a medium in everyday life. The cumulative effects of industrialization and centralization in the cities have introduced an enormous number of anonymous and diverse persons into public view. Never before have there been so many different people pursuing so many different purposes in so many different streets. Simmel suggests that this immense multiplication of visual stimulation is "characteristic of the big city. The interpersonal relationships [Verkehr] of people in big cities are characterized by a markedly greater emphasis on the use of the eyes than on that of the ears."[21] This shift from the acoustic to the visual is crucial not only to Simmel's reading of modernity, but also to an understanding of the flaneur as the modern type to be conjured and defined by this visual shift.

The primacy of perception in the living conditions of modernity resonates in an ample array of technological phenomena and psychosocial reverberations. As Simmel notes, "modern traffic yields . . . the predominant aspect of all sensory relations between humans . . . to the mere sense of sight and will therefore necessarily found the general sociological emotions upon entirely changed conditions." Positing an evolving multiplicity, ambiguity, and multiple interpretability [Vieldeutigkeit] of the visible, Simmel attributes a "higher crypticality" [Rätselhaftigkeit] to the images of modernity. Compared with other messages of his time, the visible sign appears primarily as an enigma that is not immediately "accessible to concepts," and "expressible" only in a translation that moves according to its own terms. Simmel defines the reception of the visible in terms of the impact that results from a first impression whose atmosphere tints the "modality of insights to follow" with a pictorial imprint that precedes conceptual comprehension. The increase in comprehensible images, however, associates their heightened indeterminability with what Simmel calls an increased "disorientation in the entire life" of society. Adding his own axiomatic insight to this sociopsychology of perception, he finds "the person who is able to see but unable to hear" to be much more "troubled than the person who is able to hear but unable to see."[22] Rather than naming a sociological "truth," this statement points to the contemporary disposition experienced by Simmel and other moderns who, through their eyes and theories, begin to orient themselves through the visual maze of their age, becoming "sociological flaneurs" in the early metropolis of the twentieth century.[23]

The passages to which Simmel calls attention seek to elucidate some of the material phenomena of modernity, to trace their theoretical implications both for the public sphere and the temporal foundation of Simmel's view of the world and his time. The importance of "looking" as a primary disposition of

contemporary life also allows us to reverse Simmel's observation: the modern period should understand the emergence of the flaneur and his literature as sensory texts of seeing and writing that arise more frequently in times of social destabilization. They register a decaying consensus of social sense, a state of prevailing plurality and disorientation. Periods of reduced clarity or consensus about the social or ideological rationales of their realities (be they collectively experienced in the 1920s of the Weimar Republic or in the New Subjectivity of the 1970s) seem to inspire a flanerie that, in its visual experience of reality— an experience that is constituted and transmitted by way of pictures of the exterior world, ranging from impressionist to surrealist styles of expression and reception—goes beyond rational insights. Modernity is characterized by its emphasis on the visual which appears as its primary and privileged sphere of perception. Simmel suggests that this prevailing disposition is shaped by the process of seeing that takes place in the streets. It names an ongoing project of a vision that is both communal and radically individual, especially since "not too many people will share one and the same impression [*Gesichtsein-druck*]."[24] A process of constant differentiation and increased sensitivity, it results from the fact that, according to Simmel, modern man is "shocked by innumerable factors."[25] As the modern character increasingly adapts to the shifting conditions of his times, he responds to the increasing differentiation of the world surrounding him with a "partially sensual, partially aesthetic mode of reaction."[26] Many of the unexpected stimuli to which the inhabitants of urban modernity are exposed are emitted as visual signs that emerge from the evolving technologies of street life, the organization of traffic via lights, and the innovations in capitalist display and advertising.

ILLUMINATING MODERNITY

Among the most influential visual factors in the shifting perceptions of flanerie and culture are the changes in the social and material conditions of public lighting defined at once by technological innovation and commercial consider-ations.[27] The cultural history of every illumination in the street undergoes revo-lutionary transformations, particularly in the nineteenth century, when an in-crease in the numbers of pedestrians, the extension of streets that can be passed at night, the amount of time that can be spent in the streets, and the quantities of stimuli that one may expect to experience, multiply to an extent that until then was unimaginable. With these material conditions, flanerie becomes imaginable as an all-day pursuit of everyday exteriors, precipitated by the expansion of improved gaslighting and the introduction of electrical illumina-tion. These innovations provide from the mid-nineteenth century on an all-encompassing lighting of the street, a public illumination that renders all the subjects that move in the streets increasingly visible.[28] As soon as it becomes

possible to engage in a continuous process of observation—both at night and during the day—a large number of written texts, beginning in the 1850s, are illuminated by a series of atmospheric reports on the new "city of lights," on its attraction to the crowds that pass its new boulevards while they experience novel sensations.

The processes whereby the senses began to adapt to the conditions of modernity date back to the first increases in the intensity of light, brought about by the introduction of gas lighting in the 1840s. These innovations in technology changed the cultural conditions of seeing as significantly as did the introduction of electric light in the 1880s, which culminated in the first flickers of commercial neon lights and brought about the electric advertisements of the twentieth century. As the processes of illumination were transformed, the everyday perceptions of pedestrians adapted to an unprecedented intensity of light before they could differentiate and appreciate the nuances of this new visible world.[29] Illustrating the mutual relays between technology and perception, this adaptation also reveals the decisive influences that modernity had on the mental and sensory life of its citizens. Gaslight and electric lighting introduced innovations to the state of illumination that offered civilization a degree of what Schivelbusch calls "technological progress." This progress "allows us to follow the physical microstructure of the modernisation process. The eye would have to come to terms with its results."[30]

Each innovation in lighting brings about states of increased disturbance and shock that correspond to new intensities of light and exposure in the public sphere. This initial, paradoxical disorientation prevails until the senses adapt to the altered level of light and come to accept, and expect, this new intensity as the norm of everyday experience. Initial insecurities are compensated by an overwhelming sense of exhilaration that attends these new sources of light, whose "blinding white" easily overshadows all other appearances. These significant changes in the circumstances of the gaze are amply illustrated, for example, in Edouard Dujardin's novel *Les Lauriers sont coupés*, a text whose flaneur protagonist comments on the very shift from gas lamps to electrical lighting in the 1880s. In his wanderings, Dujardin's flaneur begins to associate specific sensations in light with the corresponding spaces in which he expects to encounter them: he anticipates almost feverishly "the brightly lit foyer of the opera,"[31] as well as "the light of the gas lanterns, the three-part gas lanterns," including the details of their technological construction. As the more recent technologies of illumination supercede earlier bearers of light from the age of romanticism, he even reacts in response to his anticipation of certain sensory expectations: "The stairway will be lit by gas. . . . I extinguish my candles."[32] A sliding economy of light—related to the presence of candles or gaslight, to preindustrial and early industrialized sources of lighting—in fact structures the everyday experience of characters in the street in very particular ways. With its concomitant sense of luxury, the arrival of gas lighting introduces a previously

unknown means for the expansion of streets through lighting. From the pavement up to the façades of houses, this light highlights the new experiential economy of space and sight. With his pronounced sensitivity for impressions of light and color, the flaneur in Dujardin's text represents and embodies the characteristically impressionistic approach to new ways of seeing in the nineteenth century.[33] With a contemporary fascination, he embraces the now wider, brighter sources of light for their higher level of aesthetic revelation as well as for their contribution to the very material improvement of everyday lives. In the 1880s, the technique of gas lighting, introduced some thirty years earlier, still merits close observation: "By the gas lanterns, there is indeed great brightness . . . the gaslight to the right shines more strongly."[34] At the same time, the more recent introduction of electricity already is beginning to overshadow these same sensations. In relation to some of these even brighter hues, the "white shine" of gas lighting now fades: "the gas [is] throwing its *yellow* light" onto the houses, remarks the narrator as he tones down the brightness of his qualifying adjectives.[35]

With the First Paris Electricity Exhibit in 1881, the city encountered a previously unknown brightness, as electric lighting began to illuminate the most important traffic routes and expensive business districts. In a few years, it illuminated those representative areas of exceptional luxury that Dujardin's flaneur anticipates with feverish attention: "The Eden *Théâtre*; its entrance drive with the gas lanterns," followed by "the electrical lights."[36] This even stronger, even "whiter" electric light is said to be as "bright as the day." The more dated gaslights appear almost dark or "yellow" in comparison. If older forms of gas lighting had, in relation to previous forms of lighting, already expanded the spaces of flanerie by reducing the once pervasive fear of darkness, the more encompassing illumination offered by gaslights of higher strength and a wider radius turned the street into a virtual " 'interior' space out of doors,"[37] an interior space of artificial exterior lights that was no longer contingent on the presence of natural sources of light.

This increase in illumination transforms the boulevards of the city, touched by the powers of light, into veritable living spaces of the streets. In this new light, the public sphere is perceived as an interior space in the street, displaying a new gaze and its attentive efforts "to turn a boulevard into an *intérieur*," as Benjamin observes.[38] The material changes in the intensity of light display the concomitant developments of the civilization, with its increase in capitalist commodities, its emerging and narcissistic self-awareness of a wealthy bourgeoisie, and an entire culture of leisure that stimulates the visual sensitivity of the flaneur. The exterior of the street becomes a veritable showcase, a shopwindow turned inside out, an interior realm for the display of exterior commodities, slices of social life, and ever more differentiated phenomena of scopophilia, which together encourage the turn toward an aesthetic stance of leisurely contemplation. In his history of nineteenth-century artificial lighting,

Schivelbusch describes a "simple psychological explanation"[39] for the impression in the shifting psychology of perception that the streets begin to resemble an interior space. The noticeable spatialization of these passages relies on the new conditions of lighting that illuminate the streets as a specific form of urban space. The imaginary outdoor "ceiling" of such artificially lit interiors would be assumed to be above the first floor where the shine of light emanating from the lower row of windows disintegrates into the darkness of the night skies. The "walls" that surround this space on both sides are shaped by the material walls of the houses that line the street, the façades and windows that surround it. Beyond such physical circumstances, the visual, aesthetic, and philosophical implications of this new constellation in perception, a constellation on which Benjamin will be among the first to comment, cannot be overlooked.

These forms of illumination open up the space for modern images, new sights, and visual sensations, which bring forth an increasing crowd of observers who now reflect on these images with an increased sensory attention. Outlining wider spaces and bringing to light ever more and newer visual phenomena, these emerging methods of commodity presentation at the same time create visual forms that assemble these objects and images into ever-changing constellations. Stores frequented by the bourgeoisie and lining the boulevards begin to display a wide array of the visual stimuli of modern capitalism in shifting, shimmering arrangements of "glass, mirrors and lights."[40] The matter that makes glass translucent serves to increase the reflections of light, while the material qualities of mirrors epitomize the visual aspects of modernity. David Gross defines the "spatially oriented" thought of this period in terms of the image of the mirror: "The mirror is the perfect image of spatialization because it never takes account of time."[41] In the street's visual "interiors," the shop windows now appear as the new mirrors: decorating and surveilling the space before and behind them, they work to reflect the structures and materials on display.

A consequence of the expansion of gaslight and the construction of boulevards, of the increase in shopping and the fascination of a wave of Paris tourism, the new storefronts of the city offer an extended screenlike surface of glass, transforming these walls of glass into spaces of light. The resulting effect is one of a reflection, duplication, and multiplication of the phenomena in the street, a visual sphere that now encompasses everything from lights to objects to pedestrians. Across these enlarged screens, the flaneur can read the reflections of street life as a representation of modernity's transitory, fleeting sensations. The fascination that surrealism will derive from this modern intoxication with the image emerges from the enigmatic character of transitional spaces— the cryptic Paris arcades or the expanded spaces of light on the boulevard— that transgress the line between interior and exterior spaces. This excessive vision inspires Aragon to gather the most minute details and mysteries of *Le Paysan de Paris* into an intensive literary and visual meditation on the arcades'

strollers, the shops' façades, and their reflections in display windows.[42] These streets, spaces, and windows range from media of observation in the realm of commodities to more indirect ways of communication in the reflections and images of—often female—pedestrians, who may themselves be observing the observer.

MULTIPLYING SCOPOPHILIA

Many of these new stimuli are derived from the industrialization of society, which introduced new sources of light and modernized the presentation of capitalist commodities. Shop windows were transformed into display cases of a big city where, as Schivelbusch notes, "increasingly anonymous buyers replaced what had been a largely personal clientele. The more the streets could supply potential customers, the more the shops opened up to them."[43] These images invite extended glances from potential buyers—as well as from mere spectators—through the glass fronts of the stores' façades, through mirrors and brightly lit displays. The gaze is solicited further by an increasing aestheticization in the decoration of stores, in window arrangements, advertising posters, and walking advertisements. Extending the circulation of commodities, each of these devices worked to multiply the street's visual effects. The advance of mass media and the distribution of posters and other advertising images emerges at a time of rapid change to escalate these visual conventions. By 1860, the color lithograph poster has already replaced previous techniques of wood and copper engravings with more modern, technologically reproduced commercial images.[44] Typescripts in posters and pamphlets transport commercial messages in advertisements and furnish decorations for the walls of the street's new interiors. Shifting constellations of the moving image are set into motion and circulation by human carriers of commercial appeals such as the sandwichmen, walking bodies that literally carry new signs and images with them into the street. One of the focal points of institutionalized advertising in the street comes together in a prototypically Berlin invention which artificially multiplies even this extended street space with the *Litfaßsäulen*, voluminous cylindrical columns on the sidewalks that are constructed expressly for the commercial purposes of attaching additional ad messages at the pedestrians' eye level.

As the metropolis of modernity in German culture, Berlin was among the first to introduce the new medium of advertising posters to its buzzing streets. As Alain Weill notes in his cultural history of the poster—an art form for the public realm—"it was in Berlin, the city of commerce, that posters first appeared as vehicles with a concrete advertising aim."[45] Already by 1903, the year when Simmel's essay "The Metropolis and Mental Life" appeared, a new generation of active professionals had entered the cultural sphere. Known as

"advertising specialists," these professionals were early personifications of the vital commercial interests that for years to come fixed the street and its images in the cultural unconscious.[46] The attention of spectators and pedestrians was not only drawn by way of posters with images and inscriptions toward exterior advertising, but extended to all visible aspects of the commodity's appearance. Design, packaging, display, and all the semantic signs and typographic signals emitted by a brand name were stylized according to the criteria of an "aesthetic form of appearance."[47] With the increasing commercialization and techno-logization of capitalist production and distribution, advertising also worked to expand its material quantity and visual intensity. As the assessed value of products turned from clearly defined uses to its values in symbolic exchanges that were contingent on style, fashion, and interpretation, the " 'commodity-esthetic' aspect" of all products comes to the fore.[48] It was now, in the streets of the city, impossible to ignore the ways in which "these worlds of the trivial imaginaries of commodity ads invading the appearance of the street since the 1880s become increasingly formative of consciousness."[49]

Without implying any cultural or aesthetic judgments of these new appearances, one must register a rapid proliferation of visual stimuli in the street. The connections between capitalist markets, the concentration of cities, and the attendant shifts in the perception and display of these stimuli are in fact often commented upon by writers of the period: "The art of the poster . . . requires for its flourishing and prospering the 'air of the city,' "[50] remarks the art historian Jean Louis Sponsel as early as 1897. The emerging movement of *Jugendstil* served to elevate posters to a complex form of expression. The reception of these posters worked to further differentiate their visual impact, suggesting the potential for a democratic "art of the street," an "art for everyone,"[51] that could be perceived by everyone, everywhere and every day. Even as the didactic impetus of *Jugendstil* art failed under the commercial realities of advertising, this art introduced the important notion of an "art of the street" that acknowledged, and even proclaimed, the effective integration of advertising images and commercial designs in the public visual realm that the street has provided and accommodated since the turn of the century. An entire spectrum of images, sights, and stimuli offered a new aesthetics, a new definition of art in the street, one in which art can inhabit the everyday reality of contemporary modernity. As these images became more complex, as they encompass their spectators in ever more complex ways, they influenced an awareness of the everyday to such a degree that their images came to be seen as an ever-present "diary of the street."[52] These intensely visual documents are perceived in an equally intense process of reading that understands them as a series of "momentary snapshots of urban everyday perception, as material particles of streets inhabited by busy passersby . . . in which the emotional and consciousness content of an urban population is conserved."[53] In this way, the new urban arts of marketing posters and commercial displays—economic as well as visual

phenomena—reflect and transcend the laws of capitalist markets. Within the perspective of a variety of commercial and material purposes, these new arts help to shape the as yet unmapped but pervasive scopophilia of modernity.

As early as the 1830s, this "public need . . . for distraction in the sight of the ever new" is expressed in the ongoing interest in attractions and innovations. This hunger for visual experience finds common ground with the fundamentally visual disposition of modernity in the course of the nineteenth and twentieth centuries. Taking its point of departure from circus performances and variety shows, the growing interest in "exotic" ethnological exhibitions and commercial business fairs displays the scopophilic power of both capitalism and colonialism.[54] Early protofilmic forms of distraction such as the *laterna magica*, the diorama, the panorama, and the panopticon, attracted an unprecedented number of spectators who were fascinated by these visual illusions. The search for new optical sensations reached its peak with the invention of the cinema, the formative technological manifestation of the scopophilia produced by the nineteenth century. Central to the cinema and its human personification—the cinemorphic perception of the flaneur—is the observation that these "ever-new visual experiences . . . often are experienced as more meaningful than the actually conveyed contents of these images."[55] In terms of the intricate relations between scopophilia and technology, we might say that "the need of an urban population for images invites . . . technical innovations," while the advent of such innovations furthers the popular quest for modern images. Products of industrialization redefine habits of seeing that prevailed in preindustrial societies and, in so doing, change the worlds to be seen along with the spectators who see them.

The development of the railroads and their influence on modes of perception ran parallel to what Simmel sees as the influence of modern traffic on the visual disposition. Like other factors contributing to the intensity of urban perception, the invention of the railroad led to an increase in the number of stimuli to be encountered and perceived. This overload caused an initial disorientation which was then followed by the contemporary critique of a presumed "demolition of traditional time-space relationships and the dissolution of reality," a cultural fear that would become a dominant trope throughout nineteenth-century literature.[56] The time-lapse experience of railroad travel made this mode of transportation yet another technological move toward visualization, a medium of transportation that intensified the very spatialization revealed in its "tendency to condense time relations into space relations."[57] What all of these phenomena in the modern experience of space have in common is the primacy of a visual disposition. This new orientation, defined by changes in technology throughout the nineteenth century, increasingly elevates space to the category of perception, the most prevalent category in modern experience and consciousness.

The contemporary observers of these evolutions came to realize that the railroad does not relativize time or space so much as it relativizes the perception of time spent in transit.[58] Any continuum of space and time that had until now been perceived as a constant given became increasingly dependent on technologies of travel aimed at accelerating the process. Experiences therefore were rewritten as relative, as were the types and modes of sensory impressions to which contemporaries have already adapted in the streets of the city. As the initial phase of shock and mourning for the loss of a former state of travel faded away, a new form of perception gradually came into being. Schivelbusch suggests the sensory shift effected by the new technologies of the railroad when he notes that it " 'mechanized' the traveler's perception. According to Newton, 'size, shape, quantity, and motion' are the only qualities that can be objectively perceived in the physical world. . . . Smells and sounds, not to mention the synesthetic perceptions that were part of travel in Goethe's time, simply disappeared."[59] All of the "objective" qualities and quantifiable criteria named in this list also refer to the visual characteristics of the bodies, objects, and landscapes that soon become images for the traveller's gaze. The latent scopophilia that is legible in phenomena such as photography and the cinema derives from these same changes.

This visual disposition was accelerated by the new ways of thinking and experiencing perception that emerged with railroad travel. As Schivelbusch notes, these unforeseen trains of thought soon bypassed the cultural criticism of loss in favor of "another kind of perception . . . which did not try to fight the effects of the new technology of travel but, on the contrary, assimilated them entirely."[60] This perspective of perception is embodied in the modern flaneur, an educated bourgeois who no longer looks on the phenomena of the city as the signs of a cultural deficit but begins to regard them in their own right, as constitutive of an aesthetics of modernity. This turn toward the modern was embraced, for example, by August Endell, a contemporary of Simmel and an architect of the city. In his programmatic treatise *Die Schönheit der großen Stadt* (The Beauty of the Big City, 1908), he suggests that the extensive and sweeping look out of the compartment window can be understood as paradigmatic of modern perception: in the very speed of transportation, "the railroad choreographed the landscape."[61] By multiplying the number of different visual impressions, the train transforms the gaze usually cast on a static scene into an ongoing, continuously shifting, progressively varied observation of ever-changing details within an entire panorama of movement. The panoramic gaze of the railroad traveller links the sweeping rapidity and brevity of impressions with the heightened fascination of acute details that, rapidly flashing up, are emphasized in perception, leaving no traces except the ones left behind in the mind.

This receptivity to the multitude of details now successively meeting the lens of the panoramic gaze from the railroad window finds its technological

counterpart in the medium of photography that develops within this same period. In the work of some of its earliest practitioners, photography also focuses its fascination on the most minute visual details, forms, and structures: patterns of pavement, branches of trees, or traces of rain running down fading façades. It is in this way, Schivelbusch notes, that "the intensive experience of the sensuous world, terminated by the industrial revolution, underwent a resurrection in the new institution of photography."[62] Participating in all aspects of this visual disposition, the flaneur personifies the implications of this scopophilia and its changes in perception. As speed becomes constitutive of a panoramic gaze, the flaneur, too, defines himself in terms of the particular quality of his movement: the art of taking a walk within the space of urban perception. If flanerie pursues a decidedly less speedy approach, one that is not accelerated technologically, it nevertheless presents another process of continuous movement, a similarly panoramic way of passing. The flaneur registers the details of the street with the fleeting curiosity of a gaze that scans the crowds, scrutinizes tiny details, tracks the façades of the street, and understands the landscape of public viewing as a form of reading along an ultimately filmic perspective, a cinemorphic view that mobilizes the spectator's eyes and prefigures many of the camera's moves. At the same time, the flaneur's slowness is a deliberate reaction against an age of acceleration. Suggesting a new rate of travel in opposition to the prevailing haste of his time, he encourages a fuller appreciation of single images within the fascination of the total panorama. Like his nineteenth-century contemporaries, the flaneur believes that we will see less the more we accelerate our exposure to the world.[63] The flaneur therefore pursues the visual impressions and phenomena of his times in his own ways and at his own particular speed. He does remain partial, however, to the urban reality of modernity. Just as the ever-changing images of the street are the only experience he desires, the railroad traveller declares that the fleeting impressions "during the trip form the only possible form of experience."[64]

The panoramic gaze from the window of the railroad and the photographic perception through the eye of a camera both contribute to what the flaneur sees, directing his focus toward an overall volatilization of perception that arises during the nineteenth century and continues to shape modern experience. This mode of optics manifests itself in the lines and tracks of the railroad, in the architecture of its train stations, and in the characteristic constructions of iron and glass that sustain these halls of transportation, all of which become representative locations of scopophilia. These industrialized constructions vastly expand the space that now submits to the full sunlight of day. They variously reflect the already multiplied effects of the artificial sources of lighting available during this time, and differentiate further the subtle nuances of minute shadows and contrasts of light fractured through the frames of their modernized lines of construction. These excessive effects of sun, light, and shadows create a multitude of visual details that considerably irritate percep-

tion, until light and atmosphere can be seen "as independent qualities, no longer subject to the rules of the natural world in which they had hitherto manifested themselves."[65] As the "independence of light from nature and the dissolution of its corporeality" becomes more available and more diffuse, this mode of seeing relies more on its "impressionistic" precision, a precision that is increasingly determined by the ongoing changes of lighting in modern streets.

This impressionist approach begins to describe as well the modes of writing of those moderns who are susceptible to these effects of light. This inclination toward new ways of writing that highlight visual nuances appears above all in travel texts from Paris, texts whose texture reflects the subtle changes in illumination, from daylight in the streets to gaslit alleys to luxurious spaces bathed in the newest effects of electricity. As a document of such impressionism, Dujardin's *Les Lauriers sont coupés* presents an interior monologue of visual perception, nuances of situation, and a range of atmospheric differences.[66] Such impressionistic experiences manifest themselves on an individual level in the type of the flaneur, on an architectonic plane in the construction of architectures of glass and other reflective surfaces, and on the level of traffic technologies in the principle of the railroad. In the economic domain, this impressionism can be seen in the commercial innovations of department stores as well as in the many new forms of advertising images in the streets. These intricate labyrinths for the display of accessible commodities facilitate new avenues for the city and for the experience of flanerie. In 1852, the first Parisian version of the department store, the *Bon Marché,* opens its gates to the gazes of both browsers and potential buyers.

The primacy of the visual appears as a founding principle of this new commercial form: the personal relations between sellers and buyers that characterized the small stores of the past are now replaced in the department store by price tags that function as nonverbal signs in their own right. Likewise, the merchandise on display seduces the eye of the buyer primarily through its visual impression, through the broad appeal of the range of its products, through their variations in shape and color. The principle of selection and arrangement that organizes these commodities is manifested in the flanerie of the buyer who strolls through a landscape of display, and whose panoramic view names a new "perception of commodity landscapes." That this view touches fleetingly on the display of commodities—that is to say, cursorily, impressionistically—means that the customer "traveled through the department store as a train passenger traveled through the landscape . . . the goods impressed him as an ensemble of objects and price tags," a kaleidoscope of signs that "fused into a pointillistic overall view."[67] These signs [*Schilder*] convey the value of things while at the same time suggesting their value as signs. In this way, they provide the flaneur with a venue for both a critique of capitalism and an appreciation of its semiotics. The early commodity world of the passages and arcades, a transient culture of the street perceived in passing,

is traversed and described by flaneurs like Aragon, Benjamin, and Hessel, even as it gives way to the changing commodity landscapes of the twentieth century.

The visual kaleidoscope of the city changes in accordance with the development of a new constellation of modern images: new forms of traffic and light, displays and signs, department stores and railroad travel, glass constructions and many other forms of visual phenomena. The pervasive web of the railroads reaches beyond the limits of its tracks in order to transform the physiognomy of the cities that surround them: new districts develop around the train stations, which are now focal points of traffic and commerce.[68] New and wider boulevards along the extension of railroad lines open up new fields of vision along the trajectories of traffic and in sight of the increasing streams of passengers that now fill them. These diverse forms of modern life create their own phenomena of perception, all of which are, as Schivelbusch suggests, "distinctly oriented toward the new city landscapes and its traffic flows." This expanded sense of perception facilitates and engages an ever more conscious interest in "air, sun and space . . . along great avenues,"[69] reflecting a fascination with façades, shining windows, and the movements of the crowd. Only a few traces of this new aesthetics can be found in a kind of literary realism that adheres to preconceived, teleological structures of plot. Instead, it appears in a consciousness that, closely mapping the environs and realities of modernity, manifests itself in a specific set of texts that are dedicated to reading the experience of the flaneur.[70] This pivotal figure of modernity reconciles his—or her—existence as a literary figure with the stance of an author whose gaze helps him or her articulate a literature that simultaneously takes its point of departure from both texts and reality. Faced with the visual dimension of the phenomena of modernity, the flaneur's presence continues beyond the tranquility of anachronistic relics and after the decay of the arcades.[71] The flaneur moves one of the final personifications of the bourgeois traveller out into the streets of a new reality, transporting the impulse for collecting *Bildung* into a world of new images, structures, and optical phenomena.

The figure of the flaneur presents himself as an all-encompassing medium of perception, a visual perspective that sensitively responds to the continuously changing conditions of modernity with the specific attention and openness of a new aesthetics. Joining the images of an impressionistic, panoramic and photographic mode of seeing with the art of walking in the street—that is, an art of perception in motion, a quasi-filmic way of seeing—the flaneur becomes the human equivalent and corresponding medium of the unfolding visual multiplicity of modernity. Representing a perspective that is oriented toward exterior perception, he is as much a product of modernity as a producer of its images. His sensitivity to the objects and obsessions of this modernity renders him a significant kaleidoscope of his time.

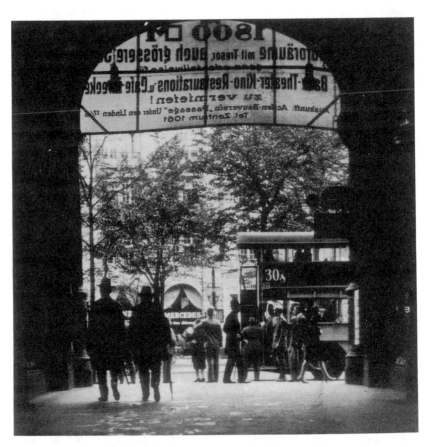

Mario von Bucovich, "Passage." Courtesy of Marquand Library.

Passages of Flanerie: Kracauer and Benjamin

AS THE REGISTERING medium of Weimar modernity, the flaneur embodies an intellectual and sensory disposition that records and responds to the new phenomena of the metropolis, the new sensations of its streets. This disposition is as much a product of the culture of modernity as is the collective state described in Berlin texts of the Weimar Republic, a collective state that Siegfried Kracauer and Ernst Bloch describe under the categories of "the employees" [*Die Angestellten*], "the waiting" [*Die Wartenden*], and the "distraction" [*Zerstreuung*] that defines their condition.[1] Indeed, it is precisely the congruence between the flaneur's manner of seeing and the collective state of the times that, for Walter Benjamin, accounts for "the return of the flaneur" in the Berlin of the 1920s. The new tendency toward "biography as an art form"[2] that Kracauer finds during this period can also be traced in the literature of flanerie. In their focus on the concrete experience of a perceiving "self," at a time in which "in the most recent past, people have been forced to experience their own insignificance—as well as that of others—all too persistently,"[3] both flanerie and biography are seen to offer concrete subjectivity its last refuge. Flaneur literature can therefore be understood as a nonchronological and fragmentary autobiography of its authors' sensory experience.

According to Kracauer's essay on Weimar biography, the literature of flanerie emerged from an experience of individual and collective emptiness and alienation, from an experience of the negligibility [*Nichtigkeit*] of the individual. Along with the resignation brought about by World War I, the confusion of a German revolution, and the uncertainty over the first years of Weimar democracy, it also reflects the insecurity provoked by technical innovations and the revolution in visual modes, both of which helped to increase the number of freely accessible images in the public sphere and external world of the Weimar metropolis. As Simmel suggests in his sociology of the senses, this quantitative increase of external stimuli is linked to a qualitative change in and destabilization of internal positions.[4] These changes coincide with the psyche's inability to resist being influenced by the incursions and advances of technology, developments that can be followed most closely in Berlin, which, as the mechanized capital city, perhaps best exemplifies a metropolis whose existence is simultaneous with the modern process of technological development.[5] This mechanization increasingly takes hold of all aspects of life in Berlin, effecting changes in work and leisure behavior alike. Berlin turns into a "city of the most pro-

nounced white-collar culture" [*Angestelltenkultur*], as Kracauer analyzes it.[6] As "work becomes more and more compartmentalized,"[7] the forms of leisure in Berlin society also undergo changes. The dissolution of the new, mechanized, fragmented, and continuous "tension to which the working masses are subjected . . . can be articulated only in terms of the same surface sphere that imposed the lack in the first place."[8] The tension [*Anspannung*] that dissects men and women into functional muscle groups can only be soothed by way of an equally fragmented culture of entertainment [*Entspannung*], that is, in the wording of Kracauer, a culture of "distraction."

Kracauer understands distraction as a constant of modern life, an equivalent to the working conditions of a Weimar white-collar culture that needs to process an ever-changing multiplicity of stimuli. Mechanized office work now reflects the processes of a society in motion: just as the "bureaucratic process initiates a journey . . . through paperwork" and as the "employment agency [is reminiscent] of freight yards" for the deportation of the unemployed, so, too, walking down the streets becomes a "process," and after the offices close, an equally distracted "journey" between "shop window decorations, [other] white-collar workers and tabloids" begins. The ultimate destination of these journeys into distraction is most often their continuation into the codified world of images, that is to say, the cinema.[9] Along with the mechanisms of technology and its carefully controlled yet fragmented working environments, the purely quantitative increase in city population breaks down the image of the city into a new quality of distraction that is not entirely external. As Kracauer explains, "It cannot be overlooked that there are *four million* people in Berlin. The sheer necessity of their circulation transforms the life of the street into the ineluctable [*unentrinnbare*] street of life, giving rise to configurations that invade even domestic space [*bis in die vier Wände dringen*]."[10] The street—both the one that has life and the one that is life—turns into the central metaphor of perception for the Weimar public sphere. Its tendency toward the "development of pure externality" is increased both by the fragmentary forms of distraction and the rapid proliferation of stimuli in Weimar modern culture, as well as by an inner disposition to which all the new media of distraction (cor)respond:

> Already one is banished from one's own emptiness into alien *advertisement*. One's body takes root in the asphalt, and, together with the enlightening revelations of the illuminations, one's spirit—which is no longer one's own—roams ceaselessly out of the night and into the night. . . . The posters swoop into the empty space . . . they drag it in front of the silver screen [*Leinwand*], which is as barren as an emptied-out palazzo. And once the images begin to emerge one after another, there is nothing left in the world besides their evanescence. One forgets oneself in the process of looking, and the huge dark hole is animated with the illusion [*Schein*] of a life that belongs to no one and exhausts everyone.[11]

Kracauer calls this inner emptiness "boredom," a vacuum that opens up an interior screen on which to project a plurality of exterior images. This sense of bored openness also provides, as Kracauer notes, "a kind of guarantee that one is, so to speak, still in control of one's own existence" (*OM*, 334), in the face of a general functionalization of life. This boredom develops along with its distraction in analogy to the newest medium of both dispositions, the cinema. In the viewing disposition of the spectator, the perceiving imagination is emptied through aimless "boredom" to form a projective screen on which a metropolitan world of "distraction" may inscribe itself with its images.[12]

Increasingly, the street becomes the scene of this experience. It is no accident that both the sociophilosophical discourse of the Weimar period and the tone of its feuilletons are articulated in terms of a process of walking. This can be seen in the beginning of Kracauer's exposition of boredom. "In the evening one saunters [*schlendert*] through the streets" (*OM*, 332), he writes. Emphasizing the contemporary lack of orientation illustrated in the "great variety of approaches being pursued [*der heute eingeschlagenen Wege*]" (*OM*, 132), he indicates what is for him an overall relativism of direction. "The *street* makes manifest" what Bloch views as the direct result of public distraction: the times are characterized by "how everything *goes* so leisurely here."[13] In Benjamin's *Einbahnstraße* (One-Way Street, 1928), street metaphors extend directly into philosophical discourse: the motion of thought immediately takes place within the mind. As Bloch notes, writing about Benjamin's ambulatory text: "Its form is that of a street, of a proximity of houses and stores in which passing thoughts are exhibited. From the street . . . other forms push their way to the fore."[14] This "street-like" disposition makes flanerie the central perspective of Weimar reality, which, emerging from many different positions of collective boredom, seeks out the street as the central location of its distraction. It is this very movement toward the street that leads Benjamin to speak of a return of the flaneur in Weimar Berlin.[15] Kracauer discusses a previous appearance of the flaneur in nineteenth-century Paris in another article bearing the title "Langeweile" (Boredom). There he explains that,

> [The citizens in that time of transition] did like everyone else and went for strolls [*flanierten*]. At this time appeared the type of the flaneur, who sauntered along aimlessly and covered the nothingness he detected around him and in him with innumerable impressions. Shop window displays, lithographs, new buildings, elegant attires, fancy coaches, newspaper vendors—indiscriminately he inhaled the images which pressed in upon him.[16]

The phenomena of capitalist Paris under the "citizen king" Louis-Philippe— shop windows, advertisements, fashions, newspapers—differ from the Berlin of the 1920s only in the quantity and intensity of their stimuli. The social motivation and function of flanerie can be recognized here in its minute details: the objective is in both cases to distract the "empty, insufficiently filled

time" of an absent utopia. Aimless drifting along the streets is the refuge of an epoch in which ideological orientations have been exhausted: it is what helps everyone "pass the time," an evasive move in the face of the prevailing tendencies of an era, whether it be the bourgeois stagnation of the times of Louis-Philippe or the postwar cynicism of the Weimar Republic.[17]

A new disposition develops out of what Kracauer describes as the initially disorienting "loneliness of big cities [and] the emptiness of spiritual space." The citizens of the metropolis experience these traits and share with the flaneur a sensibility toward their respective modernity, a latent skepticism and melancholy—"a deep sadness which grows from the knowledge of their being inscribed in a certain spiritual situation."[18] Since they can no longer escape their modern life in the city, they focus their attention on the precise perception of its environs and spaces, "and otherwise go through their lives with open eyes." Kracauer calls these Weimar individuals "those who wait" [*die Wartenden*], and he describes their situation of isolation and insecurity as the implicit basis of flanerie.[19] Their disorientation implies a potentially open-ended curiosity toward new ways of thinking, a stance in which "one waits, and one's waiting is a *hesitant openness*, albeit of a sort that is difficult to explain,"[20] an openness toward all the sensations of the present. This receptivity to the perception of exterior reality involves an "attempt to shift the focus from the theoretical self to the self of the entire human being . . . and into the world of *reality* and the domains it encompasses. The overburdening of theoretical thinking has led us to a horrifying degree to become distanced from reality—a reality that is filled with incarnate things and people and that therefore demands to be seen concretely."[21] In an effort to perceive acutely the objects of reality, to seek them out on the street, Kracauer's disoriented waiting intellectual moves from being latently melancholic to being a melancholic flaneur. This permanently waiting figure, open to all the sensations of modernity, becomes a manifestation of Kracauer's "adventurer" in modernity: one who desires "an infinite experience as such, because life should be experienced to the fullest, if there is no salvation in its infinity."[22] Insofar as many of the political, economic, and metaphysical promises of "exploiting life to the fullest" have come to be exhausted by the late 1920s, a new way of redemption is preferred by sensory experience in the visual "redemption of physical reality."[23] With its waiting attentiveness toward the street's phenomena, this new adventure of the metropolis is linked to the constellation of the detective novel as described by Kracauer. Its locations are the places both of collective boredom and of its collective distraction: streets, cinema palaces, and hotel lobbies.[24] Kracauer locates the Weimar hotel lobby as the terrain of a detective novel of the real world: it is filled with the stimulating, secretively anonymous "coming and going of unknown people,"[25] which likewise structures the aimless distraction of the crowd in the streets.

The observers waiting in the hotel lobby exhibit characteristics of the detective as well as the aimless curiosity of the flaneur in the way that they, as

"people utterly disconnected," perceive one another. As Kracauer explains, "a disinterested feeling of pleasure with a spontaneously self-generating world takes over the observers sitting around idly in the hotel lobby."[26] This point is reinforced by Benjamin when he writes that the flaneur in Weimar—detective or suspect, a loiterer who is either observing or being observed—is an "adherent to those realms, who appears and disappears in our metropolis. . . . His function is . . . to evoke an atmosphere of the outside, which only enters into the whole as an atmosphere of detachment."[27] The flaneur comes into being primarily as a figure of perception, as an epic camera, as a representative of the "pure outside" of aesthetics in his modernity. His function is visual perception per se, as a passerby on the street and a figure in the detective novel of the modern metropolis. He supplies a literary perception of the images of the metropolis and modernity in the same way that the text relates to its photographic medium, to a medium, that is, whose revelatory capacity, according to Benjamin, can no longer be underestimated. According to his *Kleine Geschichte der Photographie,* "every spot of our cities is a scene of crime . . . every one of the passersby a criminal."[28] It is here that the "literarization," that is, the textualization of reality that belongs to the flaneur's description of modernity, begins.

FLANERIE-*WERK*

Benjamin's project of the *Paris Arcades* makes the flaneur a central focus of his theoretical perambulations about the cultural landscape of the nineteenth century. At the center of Benjamin's vast kaleidoscopic reconstruction of the prehistory of capitalism, the flaneur finds himself reflected in and refracted through the various mirrors of the nineteenth century. He presents, along with the generalized figure of the "collector," the sole human center of these compiled "convolutes" of culture and history.[29] Benjamin views these two types as relatives, as related sensibilities whose particular relation to the traces of his collection of nineteenth-century texts is registered in the various ways in which their existence is inscribed within the phenomena of their exterior world. It is no accident that the sensory and material apparatuses represented by the "flaneur" and the "collector" come to be virtually surrounded by the most significant realms at the heart of both modernity and the Arcades Project. They form both the objects of experience and the medium of expression for those material worlds that haunt the spheres of their collecting and strolling. The collector and the flaneur seek out the images and scenes of the modern streets; they wish to collect and to see the phenomena of "fashion," "advertising," "prostitution," and "photography."[30]

The "flaneur" and "collector" represent two distinct, yet related manifestations of a disposition that differentiates itself above all things in the objects

toward which their respective obsessions of accumulation turn.[31] Whether the objects to be collected are composed of materials or perceptions, gathered either through a systematic process or in a flanerie of surprise discoveries, the desire of the assembling mind is directed primarily toward images and objects. Whether moving through interiors of obsession like the collector in exhibitions and museums, or traversing the phenomena of urban exteriors like the flaneur in his daily walks, it is the primacy of space and sight that shapes each one's attention. Their collections may be dedicated to items that differ in the degree of their volatility or durability: the collector accumulates material evidence, while the flaneur pursues the most transitory of sensations. On the other hand, the degree to which either materiality or visuality determines the character of their collected "objects" may differ, as the principle of accumulation still— even if to a different degree—defines their individual purpose and destination. A collector of images and texts, the figure of the flaneur in this regard provides a focal point not only for Benjamin's project but also for his principles of historiography. Indeed, the flaneuristic disposition can be said to define the entire process of Benjamin's writing, gathering his *Paris Arcades* at the very moment of their dissolution and decay.[32] Benjamin's project of the arcades might be understood as an extended document that magnificently passes through cultural time, as a kind of "meta-flanerie" that makes its way through the collected literary texts and exterior phenomena of a century. In his seemingly purposeless approach to seeing and collecting everything that he encounters in public space and culture, the flaneur prefigures the principle and structures of Benjamin's own seeing and collecting, of his own efforts to record the signifying moments and phenomena of capitalist modernity.

Benjamin maps his discovery of the figure of the flaneur as a figure of perception residing in Paris, "the capital of the nineteenth century," on the model of Charles Baudelaire, who represented for him the "lyric poet in the era of high capitalism."[33] These theoretical essays reflect on the disposition of flanerie in terms of Baudelaire's own pursuit of the radical shocks of the modern city.[34] Baudelaire the flaneur is a dreamer who observes the phenomena of modernity with his eyes open. As a flaneur himself, Benjamin conjures the *Paris Arcades* as the project of his daytime work and the object of his dreams alike, seeking to understand the period of the arcades as a formative period of high capitalism in the process of its decline: "The XIX century is a time period (a time-dream) in which . . . the collective consciousness sinks into an ever deeper sleep."[35] A link between flanerie and reverie can be read in Benjamin's formulation of his project as an effort "to go after [*darin nachgehen*]" the phenomena of this time, "in order to interpret the XIX century in fashion and advertising, architecture and politics as the consequence [*Folge*] of its dream visions."[36] Benjamin's fascination with vision surpasses even the surrealists' rapt enthusiasm for the optical dimension of "exterior" phenomena, directing this enthusiasm toward the close inspection and acute analysis of images and texts. This attentive form

of reading sheds considerable light on the potential that these images and texts have for provoking a revolutionary awakening. Benjamin's project thereby revives that of his precursor in flanerie with an eye toward its distinctly revolutionary implications, as he notes in his *Paris Arcades*: ". . . contrast to Aragon: to penetrate all this toward the dialectics of awakening."[37] The flaneur moves within the epistemological construction of the dream as a pivotal figure of thought [*Denkfigur*] that works to embrace all the phenomena of modern exteriority. Alongside Benjamin's categories for analyzing a "dialectics of commodities" and of "fashion," respectively, this figure also functions as the agent of his own "dialectics of flanerie,"[38] of a flanerie that is situated between dream and awakening, between bored contemplation and visual sensation.

As it appears in Benjamin's reveries about the nineteenth century, flanerie is characterized by a dreaming absorption in and contemplation of the phenomena of modernity, consisting in a detailed observation of the state of things. The flaneur is at once a sleeper and the one who researches this process of sleeping, the medium as well as the subject of this deep-sleep and dream-phase of capitalism. The contagious effects transmitted by the atmosphere of the city affect him like the phenomena that take sensual possession of him: "Whoever enters a city feels as if he were in a dream web where even an event of today is attached to the one that is most in the past."[39] Drawn into this dream through his walking, the flaneur continues to weave this dream web through the stories that he links to the strollers in the streets, and through the history that he ascribes to his haunts in the city. The flaneur dreams himself into a state of sensitivity that registers, with the increased susceptibility of a physical medium, its spatial sensations in decidedly sensory ways: "His soles remember. . . . Very often he would give away all his knowledge . . . for the sniff [*Witterung*] of a threshold or the haptic sense [*Tastbewußtsein*] of a tile. . . . The one who walks leads the street [*den Flanierenden leitet die Straße*] into a time that has disappeared."[40] On these strolls, his soles form the basis of this transformation into a medium of remembrance. His observations *en reverie* turn the flaneur into a subjective yet peripatetic historian of the city.[41] Benjamin in fact understands the volatile, fleeting character of this modern reality as the formative moment of not only his ambulatory attention but also its concomitant visual receptivity and recording impulse: "Anything about which one knows that one soon will not have it around becomes an image. Presumably this is what happened to the streets of Paris at that time."[42]

The visual pleasure and fascination that Benjamin associates with the fleeting apparitions of the city are not the only motivation driving the flaneur's movement. The phenomena of modernity that are disturbing the tranquil equilibrium of the city in their very newness emit indelible shocks. Such shocks define the decisive moments when an instantaneity of momentary insight communicates itself to the one who looks on the scene. This sudden insight involves the recognition of the ways in which an image only becomes an image

insofar as it is already threatened. The shock of a scene is formed either under the impression of its transitoriness—as history—or under the "shocking" expression of its innovation—as modernity. The one who puts herself in a position to receive all these shocks, to perceive these phenomena, is "the true subject of modernity."[43] In Benjamin's view, the instance of shock is embodied in the exemplary ways in which Baudelaire responds to the city as a modern man, as a poet and flaneur, a new type of the artist who approaches modernity in the mode of flanerie. This figure brings to these instances of shocks, especially in terms of their sensory immediacy, his own search for an intensity of experience, for an open disposition to which even the "new inconsolability [*Trostlosigkeit*]" of modern cities will appear "as an essential moment in the image of modernity."[44] Benjamin here refers to Freud's claim in *Beyond the Pleasure Principle*, that the shocks of modern sensory life can only be experienced by the observer "on the basis of their breaking through the protective shield against stimuli."[45] We might say that the flaneur is therefore an inhabitant of modernity who deliberately seeks to encounter these stimuli in the streets, to expose himself to these shocks for the sake of their intoxicating experience.

As Benjamin suggests, the flaneur is addicted to the perception of exterior reality and visual experience.[46] He is intoxicated by his very experience of this process, by the ways in which he abandons himself to the topography of the city. A decidedly anachronistic if not "timeless" form of movement, his walking helps him retreat from a time that is subject to functional measures and restrictions, to the limitations that arise from the imposition of any specific speed, duration, or destination to his movement: "An intoxication overcomes the one who walks for a long time aimlessly through the streets,"[47] Benjamin says about Baudelaire's flanerie. Seeking a state of aimless trance, the flaneur's movement serves to multiply his susceptibility to the multitude of sensory impressions, becoming the sole motivation of his movement. The potentially unlimited continuum of impressions in the city, according to Benjamin, can be best experienced in a state of intoxication, an intoxication that provides the only viable access to a modernity that can neither be fixed in static positions nor stopped and comprehended in the terms of a preceding generation. This is why the flaneur is driven into the modern streets in his search for new shocks and stimuli. He pursues and collects all the evidence of his visual experience that he can retrieve from exterior reality. Given this distinct obsession with the accumulation of relics and debris, Benjamin discusses the flaneur as a modern variant of the collector: "The ragpicker [*Lumpensammler*] fascinated his epoch."[48] With his predilection for the marginal and the discarded, the nonfunctional and superfluous excesses of the everyday, the flaneur finds himself reflected in this figure of the modern streets. Putting his freely floating attention to work on all the details, fragments, and kaleidoscopic particles of experience that come his way, the flaneur is as much a collector who seeks to preserve the

aesthetic marginalia of modernity as he is a chiffonnier who scavenges for discarded products left aside in the street. Thoroughly intoxicated by the processes of his collecting perception, he enjoys the excess of appearances that surround him. As Benjamin notes, "In the *flâneur*, the joy of watching is triumphant."[49] He goes on to distinguish the "perceiving" flaneur, who pursues his own perception, from the merely mindless "gaper." This distinction follows one made by many precursors of flanerie: According to Victor Fournel, for example, the true flaneur is "always in full possession of his individuality."[50] Despite all the impressions to which he is subjected in the street, his mind is never "intoxicated" by these phenomena "to the point of self-oblivion," a state that would partially obliterate his recording sensitivity. Unlike the flaneur, the "gaper" and the "pedestrian" go about their business without filtering their perception in creative ways, without retrieving the traces of their experiences in the crowd. What distinguishes the flaneur from these other figures of the street can be read in the literary difference of his project, his attempt to both read and write about the phenomena that he sees.

As a reader of reality and a writer of his own text, the flaneur's allegiance with the chiffonnier points to his larger affinities with the modern artist: All of these figures pick up the historical materials of their own time, use them in a new context, and thereby recycle some of the discarded but fundamental material aspects of modern life.[51] According to Benjamin, the flaneur is above all an artist who, emphasizing the poetic qualities of his visual pursuit, reflects them in literature, inscribes them into his texts. He finds these texts in the streets, reads them, and then translates them into the medium of a flaneuristic writing which seeks to reflect these new realities closely and attentively. In his passages through the arcades and streets, the flaneur—as a poet and "artist of modern life" who collects its visual materials—also becomes "its chronicler and its philosopher."[52] Registering in writing whatever affects him in the course of his optical passage, the flaneur is by definition the receptive medium for the aspects of modern life which form the central concerns of his text. This focus includes, but is not limited to, the forms of architecture and the new arts of advertising that are everywhere before him. His attention extends to the entire continuum of modern existence, ranging from an aesthetics of the everyday in traffic and signs, vehicles and commodities, to fashion and other more stylized expressions of life. Baudelaire defines this intense curiosity in terms of the epic "painter" who reconciles visual and verbal forms of language, who exhibits a modern aesthetic sensibility that stretches far enough to "[teach] us in lines and colours to understand how great and poetic we are in our patent-leather shoes and our neckties."[53] The details of a prosaic, everyday modernity punctuate the very aesthetics toward which the flaneur directs his scopophilic eye, an aesthetics that he inscribes in his texts of flanerie. Rendering his own imaginary "miracle of a poetic prose,"[54] as Baudelaire calls it, the flaneur's text transforms these marginal impressions into significant traces of the material dimensions

of culture and history. This work of redemption emerges as the inscription of an intense poetic endeavor, a virtual "fencing" that seeks a rhetoric that could do justice to these images of modernity.[55] Baudelaire situates the preferred space of this new language in an urban experience, claiming that such prose "is above all a child of the experience of giant cities, of the intersecting of their myriad relations."[56]

These observations locate the text of flanerie at the interstices of scopophilia and modernity. The movement of this text takes its point of departure from the city, the pivotal space of modernity that guides the flaneur's contemporary walking, stimulates the images he receives and records, and shapes the writing of his text. The language that speaks of these images often takes the shape of dream sequences, as it seeks to outline the irreality of shocks and images in forms that correspond to their intricate intensity. The "net of relations" that Baudelaire sees as formative of the city's structure expresses the close affinities that the texts of flanerie share with poetic imagery. The very plurality of metropolitan "relations" is in fact approximated most closely by a prose that weaves a similar net of poetic "correspondences."[57] These correspondences are experienced in terms related to color and light, phenomena whose very intensity calls for rhetorical equivalents to the shocks received by the modern mind. Flanerie is the decisive move that facilitates the modern artist's intense exposure to his respective reality. It casts its spell on city dwellers with "imagination," Benjamin says, with urban authors who seek to translate the images of the city in their eyes and minds into a poetic language of moving images. According to Benjamin, the flaneur is at once a poet and a "Grübler," a viewer who broods over whatever he sees, and a writer with the "willingness at any time to put the image into the service of reflection."[58] This contemplative openness lets the flaneur experience his every step as a poetic process, as a flanerie that constitutes an "essentially poetic act."[59] The street itself becomes the space where this "dream web" is woven in single steps, a structure formed in the process of seeing. For Benjamin, this act inaugurates the process of flanerie: "[The] category of illustrative seeing [is] fundamental for the flaneur. He writes . . . his dreaming as a text for illustrating the images."[60] These relays among walking, seeing, and writing form an intricate net that describes the text of flanerie: patterned after the ways of walking in the city, this moving process of vision is translated in every instance into a moment of writing.[61] Along such lines of perception and reception, the texts of flanerie constitute themselves as an *écriture automatique* of seeing and writing, an art that seeks to translate its visual impression into a textual imprint.

The flaneur reads the street—its signals, shocks, stimuli, and sensations. His perspective is above all a visual one, one that positions him as a spectator of urban signs, shapes, and structures, a walking reader who transforms these multiple and multivalent signs into written texts. In Benjamin's theories and beyond, the flaneur is both city stroller and writer of images, an author who

turns his everyday perceptions into literary description, a collector of the poetic debris and *objets trouvés* of reality. The site of this imaginary transformation itself becomes the location of a new poetic experience, a "cityscape" of modernity. Viewing the city as a topography of poetic experience that until now has been reserved for "natural" landscapes, Benjamin suggests that "a new romantic view of the landscape" is emerging. Illustrating what he calls the "principle of flanerie" in Proust, this new view "appears to be a cityscape."[62] Flanerie becomes an immediate, intense, and expansive way in which modernity and all its potentially poetic phenomena are experienced. In this regard, Benjamin suggests that Baudelaire's *Fleurs du mal* is the "first book" that features as its "poetic" words "not only words of ordinary provenance but words of urban origin."[63] Within this inclusive sense of semantics, suddenly even a "*wagon*," an "*omnibus*," or a "*réverbère*" evoke their own aesthetics, and new ways of traffic and new forms of light emit novel poetic effects. It is no accident that the three examples that Benjamin retrieves from Baudelaire's poetry signify select phenomena of modern street life and the effects they have on the experience of movement.

These effects and their experience change not only what readers and writers consider to be the intrinsic materials of literature and life; they change the relation of these materials to the presumably stable opposition between exteriority and interiority. While "the city opens itself up boundlessly [*schwellenlos*] before the stroller like a landscape in the round,"[64] it also reveals itself to the flaneur as an ever more familiar interior. The flaneur's obsessive wish to "inhabit" every metropolitan location as he does the ambulatory interior of his perception is analogous to what Benjamin sees as the "Parisians' technique to inhabit their streets." The same thing that leads him to dwell in and on the streets enables him to bring the street "inside," to gaze on a presumably familiar "interior" as though it were foreign and unfamiliar. Benjamin translates this modern alteration of our relation to space into an observation about the flaneur, who likes to "go for walks in his room."[65] Living in the streets, the flaneur travels around his house, experiencing the "voyage autour de ma chambre" as an interior flanerie that figures a new way of walking in modernity: perception becomes its action, and space emerges from the background to become a matter of experience in its own right. Both exterior and interior spaces turn into objects of scopophilia that can be experienced either by walking in the street or by tracking extended lines of serial images. What Benjamin understands as the "intoxicated fusion of street and interior" occurs along protocinematic lines, revelling in its wide panoramas of light, color, and perception.[66] It presents modernity primarily in its spatial phenomena, with the street as the privileged metaphor that links private perception to the public sphere. The street comes to signify for the "poetic" mind the pivotal scene of modern life: one in which a sensitivity is intoxicated with visual signs and moved by its scopic drive. For the inhabitant of modernity who walks and writes, the street offers, according

to Benjamin, all the amenities and necessities of home and office, of the work place and the space of leisure:

> The street becomes a dwelling for the *flâneur*; he is as much at home among the façades of houses as a citizen is in his four walls. To him the shiny, enamelled signs of businesses [*Firmenschilder*] are at least as good a wall ornament as an oil painting is to a bourgeois in his salon. The walls are the desk against which he presses his notebooks; newsstands are his libraries and the terraces of cafés are the balconies [*Erker*] from which he looks down on his household [*Hauswesen*] after his work is done.[67]

As the fundamental space in which Benjamin situates Baudelaire's writing and lifestyle, this scenario also works to synthesize aspects of exteriority and interiority within the image of the street. At the same time, it distances the bourgeois existence from the experience of flanerie. The flaneur approaches the signs of his time as a new semiotic code and highlights the characteristics of modernity in terms of a new aesthetics. His critical perception of the enamelled signs of the advertising culture of capitalism can be mobilized to revolutionize previous functions of art and to disseminate aesthetic notions through forms of decorative distraction. Journalistic media extend the notion of literature in order to supply erudition, information, and a pleasure in texts at the level of everyday readings. The recently introduced and newly illustrated journals bring together in one innovative medium the functions of both written and visual codes. This proliferation of new signs in the street gives way to the flaneur's visual impulses, while his notebooks on the wall represent the close and nearly immediate transcription of these visual materials into the textuality of writing. By reading the world and writing it anew, flanerie literally functions as a kind of work, a journalistic form of labor that involves the work of inquiry, the gathering of information, and the collection of contemporary impressions. Benjamin's short outline characteristically understands these most significant indices of the flaneur's existence to be the product of a collective disposition as much as of the individual's autonomy of perception. As he suggests in the *Paris Arcades*, in nearly the same wording with which he describes the place of the flaneur, "Streets are the dwelling of the collective."[68] In this analogy between rhetorical and spatial structures, he situates both the solitary flaneur and the collective proletariat in a location that is literally and metaphorically identical: the public sphere of the streets.

Positioned within the ambivalent intersection between individual and collective spheres, the flaneur's texts bring together two different modes of writing. As a modern journalist, he engages simultaneously the physiological tradition of reading the stories of passersby from their appearance and the feuilletonistic art of turning "a boulevard into an intérieur."[69] Transferring the city's exteriority into the reader's home, the flaneur attempts to domesticate the horrors that come with modernization. The "mental life" of the city increasingly brings

forth an overwhelming number of sensory stimuli and an incalculable crowd of strangers in the street. The function of the physiologies in the 1840s, to which Benjamin has recourse in his definition of flanerie, was to contain this disquiet: by focusing and resting the gaze upon quaint, original, and benign details, they soothed the strangeness of a multitude of strangers and thus contributed to the "fashioning" of a friendly "phantasmagoria of Parisian life," by providing guidelines for orientation, manuals for interpreting strangers and phenomena.[70] The physiologists' texts, as Benjamin reads them, assured the learning city dweller "that everyone was, unencumbered by any factual knowledge, able to make out the profession, the character, the background, and the life-style of passers-by."[71] Exercising his undivided attention by projecting this empathy toward "the amorphous crowd of passers-by, the people in the street,"[72] the metropolitan physiologist both extends the powers of his scopophilia and seeks to ban the horrors of anonymity and multiplicity, the uncanny experiences of modern life.

The modern city-strollers succeed to this disposition with what Benjamin calls his own "phantasmagoria of the flaneur: the reading of the profession, the origins, the character from the faces."[73] This form of visual interpretation becomes the aim of his excursions into the street—passages of flanerie in which he "studies" and scrutinizes the pedestrians who pass by him closely. As Benjamin suggests, these physiological studies of the street even seek to understand the larger collective physiognomies of the city itself. Among the precursors to a literature of flanerie, Benjamin lists the following excursive texts: *Paris la nuit* (which illuminates a scene of nocturnal strolls), *Paris à cheval* (which suggests a flanerie that may take place even from horseback), and *Paris pittoresque* (which unfolds a city of distracting images).[74] The ever-changing scenes and effervescent effects of light and shadows, images and figures, to be found in *Paris au gaz* and *Paris by Sunshine and Lamplight*, form the particular focus of more differentiated descriptions. In their respective modes of writing, all these texts are determined by a tranquil and patient pace of description. As Benjamin notes, "the leisurely quality [*Gemächlichkeit*] of these descriptions fits the style of the *flaneur* who goes botanizing on the asphalt."[75] That the speed and spaces of this form of walking still derive some of their specificity from tranquil modes of the nineteenth century can be seen in Benjamin's botanical metaphor, which understands collecting as a kind of "botanizing," as an activity with its own particular "mixing of country and city codes."[76]

In the course of the nineteenth and twentieth centuries, however, the flaneur is not entirely secure in his gradual and painstakingly detailed observations. The growing disquiet escapes physiological explanation, even as it suggests a sense of uneasiness that originates from the de-individualized and commodified existence of the fleeting masses that move the flaneur along with them. At this point, the physiological familiarity shifts instantly into the modern

observer's discerning distance. The poet in the era of high capitalism finds the city to be what Benjamin calls in his notes on the "Pariser Passagen" a "primordial landscape of consumption,"[77] an abundance of offerings that stop him in his strolls in order to reveal a moment of critical insight. Benjamin sees the poet as a "virtuoso of this empathy [*Einfühlung*],"[78] an artist who experiences this commodity aesthetics as an inextricable part of any modern aesthetics. The flaneur becomes, as Benjamin remarks, an "observer of the market," an observer who begins to realize that his sensory reception, his sense of aesthetics, is not only mediated by forces of the market but also requires a theoretical distantiation of the gaze. In this way, the flaneur of Benjamin's theories turns into an attentive—and thereby potentially critical—"explorer of capitalism sent out into the realm of the consumer."[79] Benjamin realizes that an exploratory gaze on a reality of commodities can open a critical perspective that offers an alternative to the concept of advertising, especially in its tendency "to gloss over [*überblenden*] the commodity character of things."[80] The pursuit of an aesthetics of modern phenomena and objects in terms of their commodity character allows us to perceive them as modern allegories in a new form. This allegorical view offers us a window on the world of commodities that potentially illuminates not only their aesthetic qualities but also their wider political implications.

Benjamin begins to describe the complex processes of this critical project in the following manner: "The deceptive *Verklärung* of the commodity resists its distortion into allegory."[81] Understanding aesthetic perception as a potentially resistant gaze, Benjamin calls the flaneur's visual empathy with the commodity a "heroic attitude,"[82] an *Einfühlung* that leads to new forms of insight through intense identification with the commodity in all its aspects. Benjamin finds this "prostitution of the commodity-soul"[83] responding to a modern "heroism" that he sees in thousands of "unregulated existences," such as the outsiders who live on the margins of the big city, or the prostitutes who exist as literal personifications of the "commodity" existence.[84] A kind of commodity that circulates in the street, the flaneur reveals his affinities with these marginalized prostituted lives, for him the truest expressions of commodification walking the public sphere. Benjamin himself identifies these striking forms of capitalist reification with a seemingly aimless yet purposeful flanerie.[85] In this view of the world, all the phenomena of modern life—including the flaneur—ultimately reveal themselves to be (in) a state of "prostitution." Though he conducts his "leisurely walks" as if he were free to "waste" his scopophilia in the street, his time has already turned into labor and his curiosity into its own commodity. The flaneur begins to enter the street as an observer with professional interests and to market himself as a journalist. Viewing "his idle hours on the boulevard" as part of his work schedule, he at once "prostitutes" and "legitimizes" his flanerie within the functional confines of the modern working world.[86]

As Benjamin notes, this functionalization changes the presumably aimless perspective of his flanerie: "The man of letters . . . goes to the marketplace as a *flâneur*, supposedly to take a look at it, but in reality to find a buyer."[87] These forces of commercial reality, as Benjamin outlines them, reinforce each other in a capitalist world of commodities. As the author turns first flaneur and then journalist, the literary space of his wanderings becomes the primary text of his writings. Within the primordial landscape of consumption, his empathy with the objects of his observation turns him into a journalistic commodity. But journalistic writing is only one feature of the "societal basis of flanerie": the stroller's aesthetic pleasure is not exhausted by the officially sanctioned activities of observing and reporting public facts.[88] In addition to accumulating gainful information, his gaze also pursues another ongoing project, the secret collection of subjective details that work to configure a critical, idiosyncratic, and subversive way of looking. The flaneur insists on his "idle hours" not only for the "market" value of journalistic *recherche,* but also for the time he needs to pay close and careful attention to the details of everyday life.

The critical potential that lies in the flaneur's scrutiny of minute details may also provide another "social legitimation of his habitus."[89] As Benjamin suggests, this minute work of investigation renders the flaneur a detective of observation. In his undivided and unmitigated attention to whatever occurs in the street, he shares the detective's "intense attention" to detail. Benjamin finds a precursor to this figure in the investigator who pursues the traces of secrets in the city, the "hunter in the urban decor."[90] Benjamin suggests that the flaneur and the detective share a similar obsession for pursuing the "traces of the individual in the city crowd," concluding that "in the figure of the flaneur, the one of the detective has prefigured itself."[91] The detective story seeks to uncover the relevant traces of a particular crime in the maze of society, while the flaneur seeks to register the traces of this uncharted terrain within the movement of his own perception. The flaneur is driven by an aesthetic fascination that gathers the signs of the city into the fabric of his text, while the detective is driven by the logistic challenge of gathering these same signs as evidence to uncover the meaning of his story. The mysteries of the city, the itineraries of unknown *passantes* and other passersby, not only stimulate the physiological curiosity present in both the flaneur and the detective—as Benjamin notes, their incessant obsession with images and traces identifies them with the media of the era, an era that increasingly tries to "compensate by means of a multifarious web of registrations for the fact that the disappearance of people in the masses of the big cities leaves no traces."[92]

As a kind of private eye, the flaneur investigates the sensations that he experiences and the riddles of modernity that he registers. While the sensory stimuli and uncanny character of his existence accelerate in the city, the modern efforts to normalize life threaten this observing existence. The flaneur finds himself viewed as either a surveilling detective or a loitering loner—in either case, he

is a potential suspect or trespassing outcast. In the opinion of an active and productive public, the flaneur remains an idle and seemingly passive nuisance, anachronistic and unproductive, a suspicious and marginal existence. In his reading of Poe's exemplary story, Benjamin suggests the ways in which the "Man in the Crowd" generates suspicion wherever he goes. As the only passerby who does not display a discernible purpose in his meandering walks through the city, he refuses the prevailing rationales of society. He frees himself in order to perceive and experience the city as a subjective medium of modernity, but it is through his own body that he experiences the shocks and effects with which the city and its spaces inscribe themselves on their subjects. He appears as "the man, who feels looked upon by everything and everybody, the suspicious one per se, and on the other hand the one who is completely indiscernible [*Unauffindbare*], the one taken in [*Geborgene*]."[93]

The very form of the flaneur's movement renders him instantly suspicious, casting his decidedly slow and anachronistic ambling into a mode of being that resists the prevailing uses of time and the "tempo of the crowd."[94] His leisurely strolls unfold in an implicit but manifest defiance of the unified spirit of the crowd within and against which he moves. His attention to the visual phenomena of reality works as a form of practical sabotage directed against society's functional purposes, its collective speed and shared labor. The flaneur questions and transcends the predominant frameworks of labor, leisure, and social life. Gathering these spheres into the experience of one individual, he insists on his own critical perception at all times. Exercising the right to unstructured leisure, slowness, and a sufficiently free space for observing the spectacle of the street in its everyday displays, his excessive obsession with the multiple sights, with the intensive redemption of this spectacle, turns him into an obstacle on the street. Benjamin distinguishes the perceptive flaneur from the merely consuming city dweller who, bombarded by new stimuli, fails to respond, does not reflect on them in writing as a veritably subversive element would: "There was the pedestrian who would let himself be jostled by the crowd, but there was also the *flaneur* who demanded elbow room and was unwilling to forgo the life of a gentleman of leisure."[95] Swept along by increased traffic and speed, by crowds in the cities, the flaneur may appear to be similar to other hurried passersby. The exterior spaces of his perception may become crowded with newer and more frenzied, decidedly non-leisurely bits of fray. Nevertheless, the "free space" in which he plays out his own reflections—the state of mind that distinguishes the flaneur from other pedestrians—increasingly is relocated into an interior space of perception, is displaced into the literary perception of these shifting scenes and stimuli.

The flaneur responds by incessantly reflecting on and recording his impressions. This creative and attentive reaction distinguishes him from other pedestrians, from every participant of modernity who mindlessly lets himself be pushed around in the crowd. The flaneur's particular relation to both the exte-

rior world and his interior reflections works to define him as an individual and solitary outsider amidst the crowd. His movements are marked by a suspicious "undecidedness,"[96] a temporary and hesitant pace that allows him spontaneously to change direction in order to respond to the shocks and stimuli of the street. Benjamin declares this critical reserve to be the terrain of flanerie: "As waiting is the genuine state of the immovable contemplative one, so does doubting seem to be the state of the one who goes for a walk [*flaniert*]."[97] For him, the realm of this critical distance opens up the possibility of a close attention to, and contemplation of, all appearances in their own right. The multitude of phenomena in the city provides the spatial and visual equivalents to the flaneur's state of distraction. As Benjamin notes, the "labyrinth" of these metropolitan scenes "is the home of the hesitant one [*des Zögernden*]."[98] If a latent state of waiting, a free-floating expectation of new images, shocks, and impressions, forms the experience of flanerie, then the time that is susceptible to a "return of the flaneur" will be characterized more as a phase of transitions than by its processes of change. In other words, a "time of waiting" always gives way to a time of flanerie.[99] In numerous observations, Benjamin delineates the means whereby the translation of such latent dispositions of flanerie into the actual perspective of an observer and writer takes place. As a figure of the modern author, the flaneur takes to the streets with the perspective of an outsider who seeks to gather his clandestine observations on modern life. Benjamin describes this position in terms of a radical refusal of codified social rituals: "The poet does not participate in the game. He stands in his corner,"[100] and views the street. He reads its images, and inscribes them into his mind. The poet observes, collects fragments, and finds locations—all of these inadvertent discoveries take the place of the "invented plots" of conventions that he seeks to avoid. Displaying an attitude that superficially we might regard as "detached," the flaneur is considered a "lonely man" in the crowd, one who often pursues his solitary ways at night, attracted by the nocturnal spectacle of lights in the city.[101] This loneliness is a paradoxical one. It is a direct function of his existence in the crowd and of his interest in its perception. The city crowds isolate but also attract the flaneur. They are the condition for modern scopophilia and distraction.

The freedom of flanerie is elevated more than impeded by this loneliness since, as Benjamin remarks, the strong urban shock "suddenly overcomes a lonely man,"[102] the man of the city, who refuses to share his undivided attention amongst an overload of activities. This loneliness ultimately becomes a state of mind, the prevailing disposition and even presupposition of the flaneur's perception. As Benjamin notes in relation to Baudelaire, his exemplary case: "Baudelaire loved solitude, but he wanted it in a crowd."[103] The observer's isolation makes possible the extended states of waiting and writing in which his lonely time of seeing takes place. The necessity of this solitary perambulation corresponds to the flaneur's predisposition for states of melancholy, a melan-

choly from which he seeks escape in a deluge of images—searching in these images for points of orientation, markers of life and "basic situations" that would help structure the alienating flow of modernity. According to Benjamin, the visual epiphanies encountered in flanerie are some of the last experiences that render a sense of meaning to modern man's itinerary in the city. Granting these experiences primary importance, he writes: "On the suffering path of the melancholic, allegories are his stations."[104]

For the flaneur, the visual stations along his way outline the path of his existence, providing the point of departure for the daily epiphanies that he expects to experience on his expeditions through the city. In a consequence that is not to be overlooked, the flaneur in this way obtains for himself, in the wording of Benjamin, "the unfailing remedy for the kind of boredom that easily arises under the baleful eyes of a satiated reactionary regime."[105] Flanerie functions as a "walking cure" against the prevailing melancholy in capitalist modernity—the melancholy to which modern subjectivity is subjected in its periods of waiting, transit, and transition. This is why the overwhelming melancholy of an existing state of things can be faced only in a redemption of physical "reality," a redemption that Kracauer will understand as the overriding impulse for his theory and experience of cinematic images. If the figure of the flaneur coincides with a constitution that Weimar theorists describe as characteristic of their modernity, it is because he shares a disposition common to many of his contemporaries. Both white-collar workers and intellectuals-in-waiting become detectives of their time and, in an aesthetically minded and visually oriented variant, flaneurs of their city. In his own theories of modernity, Benjamin lets Baudelaire exemplify the waiting times of his century through the various roles in which a "heroic," that is, an intensely existent sense of modernity, still appears to be possible, whether in the form of a "*flâneur*, apache, dandy, [or] ragpicker."[106] In his modes of roaming and collecting, the flaneur appears as the quasi-characteristic configuration of the "apache" in a metropolitan wilderness, as the "dandy" with an all-embracing sense of aesthetics and specularity, and as the "chiffonnier" who preserves and recycles its urban excess. Exhibiting all of these multiple aspects, Benjamin's flaneur appears as a composite of the visual signs and markers of modernity.

Part Two

HESSEL IN BERLIN

Walter Ruttmann, scenes from *Berlin. Die Sinfonie der Großstadt* (Berlin, the Symphony of the City). Courtesy of J. Dudley Andrew.

The Art of Walking: Reflections of Berlin

Walter Benjamin's essay "Die Wiederkehr des Flaneurs" takes as its model the writer Franz Hessel. For Benjamin, Hessel, a close friend and collaborator, a child of Berlin and tenant of Paris, is the exemplary manifestation of the flaneur in Weimar culture. More explicitly than Benjamin, Kracauer, and other Weimar intellectuals, Hessel's texts both articulate and illustrate a theory of flanerie in the twentieth century, and in so doing suggest a means for approaching contemporary Weimar Berlin. Hessel's reflections on Berlin form a phenomenology of flanerie that, in its orientation toward his very own modernity, tangibly surpasses Benjamin's studies on the flaneur, especially when the latter merely reconstructs the flaneur retrospectively as an anachronistic type of nineteenth-century Paris street life.[1] Despite the compelling aspects of his life and literary practice, Hessel has returned only recently from the margins of German literature to a certain measure of critical interest.[2] His personal stature as one of Benjamin's closest friends and his professional status as an editor with Rowohlt, the prominent publishing house of the 1920s, have been rediscovered along with his intimate familiarity with the city's literary circles of his time. Forced to leave Germany as a Jewish citizen under Nazi persecution, the writer also had been obliterated from the pages of German literary encyclopedias, his life reduced to the fragments of an oblique existence.[3] In revisiting some of the stations of this life, this account of Hessel's biography is intended less as an exhaustive enumeration of his curriculum vitae than as an outline of the formative places and times contributing to the flaneur's development.[4]

Born in the eastern Prussian city of Stettin, Hessel and his well-to-do bourgeois family relocated to Berlin in 1888, a move to the city that introduced the eight-year-old to the decisive ground of the flaneur's development, his knowledge of urban spaces. The father's death paradoxically presented the young man with the opportunities of instant leisure: the immediate leave, financial independence, and freedom from professional concerns and purposes that is the precondition of any aimless flanerie, the leisure to pursue an independent existence as a student of literary history, mythology, and archeology—a constellation of subjects that already circumscribed the focus of his metropolitan observations. These "studies" anticipated the further *Studium* of cities, reality, and history that moved him beyond Berlin to the major locations of the European *bohème* of his times. Frequenting the literary circles of Munich,

drawing on conversations with Stefan George and his friends, with Franziska von Reventlow and her admirers, Hessel began editing his first publication, the *Schwabinger Beobachter* (Schwabing Observer), aptly predicting the predominant stance of the later flaneur.[5] In 1906, Hessel moved on to Paris and the Montparnasse circles of Gertrude Stein and Henri-Pierre Roché, a writer who would soon become his close friend and intimate rival for the affections of his later wife, Helen Grund, a Berlin expatriate and fashion journalist. Their literary and erotic triangle inspired not only Roché's fabled novel *Jules et Jim*, the fictional foil for Francois Truffaut's filmic adaptation, but also Hessel's earlier, by now nearly obsolete novel of Parisian memories, *Pariser Romanze*. In 1993, the posthumous publication of Grund's own diaries from this period presented the final angle to the mutual mirroring of relays and conflicts among these three participants in one of the more remarkable personal and cultural, literary and emotional constellations of the early twentieth century.

The metropolitan existence of these strangers in and lovers of Paris was abruptly suspended through Hessel's shock-ridden encounter with the political realities of World War I, but unfolded again when—via battles in Alsace and Poland, East and West—he returned to his home city. Transferring the language, culture, and images of Paris, he began a new life in Weimar Germany, translating and editing French literature in Berlin—Stendhal, Balzac, and others. Founding his journal, *Vers und Prosa*, in 1924, he presented to the public some of the more intriguing German authors of the era, among them Robert Musil and Robert Walser. As editor for Rowohlt, a publisher central to Weimar's literary sphere, Hessel formed relationships with the intellectual minds of his times: he met Ernst Bloch, discussed cities with Siegfried Kracauer, and entered into a close friendship with Walter Benjamin. This latter relationship yielded a long and inspiring collaboration: as of 1925, Hessel spent the better part of two years in Paris translating Marcel Proust's *A la recherche du temps perdu* with Benjamin. Along the way, but certainly not as an afterthought, he introduced Benjamin to his sense of the city, to its history and its margins. It was during this time, and due to the inspiration of their mutual conversations on Paris, that Benjamin's plan of a *Passagen-Werk* began to evolve into the project that would occupy him for the rest of his life.[6] Hessel's influence on Benjamin's Parisian reflections is as indisputable as its extent is only surmisable. His own work during this time shows a significant turn toward cities and their cultures. This work includes a trilogy of revelations in the city, beginning with *Der Kramladen des Glücks*, continuing through his *Pariser Romanze*, and concluding with a return to his childhood in *Heimliches Berlin*. Besides these poetic texts on the city, Hessel's work includes several volumes of poems, a number of novellas, and a few shorter plays.[7] His most intriguing text for our purposes, however, can be found in a collection of essayistic approaches to the city under the title *Spazieren in Berlin*. These essays constitute one of the most important contributions to the literature of flanerie and intellectual thought of

Weimar Germany. Their motifs and themes are revisited throughout his writings: in the posthumously discovered fragment *Alter Mann,* and in several overlooked pieces of essayistic writing—excursions to the literary market, records of his Parisian impressions, and a portrait of Marlene Dietrich—all of which, in their very fragmentariness, closely reflect the kaleidoscope of this flaneur's aesthetics.

WALKING IN BERLIN

In contrast to preceding nineteenth-century notions of the flaneur, Hessel suggests that flanerie finds a new footing in modernity. In a number of the essays comprising *Spazieren in Berlin,* he understands the concept of walking as a metaphor not only for this particular work but for his works in general.[8] In its central theoretical essay, "On the Difficult Art of Taking a Walk," Hessel deliberately proposes to mobilize apparently obsolete forms of "walking" toward an aesthetics that might provide him with access to his own era.[9] Naming this process an "art" instead of mere "action," he accords the status of a new artistic movement and theoretical significance to the process of walking. This essay contains *in nuce* some of the pivotal aspects around which Hessel will organize his thoughts on the movement and motion at the heart of his ambulatory theory of modern flanerie. Considering movement to be the primary term of his literature and philosophy, he revisits Fournel's questions about the intricate net of reflections, thought, and looking from which a "theory" of flanerie might be articulated.[10]

For Hessel, the anachronistic aspects of flanerie are what render it a form of resistance, giving it its critical significance in an age of modern rapid transit. The "aimlessness" of the flaneur's motion works to question prevailing notions of purpose and social rationale, in contradiction to the regulated movement of modern traffic and the pragmatically defined era of "New Functionalism," one possible translation and interpretation of *Neue Sachlichkeit.*[11] With the aimless gaze of the flaneur, Hessel introduces a figure of thought into literature that responds to some of the most significant theoretical thought of the twentieth century. Walking the streets of the city, Hessel's flaneur experiences them as a "text." Modern reality, for the flaneur, consists of an incessant series of encounters that unfold in the sheer contiguity of experiences that describe its "textuality." Naming the relays between walking and seeing, reading and writing, Hessel has recourse to an analogy between the street and the text, a trope that had first appeared in the early modern period. This turn toward the "legibility" of the world allows us to approach reality as a continuum in which there is nothing to be seen and experienced "outside a text," a continuum in which every phenomenon can be read as a "text." While early examples in Jacques Derrida's *Grammatology* focus on the text of a "book" that depends for its

legibility on authorities beyond the reader, the figure of the flaneur makes the question of legibility a modern question.[12] In German literature, Börne formulates the flaneur's metaphor of textuality in regard to Paris. He describes the place that Benjamin will interpret as the "capital of the nineteenth century" as "an unfolded book, [and] wandering through its streets means *reading*."[13]

Börne's argument for an extended, leisurely "reading" of the street originates in the nineteenth century, an era in which modernity only gradually accelerates its tempo. The stroller's leisure is thus defined in terms of a preceding age, with its implicit understanding of the walker's sense of the world as that of an artist whose perception of artefacts, scriptures, words, and images is influenced further by latently romantic, nineteenth-century (self-)definitions of the artist as dreamer, outsider, and genius. In his reconstructions of the nineteenth century as a formative period of modernity, Benjamin returns to this walking figure of reflection and emphasizes its focus on the essential legibility of the world. He postulates an equivalency that registers the underlying assumption of the flaneur's textual metaphor in the city: "Perception is Reading." In both perceiving and reading "Berlin's Boulevard,"[14] his friend Hessel offers one of the more detailed definitions of flanerie in Weimar modernity as he pursues his feuilletonistic reflections on Tauentzienstraße and Kurfürstendamm. Extending Benjamin's aphorism, he writes:

> Flanerie is a way of reading the street, in which people's faces, displays, shop windows, café terraces, cars, tracks, trees turn into an entire series of equivalent letters, which together form words, sentences, and pages of a book that is always new. In order to really stroll, one should not have anything too specific on one's mind.[15]

Hessel's textual metaphor forms an essential part of his essayistic theory of modern flanerie. As he writes, "The real city stroller is like a reader who reads a book simply to pass the time and for pleasure."[16] This analogy of book and city, text and street, allows us to experience in Hessel's writings on Berlin in the 1920s a current and significant textual metaphor that has helped to formulate our sense of modernity from its very inception.[17] In spite of the seemingly timeless and hedonistically aimless character of flanerie, Hessel's aesthetics explicitly pursues its objects in the newest phenomena of modernity: "There is no newspaper that one reads with as much excitement as the glowing letterings which run along the roofs in advertisements" (*EG*, 55). To the open gaze of the flaneur, "shop windows [are] no longer obtrusive offerings but rather landscapes," a commercial art form that he understands as the aesthetic second nature of his era. Hessel's perception is predicated on an all-encompassing visual sensitivity, a sense of seeing that comprehends the fascinations of the city's past, the light effects of its real and metaphorical twilight, the muted shimmer of its iron-glass constructions and nineteenth-century interiors as much as the shrill sensations and neon attractions of modernity. With partic-

ular emphasis, the flaneur of the 1920s again and again returns to the "light advertisements shining up and vanishing, wandering and returning" (*FB*, 145), viewing them as the privileged signs of his times. Captivated by such novel illuminations, Hessel promotes the flaneur's view as an expansion of vision, of previously "unseen adventures of the eye." Indeed, the frantic display and crisis of capitalist phenomena only further multiply the variety of decipherable signals that the passerby encounters in the street: "Follow the biographies of stores and small hotels in passing by . . . how much fate, success and failure can be read . . . from the displays of wares and from the menus posted for inspection" (*EG*, 57).

Approaching Berlin's realities from its margins, the flaneur arrives to read between the lines of these street-texts. He finds the material of his readings on the surfaces of a cityscape whose inflationary increase of marginalia forms a vast "wasteland" of textual fragments, a "crowd of temporary structures, of demolition scaffoldings, construction fencings, board partitions, which become glowing spots of color in the service of advertising, voices of the city" (*EG*, 56). These voices and signals, signs and letters, together constitute a metropolitan text that abounds in countless facets and excessive hieroglyphs, a text whose decoding is carried out by Weimar flaneurs in what Hessel calls the "difficult art of taking a walk."[18] This version of flanerie transforms the textual metaphor of the city into a mode of perception that understands all of reality to be a text. The metaphor applies as much to Benjamin's expedition into the decaying arcades of Paris as it does to Hessel's reception of an evolving modernity in Berlin. It suggests that the flaneur walks in order to uncover traces of the past and to read these reflections as symptomatic of their respective time, be it the nineteenth century or Weimar modernity in all its sensations.[19]

This aesthetics, with its focus on subtle variations in light, color, and structure, is prone to perceiving these visible sensations under the aspect of a mild idealization—a sense of *Verklärung* that surrounds all of its appearances with the veil of a benevolent gaze. Hessel's version of flanerie, a search for memory through the beauty and harmony of images, offers the modernist a refuge in the relic of an aesthetics originating in the late nineteenth century but present in the 1920s. In an earlier Berlin, Theodor Fontane's writings also focused on the particular quality of light in the city, on the light effects that enveloped his likewise muted depictions of the very real dynamics and conflicts of his society.[20] Hessel seeks a similar *Verklärung*, a quasi-ethical affirmation of life in which, exceeding simple "beautification," he advises the novice flaneur to abandon himself to the light and atmosphere of the street: "Also let yourself be deceived and seduced a little by the lighting, the time of day, and the rhythm of your steps. The artificial light, particularly in competition with a residue of daylight and dusk is a great magician, it makes everything more manifold."[21] Dusk is the natural analogue to *Verklärung*, an aesthetics of indirect illumination in which everything appears in more shining, mysterious, luminescent

hues. Hessel's way of seeing endows the metropolitan world of modernity with a "veil of beauty" similar to that which Fontane had envisioned as befitting the artistic depiction of an experienced world.[22] This careful and attentive gaze lends a new aesthetic angle to any of the "objects" that Hessel perceives in his writings: "By looking at it in a friendly manner, even the ugly is imparted with a trace of beauty. The aesthetes do not know that, but the flaneur experiences it" (*EG*, 60).

Hessel's optical philosophy perceives everything that can be seen through the lens of this harmonious aesthetics. Its corollary is an equally benevolent and reserved poetics: "If the street is therefore a kind of reading, then read it, but do not criticize it all too much" (*EG*, 59). The flaneur calls for a kind of writing that might reflect his open way of seeing, a kind of writing that offers "Preferably somewhat less judgment and more description [*besprechen*]." This poetic statement reveals a host of dangers that might arise from the exhortation of "valuefree" discussion and epic depiction, the lack of an explicit critical perspective being only the most obvious one. On the other hand, however, the very openness of this maxim suggests its virtues. The somnambulatory state of flanerie and its reveries gives access, in its very undecidedness, to an entire spectrum of insights that awaken new senses of the familiar ways of observing the world. In the dream state within which he moves through the exteriors of his society, the flaneur enters realms that may not be accessible to more conscious, controlled, and controlling approaches. Experiencing and expressing aspects of reality in a nonjudgmental, momentary-minded immediacy removes the filter that would block certain revelations. In this way, Hessel partakes in the sensory metaphors of flaneurs like Benjamin and Kracauer who speak of drifting along in the intoxication of atmospheres and objects. Benjamin's analysis of what he calls the "dream-sleep" of capitalism, a state that his *Passagen-Werk* seeks to both chronicle and criticize, testifies to the significance of reverie as an epistemological concept. Similarly, the multiple insights in Kracauer's *Denkbilder*—for example, in "Erinnerung an eine Pariser Straße" (Remembrance of a Paris Street) or "Schreie auf der Straße" (Screams in the Street)—result from various states of hypnotic trance.[23]

Within their characteristically Weimar modes of thinking, these authors figure walking as a pivotal process whose movement transmits its own sensitivity as a distinct dream state, a kind of "gentle tiredness [*Ermüdung* and *Ermattung*]" (*EG*, 60). In Hessel's texts, this ongoing trance of continuous movement, of consecutive thoughts and steps, in the mind and in the street, guides the walker and thinker along the sensory stimuli of his movement, back into a past comprised of individual and collective memories. In Hessel's experience, this space most often gives way to a pleasant reverie, a daydream of the ongoing memory of a happy childhood. This reverie stands in sharp contrast to manifestations of the city trance that do not always transport a restful

dream. In Kracauer's writings, for example, this unconscious condition more often translates into a psychic nightmare. While Hessel walks safely within the comforting borders of a quiet "sensory pleasure," Kracauer is overcome by the dangerous aspects and tormenting memories of the streets, his short, piercing "Screams in the Street" or "Remembrance of a Paris Street" consistently overshadowed by a foreboding sense of omnipresent horror. As if he should defend his walking pleasure against such intrusions, Hessel warns "the aspiring walker [not to be] led too far astray into the unconscious" (*EG*, 60), unless he would have his bourgeois identity dissolve into complete intoxication. For Hessel, the flaneur's writing follows slow and tranquil forms, individualist and nostalgic paths, and proceeds at a gradual pace back to the fairytales of his childhood.

BOULEVARD SUSPECTS

Hessel's essay "The Difficult Art of Taking a Walk" forms the cornerstone of his theory of flanerie. It articulates a retrospective poetics that aims to collect every facet of the city, tracing the steps of a philosophy of the flaneur in such significant titles as "Der Verdächtige" (The Suspect), "Ich lerne" (I Am Learning), and "Berlins Boulevard" (Berlin's Boulevard). Figuring himself as a "suspect" of his times, he offers a theory of flanerie in the anthology's first sentence: "It is a special pleasure to walk slowly through lively streets." Hessel wishes to discover a measure of slowness within the margins of society's hectic activities, within the space of individual perception. "I want to gain or find again," he writes, "the first gaze upon the city in which I live."[24] This "first gaze" names a fictitious instance of perception—entirely open to impressions, uncompromised by prejudicial judgments, and free of routines and conventions. It looks upon the exterior world with the curiosity and fascination of a child, but also with the historical awareness and experience of the modern city dweller.

This "first gaze" is not the tourist's stare: it overlooks obvious attractions and finds its objects on the edges of metropolitan space, reading its insights as "a piece of city and world history" which has been preserved precisely in those very locations of the city that seem to have been forgotten. This first gaze is suggestive, not intrusive; it does not enter aggressively, it lingers tentatively upon the surfaces it touches.[25] It does not seek to reveal, uncover or inquire; it is not voyeuristically invested in pursuing gratification—it merely returns a cautionary, preliminary impression; it is a first foundation for the collection of memory. Within the city's crowds, the singular gaze of the flaneur emanates from the perspective of a kind of self-chosen "exile" that names another formative feature of modernity: "He is the native who has removed himself in order

to see, by means of this distance, the physiognomy of the city at close range."[26] This is why, for Hessel, the flaneur is potentially a critical observer of his society. His seemingly aimless search for the aura of the city pursues in time what Benjamin's definition situates in space—the appearance of a distance even at closest proximity.[27] The flaneur tries to reconstitute the primacy of his impressionability, a distance of vision even within the close familiarity of his hometown. Emerging from the attention of his tentative and slow gaze, he formulates the suspicion of other Berlin pedestrians: "In this city, you have to 'have to,' otherwise you can't. Here you don't simply go, but go someplace. It isn't easy for someone of our kind."[28] The flaneur in Weimar Berlin transgresses the city's tempo and functionalism with each of his steps. The suspicion of a society of "New Objectivity" is directed against the flaneur's privileged "waiting without an object," against a figure who is neither a consumer of commodities nor a regular pedestrian.[29] Experiencing himself as a "suspect," Hessel subjects himself to a time that encompasses both the enforced waiting of unemployment and the disorientation of intellectuals, a contemporaneous experience of those whom Kracauer refers to as *"Die Wartenden."* While Kracauer reflects on this phenomenon in the medium of the detective novel, and Benjamin in his portrait of the artist as Charles Baudelaire,[30] Hessel articulates the features of these dispositions in the context of the reality of Berlin. The flaneur encounters public perception in the age of photography with every step he takes through the streets of Berlin.[31] If Hessel's flanerie is "suspicious" to his contemporaries, it is also because it questions the prevailing "aims" and functions of this society by introducing the possibility of a mere "aimlessness" that would be free of the usual purposes and conventions of seeing. He declares this aimless drifting to be an exemplary, didactic approach to the history and modernity of the city.

In his essay "Ich lerne," he discusses the flaneur's painstaking attention to detail, embarking on a search for the traces of a lost childhood, that of the individual as well as of a culture that occupies the space of a "home" in the modern city. This position is informed by a notion of *Bildung* that preserves traditional knowledge and erudition, even as it takes its departure from Hessel's personal affinity for the slowness of past eras. Hessel's prevalent sense of space lets him realize the flaneur's concept of a "home" in the street, an extended notion of the public sphere that Benjamin sees as central to the flaneur's experience.[32] Hessel himself views the "house and street [as] one unit [*Einheit*]" (*FB*, 146), signaling in this way the relatedness of all public spaces. His insistence on the relations among history, home, and childhood directs his gaze most often toward phenomena that seem obsolete and anachronistic, about to be discarded by modernity, a forgotten part of those fascinations that used to attract his "first gaze" in the city dweller's childhood.[33] In this way, Hessel's essays repeat a movement and method that informs Benjamin's under-

standing of the nineteenth century's heuristic value for the present, for the *Jetzt-Zeit* of modernity.

Hessel's predilection for historical shifts guides his aesthetics to focus on the transient reflections of transitory spaces, such as those offered by the scenes of old-fashioned *variété* theaters. These theaters are characterized by their intense affinities to the very process of seeing, a primary affiliation that links the *variétés* to flanerie. Like fairgrounds, markets, streets, and cinema, they too belong to the traditional haunts of scopophilia. In moving through the *variétés* of Berlin, the flaneur is most vividly affected by the effects of light on display: an enthusiasm for visual shocks that relates his spectatorship and the scenes he views to the spaces and *Lichtspiele* of early cinema. During his visit on location, he extols the "heaven" that he finds represented in the "ceiling painting" (*FB*, 150) above the stage. He admires the stature of the "light commandant" (the director responsible for these illuminations) and of all the "marginal and unnamed figures" (*FB*, 153) who form an essential part of the visual spectacle of any veritable *variété*. The flaneur's search for marginal and nearly obsolete details replicates the impulse of his movement toward the "aimless" and "purpose-free," toward anything that would be "transparent" enough to transmit everything, toward any viewer who would be sufficiently "invisible" to perceive everything. The variety of objects in the *variété*, in all of its metaphorical senses, forms the focus of a flanerie whose experience is analogous to that of the many objects and phenomena that the street presents on its daily stage. Hessel's flanerie corresponds to an aesthetics of marginal phenomena that is no longer marginal to the modernity of Weimar Germany, a plurimedial time in which culture and perception appear increasingly in multiple perspectives.[34]

Hessel demonstrates this new aesthetics of the everyday in the essayistic principle of his "Rundfahrt" (Sightseeing Trip), transforming a bus tour of the city into a flaneuristic text of his Berlin anthology. The flaneur infiltrates the organized sightseeing tour with subversive views that understand it as a recent, functionalized phenomenon of the shared labor and leisure of modernity. Hessel refers to this process by its original English name: "*Sight seeing*. What a forcible pleonasm!" (*FB*, 51), he writes. He converts this event into a subjective walk through the Berlin of the Weimar Republic, ironically proceeding against the grain of the city's presumed attractions. For Hessel, any effort by a tour guide to direct or filter our perception is highly suspect; he calls this guide "trip steward" [*Wanderwart*], or "our *Führer*." "The Explainer," he suggests, "now forces our gaze" toward national monuments, or "tears our gaze" over to the "palace of justice." Hessel's own gaze resists such guidance, refusing to surrender to any predetermined interpretation of the sights before him. The "bus travels too quickly" for the flaneur, he writes, "we must put it off until a journey through the streets *on foot*."[35] Organized and motorized sight-

seeing allows neither the free space nor the unencumbered time necessary for his detective-style observations: "There is no time to research the native secrets [*Heimlichkeiten*] of the area from this tourist bus." The native flaneur focuses rather on the "secret" aspects of his "home" in the city, secrets that are intrinsically located in the imaginary place of a magical childhood. Hessel lets his gaze, resplendent of personal and cultural memories and histories, roam freely along the edges of the street. He lingers on the hidden sights and unexplained details of what is officially presented to him: "The tourists' attention is directed toward the Prussian State Bank, meanwhile I glance over to the famous wine cellar which E.T.A. Hoffmann used to frequent" (*FB*, 63) (it is no accident that he looks for Hoffmann's spaces, the haunts of another strolling writer obsessed with viewing the city).

Ridiculing all-too-guided Weimar audiences, he suggests: "Sometimes it is worthwhile to enjoy, rather than the antiquities, the entertaining presence of the doorman of the arts and lords [*Kunst- und Fürstenportier*] and his carpet-slipper-shuffling herd" (*FB*, 92). Along with this mildly ironic admonition for a critical examination of this authority, Hessel's flaneur advises his "dear stranger and fellow tour member" that it would be better to "come back to this area and have time to get lost a little."[36] Hessel's aleatory approach evokes— as it predates—Benjamin's sense of an *Irrkunst*, an art of erring and getting lost that is translated into reality, that is lived in Hessel's understanding of flanerie. For both Benjamin and Hessel, the flaneur's perception deviates, deliberately and decidedly, from predetermined routes. It ignores imposing sites and shuns prescribed "views." This independent stance is apparent in the urban critique of architecture that prevails in Hessel's flanerie, transcending the official monument-megalomania and taking its own idiosyncratic look at the buildings of Berlin. In an analysis that seems to dwell on purely stylistic terms, it formulates a critique of the collective spirit of edifices that seek to serve a unified representation of German nationalism. In the newest amusement center, "Haus Vaterland," the *Unheimlichkeit* of a perfectly planned city of entertainment strikes in the flaneur the larger suspicion of a "fatherland" that, having just emerged from a destructive war, now moves toward new constructions of totalitarianism. Hessel suggests that such structures and creations of a patriotic culture help sustain in the Republic the barbaric relics of nationalism. He detects in the newest Haus Vaterland nothing if not a construction of what he calls "das Monster-Deutschland" (*FB*, 57). Similarly, his critical stance toward political and bureaucratic authorities suggests that the two bronze dukes erected on the Mühlendamm function only in order to disturb his walking pleasure: "They need not necessarily stand right here" (*FB*, 68), he says. The walking critic pauses to criticize any instances of "conventional wisdom turned stone," from "the usual boredom of sad tenement houses and Kaiser-Wilhelms-Plätze" to those "horrible, speedily-constructed buildings built after 1870 that derive their style from construction firms and bricklayer foremen."

Like the streets he loves and walks, Hessel is disturbed by anything that is too uniform, goal-oriented, monumental, bureaucratic, and officious. "The pleasantly private character of Queen Augusta Street," he writes, "is disturbed in a few places by pretentious public buildings, the Ministries of Defense and the offices of National Insurance and that sort of thing" (*FB*, 96). His own idiosyncratic perception of the secret city through which he walks provides— regardless of its underlying sense of aesthetic harmony—a critical analysis of society and the ideology that it both constructs and extends through its architecture. In this, the text of flanerie aligns itself with other pivotal Weimar texts—Kracauer's *Straßen in Berlin und anderswo* or Benjamin's *Einbahn-straße* come to mind—which also understand the external phenomena of modernity as significant indices of cultural and social dispositions. Indeed, one might say that the decidedly Weimar genre of critical essayistic *Denkbilder* originates first in an aesthetics of flanerie, in the images it reflects.[37] The "views" [*Ansichten*] of Hessel's images of reflection can lead to surprising "insights" [*Einsichten*] which in the case of the Kaiser-Wilhelm-Gedächtnis-kirche prove to be of uncanny clairvoyance: "The guide [*Führer*] explains, this building is one of Germany's most beautiful churches. But it is unfortunately still light out, and one can see it too clearly" (*FB*, 135). Hessel's gaze already sees this church in the 1920s as a "massive traffic obstruction" that is tolerable only under the neon lights of the nearby cinemas, or through the visible effects of its decay: "If this cathedral with the long name would at least age and decay a little. Here it stands amidst the rattling and droning in a Prussian, unshaken way." It remained so until it was destroyed in the final days of World War II, after its nationalist *Führer* aesthetics had officially come to an end.

If this flaneur of Weimar culture resists official programs, he turns in fascination to the images and signs of its collective modernity. Hessel's gaze is decidedly resistant and widely eclectic in its historical scope: it connects the remembrance of the flaneur's individual past with a declared openness toward the most recent cultural modernity. He describes with noticeable enthusiasm the "enormous letters and images of advertisements on house sides and roofs . . . sharp and smooth, a most recent Berlin." In the same way, what he calls the "Broadway" of Berlin-Charlottenburg—"with its cafés, cinemas, neon lights, and running letterings"—exerts a spell on him. Despite this fascination with modern stimuli, Hessel's primary empathy extends to the historical background of spaces in time, to a history of the city that moves him beyond a "neo-objectivist fetishization with technology."[38] Hessel "feels his way" into distant eras and situations by retracing his steps along historical objects and anachronistic sights. Joining the sightseeing bus tour of Berlin, for example, Hessel remains a few steps behind the tourist crowd, aligning himself with a position beside the official route. Prone to stay behind in his mind and memory, he retraces the few steps in space that locate his reminiscences in time.

HISTORIES OF *HEIMAT*

The stops that he suggests are stations from the local history of his home and city. He directs his reader, for example, to the Gasthaus zum Nußbaum, a prototypical locale of the pub(lic) sphere that also happens to be situated in "the oldest house of Berlin" (*FB*, 67). What appears to the flaneur as a "piece of the best of old Berlin" contains the essence of the "historical charm" that he seeks to discover on his historically guided excursions. As moments of epiphany, these insights occur in a trancelike state that, transported by calm wanderings, traverses the passage of time, as when "in the late light, with *Fachwerk* and gables, an entirely old Berlin can arise here" (*FB*, 70). Hessel's flanerie presents excursions into local history as a history of its locations, in which stories and anecdotes are released by the sight of its sites. Hessel calls this project "Heimatkunde treiben" (*FB*, 75), a study of *Heimat* by way of flanerie. The flaneur pursues knowledge by walking and drifting in a stream of perception that understands the streets, the museums, and the neighborhoods of everyday Berlin as significant locations of history and memory. He renders images of the contemporary city in the mirror of pictures from its past and superimposes one layer upon the other in order to "construct," in his mind and in his writing, "a bygone city amidst the present one" (*FB*, 96).

For Hessel, a kind of "home" is constructed that fuses these various locales with the distinct notations of a forgotten, yet familiar cityscape. Each of these locales evokes a cluster of personal associations linked to the flaneur's past and childhood, and he registers its historical significance in anecdotes, citations, or other passing texts. "Heimat" or "home" are therefore interpreted as autobiographical and intellectual spaces. If Hessel's reflections overtake the tourists' rudimentary perception, it is because his are defined by the space and time of these lived experiences, by the reminiscences of this city that so remarkably enters into his description.[39] In the Alte Westen area which figures in his *Heimliches Berlin*, Hessel remembers his life as a child, joining it with a sensory memory of the city that includes those "long-familiar apartments" (*FB*, 154), those museum-like spaces, and labyrinthine bourgeois interiors of his beloved "Berlin rooms,"[40] the dwellings of the nineteenth century. He recognizes that much of his memory is attached to the area surrounding Berlin's famed Museumsinsel that housed the young student's historical and personal explorations. He moves on to scenes of petit-bourgeois dance halls that involuntarily recall, as his own *madeleines,* those "memorable violet perfumes which were in permanent clash with nature" (*FB*, 50). For Hessel, *Heimat* is this kaleidoscope of impressions and memories—redolent of the sensations of lived experience that remain stored in places and images, sensations encapsulating the collective and public implications of his own history.

The flaneur's historical method seeks out a highly personal, yet historically aware approach to both *Heimat* and history, particularly in those instances when an environment stimulates the acute spatial reconstruction of experiences that previous flaneurs may have undergone in the same place. Hessel is eager to follow these leads into history, to explore their traces in personal stories and anecdotes. A singular name might set into motion a whole spectrum of associations and narratives: "The name makes me wonder who might have in bygone courses of time [*Zeitläuften*] looked down from this height upon the old towers" (*FB*, 176). Hessel's stories are invariably linked to the visual, to the immediate sensory experience of streets, places, and buildings. Indeed, the very history of the city, according to him, seems to be located within the history of urban space itself. The city's history presents a series of phenomena to the flaneur, a series of experiences and atmospheres that can be positioned and approached until they are indeed "accessible" [*begehbar*]. But the flaneur relates as much to literature as he does to locations, remembering the "stories that are tied to the antiquities" along his way. On a walk in the park, Hessel comes across the landscaped memorabilia of another notable flaneur, in the shape of a carp pond in the Tiergarten, an aquarian mirror of literary fame: "On this very spot E.Th.A. Hoffmann himself interred his beloved Kater Murr" (*FB*, 165).

Hessel's stories and strolls bear witness to the flaneuristic traditions that preceded him. He follows the traces of a literature of flanerie that came before him and his texts: Hessel walks almost literally in the footsteps of E.T.A. Hoffmann, not only to revisit his predecessor's wine pub, or the wet grave of his literary cat, but all those places where he can share in the other flaneur's literary haunts. Following this lead, Hessel looks down over the Gendarmenmarkt from the higher, historical perspective of E.T.A. Hoffmann's "Des Vetters Eckfenster." Imagining the stance of an entire history of physiologists, he recalls "how [Hoffmann] overlooked the lively Berlin market square" (*FB*, 63). Similarly, he calls attention to a part of the city that is another piece of its literature. A seemingly inconspicuous alley, for example, turns out to be "Raabe's Sperlingsgasse" (*FB*, 65), he tells us, reminding us of the location of another nineteenth-century author's "chronicle" of a Berlin street.[41] In Hessel's understanding, flanerie cannot simply be relegated to a phenomenon of personal leisure. It is always already preceded by a specific tradition of texts. Situating itself within this tradition of history and literature, flanerie goes beyond its own particular experience and extends the realms of legible space, allowing the rambling reader and suggestible stroller to connect his or her own experience of reading to an extended history of literary flaneries. Collecting quotes and passages from texts by August Varnhagen, Heinrich Heine, and other nineteenth-century poets, Hessel provides his reader with an historical anthology of imaginary promenades on Berlin's main boulevard, Unter den Linden.[42] In extensive excursions, he again and again returns to his predeces-

sors and to their obsessions with images of the street. Reminding us of Jules Laforgue's notations on "Berlin streetboys *en flânant*" (*FB*, 106), Eberty's observations on the nineteenth century's culture of oil lamps, and Ludwig Pietsch's reports on the state of "the pavement of the 1840s" (*FB*, 253), Hessel signals the specific literary and cultural frames that underlie his own perspective on the streets of Berlin.

One street incident in particular illustrates how Hessel's flanerie seamlessly and fluidly passes right over into literature. An episode of his city essays finds the flaneur standing amidst the bustling Leipziger Straße "facing [*angesichts*] the mirroring asphalt in shining light" (*FB*, 249). He chooses this unlikely, yet predetermined location in order to reread seminal passages and descriptions from Gustav Langenscheidt's 1878 *Naturgeschichte des Berliners* (Natural History of the Berliner). Even though these reading practices make him a possible obstacle to traffic, Hessel insists on his all-around experience of reading: "but I want to enjoy this text facing the new Leipziger Straße." Hessel's textual experience and enjoyment is central to his view of the world. The flaneur returns as a reader of street-texts, strolling through exterior worlds as if through interiors of the imagination, reading books as he reads cities. Reading for the flaneur is in fact a means for casting images on the screen of his mind, for projecting into his imagination an intense perception of reality. The world is given to us in a few significant activities, he suggests—walking, looking, thinking, reading, and returning to look again. In Hessel's understanding, the essential feature of flanerie is the transformation of perception into a text that transcribes its process of seeing into a scene of writing. The flaneur author's view of space, his reading of its history, of its spatial and visual presence, becomes synonymous with his writing about that space. That Hessel's excursions are not limited to any specific medium makes it possible for him to speak of "also having sought [*ausgehen auf*] adventures of chance . . . in libraries and collections" (*FB*, 274). The flaneur comes across discoveries in the city's past as well as in its modern present, in a process that valorizes a variety of texts from different eras and diverse media.

MODERN MYTHOLOGIES

Hessel's pronounced historical interest insists that we understand modernity as a series of new texts at a specific stage of historicity. Wherever the flaneur finds himself in the city, he is always "most interested in the placards and inscriptions above and on the shops" (*FB*, 202). Ranging from "newspaper announcements and posters carried by sandwichmen" to shop windows and advertisements, these texts are interpreted as "a specific kind of advertising literature" (*FB*, 243) that is characteristic of modernity. For Hessel, all of modern life is at once flanerie and literature, a vast text that provides an instant

mixture of theory and praxis, a lived and perceived interpretation of everyday experience, an enactment of modernity in its various mythologies. This exchange of writing and reading names a dynamic process of seeing that looks back to the childhood experiences that have helped form this visual disposition. Looking at a group of stone grazias, a moving and monumental sight that touches the young flaneur as if they were living women, he writes: "They followed our path with their white stone eyes, and it has become a part of ourselves that these heathen girls have looked at us" (*FB*, 156). This exchange of gazes between Hessel and the "heathen girls" continues to inspire the later flaneur's pagan pursuit of pleasure and sets into motion a gaze that follows the silhouettes of passersby, that traces the shadows of other structures with the same desirous eyes. The walking writer imagines himself being viewed by a world of objects, subjected to the gaze of those very images that are presumed to be not only the objects of his gaze but also the materials of his writing.[43] Returning his gaze, the figures and objects of reality offer the onlooker their own invisible text, leading him to enter into a mute visual dialogue with them.[44] In Hessel's rendering of the exterior world, the flaneur's aesthetics emerges via an empathetic description of what he sees—not by a process of judgment and evaluation.

This way of looking at the world preserves a childlike affinity with things, what Hessel calls the child's "fairy-tale gaze" [*Märchenblick*]. His inclination to go beyond historical anecdotes, to imbue objects and images with an aura of the miraculous, mysterious, and magical, is grounded in this sympathy with the world of fairy tales. In keeping with this altered but magical logic, Hessel suggests that the house standing next to the Anti-War Museum in Parochialstraße must be haunted (*FB*, 77)—must house some of the ghosts that were exorcised from the house next to it. A small-town theater becomes a "fairy-tale world"—a world he enters from the streets as if he were walking into the pages of children's books and onto stages of doll's salons—a piece of suburban Berlin inhabited by "evil plum-eyed witches." The walker-writer, Hessel suggests, is inspired by myths of all kinds, even by the simple, seemingly trivial forms retained from his memories of early childhood. This childlike sense of the world flees from the monotony of adult purposes, from anything that might restrict his sightseeing gaze. The flaneur's aberrant eye takes solace from the functional world even in an old-fashioned ice-cream cart that still projects its magic as "a sweet dwarf's shop, translucent like Snow White's casket" (*FB*, 100). His eye is drawn, moreover, to the fairy-tale architecture of the Berlin Zoo, a space that for Hessel represents "the Thousand and One Nights of beautiful buildings" (*FB*, 138). Perceiving the scurrilous nuances of this "other world," the flaneur exhibits the spirit of discovery that at the same time motivates the explorer of the arcades of modernity to seek "cave-like, labyrinthian things." In the zoo's "palaces of the animals" he sees both the traces of prime-

val animal cults and the modern "stage props" of collective exotic fantasies, the hidden unconscious dimensions of society and its public spaces.

The flaneur discovers his critical perspective regarding the collective mythologies of everyday life in the Weimar Republic. This critical perspective belongs to the Weimar *Denkbild* that interprets both surface and essence, myth and modernity, as visual and sensory phenomena. At one point in Hessel's essay, the genesis of this *Denkbild*, as a genre of observation and reflection, is in fact attributed to the text of flanerie. The observer strolling in the zoo notices in passing the striking affinities between a decorative sea anemone in the aquarium and the fashionable fabric flowers in modern shop windows. Under his critical gaze, nothing is any longer "pure nature." Instead, culture assumes a second nature as commodity, animals take their places as accessories of fashion, and their palaces set the stage for collective myths and fantasies. For Hessel, everything lends itself to be read and regarded by the eye as structure, pattern or decor. Viewing Weimar flanerie as a mode of theoretical thought that emphasizes sensory reflection, his fascination with phenomena and their surfaces is inspired by a complex sense of distraction that connects his childlike viewing pleasure with the desire for social and historical insight.[45] As he suggests, "the Thousand and One Nights and the thousand and one legs of the big revues . . . these magnificent children's dreams for grown-ups" (*FB*, 238) are performed daily in the "fairy-tale palaces" of Berlin theaters and cabarets of the Weimar era. This flaneur's walks through the city are characterized by an effort to join a kind of naive viewing pleasure with the critical scrutiny of his society.[46]

Nonetheless, it could be said that Hessel's project presumes a bourgeois utopia of harmony that in turn presupposes a contented childhood: "The tumble of children," he explains, " is in our walking and in the blissful floating feeling which we call 'balance' " (*EG*, 53). This emphasis on "balance" is what distinguishes Hessel's flanerie from the often traumatic intoxication that defines Kracauer's, Benjamin's, and Aragon's versions of flanerie. Despite his prevailing fascination with the visible, Hessel's flanerie works to maintain an inner balance that prevents him from becoming fully absorbed by the phenomena he encounters. In other words, Hessel's flaneur is always guided securely back into a childhood that is deliberately devoid of horrors. If these walks into his past, his history and childhood, lead him to his version of flanerie, his particular biography and privileged background allow him to enjoy this process in a relatively lighthearted manner rather than suffer through it psychoanalytically. Whereas a more despairing sense of flanerie leads Benjamin to view Baudelaire's Paris allegorically, or evokes the traumatic shock in Kracauer's "Erinnerung an eine Pariser Straße," Hessel's flanerie is induced by a mild rather than desperate sense of melancholy. His insistence on harmony and balance allows him to direct his steps away from himself. This distance at times enables him to offer a more detailed and attentive, since less anxiety-ridden, perception

of the city and its history. As this flaneur puts it, "One has to forget oneself to be able to stroll happily" (*EG*, 59). Hessel's foundation in both a happy childhood and bourgeois sense of *Bildung* facilitates his steps into the urban past, away from the abyss of his own unconscious, to an otherwise original and idiosyncratic *Heimatkunde* of his city and its history: "Visit your own city, stroll in your quarter, promenade [*ergehe dich*] in the stony garden. . . . Experience in passing the curious history of a couple of dozens of streets."[47] Hessel's move toward local history is determined by this search for an idyllic exile amidst modernity, the stone garden amidst the city. In search of "curiosities," it signals an ongoing pursuit of the exceptional, the unusual, the different, one that may lead to a more extended understanding of what a text is, to the possibilities of a textual metaphor that everywhere opens new avenues of insight.

DENKBILD-CRITIQUE

All too often, however, the almost naive tendencies of Hessel's aesthetics reveal their limits, especially in their at times uncritical and even nebulous attempt to consider the realities of labor and politics. For example, Hessel's premises encourage the flaneur to view women workers of the Berlin proletariat as "cheerful" and "quiet" sights, or to regard a calculated film arrangement as a naturally "charming" site. Such temporary blindness occurs most strikingly when, in spite of—or because of—his being overwrought by emotion, Hessel fails to recognize that an idyllic scene on the Landwehrkanal is also, and more importantly, the scene of Rosa Luxemburg's murder. Hessel's harmonious flanerie overlooks the explicitly political aspect of this murderous place in favor of the quiet melancholy of bygone "private" suicides that there plays on his imagination. When he does recall this infamous political murder, he refers to it merely as a "desecration" of the "stillness of this bridge" (*FB*, 167).

For Hessel's Weimar flaneur, politics often remains just another spectacle, a world that he regards as "somewhat foreign" (*FB*, 124). Coming from a spectator who, casting his "fairy-tale gaze" on the "Parliament Building," views it as a "huge animal lying growling," this confession comes as no surprise. Observing the Reichstag plenum, he even tells us that he is in danger of confusing right with left, of mistaking Communists for nationalist *Völkische*. He accepts the first public speeches of the National Socialists with the same tolerance, attributing to their *Sportpalast* location "a kind of gigantic cheerfulness" (*FB*, 266). As everything else for Hessel, politics is above all a visual spectacle. But his tranquil, unintrusive magnanimity cannot see through the complex realities of a new political fanaticism—instead he understands these realities as simply "the excess of the same unbroken lust for life." Here Hessel's harmonious gaze reduces serious differences and real dangers to a purely

visual and naively humanistic way of seeing. Overlooking the actual conditions of a world of labor by perceiving its processes merely as aesthetic structures, pleasingly regular and repetitive motions, he suggests that Berlin—"when and where it is at work" (*FB*, 21)—radiates nothing if not a "special and visible beauty." As he "visits" factories, for example, he pays attention not only to "temples of the machine" and "churches of precision," but also to workers whom he views as the autonomous "guards ... of the machines." Hessel's unreflected perception of a flanerie that simply passes by its objects mirrors the fetishism of technology evident in the New Functionalism, a fetishism that fails to regard its economic and political implications.[48]

In regard to the world of labor, the impressions of an idle observer distort reality, forming an idyll of the city which no longer corresponds to the actual conditions of working. For the strolling viewer, "sacks of cement shimmer with spring green shades in the autumnal street" (*FB*, 203); workers function mostly as color accents, wearing jackets "of a green that is illuminated by the gaslight next to the machine, like the park greenery by the candelabra of elegant avenues." Regardless of the subtlety with which the observer renders the respective shades in question, the supposedly democratic impetus in such impressionistic flanerie misses its mark as a recorder of social reality, particularly in view of the very real exploitation at work in Hessel's Berlin. The pleasure-seeking flaneur understands laborers pouring cement to be performing a "spectacle of work," a *Schauspiel* that he perceives as "spectacular," as "playful" or "dramatic." He underestimates the extent of the present's unfolding drama, the politically catastrophic consequences of the Reichstag's increasingly polarized politics.

While Hessel perceives the reality of his Berlin in images, in a manner characteristic of the many flaneurs who wish to "remain with the mere sight of the present" (*FB*, 120), he at the same time seeks to prevent this balanced form of flanerie from being disturbed by the unpleasant social details of this present. Walking in the newspaper district of Berlin, he flirts with the feuilletonistic airiness that often marks the self-imposed limit of efficacy in many essayistic genres of Weimar literature. "Let's not go into the serious areas," he tells us, "where politics, trade, and local affairs are carried out. We belong below this straight line and in the entertainment section" (*FB*, 257). This deliberate but potentially problematic abstinence from theory and social criticism— what he refers to as "all too much judging!" (*EG*, 59)—aligns his sociological efforts with a naiveté that borders on an involuntary cynicism whose only recommendation is that, in these "serious times," we should all simply take a walk. The serious times to which he refers—the Berlin of 1929—are relativized by a definition of flanerie whose "aimless" pleasure can be experienced in the presumably value-neutral space of society, and this without reflecting on the social conditions of such leisure and idle walking. "It is certainly the cheapest pleasure," he says of his walking, "really not a specifically bourgeois-

capitalistic enjoyment. It is a treasure of the poor and nowadays practically their privilege" (*EG*, 54). This attempt to dispel the suspect air of elitism and luxury surrounding his leisurely strolls takes on an involuntarily cynical tone. Seeking to popularize his pastime by emphasizing its democratic character, he diminishes the reality of unemployment, a phenomenon that he romanticizes, if he does not ignore it.

Kracauer, on the other hand, is more sensitive to the situation of unemployed workers in Berlin. In his 1932 essay on the contemporary realities of "idle walking" [*Müßiggang*], for example, he describes a scene that Hessel would prefer to overlook: "The crowd . . . is in no hurry. Slowly it drags itself forward, one perceives that unemployment weighs it down."[49] Rather than idealizing "idleness" by neglecting its conditions, Kracauer recognizes that "the audience on Münzstraße is a slave to enforced idle walking, one that is less a pleasure than a way to expel the ghosts of evil times." In jarring contrast to Hessel's utopia of a public flanerie, the enforced idle strolls of unemployment suffocate the sensory perception of Weimar reality, promoting much more somber prospects. As Kracauer goes on to note: "The awareness of uselessness clouds their glances . . . the sun is shining, but what do these people care about the sun?" Hessel sidesteps the material, economic, and political privileges that distinguish the pleasure of freely chosen, leisurely walks from the despair of a state of waiting that is imposed by unemployment. His naively democratic utopia certainly wishes to see everyone happy, able to walk freely, to enjoy this "pleasurable process" and its capacity to skip over several steps on the ladder of political rights and social progress.

If Hessel's aesthetics of flanerie remains problematic, he still owes some of his most subtle images of the city to precisely this visual emphasis. Beyond all suspicious levity, the same seemingly aimless strategy manages to lead him to observations that, in the shape of *Denkbilder*, provide telling and significant portraits of his time. In a sensory and intellectual operation characteristic of Weimar flanerie, Hessel reads the modernity of his era precisely in the most banal aspects of its mass culture. As does Kracauer in his remarks on the Weimar detective novel,[50] another contemporary reflection on the public but cryptic spaces of his society, Hessel experiences the café of a central hotel in the city as a "mystery-inducing twilight assembly [*rätselaufgebende Dämmerversammlung*]" (*FB*, 242). Even though Hessel does not proceed to solve the mysteries of the Weimar hotel lobby in an extended excursus of its theoretical implications, he is still ready to perceive the signature of his time in even its most insignificant, seemingly ephemeral elements. As he notes of the acute boom in gold-framed oil prints: "Ever since the days of the inflation, the German has been in need of some glitter in his shack" (*FB*, 25). As framed collections of family pictures are replaced in the 1920s by the single portrait, the individual is isolated in space as well as in popular crafts. Following the tendencies of this period to promote liberal but superficial images of women,

Hessel reflects on a trend he observes in actresses who portray the repentant Magdalena with the bobbed hairdo of the 1920s [*Bubikopf*]: "How many Magdalenas does Magdeburg need? . . . I am beginning to get interested in statistics." Hessel consciously understands such "trivial" culture in terms of the "intellectual sustenance" it offers the people. The oil print for him always signifies much more than mere kitsch: "It furnishes an endless number of rooms and souls" (*FB*, 26).

Like Kracauer and Benjamin, Hessel also sees a connection between space and fashion. He too views "externalities" and "interiors" as collective dispositions. In contrast to his contemporaries, however, he often limits himself to atmospheric portrayals, and thereby bypasses their ensuing critical interpretations. For example, when his subtle intuition for latent dispositions recognizes the distraction in the dance halls around Alexanderplatz as an expression of despair, "as if there lurked misery or danger" (*FB*, 208), he does not proceed to contextualize these observations within the terrain of a prefascist, petit-bourgeois population. Nevertheless, even Hessel occasionally moves in the direction of social commentary. Remarking on the poor districts of northern Berlin—on how this poverty is "written" in "lightless back buildings," miserable backyards, and in the lines of despairing faces—he notes: "Whoever has the opportunity to feel his way up the stifling flights of stairs, up to the miserable little apartments with their coal vapor and the bedchambers with their sour smell of nursing infants, can 'learn' " (*FB*, 220). Yet this passage may also appear as a form of practiced "alienated leisure," with the writer becoming a tourist to a reality of living and working situations that ultimately remain alien and incomprehensible to him.[51]

In other words, if Hessel sometimes practices a flanerie of social awareness and critical contexts, he seeks out these opportunities all too rarely. A declared aesthete, this hedonistic city stroller in the long run prefers to renounce any didactic protocols about what might be "learned" from such critical practices. If Hessel's flanerie displays an obvious lack of political engagement, this difficulty derives at the same time from the unconditional aesthetics to which he owes his very insights, that is to say, from what elsewhere we might view as a virtue: his wish to accept everything that he sees without passing aesthetic or ideological judgement.[52] It is in this acute but sometimes limiting focus of perception that we can begin to read—within the process of Weimar flanerie—the ambiguity that often prevented Weimar intellectuals from taking more explicitly political stances. Even given a certain amount of empathy for Hessel's project, an engaged author such as Kurt Tucholsky here identified a dangerous negligence—one that he pointed out to Hessel in 1932 when he asked in a review: " 'Is not our aimless impartiality, which twelve years ago was still a privilege and license, today guilt and emptiness?' Yes, Franz Hessel—that is what it is. Guilt and emptiness."[53] Nevertheless, Hessel continued to drift through the city as a flaneur along the lines of his most cherished principle:

"It is not necessary to understand everything, one only needs to look at it with one's eyes" (*FB*, 23). Within this affirmation of the primacy of vision, it is not essential to "interpret" everything; rather the task is to perceive the image of exterior reality in its entirety and with the utmost intensity that one can bring to it.

This visual focus is accompanied by Hessel's appeal to the hedonist primacy of pleasure, to the enjoyment of any diversity, style, and distraction that may arise from the multiple forms of metropolitan impressions.[54] With the end of the Weimar Republic, Hessel's implicitly political and subversive flanerie would rapidly confront the harsh consequences of a reality punctuated by an unimagined degree of cynicism and brutality: Benjamin was driven to death, Kracauer chased into exile, and Hessel, the serene flaneur, continued "invisibly" to pursue his observations of Berlin until October 1938, when he became increasingly endangered and persecuted as a Jewish citizen. Finally, his status as a strolling "suspect" was concretized in intolerable ways: his expulsion and subsequent exile in France would come at a time when the state itself would occupy the streets, when the state would begin to erase a culture marked by the "return of the flaneur" in Weimar Germany.

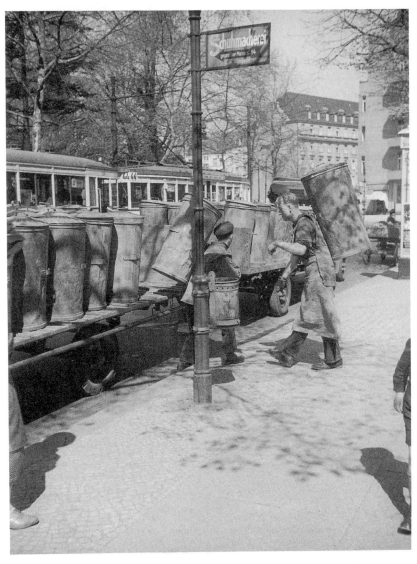

Friedrich Seidenstücker, "Müllabfuhr am Kaiserplatz" (Trash Collectors on Kaiser Square). Courtesy of Bildarchiv Preussischer Kulturbesitz.

Secret Berlin, A Junk Store of Happiness

HESSEL'S early novels, situated in Munich and Paris respectively, trace some of the autobiographical steps that take him on his way to the flaneur essays collected in *Spazieren in Berlin* (1929). Both *Der Kramladen des Glücks* (1913) and *Pariser Romanze* (1920) can be read as maps of the topography of Hessel's biography and development as a flaneur.[1] The protagonists of these novels pass through some of the same stations that also structured Hessel's life: an early childhood in a provincial town, adolescence in Berlin, student years in Munich, *bohème* in Paris and Berlin. The flaneur-as-author experiences a reality that provides him with the sensory and sensual impressions that his writings work to perceive and represent. While links between Hessel's biography and the protagonists in his novels have been noted, I wish to approach these texts not in terms of their veiled parallels to his life, but in terms of the way in which they move beyond biography into realms that are no longer contained by factual linearity.[2]

In other words, I want to suggest that Hessel's novels reflect the flaneur's re-creation of his perception through the eyes of his figures. In this way, they enable us to trace a genealogy of the forms of perception that anticipate the conditions of flanerie. These stages are particularly apparent in Hessel's first novel, *Der Kramladen des Glücks*, a text that traces the childhood and early experiences of Gustav Behrendt, a young man in Berlin.[3] The very first sentences of the text encapsulate *in nuce* a number of initial insights into the foundational psychological constellations of this sensory sensitivity: "It was early morning. Little Gustav sat alone and wonderful on the light wood of the floor. In the air was still the dust and sweet smell of yesterday's celebration" (*KG*, 7). Situating the beginnings of a flaneur's disposition at daybreak and the onset of a life, Hessel suggests the flaneur's intense empathy with the world of objects, his overall sense of nuance, detail, and atmosphere. The wooden floor is experienced in haptic immediacy, though this tangible contact is already fused with visual perception: perceived as lightly colored, the air above the child is permeated by a haze that is saturated with the lingering impressions and sensory sensations of a bygone celebration. As Bachelard notes, describing a process similar to the one that Hessel traces to the beginnings of a future flaneur, such "tranquil reverie . . . follows the slope which returns us to our childhood solitudes."[4] The essential solitude of this first scene encourages a constellation and disposition that gives itself entirely to the objects and an experience

of them. The child's solitary closeness to the surfaces and ground upon which he is situated, signals an intense contact with and complete turn toward things, toward their textures and their sensory appearance. Speaking of the experience of this privileged relation to objects, Bachelard writes: "Alone, we're free to think—we see great phenomena which one sees badly if not looking at them alone."[5] The openness of this perception gives him the freedom to devote time to even the most minute details: the diffuse, shimmering effects of light, shot through with dust and reflections, and setting the stage for an extended state of attention that enables him to take in the entire world, a space lit up by the "shimmering balls" of balloons (*KG*, 7). The nascent view of this little flaneur imagines a universe of plenitude and pleasure, complete with lights and colors that circle around the child, the center of perception. Its harmony is traversed only by an occasional breath of air that enters not as an intrusion but in order to introduce an additional series of stimuli.[6]

Even as a small child, the flaneur perceives the world as a celebration of the pleasures of perception, ranging from girls in shining clothes to the sensations of shimmering light and color. To grasp these pleasures, however, to enter into the realms of active action and tactile possession, proves a treacherous and elusive step that evades the child flaneur: as the novice is about to reach for one of the distant suns, attempting to ascertain its visual promise with the touch of his hands, the balloon bursts.[7] The world of tangible satisfactions turns out to be delusive, more difficult to hold, and to hold on to, than to behold within an act of visual reflection. In this first episode, the flaneur internalizes his approach to the sensations of life: look but do not touch. The primacy of visual stimuli on which the child learns to rely shapes his reality through an abundance of lights and colors, setting into motion the formative impressions that let the flaneur's imagination take its first steps. As Bachelard demonstrates, the very "beauty of those first images" leaves its lasting traces in the mind and orients the gaze toward the images of the world.[8]

These moments form a primary constellation in the psychogenesis of the flaneur, who again and again understands the world as a signifier of shelter and harmony, a figure that retains its basic benevolence and remains devoid of traumatic agonies. This understanding is linked early on to an aura of light that is conveyed by the maternal sphere. A sense of aesthetic enjoyment exudes from her space, an atmosphere of calm and muted twilight: "The light of day [was] veiled by green and gray curtains," he recalls, "the light floated into the space with shining gray tones. A thousand little pieces of dust danced around in it continuously."[9] The mother's room encourages an aesthetics of the miraculous and the marvelous, of a world of objects that, still indecipherable, evokes the charm and magic of fairy tales.[10] The mother is herself a source of light that illuminates the beginnings of life, thereby giving "memories their atmosphere of images."[11] The flaneur's search for this sphere of pleasure is nothing less than the pursuit of light and pictures in solitude.[12] The visual orientation

of the child's mind is stimulated from the beginning by his encounter with a series of images facilitated by the mother's presence: "The mirror over on the vanity reflected her splendor in flowing glass-gold. From the drawer chest the two plaster statues looked at him with white eyes" (*KG*, 9ff). The moment in which the act of looking takes the form of an object that returns our gaze is fundamental to Hessel's flanerie. It names an imaginary turn toward the exterior world that is at the same time captivated by an indefinite extension of this "mirror phase." That the mother's image is the exemplary visual imprint of the child's early days can be seen in the mirror's power to reduplicate her magic in ever more miraculous ways. In this scene, the child looks into a mirror that seems to return his gaze to the mother, a process that the child understands in relation to the two spellbinding statues that captivate his eyes. This reversibility of the gaze, originating in the child's "poetics of reverie,"[13] is preserved in the structure of the flaneur's gaze and returns at every step of his texts. Bachelard's suggestion that "Everything I look at looks at me"[14] is played out by Hessel's descriptions of Behrendt's early encounters with the world. They stage an experience of reality that is already moved by the flaneur's visual desire: the world of things shines and glitters, lives and looks toward him and back to him, visually demanding that the viewer return this gaze. The fascination of these early sensations sets into motion a pursuit of visual pleasures, an ongoing hunger to experience sights. Even after the mother's sudden death, the words that most closely link the child to her world retain an aesthetic memory of the images that remain inscribed in the child's text, a memory that survives within the "twilight [*Dämmerlicht*]" atmosphere, the calmly tinted harmonies of his childhood.[15]

If the mother's sphere casts a benevolent light of pleasure on the world and its perception, the father's authority comes to remove Gustav from this primordial relation to the world. Literally separating the child from his "ground," the father picks him up from the floor, thereby severing his haptic relationship with the surface of things. Presumably elevating the child to a higher plane, the father removes him from his immediate connection with the primacy of pleasure. Placed onto a chair, Gustav is inserted into the distancing position of civilization, restrained by an instrument of domestication that adjusts and controls the body and its movement.[16] The child's evolving visual mind, however, finds an escape into the world of images and filters a degree of enjoyment even from the restrained world of his father. The boy confesses to an almost furtive "pleasure in the red, blue, and black lines of the unfolded accounting book" (*KG*, 8), in the sheets of paper from big printing presses, and in "the blue miracle of the copy ink." If the "motherland of his soul"[17] first opens his eyes to the possibilities of pleasure, the father's bourgeois realm fills this position with new symbolic experiences.[18] In turn, the process of pleasure is extended and redefined, now including the world of signs as a complement to its primary sphere of colors and light. The sensory empathy that surrounds

these material manifestations enables the future flaneur to experience every object, image, or name in all its fullness and singularity. But this childlike curiosity about the realm of signs, be they visual or verbal, is threatened by the child's inscription within the process of socialization. Gustav comments on this loss, on a devaluation of vision that masquerades as education: "There was a world that was my own. I had so much leisure in all the words. . . . But since I have been taught to refer things and words to each other, I have become poorer, it seems to me" (*KG*, 74). The words of the young protagonist bear on a moment of *Sprachkrise*, wherein the awareness of loss within the realms of sense and sensuality is linked to an experience of linguistic disassociation that surpasses individual scenarios of trauma.[19] It points to the restricting effects of socialization on the mind of an imaginative child, effects that subjugate the imagination to preexisting patterns of "objectivity" and "sociability." In the wording of Bachelard, the child "loses his absolute right to imagine the world."[20]

This dynamics suggests that the flaneur is a figure that aims to resist such restrictions and rational purposes by trying to preserve the traces of the child's free imaginative access to the world. The developing flaneur begins to evade this rationality by looking "in trash and niches for mysterious things." He derives "no pleasure at all from . . . all the useful things" given to him in preparation for the bourgeois life of functionality and purposes.[21] This is why school for him is an institution devoid of all pleasure, experienced predominantly as a form of visual deprivation: "One was not allowed to take a look at anything attractive." Nevertheless, he finds a certain pleasurable arbitrariness and diversity within the world of letters that draws his attention to the mysterious visual qualities of writings and hieroglyphs. Taking pleasure in the realms of objects and signs, regarding them as ubiquitous systems of attraction and fascination, the flaneur embarks on a life-long pursuit of images in which sights and surfaces always mean more than they seem to. His increasingly visual and sensual relation to the world of signs and objects becomes compellingly associated with an affirmation of life. At a critical point in his adolescence, Gustav takes his first walk into the outside world since his attempted suicide. The convalescing melancholic soon fastens his gaze on the torsos of marble statues that he encounters in a museum: "Nothing is actually as foreign to me as marble. But it was good to look at it" (*KG*, 85). The mere sight of the statues conjures an aesthetic reaction that attracts and distracts the melancholic's mind with therapeutic effects. Viewing them becomes a form of meditative medication. The situation recalls to him his earlier pleasures in contemplating visual and rhetorical images: "[Flowers and animals] I also love, especially if I do not know their names. And I also love the names, especially if I do not know which flowers and animals belong to them."

Existing within a linguistic realm that aesthetically favors either a sign or an object, a signified or its signifier, over the act of viewing or naming the

object, Gustav's experience reflects a crisis of language, a shift in logocentric position that helps form the mind of an aspiring flaneur. Refusing to succumb to the passive resignation and stagnation of this *Sprachkrise,* he mobilizes his modern predicament in the direction of the world of things, viewing it as an enchanting realm of signs in its own right.[22] He discovers that sensory sense may be the last resort of meaning in a world where the conventional means of sense are absent: "I do have pleasure, but not in life, that is to say not in my life. I have pleasure in things that are none of my business [*die mich nichts angehen*]."[23] This pleasure is directed toward objects, things, and images that engage his free-floating fascination—an aesthetic state that Kant calls "*interesseloses Wohlgefallen.*" He comes to understand that such marble torsos, images that he would not have expected to speak to him, are not limited to the sites and spaces of a museum. The prevailing disposition that introduces the flaneur to the pleasures of perception arrives as an antidote to the disillusionment, resignation, and melancholy of his time. His attempt to distance himself from the distress of his interior world provides the point of departure through which he becomes a medium for the perception of an exterior world.[24] The future flaneur describes this shift in orientation in his diary, referring to it as the only alternative for young Behrendt to answer to his father's dominant questions: " 'What are you actually interested in? . . . What do you want to be one day?' " (*KG,* 69). Significantly, the renegade son's answer finds its way into the pages of another "accounting book," one that is also preferably "lined." In other words, this flanerie emerges from a bourgeois "background," and never quite surrenders its needs for structure and the "educated" legitimation of individual leisure. This helps explain the ways in which Hessel understands his Berlin walks as a form of *Heimatkunde,* a knowledge of the city and its images that is cast in the form of educated quotes and fragments of *Bildung.*

The adolescent flaneur's observations become the condition for his becoming a serious observer, a left-handed outsider who is unwilling or unable to follow the pragmatic lines of functional purpose.[25] This declaration of a freedom of mind characterizes his movement of flanerie as an exterior process that gives him the right to "let himself go," that is, to walk. In this way, the young flaneur begins to encounter the seemingly marginal phenomena of the everyday as significant sensory insights that he gathers from the waste products of urban life: "For all things that do not count [*auf die es nicht ankommt*], I have an excellent memory" (*KG,* 71). The flaneur's empathetic sensitivity can be said to compensate for his sense of loss, transforming this absence of meaning into a decided pursuit of the sensory pleasures derived from the exterior world. Evading realms of love and death, suicide and romance, the flaneur chooses to embrace a reality comprised of images. Immersing himself in the infinitely changing world of scenes and sights, he explains: "For some time now, [he] was out for so-called reality [*war er auf die sogenannte Wirklichkeit aus*]."[26] The young city stroller turns to the visual distractions and eroticized sensations

of Berlin-Friedrichstadt, a district that redirects his sensitivities toward more pleasurable views and tangible attractions: "The dim shimmer of worn-out silk," he tells us, can be seen in the reflections of women's eyes "like pale lakes with phosphorescent will-o'-the-wisps [*Irrlichter*]" (*KG*, 90). Such stimuli play on his prevailing partiality to a world of feminine fashions and fascinations, the fractured spectacle of an eroticism borne from afar in the images of women "walking the streets," a spectacle that, emitted in the matte light effects of appearances, returns him to the twilight world of the mother. As the student leaves the city—recalling Hessel's own life in the university towns of Freiburg and Munich—he continues his quest for visual stimuli in his vocation as a student of life.[27] He turns his boyhood sense that he has no "particular talent for philosophizing" (*KG*, 114) into a principle: he will take no pleasure in the pursuit of a theory that would remain a nonsensuous abstraction. His desire is to become an observer in "the real world," compensating him for this decision to exclude himself from the world of active action, in order to refine his ever more differentiated sense of attention and awareness. The more he secludes himself from the crowds, the more he frees himself to participate in its collective perception, in an ever more nuanced and extended exploration of the streets. That the flaneur's increasing attentiveness corresponds to a world of anonymity and isolation can be registered in the contemporary thought that precedes Hessel's time. What Simmel perceives as the prevailing forms of multiplicity in modern cities, what Nietzsche views as the polyperspectivism of modernity, is nothing less than a model on which we can base our understanding of the flaneur's perception and expression. This phenomenon of multiplicity finds a material site in Hessel's image of the "junk store of happiness."

The context in which this spatial image first occurs coincides with a pivotal point in the observer's life. He encounters this imaginary space during a Zionist Congress in Basel that he attends in the hopes of discovering his identity as a committed Jewish citizen.[28] Rather than embracing this identity, however, he sets out on an extended walk to flee the alienating boredom of the congress. His distracted gaze turns toward an anachronistic shop in a narrow street, abandoning himself entirely to an intense sense of optical curiosity, to the attractions displayed in the shop's windows: "[He] stood still in front of a variety store in whose window could be seen a goldfish basin and, above that, on a shelf, wooden toys, string rolls, and glasses full of colorful candies. If I were a little boy, I could go in there now, he thought" (*KG*, 117). Gustav's impression of this overwhelming multiplicity structures the displays into a kind of visual continuum that far transcends the limited, specific use-value of the commodities in the window.[29] On a more general level, his detailed representation of the displays reveals the poetic processes of his text, the aesthetic approach that defines the work of this flaneur. In other words, neither the novel nor the life of the protagonist can engage the "real" commodity values encountered in the

displays of these fictitious streets in an objective or quantifiable manner. Rather, the kaleidoscope of their perspectives offers the reader's eye a description of the protagonist's state of mind as it is projected onto his view of the realities before him: "And again he gazed at the cherished multitude of the display [*liebe Allerlei der Auslage*]. There were also noodles, dented ones and round ones, next to little childrens' balls and cloth samples, and further containers with lime blossom tea and chamomiles and currants."

The store's variety of sights and childlike wonders restores a sense of happiness even—or particularly—as Gustav drifts through the streets in search of meaning and diversion. The flaneur he has become shares affinities with the marveling child who encounters the entire world as a "cherished multitude" on display, as an open window of assorted offerings in the "junk store of happiness." Evoked at a crucial moment in the narrative, this image of a store that holds unlimited variety answers to Gustav's desire to participate in reality. Not surprisingly, this wish-fulfillment is framed by a Zionist convention which, as a convocation of individuals who throughout history have been considered proverbial "others" and "wanderers," refers to the wandering future of the maturing Gustav.[30] Yet, Gustav remains marginalized even amongst this historically marginalized group, a spectator doubly removed from their spectacle of exclusion. As Hessel's novel signals in its foundational metaphor, the space of a "junk store of happiness" and its multitude of images offers a refuge from alienation and exclusion, and functions as a metaphor for a certain approach to the world, apparent in the multiple affinities and connections that the *Kramladen* concept shares with Benjamin's project, a principle of collection that structures the materials held in store by his *Paris Arcades*. The "junk store of happiness," a metaphor of pleasure and sensory thinking, travels, as it seems, from Hessel's novel into his friend's thought. Charlotte Wolff, a mutual friend and female flaneur who introduces Benjamin to Hessel, points out that Benjamin first uses this image at the sight of an antiquarian bookshop in the Danzig Stockturm district, an area that will inspire the latter's essay on colors and images in "Aussicht ins Kinderbuch" (1926).[31] The adoption of Hessel's title by his reader Benjamin is an implicit homage to their friendship, emphasizing a world composed of diverse images, an expression of both assemblage and excess that characterizes Benjamin's thought as much as it situates Hessel's particular form of flanerie.

At pivotal intersections throughout this text, Hessel's Behrendt experiences the epiphany of such visual constellations. In one instance, the apparition of a store with multiple possibilities provides the only discernible manifestation of reluctant romantic interests. Habitually avoiding any action, Behrendt's love plot disappears as the text progresses. The would-be lovers displace their intimacy into visits to the mysterious interiors of yet another *Kramladen*. Gustav's approach to its marvels mirrors his hesitancy toward the offerings his companion Marianne may hold in store. In the "little shop in Türkenstraße . . . there

were very beautiful shining stones next to colored boxes and braided little boxes. . . . Gustav admired everything but he didn't know what to buy."[32] Analogously, the flaneur cannot suspend his aimless admiration in order to focus on other, more direct forms of consumerism. His happiness requires an absolute attention to the entirety of the marvelous objects in the *Kramladen* of physical reality, to their respective nuances and aesthetic variety in a state of intense contemplation.[33] The trope of a "junk store of happiness" is constitutive of the scopophilia of this novel, contemplated in ways that suggest an extended metaphor of the pluralities and multiple meanings of life.[34] Indeed, at a significant juncture of this novel, Gustav's attraction to Marianne functions more as an impulse to move his flanerie across a fairground of images than as an excursion meant to take his lover home. The fairground—a location of public scopophilia since the nineteenth century and a particularly suggestive materialization of the *Kramladen* principle—offers a variety of rapid changes in colorful lights, the mysteries of darkened store booths, and the fascinations of an antiquated "magical theater" (*KG*, 237), along with the newest attractions of moving images in the "cinema [*Kinema*]":

> Then they hastily experienced in a cinema London diamond thefts and Paris street corners, whose protruding wedgelike houseblocks also were to blame for many collisions and accidents. They were prosecuted through stairways and saved themselves through skylights, in order to sink into Moscow deluges, before finally, in a hurry, they were instructed about the fabrication of iron and tuna fishing.[35]

The newest medium of looking presents itself as a renewed, technologically accelerated sequence of flanerie, moving at the curious speed of early cinema. It evokes the flaneur's somewhat ironic interest for a mechanically reproduced series of shocks that repeats the rhythm of flaneuristic enjoyment of the visual realm. That the flaneur experiences his frantic sensations in a succession of scenes suggests the degree to which his strolls across the territories of public distraction replicate the pace of the cinema of his time. Anachronistic sensations continue to punctuate his experience of several attractions: carousels moving under a sky of "wandering sequins," giant snakes, strong men, and "colorful parrots in their rings behind the snake bearers before a painted landscape of the tropics." The space of a bygone scopophilia, the fairground evokes the pleasures of the forgotten realms of childhood. Challenging Behrendt's "passive" attitude toward his life and lover, a friend problematizes this purpose-free and harmonious gaze on the world.[36] It is this very aimless reflection "that makes [him] happy," Gustav says, defending the ways in which the flaneur relates to women and images of the exterior world. Along with scopophilia, melancholy characterizes the young flaneur's visually defined desire for the objects and people of the world, a "*Fernliebe*" (*KG*, 62) that suggests a longing, in Benjamin's sense, for the aura of things. Behrendt's singular ability "to secretly admire from afar" evokes Baudelaire's attraction to the woman of

modernity—*A une passante*—a trope for his instant fascination with women passing in the street, who, in Hessel's words, "walk by and do not look at me."[37] Explored as a disposition of resignation, this desire, determined by the distance between it and the objects toward which it is directed, names an aesthetic pleasure in the aura of appearances rather than in their immediate possession. This extended sense of seeing induces a mode of distraction that is linked to cinematic viewing.[38]

In other words, if the flaneur does not reach for the appearances of the world, it is because he remains a spectator who encounters the women of this text in their passing images. The passivity of his relations to women borders on latently misogynist representations, reminiscent of the male fantasies delineated in protofascist male biographies of the time that position women at a distance.[39] The hesitations of Hessel's protagonist, however, are predicated on distinctly different premises. His character does not arrive at his apparent erotic disinterest through repression and misogyny, but responds with a polymorphous, if slow, degree of sensualization toward all of the appearances of reality. His circumspect approach shows a similarly gradual, attentive regard for both the images of the street and the women he encounters in these environs.[40] In other words, images in the street are not, for the flaneur, "only" objects. While the women in Hessel's works may not appear as acting subjects in their own right, they receive no less respect—indeed they receive an incomparable degree of visual autonomy and attentive regard—than any of the other images of reality that he encounters. One might say that they become the "objects" of an author who has abandoned his own subjectivity to the images before him.[41] After all, this flaneur defines himself as the ultimate object—the *Objektiv*—the "objectively" looking lens of the camera itself. The transitory character of Hessel's passive protagonist leaves open many of the details of his fictional biography. The "junk store" of life and happiness, a metaphor for the multiplicity of modernity in the innumerable facets of the city, functions as a term that multiplies the experiences of this contemplative existence. While avoiding active participation in any particular walk of life, the flaneur is a spectator who, captivated by all of modernity's phenomena, is also held at a remove by his own fascination. This infinite desire for the life of appearances moves the flaneur to drift on insatiable excursions through city streets, to roam what he perceives to be an inexhaustible "junk store of happiness."

FLANERIE AS ROMANCE

The flaneur of Hessel's second novel, *Pariser Romanze* (1920), enters not only another city and culture but also a new sphere in history, a period of transition shortly before and after World War I. The novel relates the fabled romance and flanerie that has become one of the most celebrated erotic triangles in

twentieth-century film and literature, a configuration that includes Hessel, his friend Henri-Pierre Roché, and their lover Helen Grund, a Berlin journalist and Paris fashion writer who goes on to marry Hessel even as she continues to live with both men. These figures appear in Hessel's novel as the narrator and his friend "Claude," and in Roché's later account of their encounters as "Jules and Jim," figures that have served the cinematic lens as the models for François Truffaut's adaptation of this triangular romance. Looking at this text through the lens formed by the relation between writing and walking, we could say that this flanerie appears in four "notebooks" by a stranger in Paris. These "Papers of One Lost Without a Trace,"[42] as the novel's subtitle refers to its pages, record the period from January 1915 to February 1916. Supposedly written in the trenches of World War I, these notebooks are presented as a series of letters composed by the "missing man" to his Parisian friend. The final notebook commences as a farewell letter and remains without a date, thereby marking the time when its author disappears without leaving another trace beyond his posthumuous letters. Both author and addressee of these letters, however, already are "missing" characters during their lifetime, subjectivities submerged out of their bourgeois existence into the international *bohème* of prewar Paris.[43] After his arrival in Paris amidst a generation of expatriate travellers, the letter-writing narrator soon loses "the desire to move on, unlearning his profession and everyday life, [he] remained" (*PR*, 25). He "falls out of a world" of functional relations, just like the novel's author moves away from its romantic plot, "happy to be away from the world of success and relationships. I . . . lived as a stranger at the margin of life and loved the city . . . without desire and demand."[44] This detachment and absence of purpose signals the space of flanerie that Hessel's narrator inhabits.

The city is inseparable from the aura of this "romance," a romance that soon dissolves its links to the genre and engages the freedom of a flaneur's narrative. "The city," as the narrator remarks, is "the home [*Heimat*] of strangers" (*PR*, 24), the sole necessary "destination" for this café society of accidental encounters. The city's scenes provide visual possibilities for a free-floating existence unanchored in bourgeois positions; at the same time, their anonymity sets the stage for a prevalent sense of melancholy. "We homeless [*Heimatlosen*]," he writes of his contemporaries who pay with this lack of sedentariness "possibly the penalty, the cost of our detachedness" (*PR*, 96). While a sense of liberation from traditional homes and national societies prevails, sudden expressions of melancholy still paralyze the younger flaneur. "Sometimes we become dead tired," the "missing man" concludes, overwhelmed by the shocks we experience in the city, "so tired that every car could run us over and everything underneath, grass, pavement, asphalt . . . weigh on our weakness."[45] This premonition of an experience of annihilation through impending shocks is linked to the narrator's retreat from prevailing notions of the nation. These metropolitan strangers establish their new sense of *Heimat* in the city, a tentative but

international and urbane space that grants the flaneur a privileged position in relation to its visual attractions. The very unfamiliarity of the city is what is most "familiar" to its flaneur, a literary walker who pursues the respective secrets [*Geheimnisse*] of Paris, London, or Berlin—ranging from the uncanny [*unheimlich*] aspects of urban underworlds unfolded by Sue and Poe to the haunted structures explored by E.T.A. Hoffmann.[46] The ambivalence of these "secrets of Paris" in Hessel's *Pariser Romanze*—projecting the city of lights on a darkening screen of history—produces idiosyncratic flights of association that disclose themselves to the flaneur in his slow, eclectic reading of the street.[47] This secret world appears particularly in what the writer calls its "secret corners" (*PR*, 15), spaces and exteriors that he considers the "true old Paris . . . not that of the famous sights but the secret one we discover in passing old corners" (*PR*, 57). Hessel will proceed to unfold these features of a hidden *Heimat* in the first home of this experience, the next novel of his city experience, *Heimliches Berlin*.

At the opening of his earlier *Pariser Romanze*, the "missing" narrator situates himself at a remove from the Paris referred to in his title. This distance evokes the auspices of the coming catastrophe that clouds the years of this prewar Parisian romance and defines these notebooks as writings from the margins and trenches of society. The narrator's oppositional distance [*Nicht-Zugehörigkeit*] from any form of functional coherence expresses itself in the dissolution of the notebooks' narrative structures, with secret associations and visual impressions assuming the position previously occupied by constructions of "plot." This *Pariser Romanze* displaces the narrator's "romantic" encounters with a mysterious, androgynous woman onto a flanerie obsessed with urban attractions.[48] Those moments of the text involving the narrator's pursuit of this woman through the city delineate the transition in their relation as well as that of a prewar society waiting for its future.[49] This suggestive span of time and sense of place supersedes the suggestions of their romance, thereby redefining the expectations we might have of such a plot. In the words of a narrator versed in the ambulatory structures of flanerie, it is "hard to tell it, and I evade and write about this and that" (*PR*, 32). Consequently, the narrator's peripatetic reflections take the shape of notes whose destination remains unknown. Only the first notebook is expressly addressed to his friend, Claude. It describes their shared memories of Paris, in contrast to a wartime situation that the drafted German expatriate seeks to escape in writing his reminiscences of the city.[50] These wartime letters find no closure, just as Hessel's romance refuses any formal conclusion. Rather, the circular and ambulatory structure of the story emerges as a romance only through a series of readings that guide the writer back to the privileged site of a city composed of aesthetic and literary reflections. At the conclusion of a romance that only takes place in a series of shared impressions and strolls, the writer returns to the National Library: "I

. . . ordered the book on the Doric temples, which I had not received on that Carnival Tuesday. This time it was available, and I continued reading."[51]

The reading of a book that is to prepare the narrator for a journey initiates the romantic atmosphere of Hessel's text. Recalling earlier experiences of flanerie, the gaze and smile of a marble statue seize the spectator's attention, a gaze and smile that the tourist will soon recognize in a woman of his city.[52] Fusing the privileged relation of classical art to the mind of an educated bourgeois with a sense of erotic "recognition," the flaneur encounters this same gaze in the streets of Paris.[53] The drama of this romance, however, threatens his contemplative tranquility, enveloping him in forms of experience that direct his digressive ways toward more purposeful channels. Its emotional subtleties and details evade him after all, suggesting an event that might have taken place but that finds his ridicule in narrative self-irony: "It was [as if I was] in a smooth novella," the narrator remarks. The writer-flaneur prefers to replace the suspense of linear action with the assorted distractions of urban reality. Conjuring the atmosphere of a prewar Paris, he recomposes the metropolis in terms of his sensual, visual sense of things. In the great detail of his writing, he recalls the material objects that furnish these sensory surroundings: the side streets, byways, and forgotten alleys of the city. The writer's identity is reflected in the layout of his Parisian apartments. The spaces he inhabits allegorize formative scenes in the course of his life. He revisits these locations in his mind as sites of impressions and sensations that compose the interior structures of his city: the well-known, well-worn abode in a Montmartre hotel, situated on an "ailingly green square," succeeded by a narrow room in Passy, a hideaway, modelled on Hessel's room in Berlin, that gives way to "the atelier deep in the south of Rue Vercingétorix."[54] Hessel's abodes favor small, secret, and secretive spaces. The flaneur who faces the daily labyrinth of the city, the writer who finds himself exposed to a literalized bombardment of shocks in World War I, requires a retreat to the "closeted and hidden spaces of his own interiors"—a position that, as de Man would have it, enables him "to read what's outside."[55]

Submerging himself in the city, hiding in interiors, finding shelter even in trenches, all in order to be alone with his own reflections of exterior reality, Hessel's narrator enacts a recognizable form of flanerie. The obliqueness of small rooms replicates the child's habit of hiding on the ground, close to objects, a literally utopian stance of observation that seeks not to be seen in order to see more, that seeks to see ever more diversely. Hessel's suggestions about the necessity of inhabiting secret spaces therefore hint at a new way of relating to the public sphere. Locating himself within the transitory spaces of the city— spaces that, for him, suggest a continuous state of disappearance—he betrays the utopian position of this thought. He occupies an ultimately untenable place from which, as "from all previous apartments, the 'now time' [*Jetztzeit*] [drives him] away."[56] "Now time" refers to a wartime era that erases the past, replacing

it with ruins of its own. Against the extreme "actions" of a World War which acts out the rationales inherent in the constructions of modern political collectives, the solitary stroller builds a "passive" and pacifist world that encourages his more "active" contemporaries to direct their attention toward the objects of bygone times. He preserves the signs of such objects in a patient and detailed text that records his solitary observations. His gaze wanders around anachronistic spaces, scanning the bric-a-brac of old-fashioned hotel-pensions, lingering on flowery decors and decorative surfaces, and dedicating its attention to the furnishings and decorations of his friends' apartments. Engraved in his memories as visual imprints, such ornaments are likened to a strangely futuristic wallpaper, whose designs are haunted by painted submarines and wartime aeroplanes (*PR*, 67ff). In an age of militarization that actively requires visual surveillance and the aerial reading of signs—what Paul Virilio terms the "geometrification of looking"—the flaneur is among the first to recognize the visual character of his era wherever he goes.[57] Focusing on society's interiors in order to decipher objects and patterns of its modernity, he reveals more about the mythologies of his day than he might in a discussion of more concrete manifestations of war. Joining the wallpapers of prewar Paris to his generation's traumatic experiences of World War I, he suggests the aesthetic dimension of a prewar world that will eventually furnish the future.

On his excursions through a metropolitan world threatened by apocalyptic collapse, the flaneur casts his eye on the consequences that new forms of living and writing hold for his own narrative. His text extends the limits of his poetics into the realms of painting, playfully exceeding the oppositions theorized by an age of Enlightenment: narrative writing becomes pictorial depiction in a visual turn that allows the narrator to engage his transgressive desires. Writing amidst World War I, in the face of an alarming and even criminal "plot," the flaneur turns toward his own nonlinear explorations. Inhabiting a sphere of distraction, he marvels at the surfaces of its objects and thereby performs multiple "readings" of life in the street. He transforms these spheres into the "thought image" (*PR*, 41)—what Hessel calls a *Gedankenbild*—of an exterior perception that has passed through the interior stations of interpretation and representation.[58] The text acknowledges the intricate, imaginary relation between images and their reflections, between the cultural and theoretical significance of visual material that, for him, constitutes the *Denkbild* of contemporary thought. This is why the underlying aesthetics of his text articulate the art of taking a walk. An activity that enables him to pass through cities, libraries, and other urban structures, walking becomes the privileged metaphor for his access to the world. Noting significant topographies and itineraries, the flaneur encourages his reader to move with him along a sequence of images. He leads his reader along the winding paths of his narration, allowing his words to project exterior images onto an interior mental screen. This meandering of visual and rhetorical meaning defines his work of literary redemption. Flanerie

is at once an aesthetics and a utopian project for the narrator who seeks to fill an essentially empty world with his reflections, who reviews the decaying, marginal structures in the streets and regards them as manifestations of the city's modernity.

The flanerie of Hessel's text is refracted across a variety of diverse perspectives reflected through the lenses of varying spectators. The narrator's encounter with the world defines a spatial realm of experience, dissolving in its romance the "interior" zones of the body into "exterior" spheres of experience. The flaneur experiences the city with all his senses, that is to say, in both sensory and sensually suggestive ways—and potentially as a woman.[59] Hessel's suggestion here differs from the more usual projection of a male phantasy on a feminized body that is then superimposed on urban territory. Hessel's trope reflects the tentative, tenuous relation to the exterior world experienced by his flaneur, a hesitant disposition that he extends not only to phenomena of the city but also to women. Indirectly, the narrator of this "romance" approaches the objects of his desire only as a flaneur, that is, with a detached gaze rather than the penetrating grasp of concrete action.[60] Hessel's novel stages the perceptual priorities of his flanerie in the visual constructions and material architectures that, for him, present the truly eroticized elements of this "romance." Articulating foremost a desire for the process of the gaze is commensurate with his primary eroticism of a flanerie that is discovered in the flaneur's "secret" relations to the city. It belongs to the larger project of "secret" seeing and secretive writing that characterizes Hessel's *Heimliches Berlin*, the first home of his reflections on the city and its images.

THE SECRETS OF BERLIN

In a paradoxical movement, *Heimliches Berlin* (Secret Berlin, 1927), Hessel's last novel to appear in print before he was driven into exile, describes the flaneur's return to Berlin, the city of his childhood.[61] At the same time, it signals the author's arrival in a sphere of more extended linear fictions, suggesting a story line that is more coherent than his fragments of flanerie. After the episodic, autobiographically relayed stations of *Der Kramladen des Glücks* and *Pariser Romanze*, Hessel here points to an approach to the city in which the flaneur finds the fictional structure of his text in the street.[62] In other words, what is perhaps Hessel's most substantial novel is at the same time yet another extension of this flanerie. Recording the flaneur's experience of a secret Berlin, it presents the city through the lens of an eye that is both clandestine and familiar, *heimlich* and idiosyncratic. The first scene introduces Wendelin, the novel's protagonist and a privileged member of the bourgeoisie, who is born into a life of sensory pleasures and enjoyment.[63] His memoirs as a young man in the city recall a carriage ride in the company of his father, an excursion that

conjures images of other men in the streets, synaesthetic memories of "gleaming top hats on their heads and good-smelling leather briefcases under their arms" (*HB*, 67). Such sensory signposts from the era of Hessel's childhood anchor Wendelin's identity in Berlin: "since then," the narrator tells us, "Wendelin felt like a citizen of this city."[64] This sense of nuance and atmosphere translates the image of a figure in the mirroring waters of the Landwehrkanal into a reflection of the melancholy that characterizes the city dweller's identity. Wendelin, he says, feels "old and homeless. Was he really that young tenant and student, this boarding and sleeping guest [*Kost- und Schlafgänger*] of Berlin?" (*HB*, 94).

Suggesting Wendelin's shifting sense of home, his departure from the familiar limitations of his faculties, the narrator traces his transformation into a student of the city, a "guest" who walks its streets with his eyes open, a "tenant" who truly inhabits its spaces. Both "*Schlafgänger*" and "sleepwalker," he inhabits the city by "walking" in a dream-state of changing orientations.[65] Wendelin's shifting identity as a figure of attraction oscillates between the roles of narcissus and dandy, an object of beauty to his friends as well as a figure who himself pursues a sense of beauty. This observer presents himself as an elegant idler in the tradition of the nineteenth-century dandy who engages in extended reflections on décor and styles of clothing. Recalling Barbey D'Aurevilly's or Dujardin's writings, considerations of habit and attire inform every one of Wendelin's actions, while observations of fashion accompany his every step.[66] Pressures to sustain his social standing overwhelm the student in an expensive city, shifting his dandy disposition, almost by default, into the seclusion that defines the flaneur. Conflicts over his attire compel the contemporary dandy to abandon his usual destinations and assume the more solitary stance of flanerie, to seek invisibility within the social hierarchies of an increasingly anonymous city. The dandy's obsession with status is replaced by the flaneur's more extensive image-consciousness, redefining his aesthetic relation to exteriority. The lack of an appropriate pearl stud for a dress shirt, for example, precludes a style-conscious entrance to his social sphere and thereby encourages aimless anonymity instead: "In short, I saw, it was not possible, walked away morosely from home . . . drifted through the streets" (*HB*, 84f). His failure to inscribe himself in the prescribed interiors of the wealthy bourgeoisie makes Wendelin turn to the exteriors and margins of society at large. Flanerie becomes an alternative means of entering the public sphere, enabling an avenue of aesthetic participation for those who are excluded from the events of an interior circle. The visual aspects of a previously ephemeral, marginal, and accidental everyday life begin to determine the frame of this novelistic action.

Hessel's text opens with a letter calling Wendelin back to the family estate and closes with his departure from the city. It names an urban site of transition where friends "separated with simple words of farewell at Potsdamer Brücke" (*HB*, 126). Rather than developing a fuller frame of action, the narrative dwells

on such spatial determinations, making its plot secondary to the text's images and lights, visions and impressions. This emphasis on space affects even the potentially antagonistic configurations of the novel's romantic triangle.[67] A traditional plot might suggest that Karola's husband Clemens opposes his wife's young lover, Wendelin. In a text whose flanerie also figures the meandering character of all romantic entanglement, the potentially threatened husband refrains from predictable judgments, appreciates the younger rival as a future flaneur, and welcomes him as a mentor. Clemens is in fact the first to view Wendelin as a focus among the many phenomena passing by the scenes of Berlin rooms and streets. A figure of many facets, Wendelin strolls and changes—both *wandeln* and *sich wandeln*—on his walks, shifting from an object of visual desire to the subject of his own perception. He becomes a walking medium of the changes that he encounters in his passage through the city, of his observations on the many ways [*Wandel*] of the urban sphere.[68] Deriving his own serene openness from his particular philosophy of life, Clemens anticipates Wendelin's transformation into a benevolent spectator.

Like his author, Clemens is characterized as a writer, walker, and reader, a more devoted and reflective intellectual and academic. The narrator introduces him as an "adjunct professor [*außerordentlicher Professor*] of philology at the University of Berlin" (*HB*, 24), situating his character both professionally and philosophically in a way that exceeds a marginalized position within the academy. This "extraordinarius" represents an original, far from "ordinary" intellectual, a professor who pursues his own "extracurricular" avenues of thought.[69] The "university" of Berlin that he charts as his primary realm of research points to both an existing institution and the space of the city itself, a cityscape that the flaneur-as-professor considers his object of study, his object of perception and analysis, comprehension and appreciation. A fictional professor of reality and "philologist" of its texts, Clemens's life joins the texts and streets that structure Hessel's flanerie. In so doing, it extends our understanding of intellectual life, of the spaces in which it can flourish. As Hessel's narrator puts it:

> My friend Kestner is not a scholar in the usual sense [*schlechthin*]. . . . He lives in a circle of people who belong to an entirely different world. Before the war, they were free-floating inhabitants of the clouds [*Wolkenkuckucksheimer*] who lived in Munich and Paris ateliers, painted, wrote, and philosophized. Now they have had to "adjust their ways," as the beautiful phrase goes. (*HB*, 63)

Anticipating "those who wait" in Weimar Germany, Wendelin's friends belong to a transitional generation that has emerged "shell-shocked" from the apocalyptic experiences of the early twentieth century.[70] The shock of their wartime experiences turns them more fully toward the postwar realities of a new era, encouraging them to embrace the real and to live a life that is dedicated to its expression. The position that these unorthodox intellectuals assume inaugu-

rates a different kind of "university," one that shifts traditional institutions of thought toward what Derrida has called "non-university centers of research."[71] That the sites of knowledge have now moved from institutional interiors to exteriors of perception and artistic practices—such as flanerie—reflects the growing sense that "certain objects and types of research are escaping the university." Hessel's flaneuristic approach to visual and social knowledge presumes a "university" whose disciplines would study the entirety of the visual world and assumes a way of seeing that responds to the epistemological shifts that characterize the modern world. Instead of living, writing, and philosophizing within their interior confines, Hessel's flaneurs seek to define an aesthetics of exterior reality that Benjamin ascribes to the artist of modernity. They "live" in streets decorated with neon signs, the new "paintings" of their age. Walls become "writing desks," kiosks become innovative extensions of their "libraries," and gazes in cafés become "windows" that open onto the spectacle of public scopophilia.[72] The new "research" of these scholars-flaneurs works to uncover the traces of urban histories. Pursuing their newly defined "love for knowledge" in the modernity of Weimar Berlin, the community of Clemens's "intellectual" friends enacts what Derrida has called "the principle" of the university: "The concept of *universitas* is more than the philosophical concept of a research and teaching institution; it is the concept of philosophy itself."[73]

Clemens seeks a philosophy of contemporary life, a new philology of its texts, in the streets and everyday life of the city. Flanerie becomes for him a medium for representing and recording the ephemeral practices and transient phenomena of modern urban spaces. If, according to his friends, Clemens is not considered "a scholar as such," he nevertheless embodies the intellectual presence of a kind of "professor-at-large," a figure that Derrida has referred to as "*un ubiquiste*"—a term that evokes the specter of flanerie. Like the flaneur, the "ubiquiste is someone who travels a lot . . . giving the illusion of being everywhere at once."[74] The flaneur's desire for a public presence is legible in the multiplicity of his insights and perspectives, even as he maintains his detachment from the business of the streets. The urban stroller and the *ubiquiste* both suggest an intellectual frame of mind, a perspective that has been "given leave to consider matters loftily from afar." From this perspective, Clemens's flanerie—performed in his reading of city-texts—structures the movement of Hessel's novel and points to Hessel's sense of the public sphere in Weimar culture.[75] The *ubiquiste* in this "extraordinary professor" defines flanerie as a kind of movement in the free space of existence, removed "from 'useful' programs and from professional ends."[76] This lack of predetermined purposes becomes the precondition for presenting an alternative view of a secret Berlin.[77]

For Hessel's flaneur, the bourgeois world of functional coherences has disintegrated into an array of fragments, thereby enabling the discovery of new signs through a seemingly aimless but intense mode of perception. This pri-

mary disposition of flanerie is recognized throughout a text that privileges the phenomena of the material world in all of their manifestations.[78] Hessel's "extraordinary" professor suggests that we should "Gladly enjoy what [we] do not have."[79] This seemingly picaresque, only paradoxically cynical, maxim indicates a kind of withdrawal that corresponds to an aesthetic resistance against the capitalist world of commodities, a resistant gaze that surfaces in the minute perception of this world's structures and appearances.[80] The flaneur's eclectic affinity with Benjamin's project of collecting the sights, sites, and cites of nineteenth-century Parisian arcades returns in Clemens's view of a world composed of everyday presences. An example of this perspective emerges in his view of window-shopping as a way of enacting a visual life: "I do not need to enter stores, I am content with windows, displays, the giant still lifes of sausages and grapes, pink salmon, melons and bananas . . . " (*HB*, 98ff). By evading functionalist prescriptions to "comprehend," that is, to grasp and condense his impressions into predetermined meanings, Clemens transposes these objects into spheres in their own right, spheres wherein they signal the contours of a new aesthetics, the protocols of critical examination and novelistic action. In the eye of the impressionable observer, for example, neckties come to life as "snakes," fabrics "spread," leather jackets "weigh," and revolving doors ceaselessly "shovel" respective customers and prospective spectators into commercial spaces. A contemporary of Weimar modernity and its *Kino-Debatte*, Clemens neither desires nor requires more traditionally constructed works of art. The flaneur is content, indeed elated, to indulge in the still lifes of window displays, in the moving images of the street.[81] The cinema of daily life supercedes the fictions of his bourgeois *Bildung*, while performances of classical drama lose their appeal—he is "satisfied with the spectacle of exits and entrances." Historical films hold little attraction for him—the modern flaneur is "happy with the [film] of reality." Rather than pursuing the "grand historic film," the flaneur professes an interest in the "colorful pictures" in the entrance halls of the cinema, the cinematic semiotics of everyday reality.[82]

Clemens's contemporaries no longer presuppose a definition of modernity that would not involve an attention to its semiotic dimension: "Advertisements on the rear-house walls along the Stadtbahn, in waiting halls, and on the window panes of subway cars, titles, inscriptions, instructions, abbreviations, all this presents you with the entire life of the present, you can read it from them as you pass by" (*HB*, 99). The focus of this passage on the semiotics of modernity, with its overwhelming abandon to the multiplicity of signs, reveals a reception of the public sphere that adheres to the structures of its letters and images.[83] This intense and potentially critical perception of modern objects is preceded by a prevailing scepticism and melancholy about the meaning of things. Clemens formulates this point in an oblique observation that is organized around his acute awareness of the transience of these phenomena: "I am not beyond, I am in the midst [of things], yet I know that everything given is

already memory."[84] Hessel's Clemens here signals his indebtedness to Henri Bergson's *Matter and Memory*, his belief in the virtual reality of all images. If "perception is only a true hallucination," as Bergson suggests, then we are "no longer able to discern what is perception and what is memory."[85] Yet pointing to the very transience of reality does not preclude a profound fascination with its traces, reflections, and representations. Mapping Bergson's assertion of the equivalence between images and memory onto a paraphrase of Clemens's own emphasis on the visual domain, we can state that "everything given is already an *image*" (emphasis in original). This observation bears a close relation to Benjamin's findings on the status of the image in the course of modernity: "Everything of which we know that we will soon no longer have it before our eyes becomes an image."[86]

Melancholy here becomes one of the founding characteristics of modernity. Linked to a scepticism toward the reality of modern images, it signals a world of objects whose very transitoriness and intangibility defines its desirability. As Clemens puts it: "To mourn or to cherish this, that is left to us, but we have to take it, and we can take pleasure in it."[87] That this focus on pleasure beyond any mourning forms a central feature of Hessel's flanerie is confirmed by the title of his book, *Ermunterungen zum Genuß* (Encouragements for Pleasure)—a title that suggests what the flaneur hopes to find in every space he encounters. The world as aesthetic experience is inscribed into Hessel's writings as late as this 1933 collection of feuilletonistic essays, a collection whose very title carries these encouragements for pleasure even in a darkening time.[88] Clemens suggests that this aesthetic experience belongs to the essence of modernity in the city. It is inscribed in his sensual relation to the world: in the moments of transition that characterize "twilight time" in the streets, in the city's "evening fever," its moments of transit, and all of the transitory, the fugitive and evanescent situations that correspond to its modernity: "Go with a platform ticket to the long-distance trains: How much glory and misery and destiny from Warsaw to Paris. . . . Life is everywhere there for you, gratis at every time of the day, just do not get involved, enjoy everything, own nothing. Property deprives" (*HB*, 100).

Seemingly "passive," the flaneur participates in this world critically and intensely through his eyes. Calling for an aesthetics that would encompass the continuum of everyday reality, Clemens enacts a flanerie that announces a philosophy of modernity as well as the author's textual aesthetics. Just as "life is there everywhere" for the spectator, so are the texts that arise from these places everywhere there for the writer to record.[89] For the writer in the process of flanerie, there can be no question of overlooking even the smallest detail in his effort to redeem the world by inscribing it in a text. If, as Jean-Luc Nancy points out in his essay "Exscription,"[90] "there can be no question of 'refusing' " to read a text, the flaneur shows us that we cannot refuse to see, wherever we go and look, the world as so many texts. These texts of the street speak to the

stroller on all his walks. They unfold before him like an open book, while every step that he takes and every image he sees traces the physical and cultural reality of his secret city. The flaneur follows the inscriptions on store façades and signs in the street with his eyes, in a movement that resembles the tracking shots of a film running in the continuum of his perception.[91] The texts of flanerie provide an ongoing reading of these writings of the present, in the form of a consecutive chain of current subtitles which comment on these images in the mind.[92] The most striking scenes of his text arise from those specific situations when observation and insight coalesce into revelatory *Augenblicke* of a visually-minded narrator. In these constellations, spatial appearances transcend the declared intentions or functions ascribed to these figures. Subtle shifts in lighting or positioning in interior spaces introduce visual qualities that say far more about these characters than their often formulaic descriptions. In one example, the text replays images of a walk along the Landwehrkanal in the twilight of lanterns, a stroll in which lighting, atmosphere, and urban topography become the erotic catalysts of its action: "They didn't talk much and hurried in silent agreement, in order to arrive faster at the dark stretch of garden path behind the little pedestrian bridge. As soon as they were on the sand path at the weeping willows, they sank into each other's arms" (*HB*, 76). The conditions of exterior lighting and walking delineate the contours of these lovers' relations more than intimate conversation or psychoanalytic introspection. The flaneur-as-author lets his protagonist Wendelin pass through a passage of light that also reflects an erotic play of change, chance, and transition, leading from elated light to sudden shadows. The novel becomes a kind of literary *Lichtspiele*, translating its narrative into the cinematic mise-en-scène of romantic interests and urban recollections.

As effects of light in these highly-charged spaces dim and fade, both visually and narratively, so does the plot of Wendelin's planned escape with Clemens's wife. The end of this suggested action comes again in a play of lights that is projected into a spectacle witnessed from the street below Kestner's house on Lützowplatz. Wendelin observes the façades behind which a shifting decision is played out between the woman's family and her lover, her house and the street: "He looked up to Karola's apartment. In the child's room was light. Now Karola's window also turned light. And now the lights expired. She is coming!" (*HB*, 123). Paying close attention to subtle changes in lighting, the passage approximates the directions in a film script. Its observations could easily enter into the sequence of a sceenplay that structures its text around a series of visual effects. Following a logic of detour and distraction, these observations could lead any preconceived conclusions astray. In the place of his lover, Clemens emerges from the door on which the implied viewers and readers have fastened their mental gaze: he relays his wife's message that, remaining in the city, she will stay with her marriage and child. In retrospect, the sudden flash of light visible in the child's room signals the visual instance,

the very *Augenblick* of Karola's decision to remain within sight of her sleeping child. As the light is extinguished, it also erases Wendelin's attempt to step out of the role of mere observer into a more active participation in life. A kind of mentor-flaneur, Clemens suggests an interpretation of this text that describes the city as a meandering space of many harmonious turns: "You will surely return . . . and live with us in our secret Berlin, here in the old West, on the highway between Rome and Moscow. Then we will walk again by these waters and speak of memories and hopes that meet each other in circles" (*HB*, 125).

The passage addresses its own paradoxes as well as those of the narrative it concludes. In encouraging his rival to return, Clemens has recourse to an inclusive, meandering text whose spatial designs and principles register the novel's emotional and psychological encounters. The paradoxical structure of this experience is literalized in the notion of a "secret Berlin," a concept of consolation offered to Wendelin's melancholy that already circumscribes a secret yet communal place—"our secret Berlin"—open to everyone who engages a particular kind of experience.[93] This secret Berlin is a space of repeated viewings and circular walkings, a place of memories and reflections, a dream-like Berlin which, like other cities that belong to memory and thought, displaces the novel's plot into a sense of location, supplants jealousy with topography, psychological conflict with a mental space that inscribes the harmonies of Hessel's flanerie. The author's novel corresponds to the movement of a flaneuristic text whose most compelling aspects unfold in the visual sphere of the city, conjuring memories of a Berlin childhood, mysteries of momentary encounters, footnotes of a mind shaped by walking "the reflected, dreamed, imaginary city."[94] *Heimliches Berlin* evokes the imaginary city of Hessel's flanerie, a place of visual pleasure and the enjoyment of urbanity that structure his reflections on the street, his evocation of a "secret Berlin" whose aesthetics belongs to a flanerie of seeing and writing.

BEYOND THE DEATH OF FLANERIE

Hessel's final work was rediscovered and restored for its first publication in 1987, under the tentative title *Alter Mann* (Old Man). The fragmentary version of a long-lost novel, it was assembled decades after the author's death. This last text offers a view of Hessel's flaneuristic aesthetics that is even more evident in the fragmentary structure of an uncompleted work than in the closure of a completed novel.[95] Retrospectively presenting some of the recurring fragments from the life of the flaneur as an old man,[96] the text inscribes the ambulatory qualities of all of Hessel's texts. In keeping with the strolling principles of flanerie, the flaneur's testament has to remain an open fragment. The novel's protagonist revisits the features of a man of visual leisure. A painter and pensioner, Küster is dedicated to images, pursuing amateur painting as a

"*Liebhaberei.*" Hessel's text follows the slow steps of an old flaneur, a figure retired from professional purposes yet ever aspiring to his true calling of roaming the familiar haunts of his city. The old flaneur, gradually and leisurely, spends every remaining day of his life working to understand the ways in which his life will remain an assemblage of fragments. His sense of sensory impression extends to nuances from both the present and the past: observing girls dance, overhearing children play, spending a day in the Tiergarten. His pursuit of images of the present sets into motion an imaginary perambulation back into the depths of his memory. "Küster" becomes a figure of roaming and drifting, a "custodian" of bygone and ongoing sensations in sensory spheres both past and present, literally guarding and retaining the remains of memory.[97] All of Hessel's flaneurs can be seen as these guardians and bearers of visual memory, figures who preserve and conserve observations, walking media who transmit the relics and traces of their perceptions.

A former bank director, later its employee, finally unemployed, then retired (*AM*, 7), Küster is free to become a custodian who devotes his time to collecting the "containers of memory [*Erinnerungsbehälter*]. Things which do not have an exchange value" (*AM*, 23). Those tranquil "imponderabilia," as he calls them, consist of the memories of images and objects that coalesce into a reactive resistance to the acceleration, consumption, and circulation of images and commodities. As Christoph Asendorf has remarked in his study of perception in the industrial age, the flaneur resists this pace by "preserving the things which he has removed from circulation as rudiments of the past."[98] Küster's fascination with all visual sensations reveals his effort to preserve and redeem exterior reality. This work of preservation is less a conservative impulse than an attentive perspective directed toward the entirety of the visible phenomena belonging to a given era. In this light, the old flaneur becomes fascinated with Doris, a young woman who enters his text as a "shining" model of the "New Woman" in Weimar society and culture.[99] A modern advertising artist of the 1920s, she quickly recognizes in Küster's tales the relics of what she calls a "potentially redeemable mythology" (*AM*, 26). The sensations that he records and replays from his previous experiences of flanerie associate the visual woman of a new age—a woman endowed with a gaze and trained to register all images—with the "mythologies of the everyday" produced by modern advertising and the fashion industry.[100] Küster discusses even minute material nuances of bygone times with Doris, focusing on the sense of life conveyed by crinoline clothes, the spirit expressed in forgotten fashions, or the interior atmospheres of periods past.[101]

This fascination with every visible moment exceeds the past in order to embrace the phenomena of the present. This open, potentially infinite perspective becomes apparent when Küster revisits the classical site of Berlin flanerie, taking his favorite "detour via the Kurfürstendamm" (*AM*, 74). The flaneur walks along this most familiar of boulevards, listening to the "softly droning

voice ensemble of the city," abandoning himself to the symptomatic moving trance that surrounds the stroller in the "mild daze" of flanerie. But this intoxication not only evokes memories; even in the old flaneur, it induces a continued critique of conventional structures. On his final excursions during the Nazi reconstruction of Berlin, he emphasizes the subtle signs that point to the processes of modernity. As the aging observer casts a benevolent light on modernization, particularly in the 1930s, he overlooks some of the more disturbing and reactionary developments of his problematic present. Yet his explicit valorization of the signs of a commercial, capitalist modernity—legible in a variety of advertisements and store signs—offers a flanerie that critically views the more sober ideals of the streets now enforced by National Socialism.[102]

A similar conflict between tacit agreement and keen awareness, between critical practices and practical acquiescence, is played out in the old man's critical assessment of his own life. Ultimately, the flaneur only professes a love of visual pleasure, declaring his hedonist allegiance to images and to his visual perspective, to the enjoyment of exterior reality, and to the pleasures of looking and writing. He withdraws from active participation and emphasizes instead a world of present and past perceptions, (re)living what he calls the "thought images and image thoughts [*Gedankenbilder und Bildgedanken*]"[103] that unfold in his cinematic memories. Even as an old man, the flaneur prefers these real and imaginary images to any of the events of his life, including his poverty, his unemployment, and his daughter's suicide. The problematic implications of this visually attentive but guarded detachment involve the very lack of engagement and emotional responsibility that remain unresolved in the flaneur's reformulation of the aesthetic principle of his existence: "I have always left everything as it was. I have not intervened. Have found everything beautiful" (*AM*, 127). In relation to more active approaches to life, this attitude suggests one of defeat, passivity, and resignation.[104] Its very oblivion, however, also has always enabled a mode of intense perception that participates in the visual sensations it encounters. The flaneur's focus highlights the semiotics of his environment, allowing his text to formulate new approaches to an optics of modernity, to register the intense visual reflection that characterizes his close analysis of images. With their wide angles and open perspectives on the public sphere, Hessel's novels in their fragmentary moments translate what Benjamin and Kracauer call *Denkbilder* into a new mode of the modern novel. Hessel's idiosyncratic images become reflective screens for the projection of Weimar thought, his flaneuristic writings perform an art of visual thinking. Advocating the enjoyment of exterior reality, they encrypt the visual pleasures that for him represent modernity.

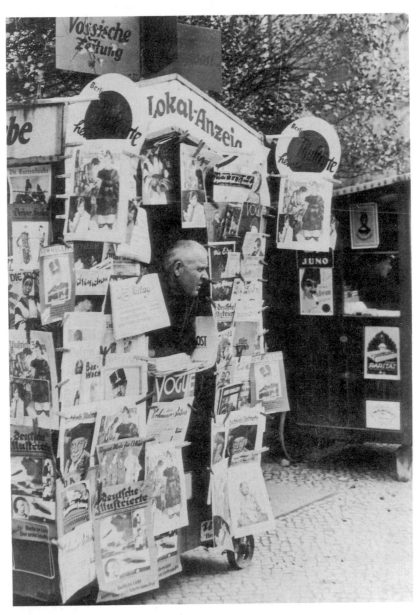

Friedrich Seidenstücker, "Zeitschriftenstand in der Schöneberger Hauptstraße" (Newspaper Kiosk on Schoneberg Street). Courtesy of Bildarchiv Preussischer Kulturbesitz.

Fragments of Flanerie

HESSEL'S last texts about the Weimar Republic and Nazi Germany, gathered from his later walks in Berlin and eventual transit into exile, move along the borders of established forms and beyond fixed genres. In so doing, they extend the terrain of flanerie in Hessel's works, mapping out the margins of an even more mobile landscape. Both as a flaneur and as a writer, Hessel articulates an aesthetics that is intrinsically fragmentary, that is highly responsive to, and therefore complemented by, the consideration of fragments. Despite the pivotal importance that Hessel's writings give to the fragment, it is perhaps the very fragmentariness of these texts that may explain why they have so far been neglected by any critical regard, why they have been thought to fall outside the confines of his writing instead of at the very heart of it.[1] Formulated for accidental contexts, occasional purposes, and commercial genres, these writings include texts as preliminary and tentative as the assorted entries of his "Tagebuchnotizen" (Diary Notes), ranging from the summer of 1928 to March of 1932. These fragmentary notes reflect the intimate background of the times by recording Hessel's conversations with Benjamin as well as his encounters with Kracauer and other contemporaries. Other writings convey a sense of finality and finitude. Taking leave of Weimar Germany, Hessel's text about his "Letzte Heimkehr nach Paris" (Last Return to Paris) describes a final homecoming that involves his leaving behind the city that has by then become Nazi Berlin. Regardless of their differences, however, all these writings come across as everyday and tenuous documents, traces of a journalistic practice that finds itself reflected in book reviews and literary journals, in contributions that suggest a mind strolling across the publishing market of literature.

One of these texts explicitly appears as an excursion and exercise in the appreciation of images and idols: Hessel's short, phantasmatic portrait of an imaginary "Marlene Dietrich." Less a study of her films than an homage to the woman in progress, it suggests a reading of the cinematic medium in terms of one of its stars. In particular, Hessel approaches and appreciates Dietrich with a gaze of flanerie that views woman as a passing, transient image. Hessel provides another measure of this gaze in a piece of writing that has never been discussed, or even mentioned, in any critical form or context. An advertising supplement to the Weimar weekly *Die Literarische Welt*, this little text introduces the books of the 1930 Christmas season's sales. Perhaps Hessel's most commercial and thoroughly commodified enterprise, it describes and enacts a

flanerie that enters entirely into the service of advertising: subscribing to its rules by displaying images, he continues to observe them through the eyes of a flaneur. Literalizing the latent affinities among flanerie, capitalism, and prostitution, this process also reverses and redefines its limits: if an advertising tour into the German publishing market is elevated to the status of flanerie, flanerie at the same time re-enters a world of literary purpose. It is this very juncture that marks the overall aim of Hessel's literary productions: to engage and proclaim the stroll as the metatext of his writing. This mode of writing works in the ways of *Reklame*: to reclaim and advertise the many facets and angles of exterior reality.

STELLAR EXCURSUS

Hessel's short study *Marlene Dietrich* (1931) seeks to give us a glimpse of the life of a new star in the new medium of images.[2] Written as a forty-page homage to the feminine icon of his times, the text can be read in relation to the wave of contemporary adulation and enthusiasm engulfing this emerging star of the cinema.[3] Despite its brevity, however, Hessel's text is extremely evocative. He approaches his subject as both a lover and ardent admirer. A contemporary affected by the media aura of his idol, he experiences a sense of personal identification with Dietrich and reveals this identification without even the pretext of biographical objectivity. His "biography" of Dietrich therefore reads and speaks as much of the life of its author as of that of his subject. In every one of its lines and observations, the text projects into the course of Dietrich's life the *Weltbild* of a flaneur, a childlike dreamer and artist who unfolds the images of his (her) native home in the city. Pursuing a sense of harmony and nostalgia that would grant them both a temporary refuge from the melancholy they can never really escape, Hessel throughout gives special privilege to the realm of the visual. The text reveals a libidinal investment in spaces and images that goes far beyond his immediate project. In fact Hessel's very first sentences view Dietrich not merely as "a young German" but foremost as a "child of Berlin," emphasizing her links to his own urban background in the Weimar metropolis. For the flaneur, Dietrich's image is linked inextricably to her status in cities: she has become the "film star of *Hollywood and New York*,"[4] an artist of the medium of modernity, intrinsically connected to a metropolitan identity. Dietrich's "home" is given more in the name of a city—Berlin—than by any other qualities or characteristics. Within the course of the flaneur's priorities, the names of three cities—Berlin, Hollywood, New York—come to precede the name of the woman whose biography is aligned effectively with the spatial considerations within which he situates her life.

Names and places take precedence over any psychological or narrative approaches to the subject of his biography. *Dietrich* is in fact mediated primarily

by topographies of writing. As Hessel notes, "Airplanes with her name in gigantic letters fly overheads in the U.S.A. In headlines and long columns, the American newspapers announce" the arrival of a new star. Understanding the first appearance of Dietrich's persona in her name, Hessel suggests that her identity is to be found more in announcements that are staged widely and publicly—and mostly spatially—than in her person.[5] Throughout Hessel's biography, Dietrich's life is presented as a kind of pretext for the various ways in which a public can commemorate the shared past and lost atmosphere of a city. He places her in a context that regards her qualities as "public property," a quasi-collective *Denkbild* that forms a reflective screen for communal desires. The flaneur as biographer interprets his subject primarily in terms of how she is inscribed into cities, by large letters in newspapers, and on the faces of audiences under the spell of a new star.

Hessel constructs the phantasmatic image of a "Marlene Dietrich," assembling a configuration of images whose key lies in our understanding of the flaneur's imaginary as an itinerary of suggestive stations. The desired image that he calls "The Woman One Longs For" appears to him as a *"Zauberpuppe,"* a magic doll.[6] A persona who magically motivates the dreams of her public, the eroticized star presents the secret observer of images with an obsessive and provocative presence. Nevertheless, she is perceived less as a vamp than as a woman whose "motherly" appearance can be read in her "kind" and benign aura. Here Hessel ascribes to Dietrich the very same traits of underlying innocence that have shaped his own life and writings. Again, his desire remains in character as a strangely detached and curiously undesirous one. In this way, he writes as an unstereotypically male spectator who pronounces the most seductive, commercial female image of his time to be "at once *soothingly* exciting and satisfying [*stillend*]."[7] It is not an accident that Hessel seeks to relegate Dietrich's erotic magnetism to seemingly innocent traits and involuntary gestures.[8] He stylizes Dietrich's manifest eroticism into the latent image of a mother, an image that for him is always linked to a more primordial realm of pleasures. Projecting on his subject a childlike perspective of the world, he casts upon the star the same innocent gaze that the flaneur sheds on his strolls, a gaze that names both the light of enjoyment and a pleasure in reality.

Displacing Dietrich into the world of his childhood, Hessel situates the transfigured star within the space of child's play, the realm of magic and dreams. In her presence, he says, he is once again faced with a sense of "nursery confusion and nursery orderliness."[9] Dietrich's film sets likewise appear to these childlike eyes as a theater of dolls. Viewing this theater as her most congenial stage, the flaneur gives us extensive descriptions of the *variété* ambience in *Der blaue Engel,* a film whose varieties and excess place the movie star in her—and the flaneur's—very element. Hessel reads in these "childhood pictures" an aura enhanced by a fairy-tale shine. As both the redemption of an apparent fascination with visual reality and an excavation into the hidden

objects and atmospheres of an urban childhood, Hessel's flanerie suggests that these charms could only be conveyed by a woman—and daughter of Berlin—whose experience is akin to his own: "Only a woman with a lot of redeemed childhood could do such magic" (*MD*, 7), he writes. Expressing his own sense of wonder in the face of reality, Hessel's writing here belongs to a contemporary discourse of redemption and childhood that is also shared by Benjamin, Kracauer, Bloch, and others.[10] Employing a rhetoric that both neutralizes and amplifies her sex appeal, Hessel extends his search for childlike magic to the remembrance of Dietrich's own past as well as to her present state as a mother herself. His visit to her "little daughter's playroom" draws out enchanting vignettes that linger in detailed descriptions on a doll's house, a doll's cot, a play-store, and a child's crib. Dietrich's imaginary status as mother and child at once allows Hessel's affective attractions to inhabit both a child's gaze and the objects on display. In this way, he can indulge while displacing the empathetic, latently erotic attraction that the world of the mother always holds for his life and works.

In particular, this oblique seduction yields a metaphor that explicitly reveals the flaneur's visual desire: "I have been shown a delightful piece of footage [*Filmstreifen*]: a young mother who strips the woolen coverings off her little creature, returning from the ice rink, and unbuttons her, and wherever a bit of skin is laid free, quickly kisses it" (*MD*, 17). Hessel's description of moments and images from Dietrich's life as "a delightful piece of footage," a kind of filmic imprint engraved in his perception, exhibits the cinematic metaphor that constitutes his specific mode of flanerie. Linking flanerie to filmic perception, Hessel reveals the manner in which he approaches his objects, not only in this biography. His writing works to edit an arrangement of spatial outlines and visual situations, and offers a swift change of scenes in order to situate and highlight his subject. This is why his portrait of Dietrich takes its point of departure from the material nuances and spatial contours that shape her status as a star. The flaneur's focus on places guides him through the biographical stations of Dietrich's life, identifying in her child's room the locations that circumscribed his own life as a child:

> She grew up where the Berlin West becomes Wilmersdorf and Westend, as an officer's child early on familiar with the ever-moving change of garrisons, yet always at home again in the city, whose soberly light [*hellnüchtern*] colors of day and long dusks, whose soft winter morning dawns and long summer evenings no one who was a child in Berlin ever forgets. (*MD*, 5)

Hessel weaves his biographical account of Dietrich with autobiographical reminiscences of his own life in the "Berlin West." He too feels "at home" in this city of muted colors and changing lights. The flaneur's travelling outlook resurfaces in the spatial configurations in which he locates Dietrich's roles in her world, that is, in the reels of film, in spheres of reality that follow the filmic

principle underlying all of Hessel's imaginary and perceptional material: "The milieu in which she moves, sleeping car, hotel lobby, hall, and bar, have something confiningly mondaine, a kind of travel elegance, an atmosphere in which she must remain the novelesque adventuress."[11] His attraction to this transience registers one of the preeminent erotic spells that Dietrich casts over the male flaneur and spectator. The obliqueness of these stimuli and effects reveals one of Hessel's most coveted visual tropes. In a striking image that is itself the title of one of her films, he writes: "The Woman One Longs For. There she is behind smoke fume and wagon window, the travelling appearance who gazes into the indefinite and whose gaze meets us at once like a calling, like destiny, changing life" (*MD*, 10). The fascination with which he explores transient phenomena, the "travelling appearance" of a woman whose movement evokes all the dangerous pleasures of an object of desire as she returns the spectator's gaze, at once uncovers the flaneur's susceptibility to erotic attraction. His sensitivity to visual phenomena, revealing an existence situated between the gaze and an image, suggests the erotic involvement of scopophilia. Describing "how the eye suddenly . . . remains lingering, captivated by one face" (*MD*, 15), Dietrich's longing observer indicates how one discrete image can emerge as the focal point of desires that are shared by "the eye" of a contemporary viewing collective.

Hessel, the flaneur and filmic spectator, likewise perceives Josef von Sternberg's *Morocco* as an erotic drama that unfolds primarily in its nuances of "bright light" and "sharp shadows." He situates the film's appeal in its capacity to evoke the tension of sensory perception in a trajectory that sends the "child of the North" to "feel [*tasten*]" her way through the "splendor of Arabic walls" and "into the stony darkness of foreign alleyways" (*MD*, 16). Lights, shadows, and their respective textures are experienced in the very distinct, tactile and visual effects they induce. The gestures, gazes, and veils of eroticism are played out as dramatically concealed alterations of visual nuance: "The drama of this love plays itself out in very slight changes on her face." Hessel records these shifting images of love in a lovingly attentive manner, reflecting closely on what it means for them to be reflected on a screen. He reads the dynamics between an image and the gaze that views it as a shifting scale of emotional and erotic experience, one that is in turn perceived as it is inscribed into surfaces and faces. This phenomenon, he tells us, is registered as a kind of visual effect: "And then new veilings and revelations of her gaze emerge from scene to scene: observing obstinacy, fear of her own passion . . . helpless abandon" (*MD*, 17). That Hessel's biography of Dietrich explicitly focuses on what can be seen, on the realm of the visual, means that we can read in Hessel's flanerie the protocols that give shape to his approach to this star, especially in her relation to the new filmic medium. It is no accident that Hessel constructs his portrait of this icon of visual dreams, this goddess of scopophilia, around a quote from a text, and not just any text but the "Paradise Poem" of

Goethe's "West-Eastern Divan,"[12] a poem that is inflected in a distinctly visual and sensual direction: "With your eyes you begin to taste. The sight already satiates you entirely" (*MD*, 13). This quote from an early classical text on the sensuality of vision captures the spirit of Hessel's approach to the newest medium of images, serving as a metapoetic epitaph for all of the flaneur's texts and perceptions.

DAILY NOTES

The focus on the visual exteriors of biography is revisited in Hessel's own "Diary Notes,"[13] another treasure-trove for a thinking of flanerie. Although it exists only in fragments, the flaneur's diary is an important supplement to Hessel's writings and walkings, recording his memories of notations and observations.[14] As a written record of past perceptions, it provides a kind of memory bank from which many of his texts of flanerie take their departure and receive their shape. As his ongoing practice of flanerie suggests, Hessel was an avid and daily note-taker of reality. "All his life," his contemporaries noted, he would carry the materials he needed to record the incessant stream of impressions that he experienced at every step. "Daily, at times hourly, he would write down" whatever it was that met his gaze: images of pedestrians, streets, signs, and any other elements of his surroundings that he encountered on his walks.[15] Helen Hessel-Grund remarks about both her husband, Hessel, and her lover, Roché: "One has never seen them without their diaries."[16] These Paris bohemians in fact lived their lives according to the protocols that Benjamin sketches for the flaneur. They translated reality into the note-books they carried with them at all times, pausing at street corners for a surface on which to place their writing papers, frequenting cafés along with libraries and bookstands, viewing all of these spaces as the haunts of their scopophilia.

Published posthumously along with his last piece of flanerie, a slim volume entitled *Letzte Heimkehr nach Paris*, Hessel's diary provides an ostensibly unsorted kaleidoscope of perceptions and encounters, fragments and findings. The diary unfolds as a sequence of written perceptions that replicate the continuity of film stock exposed to the light of photographic writing, presenting a large collection of recorded materials and images for his subsequent novels to come.[17] He enters minute notations that describe a city "heavy with Sunday," the streets of an "empty large Berlin," and a pedestrian's stroll "with Doris to the Schöneberg fairgrounds."[18] In particular, he describes his excursions to these assorted urban sites in the language of picture-taking. Linking the activity of flanerie to that of photography, Hessel even introduces his own special abbreviation—the diary repeatedly mentions his intention to go "to Kleistpark in order to photog [*photon*] old men."[19] This is to say that the primary purpose of flanerie is to take pictures, regardless of the medium through which these

pictures are taken. Whether the traces of reality are registered by the flaneur's mind, the photographer's film, or the writer's page, they are in each case filtered through an interpretation that results from the flaneur's creative sensitivity. The flaneur's processes of seeing and writing are essentially interchangeable with photography's own processes of recording. Pursuing the multiple facets of visual reality in terms of the optical dimension of his era, Hessel describes a reality that can be communicated by his eyes to his mind, by his pen on the page, or by the camera on a photographic plate.

Hessel's emphasis on the visual shines through his discussions and debates with some of the major theorists of his time. The diary is traversed by his recollections of encounters and conversations with friends and contemporaries. Whether it be a casual "tea talk with Benjamin about the collector" (*T*, 46), (a central figure of reflection for both Hessel and Benjamin), social and theoretical events accompanied by eating and dancing at Benjamin's abode (in the presence of Asja Lacis, Bernhard Reich, and others), or a detailed discussion with Kracauer about "his work on white-collar workers and the plan of a novel" (*T*, 41), Hessel always chooses to describe his surroundings as primarily a visual spectacle, one that must be beheld in images rather than comprehended in concepts. The flaneur here prefers an approach that is compatible with reflections on a given *Denkbild*, emphasizing what for him is the difference between this visible approach and mere abstract verbalization. Dedicated to describing whatever is before his eyes, Hessel's diary records the tea party at Benjamin's mainly as a succession of memorable miniatures and visual impressions, ranging from Kracauer's "strange Mongolian face" and "Frau Asja's belligerent cap," to the sight of Benjamin "on the sofa, lurking silently and somewhat bent like a reptile." In lieu of recording or analyzing the arguments of their conversation, the flaneur maintains, even from his sedentary viewing position, this focus on the physiological interpretation of their interaction. He reads these and other encounters with such eminent minds as Benjamin and Kracauer predominantly in terms of their visual dynamics; for example, his picture of the theorists is at one moment predicated on how Lacis responds to their physiologies and movements as she dances with each one of them—as Hessel would have it, "the most humanely still with me . . ." (*T*, 40).

Among these three contemporaries, all of them inclined to a reflection of images, Hessel, himself more observer and flaneur than theorist, perhaps displays the widest patience with any particular image, always letting its impressions and atmospheres stand and speak for themselves. In the eyes of some of his more explicitly, or abstractly theoretically-minded friends and critics, this predilection simply verges on a "lack." Kracauer, for example, is taken aback by Hessel's seeming inability to recall the ideas he had communicated to him in a previous encounter. In a characteristic move, Hessel explains himself with an argument that is more sincere than either simplistic or sarcastic, revealing the intrinsic workings of his visual mind: "I say that I was probably more

impressed by what he looked like than by what he said" (*T*, 41). In the course of their conversation, Kracauer comes to realize that they do indeed share a common view of the world: their fundamentally visual perspective. Reading many of Kracauer's writings and essays with particular attention for their urban details, their "Berlinian and Marseillaisian" angles, Hessel notes their shared metropolitan discourse, their experience of the melancholy and sensuality of the city.[20] Modernity's focus on cities and their images can be read particularly in the most urgent and immediate notes of Hessel's flanerie, the diary notations into which he translates his daily perceptions. The privileged relation of these notes to his other writings appears in a description of one recurring image, a scene from Parisian streets that enters the diary in stenographic form and travels into his later texts as a *Denkbild* of the future: "On Boulevard Strasbourg poster: Hermes with helmet and telephone from same silver material" (*T*, 44). Hessel records this rapid impression in an equally telegraphic notation—no verbs, no articles, all object—describing an icon of modernity as an image already mediated through advertising, that is to say, the industry that is most centrally engaged in modernity's production of visual stimuli. The flaneur recovers such images from his daily walks in the streets, retains them in his mind, and registers them in written form. In other words, the flaneur's eye captures the fleeting image travelling into and out of his diary, eventually entering some of Hessel's more evolved and elaborate texts.

PARIS REFUGE

One such text is Hessel's biographical essay "Letzte Heimkehr" (Last Return), a text that speaks of his exile and return to Paris, the classic city of flanerie.[21] Significantly, his diary image of a modern-day Hermes with helmet and telephone reappears in this text, and in fact helps him to retrieve his memories of these bygone days.[22] At the beginning of this last return to Paris, Hessel recalls his lifelong experiences as a transient, a stranger and flaneur, arriving again as "a real stranger in this city in which I had after all lived my best years" (*LH*, 14). Through the textual medium of this estrangement, Hessel continues to invoke the visual markers of the memories he revisits.[23] One of them memorializes an image from his earlier text—Hermes with the helmet—that now, at the onset of World War II, is associated with Claude, the French friend whom he had known before World War I. When this image of the diary wanders into the text of flanerie, it takes on the status of a *Denkbild* that, within the mythic world of modernity, situates Hessel's friendship within the context not only of the passage of time but also of a change in political relations.[24] In Hessel's *Letzte Heimkehr*, the intimate circuit between diary and essay gives way to some of his most immediate observations on society, some of his most outspoken political commentary to be found in this flaneur's texts. The essay is at

once the epitome and end of a flanerie whose stance is one of disinterested detachment. This final excursion to the city can no longer be purposeless when it is expressly driven by political circumstances. More flight than flanerie, it names a kind of permanent exile rather than another transient change of place.[25] But this state of "exile" has in many ways always been the "home" of flanerie. As Hessel notes, the flaneur's existence depends on his being "incognito . . . anonymous, not dependent on identity" (*LH*, 7). At the time of his last arrival in the city, both "Paris" and the concept of "*Heimat*" are contested grounds. The last return to his home in one city names a *Heimkehr* that at the same time marks his turning away, his final *Abkehr* from another former "home." Hessel's first "*Heimat*" in Berlin has become the capital of Nazi Germany, a city inhospitable to the flaneur, where the streets are filled by the movement of organized masses and the broken shop windows of anti-Semitic pogroms.[26] The epitaph that governs the expelled flaneur's *Letzte Heimkehr* to the city that he now regards as his last refuge and final "home," also speaks of this newly awakened sense of political awareness: "And *Heimat* is secret [*Geheimnis*]—not screaming [*Geschrei*]" (*LH*, 5).

If Hessel's "last return" covers even more remote realms than his previous flaneries, it pursues these new secrets and discoveries in order to distance himself from the violent streets of a Nazi Berlin. This Berlin is no longer his *heimliche* city but rather, for himself and others, a thoroughly *unheimliche* location. Hessel's outspoken opposition to the Nazis' usurpation of familiar terrain, and even the very term of his *Heimat*, structures the entire text of his departure from one home and *Heimkehr* to another. Toward the end of this text, the figure of Georg Behrendt reappears from *Der Kramladen des Glücks*, in a significant return of the flaneur's first alter ego. Behrendt's urban values cast their critical light on the Nazis' reactionary innovations, which have left their tangible marks on the streets of Berlin.[27] In this context, the flaneur seeks to redeem some of the recent processes of destruction, reconstruction, and transformation in his native city: "In these days—and also at other places where destruction took place to make space for the new, overly high buildings and overly wide marched-through streets and empty squares—something that Berlin did not actually ever have before has developed: a visible past" (*LH*, 25). As a long-time observer, the wanderer retrieves—even from a city that has displaced him violently—the sights of disappearing charms, matters, and materials that he preserves as images in his text.[28]

More explicit accounts of the changes effected by what he calls, with euphemistic sarcasm, the "new masters" of Berlin do not appear in this text. For him—and in this lies his strongest objection—these new rulers are merely "pale and theoretical" (*LH*, 23). They lack the qualities that the flaneur, who cherishes the material experience of reality, is inclined to dignify by consideration and by critique. Hessel's most outspoken criticism of the Nazi regime enters almost imperceptibly into his text: in a critique of styles and fashions,

he condemns the new ideology's reactionary rigidity. He finds this rigidity, in particular, in its defamatory uses of language. Hessel cautiously but distinctly mocks the newly forged terms of a bureaucratic and racist language: In bitter irony, he applies the Nazi neologism *Nichtarier* to himself in order to "explain" the political impositions and intrusions that prevent him from returning home to his children even in occupied Paris (*LH*, 14). If Hessel does not denounce Hitler's seizure of power outright, he still holds the Nazis answerable for their abuse of a favored term for their process of sudden occupation—as he notes, "the event that is being called so disgustingly in the jargon of journalistic technicalities an *Umbruch* [layout, radical change]." Yet, as much as Hessel resents the Nazis' redefinition of terms and territories in space and language, he prefers not to dwell on these disturbances of the present. Instead, he immerses himself in a series of reveries on the streets of Paris that render, as he suggests, "nothing of what has been recently experienced, but a lot of the past" (*LH*, 7). These reveries bring his sense of the beloved city back to him, fill him with memories of previous sights, of images that precede the recent private and political perils. This Paris remains a suggestive site for the state of perpetual flanerie evoked in the last sentences of his text: "Life—a wandering of eternal presence without yesterday and tomorrow" (*LH*, 29). His exile therefore reconciles his lifelong practices of flanerie with the myth of "wandering" that had been recently redefined as perilous for German Jews. These principles of a wandering flanerie in fact become a crucial form of survival in Hessel's work. The "art of taking a walk" turns out to be the final and formative signifier of both Hessel's writing and experience. Inspiring his life and his works, this art provides him with a principle, and a philosophy, for living and redeeming the realities of life.

URBAN REVIEWS

That Hessel's professional duties included the writing of book reviews for a number of Berlin papers reinforces his belief that he must review, report, and record in minute detail whatever is before him. These reviews incorporate his views of flanerie into everyday vignettes that extend the poetic and philosophical principles that inform his writings. As a regular reviewer for *Die Literarische Welt*, Hessel focused on texts that were in some way related to his other writings and pursuits in flanerie.[29] Given his predilection for anecdotes and city histories as well as for collections of images in photography books, we might well consider Hessel's "reviewing" activities not only as the singular result of his writing talents but also as constitutive of a genre of writing that is emblematic of his approach to all other walks and writings of life: he is a reviewer.

His reviews reveal a significant literary interest in books on Paris, ranging from histories to books of photography to French literature in translation.[30] What attracts him to this city are its multiple metropolitan layers, its many coexisting realities, its sense of the continuous "next-to-and-amongst-each-other [*Neben- und Durcheinander*]" of buildings and styles from different times.[31] The redemption of images that have "outlived" themselves transcends their transitory nature, translating them into the more permanent shape of a text of flanerie. What Hessel seeks to retrieve "Aus alten Pariser Gassen" (From Old Parisian Alleys)[32] is the experience of a primary "desire for signs, for the *enseigne*." He seeks, that is, a pictorial pleasure in the image and its texts that derives both from historical surveys and the observation of historical sites.[33] Signs and names fill in the spaces of these sites, even where not many visible traces are left to be retrieved. Hessel pursues the theoretical implications of this early semiotics of historical space by considering the street signs of a twentieth-century Berlin, suggesting that we may "read the short history of the world" in the movement "from the *enseigne* to advertising [*Reklame*]."

While the origins of Hessel's flanerie as a semiotically oriented theory of reading and writing are anchored in Paris, the first metropolis and capital of the nineteenth century, its implications travel seamlessly to Berlin, the capital of the 1920s. Hessel pursues these affinities in his passionate reviews of books on cities and the collection of their images in photographic monographs. His reviews of metropolitan photobooks closely reflect the focus and fascination of his own flanerie. As a practice, flanerie might even be defined as a literary medium for "photographing" some of the same times and places. As Hessel writes of Mario von Bucovich's collection *Berlin*, the fascination of photography—and by extension the photographic character of flanerie—lies in its capacity to "make visible an entire Berlin."[34] In one review, he understands Adolf Behne and Sasha Stone's photographic monograph as a comprehensive effort—involving both a writer and a photographer—to render their *Berlin in Bildern*, and Hessel praises the ways in which they "enter into the heart of the city."[35] Their collection focuses on those spheres of attention around which Hessel's works are so often organized: architecture and atmosphere, history and modernity. According to Hessel, Behne and Stone represent the full range of the city's often contradictory dimensions and extensions. Focusing on its avenues and places of public transit, they suggest the means by which "the oldest house, the oldest courtway take turns with the youngest train station, sports forum, and the Avus," the most modern freeway and automobile racetrack of Berlin's recent tempo.

In another aspect of Hessel's engagement with the city, he displays an often overlooked yet characteristic passion for the public implications of architecture. His review of Werner Hegemann's *Das steinerne Berlin*, entitled "Die größte Mietskasernenstadt der Welt" (The World's Largest City of Tenement

Houses),[36] shares both the book's subtitle and its social concerns. He recognizes the political agenda of the urban housing project as his own. Hegemann's architectural critique in fact serves as an impetus for Hessel to reformulate some of his own previous "horror of the city [*Großstadtgrausen*]," a state of critical anxiety that the flaneur experiences in the architectural malfunctions and misconstructions that he encounters at every step: "We children of the city, with all the trouble that we go through to inhabit our city as intensely as possible, experience in many parts of Berlin a feeling of emptiness, a terror vacui [sic]." Here flanerie returns as a means to live with and within urban spaces, a way to inhabit the city, to be at home in its streets. This sense of familiarity and closeness would facilitate, for Hessel, both discovery and critique. Hessel's complex and differentiated perspective here paves the way for another critical insight—the observer's passionate and constructive involvement with the city's architecture: "Hegemann has a memorable kind of polemics. What he criticizes becomes not simply deplorable, but exciting, he makes the reader a contemporary of all those who have sinned against the city; he argues about every stone, and the reader argues with him."

The rhetorical process that such an urban critique involves—looking and arguing, both implicit processes of reading—replicates the textual strategies underlying Hessel's excursions through the city. He ascribes this attentiveness to Hegemann's text as well: "The author does not leave the reader behind, tired, timid, but in a [state of] angry 'quand même,' he activates our critical insight." A critical reader of structures, Hessel finds himself susceptible to Hegemann's dream of utopian "wish cities,"[37] imaginative *Wunschstädte* that would arise and stand up against "stupid speculation, against senseless waste of space, against all the highly bourgeois and pretentious [*hochherrschaftliche*]" constructions that prevent a wider access to all aspects of reality. Hessel conflates this utopian, that is, political stance with a declaration that invokes the positions of his own flanerie. He notes that even "as a layman, as a viewer who observes the city by way of flanerie [*flanierender Stadtbetrachter*], as a spectator who only enjoys the picturesque quality of the historical, he suddenly [has] the feeling: . . . Tua res agitur!" Recognizing the city as both the most intimate and public matter that concerns him, Hessel does not leave Hegemann's written city without a renewed sense of the political implications of his own commitment to the place that he traverses every day and night. Recalling his own stance as a flaneur, he writes: "The contemplative reader is being politicized."[38] Hessel's reviews of a Berlin cast in stone or encountered in literature and photography finally suggest, if ever so ironically, that the intention of both his viewing flaneries and his reviewing readings may be "to set out . . . to improve the world, and for the time being in Berlin first [*zuerst einmal Berlin*]."

This affinity between flanerie and reading locates Hessel's excursions to the city in the interstices between perception and action. Flanerie is understood to

mediate between poetics and criticism within, but also beyond, the confines of critique and contemplation. This understanding is evident everywhere in Hessel's reviews of "written" literature—reviews that are themselves flaneuristic journeys through language—extending from marginal affinities to wider metapoetic implications. Some measure of flanerie in fact accompanies Hessel's judgment of all "literary" texts.[39] If the space of Arthur Schnitzler's novel *Flucht in die Finsternis* strikes Hessel as familiar terrain—as a text populated by a "wanderer toward death" and furnished with the "streets and rooms of hometown Vienna"[40]—the flaneur reserves his highest praise for Georg Hermann's *November achtzehn* which demonstrates an affinity with flanerie when it encourages us to "saunter [*spintisieren*] along the streets and, in passing the past and present, read [*ablesen*] the strange destinies of others and of one's own life from the cityscape."[41] These analogies enable Hessel to speak of his own writing as a mode of reverie related to the process of reading.[42] Linked to the underlying poetics of flanerie, these textual metaphors find one of their most succinct expressions in an homage to Knut Hamsun on the first page of *Die Literarische Welt*. Among the many literary responses, we find the following praise by Hessel: "So we thank him whose books have this *sacred epic slowness*."[43] The high regard in which Hessel holds this leisurely pace of walking, in writing books as well as in reading reality, becomes the most precious way that he can celebrate another author's work. The practice of an "epic slowness," revered by the reflective flaneur, figures as one of the most eminent literary modes and achievements of Hessel's work.

FLANERIE ON THE MARKET

A related principle is at work in one of Hessel's extended articles for *Die Literarische Welt*, perhaps his most commercial project yet at the same time his most original piece of reviewing. Although this review presents Hessel's most extensive text of journalistic writing, his most widely circulated prose piece, it is also his least known and critically most overlooked work. It has not even been mentioned, let alone discussed, in any of the existing critical accounts of his writings.[44] Under the mockingly baroque, yet seriously indulgent title "Des deutschen Buches kurioser Tändel-Markt" (The German Book's Curious Trade-Market),[45] incorporated in an advertising supplement for the 1930 Christmas edition of *Die Literarische Welt*, Hessel's review is a commercial tour de force, a literary junkstore, and source of diverse pleasures—that is, a form of flanerie directed toward the explicit purposes of selling rather than a purpose-free form of window-shopping. Identifying itself as an excursion into the realm of capitalism, whose destinations are those of marketing and advertising, this review indulges its flaneuristic predilection to an extreme. The task of appraising texts as commodities paradoxically turns into the aimless but

dedicated celebration of an art of purpose-free pursuits. The flaneur goes to the market and returns by way of literature, packaging a wide-ranging survey of German publishing houses and their seasonal offerings in the guise of an extended stroll across a commercial landscape of books. As the flaneur revisits one of his main haunts in life and literature—the unlimited resources of the fairground—the reviewer introduces himself as a guide through the commercial fairylands of a bookfair, "a fairground meadow [on which] the gentlemen publishers have set up their booths."[46] These fictional stations in the reader's mind stand in for and offer to sell the products of their publishing "houses." Hessel joins this metaphor of the fairground with the markers of an explicitly discursive immediacy: "The meadow represents the German lands. *Here* in the North-Eastern middleground is *our* linen Berlin. *Here* we are *already* at the Fischer hut."[47]

Such discursive signs of the here and now are the rhetorical gesture of a highly engaged reviewer of his environs, one who fuses the advertising style of a modern salesman with the rhetorical conventions of his own flanerie's visual fairground. Hessel pauses along the many stations of what he calls "our tour [*Rundgang*]," in order to pose as an advertiser and salesman who, facing the display booths, draws in his audience with the most immediate and appellative forms of address: "Come in [*Hereinspaziert!*] Ladies and Gentlemen! Here Knut Hamsun shows . . . the lightweight *August Weltsegler* in a boxing fight against heavyweight sedentariness" (*TM*, 27). This short sample from a stream of attractions demonstrates the extent to which Hessel favors the haunts and processes of flanerie even in this seemingly prescribed and circumscribed piece of work. Commissioned to advertise and announce his appraisals of books, Hessel still registers his pleasure in texts through a series of metaphors of motion, mobility, and travel—in terms, that is, of a passage through time and space that traverses all of his writings. While the copy writer might have little choice in the material that the commercialism of his trade prescribes, these metaphors belong to the flaneur. Privileging the circuitous processes of flanerie even in commercially focused transactions allows him aesthetically to transcend the business imposed on him. In this way, he exhibits a critical awareness of the relation between the flaneur's focus on the appearance of commodities and the rules of their display in the commercial transactions of modernity.

The link between explicit commercialism and Hessel's discursive address of his reader facilitates a greater engagement with contemporary political issues than in Hessel's previous work, where any direct political critique seemed at best submerged. On the occasion of a "German book's curious trade-market," two winters before Hitler's ascent, even the flaneur feels compelled to take the reader on an imaginary walk, guiding him by a pedagogical but nearly invisible rhetorical hand: "We walk a piece of sandy path, which means the high- and the subway, and so we come into Passauer Straße. There is pushing and shoving in front of a booth. The customers seem to have a fight—the

German term *Händel* calls for both pushing and fighting—among them."[48] Directing and presenting this small part of a larger German fairground, Hessel calls forth a benevolent Ernst Rowohlt to mollify this public unrest. The mighty publisher proceeds to appraise the multiplicity of offerings for a community of buyers who are increasingly fractured across the political spectrum. The divisions within this community signal not only a commercial multitude but indeed, as Hessel notes in an amazingly explicit appeal, an ideal of political plurality and tolerance:

> Just be quiet, gentlemen, at my [store] there is something for everyone. . . . You, young man in the brown shirt with the swastika, here, have the Messiah . . . who wants to bring about the realm [*Reich*] of god on earth, just as you do the Third Reich. He will certainly become sympathetic to you, and you will learn much from his fate for your own future.[49]

Hessel has his publisher Rowohlt hawk other goods to other constituencies as well: an imposing volume to the "venerable senior editor of the state party," a provocative pamphlet to the "young communist gentlemen," and, taking a decidedly revolutionary stance, a text that "like you, shook the state." This passage provides the most explicit acknowledgement in Hessel's writings of the necessity to address the forces of National Socialism, which will soon come to dominate the streets. Even though the flaneur's tone remains benevolent, he does not disguise his ridicule when he peddles a blatantly religious text to the new Nazi. Even as he seems to address the man in the brown shirt with the swastika as an equal to other political customers, he never conceals his ominous warning about the impending future. If, on the one hand, Hessel still resorts to the harmonious vision of political tolerance and benevolence that he exhibits throughout his essays—as when he exhorts passersby of his curious book market to "Just come all in to me, from your different camps, make a small private *Reichstag* of all the living"—on the other hand, he demonstrates an awareness of those constituencies of the public that might wish to violate such high-spirited, equal-minded solidarity. Calling our attention to these emerging forces of intolerance and barbarism, Hessel's "salesman" goes about his business in this "commercial text" in a more politically direct fashion than he does in preceding works.

Under the guise of an advertising guide who hustles his clients through a literal terrain of literary commodities, he encourages his readers to buy a bold, last-minute change of political direction: "Stay here, do not travel to Bavaria, do not go to a Hitler meeting: Do read Lion Feuchtwanger's *Erfolg* first." Hessel advertises a critical novel by a Jewish author who will become one of the first to be driven into permanent exile by the Nazis. If the wares and commodities that Hessel seeks to sell seem bookish, this is only at first sight. They soon assume an amazing currency beyond their immediate literary character, turning into the conditions for vital choices and deals that may determine a

nation's future in the political exchanges of the time. Hessel here advocates a political engagement that does not hide its active and provocative opposition to the prevailing developments of the early 1930s: "Hey, you Brownshirts, what would you say if one would arrest one of you, without saying why, here on the spot?" Pretending to recommend a companion reader, the reviewer of his time calls on the possible Nazi population in the market to come forward, to consider and to "discuss" their threatening actions. Unless they do so, he suggests, they will indeed—regrettably not heeding the *Literarische Welt*—continue to commit the increasingly intolerant and illiterate brutalities of which he warns them.

Still, despite its unmistakable political engagement, Hessel's review does not pursue its implications to the end. It often seems content to regard the political realm with an eye bent on harmony, irony, and balance, as a realm that is only one aspect of a larger world predominantly composed of images and texts that are to be experienced in their uniqueness, and for the sake of experience alone. If books are presented as part of a stroll through the real world, this real world is viewed as an assortment of texts that can and must be perceived as such. If Hessel never really assigns the realm of political messages any clear privilege, it is because his priorities will always follow his lifelong passions, the pleasures of slowness and quietude among an accelerating political process. Books for Hessel are enough to encapsulate the essence of reality as he sees it in his strolls: "Novels. The element of reality is contained in them," he remarks, walking through a public political reality that he reinvents as a market of literature. This high regard for both movement and books—that is, for reading in general—is central to Hessel's version of flanerie, one that remains a fabric of textual and spatial metaphors. Addressing the contemporary readers that he takes along on his imaginary trip—"we book-meadow-wanderers [*Buchwiesenwanderer*]"[50]—he offers a neologism that indicates his overall approach. "Bookwalking" names an aesthetics of flanerie that asks us to remain "wandering" and "reading" in regard to the spaces and times in which we live. The flaneur's understanding of a text leads his readers along minute, open-ended excursions through society and its exteriors, imaginary strolls that reveal the significance of the margins and the transience of the everyday.

This significant Weimar mode of accessing the public sphere in a critical fashion—recalling writings of the *Denkbild*, the essay, and the fragment—informs all of Hessel's work.[51] It is no surprise that one of his advertisements pays homage to the way in which this mode of critical thinking appears in one of his friend Alfred Polgar's titles.[52] Polgar's text, he says, evokes a movement of *Gedankenspaziergänge*, "thought strolls" or thinking walks, strolls conducted in the mind or walks traversed by reflection. Within this wider context of writing—a context that includes the intricately related metaphors of text, space, and movement—Hessel uses a colloquial phrase toward the end of his essay that deliberately positions the reader within this same process of

thinking: "Alright, now continue right on *in the text*. . . ."[53] Hessel encourages his readers to continue reading within and beyond the textual system to which they belong, defining the transition to new forms of writings as the condition for new experiences.[54] The goals of flanerie demand that we become reporters of the everyday, readers who are acutely aware of the textuality of life, and writers who wish to record everything around them. The realization of these goals would bring the textual metaphors and theories of flanerie to life, setting them in motion, and thereby opening up the possibility of changes in reality and its perception. The ultimate destination of this theory of flanerie and its philosophy of life is to redeem the images of the world in the words of its time, to respect the shifting differences of each unique, tenuous, and transitory text.

Preserving the experience of seeing in writing, the flaneur encourages his readers to revive their passions, and thereby to pass from a state of paralysis to one of awareness. This is why Hessel concludes his stroll through the market of books with an ironic eulogy that is passed on with only seemingly disrespectful light-handedness: "Books are a passing of time and of pain [*Zeitvertreib und Leidvertreib*]. Books don't take up much space and yet they are the most beautiful decorations in rooms. . . . They last longer than gingersnaps [*Pfeffernüsse*] and liquor, friendship and love." In this slightly facetious appraisal of the season's most desirable gifts, books offer everything that Hessel wishes to gain from his flanerie: a visual sensitivity to the sense of "decoration" within reality. This sensitivity does not require much "space" since it comes with a moveable frame of mind, one that is carried away with one's eyes at every step. His flanerie through the assorted texts of the world overcomes boredom—*Zeitvertreib*—and offers a temporary antidote to melancholy—*Leidvertreib*. Adding "sugar" to daily routines and "spicing" up his sense of experience, it simulates the savory sweetness of *Pfeffernüsse* and stimulates an intoxicating view of the world. The art of redeemed experience in Hessel's writings, flanerie emerges as a way of life that accompanies the flaneur through time, giving him a perspective more reliably comforting and more consistently exhilarating than either "friendship" or "love." That is to say, the texts of flanerie provide the flaneur with not only everything that "friendship" and "love" would offer but also the means to preserve, collect, and present these pleasures between the covers of a series of readings.

Part Three

FLANERIE AND FILM

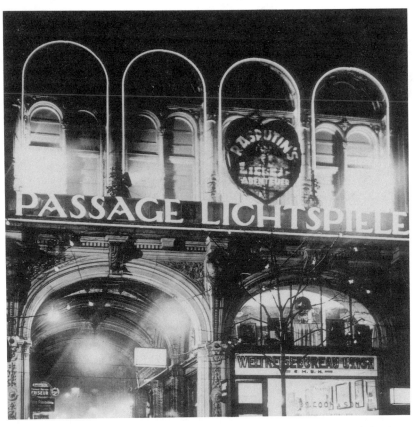

Anonymous press photo, "Lichtspiele" (Light Plays, or Effects of Light, i.e., Movies). Courtesy of Landesbildstelle Berlin.

A Short Phenomenology of Flanerie

THE FOLLOWING reflections seek to inscribe the phenomenon of flanerie within a more extended excursion into the modern debate on visuality. Pursuing a passage of thought that requires them to assume a range of disciplines, they also exhibit a certain ambulatory quality that corresponds to the figure they seek to discern. In order to outline the cultural contours of the flaneur more closely, we might begin by describing the possibility of an observer and witness of modernity. To speak of the flaneur, as Jonathan Crary explains, attempting to position the modern observer in general, would mean "to delineate an observing subject who was both a product of and at the same time constitutive of modernity."[1] Suggesting that this "observation" is the signature of modernity, Crary locates the beginnings of this perspective in the first half of the nineteenth century, an era characterized not only by its "uprooting of vision" but also by a new "valuation of visual experience [that is] given an unprecedented mobility and exchangeability."[2] This renewed valorization of vision and visual experience can be said to characterize the flaneur's existence. How can we delineate more closely the specificity of a "modernity" that mobilizes its observers in such a way as to multiply their gazes and thereby facilitate new approaches to viewing reality? To trace this perspective in relation to the modern observer-subject—to the flaneur—requires a view of this figure that situates its visual perspective in relation to other spheres and perspectives of his time.

One early definition of modernity that allows us to chart the multiperspectivism at work in the territories of flanerie may be found in Nietzsche's writings. In a passage entitled "Modernity" in his *Will to Power*, Nietzsche suggests that "modernity" is characterized above all by an omnipresent sense of multiplication and differentiation. He speaks of an immense increase in the overall "irritability" displayed by the senses and sensitivities of its subjects, an increased sensibility that is produced by a "greater than ever abundance of disparate impressions."[3] Nietzsche links the signs of this increase to the multiplicity and velocity of the stimuli encountered. This multitude, he suggests, is accompanied by a noticeable decrease in the quality of the responses it elicits, leading to a "profound weakening of spontaneity" in the subjects exposed to this altered and shifting world. Nietzsche then names a series of subjects whose types are not only being produced by this new world but are also marked by its "modernity": "the historian, the critic, the analyst, the interpreter, the observer,

the collector, the reader," a delineation of subject positions that are remarkably similar to the figures later associated with the flaneur.

Mapping these positions onto Hessel's sensitivity and writings, for example, the flaneur emerges as a "historian" of his particular *Heimat*, a reflective "critic" of his city, a close "analyst" of its architecture, a "collector" of scenes and images, and an "interpreter" who translates these impressions into his text. Above all, he is an all-encompassing "observer" of modernity, a "reader" who is intent upon deciphering carefully and imaginatively every phenomenon that comes his way. If we extend the notion of a text, we can describe this man of the streets in terms of characteristics that are not immediately related to visual spheres but to verbal ones. He arrives in modernity as a collector of images and scenes, but he is also a reader who views reality as a text, an interpreter of signs who transforms visual stimuli into verbal style.[4] To the extent that all of these fields of experience share characteristics that are informed by a sense of flanerie—and vice versa—they serve to anchor their respective phenomena in this primary sensitivity of modernity. Nietzsche defines the characteristic qualities of these modern personae as distinctly *"reactive* talents" (emphasis in original), exhibited by men—and women—in modernity who are surrounded by its stimuli even as they do not exert a decisive influence on the action of their time. Their attentive yet not explicitly active engagement resembles the flaneur's inclination to "look but not touch," to see everything without partaking actively in anything. Nietzsche's notes on modernity are as suggestive of this stance as they remain sketchy in detailed definition, proceeding in a manner that mirrors the process of flanerie as much as it circumscribes its principles. But the categories that Nietzsche outlines are particularly apt for distinguishing the flaneur from other modern contemporaries: the transformation of "one's nature into a mirror," for example, characterizes the flaneur's stance as an observer who reflects the world around him. Like the photographer, this man of vision can be described by what Nietzsche calls a "coolness of principle, a balance" that associates his detached gaze to the sociologist who gathers and analyzes the scenes of society. Finally, Nietzsche ascribes to this collector of impressions the fundamental principle of an "external mobility" that describes the flaneur's moves as distinctly as it evokes another phenomenon of modernity: the emergence of tourism and commercial mass mobility.

Linking the physiognomy of modernity to this Nietzschean lineage of modern types, I wish to read this series of modern figures with an eye toward distinguishing them from, and relating them to, the activity of flanerie at work within each one of these constellations. The close affinities between these modern types and the flaneur suggest the flaneur's pivotal position in modernity even as they call for a differentiating perspective. In what way does the course of flanerie intersect with, yet diverge from, these other avenues of modernity? How does the flaneur participate in, yet differentiate himself from, other sub-

ject positions of modernity, such as those of the tourist and the consumer, the sociologist and the photographer? If modernity is defined above all as an era that mobilizes its subjects, a time that is predicated on increasing circulation and making "exchangeable what is singular,"[5] it is no accident that such characteristics can be understood in relation to a type that is defined by movement— which, in its most organized circulation and institutional exchange, results in the modern mass movement of tourism. At the same time, these assembled criteria of modernity—mobility and circulation, the increased awareness and exchanges of experience—together define flanerie as a process in the modern world. In what ways can flanerie be regarded as a forerunner of tourism, and at what point do these two movements take separate directions? The most pervasive form of organized mobility—propagating both the circulation of its subjects and the consumption of experience within modern capitalism—tourism presents itself as a pivotal feature of modernity. As Dean MacCannell asserts in his study of the phenomenon: "There is no other widespread movement universally regarded as essentially modern."[6] In many accounts of tourism, flanerie is regarded as an earlier emanation of this mobility. For example, John Urry's study of tourism states the genealogy in the following way: "The strolling *flâneur* was a forerunner of the twentieth-century tourist."[7]

In looking beyond the moment of their movement through the public spaces of modernity, both the flaneur and the tourist establish their presence in these spaces in specific ways. The ways in which each registers and records these spaces exhibit distinctive processes for the seeing and collecting of images. Although the image brings both the tourist and the flaneur into the public realm, they differ in their response to the abundance of images shaping modern reality. MacCannell emphasizes the visual dimension of tourism when he defines "sightseeing as a modern ritual," as a characteristic that originates from the "collective sense that certain sights must be seen."[8] While the rise of tourism in modernity does have relays with the flaneur's sense that vision is the primary and privileged focus of his time, this focus also points to some of the fundamental diversities between the tourist's and the flaneur's point of view. Unlike tourism, flanerie is not based on an intersubjective agreement, a "collective" sense that certain "sights" should be regarded as more "worthy" of perception than others. Mocking the organized sightseers in his city, Hessel suggests that the flaneur seeks out neither predetermined sights nor professional guidance, but instead goes after the immediate process of seeing itself. The flaneur's effort to distance himself from what is all-too-accessible, a stance apparent in Hessel's protestations of a touristic *"Rundfahrt,"* can also be read in Susan Sontag's refusal to equate his position with that of the tourist: "The flaneur is not attracted to the city's official realities but to its dark seamy corners, its neglected populations."[9] While her statement distances the flaneur's fascination from the "official sights" of tourism, it too quickly encloses the flaneur's presumed point of view again within the city's blind spots and "dark

corners." Nevertheless, if the flaneur would indeed choose to ignore any aspect of the city, it would certainly be those sights specifically prepared for tourism. Yet Hessel scans even these locations for redeeming aspects by turning his gaze on the very spectacle of the tourists themselves, suggesting in his ironic recommendation that we view the sightseers themselves as occasional "sights" in their own right.[10]

Flanerie's signature therefore can be read in a critical reversal of the gaze that significantly distinguishes its approaches from those of tourism: the flaneur digresses from guided and packaged tours by pursuing his solitary walks away from prescribed routes and along unpredictable avenues, continuously aware of the distinct reflective processes of his perception. The flaneur's discursive reflection sets him apart from the touristic consumption of prepackaged sensations and images.[11] The flaneur distinguishes himself—or herself—from this scenario of passive tourism as a figure who not only pursues her impulse toward drifting, but also feels compelled to retrieve these urban images in her mind, reflect on the impressions encountered, and seek to preserve them in a writing of letters or light, on either celluloid or the page. Flanerie moves according to this impulse to write, register, and redeem what has been seen. MacCannell attempts to redefine the dichotomies between the tourist's gaze and a different, more encompassing visual sensibility, by ascribing an expanded definition of "tourism" to more liminal, marginal ways of looking that display sensitivities characteristic of "flanerie." Among these alternate forms of tourism, MacCannell includes "people watching" and the activity of looking at "almost anything that is moving—[even] a scrap of paper blown by the wind."[12] These nuances of scopophilia, these cinematic sensitivities embrace the very sensations of flanerie. In consonance with this more permeable concept of tourism, MacCannell also recognizes capacities of critical reflection that we might link to flanerie: "Sightseeing is . . . a way of attempting to overcome the discontinuity of modernity," he writes, "of incorporating its fragments into unified experience."[13] As a predetermined and packaged product for consumers, the sightseeing of tourism encapsulates the totality of this approach. At the point, however, when it begins to exceed these prefabricated visions in order to reflect on and record its ensuing views in its own texts, the experience of this form of "tourism" would indeed stray far enough from prescribed routes of travel to approximate the art of flanerie.

To distinguish between the predominant touristic consumption of sites and a reflective, creative response to the sights of modernity would be to distinguish between "tourism" and "flanerie."[14] While the specularity of flanerie has relays with its emergent consumption in the phenomenon of tourism, other differences accentuate the distance between these two realms of modern cultural experience. As tourists may also choose to stroll, even under the constraints of maximizing the time and money of a packaged tour, such decidedly aimless and deliberately wasteful forms of movement could describe the flaneur's very

existence. As a traveller of preferably "local terrains," the flaneur chooses for his explorations the sites of culture that are closest at hand, that can come to mind at any given point in time. While tourism "necessarily involves . . . different experiences from those normally encountered in everyday life,"[15] John Urry observes, flanerie is predicated on "everyday" experiences that deliver the perceptual raw material of this curious, urban traveller's particular way of "daydreaming."[16] These limitations on the sphere of flanerie increase the degree of respect that he exhibits toward the processes of seeing, the infinite attention that he directs toward the singular, minute perceptions that come his way.[17] The flaneur's response to the stimuli of the exterior world suggests a degree of creativity and reaction that lends this perspective a subjective and potentially resistant dimension: It brings to the flaneur's seemingly passive stance an active refusal of the rituals of consumption that define the tourist's identity. In contrast to Urry's claim that the activity of "universalising the tourist's gaze . . . is intrinsically part of contemporary experience, of postmodernism,"[18] the flaneur's insistence on his own vision and on the preservation of this vision in his own text marks the difference of his modern perspective. While postmodern "daydreaming" may be "socially organised,"[19] the flaneur's form of idiosyncratic daydreaming seeks to organize his social experience and perception into a design of his own remembrance, one that would resist social organization in order to rework collective daydreams into the textual reveries of individual perception. We can even say that the transitory quality that links the social sphere with an observing and collecting mind also traces the ways in which Benjamin conceives an imaginary awakening from the dream-state of capitalism.

The flaneur pursues moments of reflection, comment, and critique that together serve to distinguish the touristic consumer from what Urry calls the "post-shoppers"—consumers who, transcending this role and thereby following the model first suggested by the flaneur, "assert their independence from the mall developers."[20] On the other hand, expanding the phenomenon of flanerie to include any moving shopper who finds himself bombarded by predictable stimuli, rendered homogenous in a consuming crowd and ultimately silenced into merely economic responses to his environment, would reduce the highly differentiated, distinctly intellectual phenomenon of flanerie to a rather "flat-footed," indeed pedestrian, notion.[21] Rather than conflating the process of flanerie with an undifferentiated state of mindless gazing—for example, the total consumption of images through remote control, or through preordained paths of relaxation in planned communities and suburban malls—the phenomenon of Weimar flanerie may be linked to a different visual phenomenon of modernity. Flanerie is as much about indiscriminate consumption as it is about movement that remains unreflected. Its focus on the perception of images redirects the emphasis on the flaneur's gaze to the scenes of his perception. Beyond defining the movement of flanerie exclusively as an incessant perambulation

through a moving scene of bodily images, we could say that it highlights the very movement that is pursued by the viewer's eyes, to the point of limiting the process to that of the perceptual apparatus alone.

This move names the flaneuristic transit between literal acts of walking and extended movements of the eye. The flaneur's gaze is perhaps the only factor moving within this scene of observation. Detached from the body that traditionally transports this mobile gaze, its attention is directed primarily toward the spectacle that presents itself as a kind of motion in the world. Within the context of film theory, we might assert a certain equivalence between the stationary gaze directed toward a spectacle and the mobilized specularity of the gaze—a dialectical dynamic that describes the actions of the camera that sets out to capture the life of modernity. The medium that reflects modernity in its images acts as a technological double of the flaneur's presence when, as film theorist Yvette Biro explains, it "penetrates" one space or "mingles" with others, "capriciously lingering here or there, then rushing on . . . because movement and the throbbing beat describe this life no less than stationary spectacles."[22] As long as an object or subject of vision is in motion, undergoing constant change and shifting configurations, the flaneuristic gaze emerges in any movement of the feet or eyes that potentially enables perception, that works as a medium in the act of recording. Its activities are directed toward the public spectacle in which the flaneur—occasionally an exceptionally alert, curious, and sensitive "tourist"—may pursue the search for knowledge that MacCannell describes as its ultimate destination: "Although the tourist need not be consciously aware of this, the thing he goes to see is society and its works."[23]

The Weimar flaneur who goes in search of the reflections of his city certainly seeks the images of his society and its workings. While his movement may slow down almost to the point of transforming him into a stationary observer of the spectacle moving all around him, this modern spectator moves toward a sphere of theoretical activities and affinities that seek to "gaze upon and collect signs."[24] Such critical analysis of the public sphere renders the peripatetic viewer an ambulatory student and an—at times rambling—theorist of social processes, a reading-and-writing flaneur who displays a frame of mind that is not surprisingly linked to related fields in the social sciences. As an observer who finds himself arrested by the sights surrounding him, the flaneur occupies a position of observation that is not immediately apparent and accessible to the crowds around him, blinded as they are by other business and occupations. Flanerie also opens an ongoing sphere of more stationary reflections, a degree of theoretical scrutiny that moves the flaneur away from the hectic business of tourism toward more theoretical fields of observation. MacCannell suggests that these diverging approaches are intrinsically linked extremes: "The twentieth century has made both a science (sociology) and a recreation (tourism)"[25] of the study of society. Defining a movement that casts

its gaze upon society's most spectacular and photogenic spaces and institutions, he suggests that, keeping its eye on "the visible, public representations of social structure found in public places,"[26] it also focuses on materials that enable both "tourist attractions" and sociological analysis.

Following these modern pursuits in circuitous ways, the Weimar flaneur refers to similar images and (re)collections in the scenes and situations that he conjures as *Denkbilder* before his readers' eyes. Evoking visual sights under the specter of social analysis, he stores and holds on to the fleeting exterior images of an ever faster moving society. Similar processes also define a distinct medium of images that brings exterior reality into the cinema: both film and flanerie work to preserve these visual stimuli in a mode that Biro has named a "recording-for-posteriority,"[27] a mode of remembrance that creates an inventory of culturally significant and historically specific images. Evoking Hessel's trope for the preservation of the images of flanerie—the junk store of happiness—Foucault explicitly speaks of this impulse to record as one of the formative characteristics of modernity: "The *flâneur*, the idle, strolling spectator, is satisfied to keep his eyes open, to pay attention and to build up a 'storehouse of memories.' "[28] Within the context of her cinematic perspective, Biro repeats this construction by describing, in strikingly similar terms, the means whereby the filmic medium preserves its images, means that we can now associate with the activity of flanerie. The medium houses and constructs, she says, "a curious museum [in which] not only the props and the objectified memories of the human comedy are amassed . . . but also the action itself as it all happened, in the lively process of change."[29]

To the recording eye of the stationary observer or the slowly moving stroller, the city is an exterior landscape to be explored in a sequence of seeing. The line of sights immerses him within the succession of life as it unfolds in the city, detailing structures and constellations that are the foundational matter of the flaneur's *Denkbild*. These materials provide the offerings of tourism and supply the sources for social and psychological investigations. Both the literary excursions of flanerie and the observations of metropolitan sociology take their point of departure from similar spheres and phenomena: the social spaces of modernity, in particular those of the city, figure as the privileged locales of film and flanerie even as they are also scrutinized extensively by the modern sciences of sociology. These spaces of society—frequently visited by both the sociologist and the flaneur—provide "a panoramic view of a modern arena of leisure and public contacts, and *how it functions*."[30] Films that pursue this exterior orientation with the gaze of flanerie exhibit a fundamental "predilection for heroes from the ranks of marginal people," as Biro would have it (*PM*, 71) an impulse to investigate every realm and level of society, including the most neglected ones. This scrutiny of the ways in which society functions works according to the logic of a sociological gaze, a logic linked to the sense of curiosity that drives the flaneur to his favorite haunts.

A WALKING CURE

Such an inquiry has not only exterior and spatial implications but also interior and psychological ones. The close and detailed observations of events and phenomena, along with the means of recording them, can be understood in terms of the psychoanalytic process. The activity of observing and describing the inner states of the mind may indeed serve to alleviate the psyches of modern subjects from an overload of both perception and introspection, thereby enabling a sensitivity toward the multiple possibilities of the exterior world. As a means of eluding the melancholic's state of mind, flanerie induces an approach to writing whose emphasis on detail replicates—much as it resembles a sociological log—the therapeutic records and ongoing diaries that Freud suggests his patients keep in order to gain access to, and establish the traces of, the daily phenomena that move their souls. The process of flanerie repeats the formulas that psychoanalytic theory prescribes for its patients, closely following the analyst's verbatim outlines that, step by step, read like encouragements for flanerie: "Act as though, for instance, you were a traveller sitting next to the window of a railway carriage and describing to someone inside the carriage the changing views you see outside."[31] At this moment in his *Interpretation of Dreams*, Freud encourages his patients to become flaneurs of the imagination, pedestrians within the interiority of their minds. Recording the details of their observations, these exploratory writings range from feuilletonistic impressions to journalistic recordings and scientific notations. They implicitly embrace the sensitivities of the flaneur.

As a kind of "walking cure," flanerie not only facilitates psychoanalytic analysis or mobilizes sociological description. It also transgresses its society's sense of time by returning to the past and anticipating the future, by suggesting the methods and destinations of historical collection. Its modes of recording, its taking inventory of the spaces of society, lead to the collecting of vast archives of images from varying contexts, be they historical sites or contemporary scenes. The fluidity of flanerie, its capacity to capture a sense of life in its transitions, corresponds to a recent awareness of the finitude of all figures and spaces, an awareness that is registered particularly in the arts and philosophy of a postwar period.[32] We could delineate a historical description of the movements and writings of flanerie that would account for its emergence primarily in terms of the vast wartime destruction of lives and sites. These visual and material losses give way to a flaneuristic sensitivity that steps in to preserve the memory of lives and images, as traces of experience in a more persistent medium. The "return of the flaneur" that Benjamin registers in Hessel's writings, for example, emerges from out of the postwar wastelands into the Berlin of the 1920s. According to Kracauer, so does Baudelaire's own revival of flanerie in the Paris of Jacques Offenbach, whose flaneur culture emerges from

a bourgeois society in the wake of the 1870–71 war. This gaze, evident in the records of Parisian travellers, is also liberated and released after the June revolutions in 1830 and 1848, as well as after the Napoleonic wars of 1812, an era that set into motion the period of flanerie described by Heine, Börne, Donndorf, and Spazier. These writers return from catastrophe with a renewed appreciative eye, an impulse to preserve life in all of its facets, for an experience of peace within the details of the everyday. The historical constellations and psychosocial dispositions that come together here suggest that flanerie flourishes during moments of transition between equally blinded periods of historical violence. As a privileged means of looking closely at exterior reality, flanerie works to register the minute historical nature of things, taking note of the immediate material changes that shape the images, sights, and spaces of society. Its open curiosity for every phenomenon that comes its way, along with its declared indifference to anything other than the sheer act of perception, renders the flaneur's perspective a perspective of testimony and reportage. The gaze of flanerie not only reveals the shape and structures of many social processes but also works to provide an inventory of its society and its imaginary spaces, of its own historical moment. Whether the orientation of these investigations is modeled on a social, historical, or psychoanalytic project, its point of departure can be located in a similar disposition, in a perspective that, as Biro notes, "calls us only for the exploration, promising no arrival."[33] Visual experience itself encapsulates the ultimate, and ultimately the only aim of these excursions. Similarly, in many of the realms charted above, one of the primary methods of approach is that of "taking pictures" of the scenes and sites that come into focus.

This emphasis on the image renders photography the shared metaphor that not only underlies the realms of tourism, sociology, and psychoanalysis but also partakes in some of the preeminent social spheres through which flanerie moves. At this intersection, photography and flanerie take parallel paths as two of the ways in which modernity receives its exteriors and experiences, in a process of seeing and recording that focuses on the surfaces and structures of their respective realities. On the other hand, both photography and tourism are also products and processes that emerge in relation to flanerie, deriving their origins from the same sense of scopophilia. This is why photography and flanerie can be considered among the distinct but related ways in which the sociologist collects his evidence. The shared affinities of the two visual media, especially in terms of their relation to reality and to the preservation of its images, suggest that we consider them as analogous dispositions. These dispositions enable us to define flanerie as a metaphorical extension of both photography and film. Flanerie in fact bears close affinities to the realms of photography and its extensions: the eye acts as both camera and pen, and its perceptions present both still photographs and moving images, visual and verbal texts. Nevertheless, in the kaleidoscope of its fleeting moments, flanerie evades, es-

capes, and extends the sum of these previously visited inscriptions. The flaneur touches on, but is not limited to, any of the isolated activities that define the tourist or sociologist, the detective or analyst.[34] He emerges as a pivotal historical figure within the modern debate on specularity, but one whose perspective exceeds the accumulation and analysis of "objective" or visual "facts." The aesthetic dimension of the flaneur's approach can be read in the quasi-photographic and filmic footage that the camera of his eyes retrieves from the world. The theoretical implications of these processes, as we will see in the following passages, resonate through many formulations of early film theory.[35] The figure of the flaneur accompanies one of the first theoretical discussions in which early modernity reflects on the seminal aesthetic shifts and visual sensitivities of its time, the so-called *Kino-Debatte* in the early twentieth century. The history of flanerie, from the nineteenth century on, runs as a subtext to the prehistory of the cinema and returns as a visual text that concurs with, and is recorded in, the texts of the *Kino-Debatte*. Conducted primarily in Berlin, the capital of the modern medium of cinematography in Weimar Germany, this "debate" represents one of the primary and pivotal manifestations of a discourse on spectatorship and scopophilia in the modern metropolis. In an ongoing but often discontinuous way, it not only revisits favored arguments, running circles around its favorite visual tropes, but it also itself pursues a form of rhetorical flanerie across a landscape of discourse in the Weimar public sphere.

AESTHETICS OF MODERNITY

Preceeding Hessel's writings and defining a cultural sphere with its "return of the flaneur," the perception experienced by modern-day flaneurs and early theoreticians of the cinema coincides in time, space, and atmosphere with the thematics and aesthetics of early film. As some of the first observers susceptible to these new phenomena, Berlin art historians and city architects such as August Endell and Wilhelm Hausenstein experience examples of visual variety, multiplication, and differentiation on their daily strolls through the city. Endell reacts to them not with familiar cultural pessimism for the crowd and its phenomena but receives them with a sensitivity in search of the visual spectacle, the display of images offered to the senses: "Sometimes on the hottest days . . . Sundays, I would go downtown, Unter den Linden, to see the grandiose return of dressed-up people . . . black hats, light men's suits, and the women's colorful glitter forming a compact and shimmering band which passes like a colorful snake."[36]

This succession of sights originates in the street, as scenes of modernity pass before the observer's eye—or flit by his perception like the sequence of images registered by a stationary camera. This scene is entirely one of visual situation and sensation, and primarily a play of light akin to the experience

and institutions—literally the *Licht-Spiele*—of early cinema. Endell goes on to say: "Everything has been poured into a wonderful light; reddish dust seems to embrace everything . . . the slowly fading buildings, just here and now struck by the sun, are shining . . . their slightly moving outlines limit and form the wide space. Against the dark grey, illuminating the distance, a few windows of the castle light up in the sun, and below flashes the shrill yellow of a postal car." The dynamics of this scene unfolds entirely in its lighting effects, with the fading atmosphere of twilight virtually enveloping all appearances to recall the tint of the sepia copies of early silent cinema. Indicative of the perception of an early flaneur, this scene turns into a cinematic site via its close affinity to the subjects of the earliest films, all of which return again and again to the reality of their times in order to display the city in light and movement. Scenes of detective-like perception, the pursuit of other pedestrians through the city, the very activities of *Leben und Treiben unter den Linden* (1897), form the first objects of filmic interest at the same time that they represent configurations of perception characteristic of flanerie.[37] Endell's city aesthetics, representing a mode of perception genuine to the flaneur, anticipates an aesthetics of the cinema while simultaneously participating in it. Hausenstein comes to perceive how the "metallically shining mirror of the asphalt reflects the thousand-fold shimmer,"[38] a visual trope that also figures prominently in the city and street films of early cinema, especially in Karl Grune's *Die Straße* (1923) or Joe May's *Asphalt* (1928). Within Endell's impressionistic aesthetics of differentiated light and color effects, "the phantastic nets of shadows of leaves stand out against the cool shimmering stones in fine and warm tones."[39] In keeping with this sequence of sensitively perceived images, the following scene also perfectly aligns itself within this succession:

> And I remember, as if it were today, the marvels themselves. What thrilled me so deeply was an ordinary suburban street, filled with lights and shadows which transfigured it. Several trees stood about, and there was in the foreground a puddle reflecting invisible house façades and a piece of the sky. Then a breeze moved the shadows, and the façades with the sky below began to waver. The trembling upper world in the dirty puddle—this image has never left me.[40]

This fragment of modern aesthetics could as easily be derived from Endell's *Die Schönheit der großen Stadt* as indeed from Kracauer's initial effort to define his theory of film as a "redemption of physical reality." The communicating element between these varying modern avenues of perception is an aesthetics of flanerie that perceives modernity and the city as a film and likewise, the perception of cinema as an act of flanerie. The flaneur's territory is the street—the very scene also inhabited by early film. His fascination focuses on images in their colors, forms, and light—also the very emphasis of any cinematic picture. Ultimately, his primary impulse moves along with the dynamics

of flanerie as a form of perception-in-movement, in this way incorporating the very principle of the new kinetic art of cinematography.

The principle of light structures the scenes of cinema pictures in the same way that it informs the "mise-en-scène" of action in flaneuristic texts, especially by the fascination exerted on them by the city night.[41] Observing that "in darkness, light is life," Wolfgang Schivelbusch defines the fascinated attention of the gazing movie-goer as (well as) that of the street-walking flaneur.[42] Likewise, the principle of movement constitutes the succession of shocks one experiences in the course of watching images in the cinema and describes the flaneur's seeing-in-walking in the city. Kracauer notes this correlation when he suggests that Germaine Dulac would "define cinema as 'the art of the movement and the visual rhythms of life and the imagination.' "[43] In so doing, she implicitly describes the inner associations of the flaneur's perception, which are stimulated in transition by exterior images. The perception of these effects of movement and light, the circulation of images into decipherable signs of life, converges with an aesthetics of the flaneur. The production and reception of moving *Lichtspiele* also constitutes the medium of film from its very beginnings and in its earliest definitions, locating it between the poles of life and movement, between the "bioscope" and the "cinematograph."[44] The figurative equivalent of a sensitivity writing on modernity in movement—his own or that of its objects—is presented by the flaneur moving about in the cities. In view of this equivalence, film literally becomes a variant of an aesthetics of the flaneur. The parallel traits shared by the city and the cinema form a topos of Weimar modernity, which all of its contemporaries formulate in a new way on a daily basis. These are modern-day flaneurs, who in the streets or cinemas of the city "stand under [the] hypnosis" of modernity and experience "this Berlin [as] silent as a cinema."[45] They are fascinated in three-dimensional ways by the new and innovative images moving around them, images among which they themselves move. Bernard von Brentano's attempt to situate *Wo in Europa ist Berlin?*, for example, can only ascertain a certain degree of kinetic energy: "In the morning, at noon, and in the evening, this city, if looked at from a focal point of traffic, resembles an immense, uncontrolled film."[46]

This cinematic metaphor of the city as a film unfolding beyond any editing is shared by the literary participants of the Weimar *Kino-Debatte*. Their journalistic exchange constitutes the most important documentation of this disposition toward a permanent and ubiquitous reception of images, whether these images belong to the shock-ridden modernity of city exteriors or to the institutionalized interiors of the cinema. The images, sights, and sets which Egon Friedell's "Prolog vor dem Film" (A Prologue Before the Film) conjures to illustrate his city hypostasize this experience of reality as a metacinema of modernity: "Berlin is one wonderful modern machine hall," he writes, "an enormous electrical motor . . . the life of a cinematographic theater."[47] The metaphor of the *Kino Berlin* corresponds to the topos of the "film of the street,"

at once indicative of the place of the city, its time in modernity, and a reality experienced as essentially filmic. "I see streets, people passing, very rapidly . . . some stop and look over to me in an uninvolved way."[48] This description by Max Brod could easily approximate his daily experience of flanerie in the streets, as it reflects the suspect status of critically observant Weimar intellectuals, often regarded as suspicious strangers in the streets and public spaces of Berlin. Instead, it really describes an experience he undergoes in the movie theater: the passage renders his reception of a short scene from a filmic *Journey to Australia*. The modern medium as a form of perception would seem to simulate modernity even in its faraway, exotic, and premodern objects and sensations.[49]

The medium displays its close affinities with the realm of the street and thus the territory of the flaneur. Following his own city and film experiences, Carlo Mierendorff claims that the cinema predominantly shows "the pushing and shoving of the cities, lamp posts, automobiles, façades of hotels, train stations"—the same world of modernity he also finds reflected through the eyes and obsessions of the flaneur. This congruity of film and the street originates in the medium of movement in which they both participate: "The flash-like and disjointed succession of movement characteristic of early silent cinema seemed to correspond to the receptive disposition of the city dweller."[50] The prototype of a city character disposed toward his own movement in the observation of the movement of others is the flaneur, to whom all surrounding images add up to one continuous "film of the street." As another observer would have it, "the psychology of the cinematographic triumph is the psychology of the city . . . since the metropolitan soul, staggering in frenzy from fleeting impression to fleeting impression, this curious and unfathomable soul, is essentially the very soul of the cinematograph."[51] Georg Lukács's "Gedanken zu einer Ästhetik des Kinos" reinforces this point as it defines "the essence of the 'cinema' [as] movement as such,"[52] much in the same way that Hausenstein had come to define the essence of Berlin. These two spheres of movement become interchangeable equivalents, each received by the visual flaneur of either sphere. Bernard von Brentano casts this insight in a strikingly contemporary realization when he suggests that "the film of the Germans is the auditorium, the Kurfürstendamm."[53] Film and street are synonymous in a city in which cinema and modernity have taken parallel courses in the age of their mechanical invention, in the significance of their light and images, and in their specific city-oriented dynamics, a dynamics that Yvan Goll chronicles in a breathless voice subject to immediate shocks:

> This planet has received a shock. We are standing amidst a new age, one of movement per se . . . gigantic train stations, New-York with its skyscrapers [as] mountains of light. . . . Movement nothing but movement. Business chases business.

Experience experience. Image chases image . . . A new element, like radium, ozone, acts on all of art: Movement. . . . We have the film.[54]

Linking the principle of film to the rhythm of contemporary reality, Goll deduces the primacy of an aesthetic reception of modernity: "The basis for all new and coming art is the cinema."[55] The point of departure for this reception of modernity as a time of the cinema in and of the city, as a time of the "cinematographic theater Berlin" and its "film of the street," is ultimately derived from the flaneur's aesthetics and his sensory conviction in the textual character of reality. From Börne, who reads Paris as a "book unfolded" [*ein aufgeschlagenes Buch*], to Hessel, who regards his flanerie as "a form of reading the street" [*eine Art Lektüre der Straße*], walking and looking are not only synonymous, but the process of seeing takes on significance as the concrete experience of material reality. Flanerie as an act of deciphering the signs of exterior reality precedes in an associative and *en passant* way a latent disposition of semiotics: one need only look as far as Hessel's reflections on the hieroglyphs of early billboards or the cryptic presence of flickering advertisements, which represent an explicit formulation of an aesthetic experience unique to his time, his space, and to the medium that records this time and space.

This aesthetics of modernity, the city, and the cinema, is contingent on the textuality of these spheres, whose objects are constituted in the flaneur's eye as the subject of their perception. The textuality of film is the consequence of an understanding of modernity as an infinite succession of images, an understanding that corresponds to the proliferation of image-based discourses in the modern era: the development of photography renders possible the exact scrutiny of the moment [*Augenblick*] as a sight and a site fixed in the permanence of duration and perception, reflection and writing. The dissemination of advertisements, announcements, flyers, posters, and Berlin billboard columns [*Litfaßsäulen*] pervade the continuum of the street with privileged signals that are legible in both verbal and pictorial ways. As stimuli and information, they challenge the eye to increase its efforts of perception and deciphering. In a symbiosis of image and text, illustrated magazines, with their reproductions of the visual world, intensify this disposition toward reading by encouraging their readers to "read" images inserted into the text as autonomous "texts" in their own right and with specific structures. Analogous to this development in advertising and magazine publishing, the passages and displays in the streets of everyday reality have already been read, that is experienced, by the flaneur as a text of images. The streets abound with images and their textual metaphors. Brentano observes: "Beautiful women . . . like to reflect themselves in display windows which are as entertaining as the magazines are."[56] With its readings of advertisements, magazines, the city and its streets as textual metaphors of modernity, this semiotic reception of reality reaches its epitome in the cinema, the imagistic medium most characteristic of modernity. In the words

of Joseph August Lux, "the cinema continues successfully what our picture magazines have started so wonderfully. It illustrates. On quite a large scale it replaces the word with 'illustration' [*Anschauung*]."[57]

The image-oriented era of the 1920s is also a time of the relativization of literature in its traditional forms, with debates ranging from a "weariness with literature"[58] on the part of the public to a tendency toward visual definitions of textuality. While the fascination of literary forms begins to fade in the face of modern reality, its readers turn, according to some of the most perceptive observers of the *Kino-Debatte*, toward the immediate reception of their reality as a text in and of the street. For these movie-goers, "an entire literature, no, an entire confusion of literatures, torn into shreds, [flies by]" in the cinema. Film offers a kaleidoscope of visual-textual shocks. It comes as "the replacement for dreams" as well as a substitute for literary forms that have rendered themselves obsolete.[59] In the place of an increasingly anachronistic and "aristocratic book-literature [*Dichtung*] steps the democratic film-literature—an art from below,"[60] the textuality of which the flaneur has long since experienced and formulated in the street: "The public of modernity nightly sits before that modern book and learns how to see, think, feel by way of the film—the book read by millions and not 'owned' by anyone."[61] This same description applies to the streets of the city, to the visual public of modernity: the street is a three-dimensional text composed of images, a simultaneous film with no intertitles. The spheres of cinema and the street intersect in the textual metaphor of their perception, in their collective reception as texts of flanerie: we are here to read and "enjoy [them as] visual reading [*Lektüre*]."[62] As an anonymous observer charts the "new territory for cinematographic theaters": "The pleasure in pictures [*Bildwerk*] is generally present, we are now more disposed toward viewing than reading, and so as if hypnotized everyone streams willingly into the cinema, the picture-paper where one indulges in reading."[63] The fascination of the cinema transcends that of an illustrated "picture paper." In this new medium, modernity finds its adequate aesthetic form: "Film is something essentially new, film is very truly the poetry of our time."[64] As the first poetic condensation of an aesthetics of its times, film is the "more intensive form, a better means of transportation . . . the simple, direct, and legitimate continuation of the book" by other means, through which modernity recognizes and rediscovers itself in the "most subtle way." In film, the shapes and structures of modern reality, the "achievements of modern technology [become] phantastic and poetically gripping."[65] Speaking in the mode of the flaneur, Benjamin defines Charlie Chaplin's aesthetics of film by suggesting that, within this aesthetics, in Philippe Soupault's words, "a poetics prevails which everyone comes across in life without however always knowing of it."[66] This aesthetics of the visual links the phenomena of the *Kino-Debatte* to some of the considerations that Kracauer will work out in his *Theory of Film*.

KRACAUER'S *KINO-DEBATTE*

Most significantly, the paradigms of flanerie that implicitly inform the *Kino-Debatte* traverse the theories, texts, essays, and, above all, cinematic writings of Siegfried Kracauer. A correspondent of the *Frankfurter Zeitung* in Weimar Berlin, Kracauer finds himself a theorist of film in postwar New York City, the capital of the twentieth century, where, informed by the terms of an urban *Kino-Debatte*, he writes his *Theory of Film. The Redemption of Physical Reality.*[67] Within the cultural context of Weimar Germany, and from the specific perspective of the flaneur's experience, Kracauer's theoretical writings of the cinema—and, in particular, this seminal text of film theory—form an extended paraphrase of the terms and sensibilities of the flaneur's filmic perception. Kracauer's theory of film is situated here as a text that continues to suggest some of the sensibilities expressed by Weimar intellectuals in the *Kino-Debatte*—one of the earliest attempts to define an interface between cinema and the spaces of modernity. In terms of contemporary urbanity and Weimar sensitivities, the very conjunction of a return of flanerie and the arrival of the cinema—phenomena of both a privileged mode of specularity and its newest medium of recording—evokes an illuminating debate on questions of perception and focuses on the encompassing, evolving spectacle of modernity in the cities. Defining a filmic aesthetics of the everyday, the literary *Kino-Debatte* approaches the cinema in the same way that the flaneur approaches the experience of modernity in the streets. In his *Theory of Film*, Kracauer maps this terrain of an exterior reality onto the realm of cinematic perception. The aesthetics of the marginal and profane aspects of reality that the flaneur pursues in the street—in terms of his own particular film of reality—are the very aspects which, according to Kracauer, account for the essential contents of "film," whether they are fixed in celluloid or recorded on the page. For Lukács in his "Gedanken zu einer Ästhetik des Kinos," this constellation represents a fundamentally new aesthetics and a direct expression of modern life. As he notes, film shows a "new beauty . . . the ascertaining and assessing of which belongs to aesthetics."[68] The variety, directness, and rapid movement of the fragments of modernity in the city "correspond to a poetics which minimizes, if it does not revoke, the separation between art and life. The manifestation of such a poetics is film."[69] This poetics is inseparable from an aesthetics of flanerie.

As Kracauer's theory of film implies, each of these two models of modern experience collects its objects from exterior modernity. It is no accident that Kracauer himself, as much the practitioner of flanerie as a theoretician of film, names as the most eminently "filmic objects" the very avenues, haunts, and objects pursued by the flaneur: urban streets and public spaces. Kracauer entirely concurs with René Clair when the latter claims that "if there is an aesthet-

ics of the cinema . . . it can be summarized in one word: 'movement.' "[70] Voicing a consonant concern throughout much of early film theory, this thought also describes those spheres and modes of action which define the existence of the flaneur in the debates of the time. Choosing sides with the realist-perceptual tradition of cinema over the fictional-fantastical one, Kracauer quotes Mesguich, one of the Lumières' cameramen, on "the true domain of the cinema": "The cinema is the dynamism of life, . . . of the crowd and its eddies. All that asserts itself through movement depends on it. Its lens opens on the world."[71] The most contemporary manifestation of this phenomenon, I would argue, takes its human shape in the flaneur, who asserts his urban existence entirely through his movement, with his eyes opening onto the world, perceiving modernity. "Movement" and the "dynamism of life" describe the constants of a filmic disposition toward collecting and experiencing "indiscriminately, all kinds of visual data, gravitat[ing] toward unstaged reality" (*TF*, 60), a tendency that cinema shares with the flaneur. Both display the "affinity of film for haphazard contingencies, [which] is most strikingly demonstrated by its unwavering susceptibility to the 'street'—a term designed to cover not only the street, particularly the city street in the literal sense, but also its various extensions, such as railway stations, dance and assembly halls, bars, hotel lobbies, airports, etc." (*TF*, 62). As a term that encompasses the entire spatial world of modernity, "street" becomes synonymous with experiences that the contemporary flaneur perceives and pursues in the film of the street. Cinema and flanerie share an affinity toward unstaged reality whose objects, shocks, and stimuli "call forth irritating kaleidoscopic sensations."[72] Whenever Kracauer quotes texts as significant to the medium as the early Lumière films, he implicitly describes the images of flanerie:

> Their themes were public places, with throngs of people moving in diverse directions. The crowded streets . . . reappeared on the primitive screen. It was life at its least controllable and most unconscious moments, a jumble of transient, forever dissolving patterns accessible only to the camera. The much-imitated shot of the railway station, with its emphasis on the confusion of arrival and departure, effectively illustrated the fortuity of these patterns, and their fragmentary character was exemplified by the clouds of smoke which leisurely drifted upward. (*TF*, 31)

Yet even before the camera that would come to capture them, these phenomena already had been immediately accessible to flaneurs—walking human cameras—in the streets. In the same way, flanerie was recorded by their contemporaries in the nearly identical formulations and observations of the *Kino-Debatte*, registering some of those same sentiments and perceptions. Their "full absorption in the given material" (*TF*, 40), their impulse toward recording, preserving, and "capturing material phenomena for their own sake" (*TF*, 39), and the " 'pure poetry of displacement' manifest in cinematic travel films,"[73] describe an aesthetics of flanerie as closely as does the early cinema of reality

described by Kracauer. If the Weimar flaneurs' aesthetics defines itself through filmic perception, themes and objects, how does this contemporary affinity for film affect the poetics of their texts?

Kracauer's film theory does provide us with some access to the poetics and debates of literary flanerie: as an illustration of truly "filmic" films, for example, he commends Lumière as having "realized that story telling was none of his business" (*TF*, 31); it involved problems with which he apparently did not care to cope. In a similar—and thus filmic—way, the entry of physical reality into the consciousness of a flaneuristic narrator begins to dissolve the novel's more plot-oriented narrative structures. Like the close-up in film, the flaneur text simulates, in detailed depictions of exteriority, film's capacity "to sensitize us, by way of big close-ups, to the possibilities that lie dormant in a hat, a chair, a hand, and a foot" (*TF*, 45) and, in so doing, renders its readers susceptible to a complex aesthetic reception of everyday contemporary reality. The more both film and the flaneur text "bring the inanimate to the fore and make it a carrier of action," the more they tend to include man as only another, equally respected "object among objects" (*TF*, 97), the more narrative conventions of fictional personae, psychological contrivances, dramatic dialogues, and constructed plots lose their significance. In texts of flanerie by Hessel, Benjamin, Kracauer, and others, verbal confrontations give way to the fascination of visual impressions, and fictionally constructed action recedes before objets trouvés and structures derived from reality. Some of Hessel's most exemplary flaneur texts can be found in his last and entirely fragmentary novel, *Alter Mann*, as well as in his Berlin essays on "The Difficult Art of Taking a Walk" ["Von der schwierigen Kunst spazieren zu gehen"],[74] a work in progress that abandons acting protagonists in favor of the flaneur as the sole medium of perception. Liberated from all elements not directly taken out of exterior reality, Kracauer's flaneur is both a writer and director who takes "positive delight in being released" from conventional "story necessities," "in being for once permitted to record, or rather seem to record, a plethora of sense data without too much regard for their contribution to the total effect of the story itself" (*TF*, 67). This narrative constellation simultaneously describes the situation of a filmic director, of the author as a flaneur, and of the recipient of film in the *Kino-Debatte*. For these contemporaries of Weimar modernity, "story as the main element of feature films is something alien to the medium, an imposition from without" (*TF*, 178). The actual "*Urstoff* of the filmic element," of film and flanerie, is "movement," the very movement "which also characterizes modern everyday life."[75]

Thus Goll, contributing to the *Kino-Debatte* in an "age of movement" and amidst "mountains of light" in the cities, declares the cinematic light plays of modernity as texts of flanerie: "Not action but movement forms its basis. . . . Its space is unlimited."[76] The fascination of exterior reality can no longer be relegated to the backdrops of narrative structures before which seemingly

autonomous figures act out an author's imagination: such plots and persons lose their reality and interest in relation to filmic objects and constellations. The exterior world of objects, a world redeemed in early cinema and its accompanying debate, emerges from the marginal spaces of modernity, as Anton Kaes notes: "The revaluation of matter corresponds to the abolition of psychology in silent cinema."[77] Kracauer concurs with this intoxication of images and this rejection of positivist psychology, an intoxication and rejection that in this constellation border on the surrealist.[78] He posits for his flaneuristic film wide-ranging spaces exempt from constructed personal constellations. Truly filmic story forms, he tells us, can only be "found in the material of actual physical reality" (*TF*, 245); they shall convey nothing but "a shade of human interest apt to lend color to the juxtaposed documentary shots; and they are sufficiently sketchy and inconsequential to dissolve again into the general city life within which they accidentally crystallized" (*TF*, 246ff). Kracauer's notion of the personal economy of filmic plots coincides in detail with the flaneur's transitory encounters in the street. This newly episodic way of experiencing the world and presenting narration understands flanerie as its new poetics "in a topsy-turvy world in flux not identical with documentary reality either" (*TF*, 252)—a new poetics, that is, of modernity. The flaneur passes through a series of episodes, all of which are connected only within the consciousness of his perception in the continuum of his walks, or "achieved in terms of space, different stories being laid in one and the same locality" (*TF*, 253).

According to Kracauer, the episodes of flaneur films and texts constitute a form of action adequate to modern reality: "The story they narrate is inherent in their succession. So we inevitably get the impression that they follow a course strangely devoid of purpose and direction; it is as if they drifted along, moved by unaccountable currents" (*TF*, 256). This very "process of drifting, which runs counter to the cherished conceptions of traditional aesthetics," nevertheless leads in a paradoxically direct line to the texts of flanerie. In film, this "counter-aesthetics" is evident in its own typically flaneuristic forms of experiencing exteriority: idle strolling, "the gloomy walk in the nocturnal streets," and the "journey through the maze of physical existence" (*TF*, 257). With its episodes of transient perception, the flaneur's filmic writing achieves for the twentieth century one of the poetological postulates Lessing's *Laokoon* posed to eighteenth-century literature: the depiction of linear and continuous actions—of perception, of pure seeing—in the succession of time.[79] With its particular symbiosis of visual depiction and ambulatory action, the flaneur text transcends "the limits of painting and poetry" [*Die Grenzen der Malerei und Poesie*], as Lessing has it, in both directions at once, combining aspects which no longer appear contrary in modern reality. As Ekkehard Kaemmerling puts it, in "filmic writing, the separation between the immobility of the visual work of art that is being experienced in all of its parts in the same instant and the

movement of the text being written in an ongoing manner, is suspended; [a] separation which has determined aesthetics since Lessing's *Laokoon* essay in such decisive ways."[80] As a continuum—as a continuity that is neither cut nor subject to montage—this symbiosis is accessible in films of reality and flanerie, in films, that is, that move according to the strolling or drifting mode of either the camera's lens or the flaneur's eyes. Gazing at reality via linear movement translates the experience of modernity into its images, as a succession of perceptions in time within the space of a city in transition. In the flaneur's strolling, modernity not only pursues its aesthetic shape, but potentially also its critical expression and perception of capitalist society, even in and particularly through its very commodity surfaces.[81] The images forming in the flaneur's head proceed as an aesthetic film of modern reality, and thereby propagate their critical reflection, in "thought images" [*Denkbilder*] of a thorough "reading" [*Lektüre*] of contemporary reality—"reality" understood here, in all of its senses, as a text. The work of reading the street, therefore, translates exteriority into a text: a flaneuristic text—itself a kind of film—that occurs via the apparatus and lens of the mind. As Kaemmerling suggests in "Die filmische Schreibweise," "the filmic mode of writing creates reading anew as a filmic seeing through the act of reading the written text."[82] The reading of the film of exterior reality and the imaginary gaze of the flaneur's text form inextricable parts of the same perception, aesthetics, and textual metaphor. If Béla Balázs speaks of the "legibility"[83] of film, and Kracauer of the filmic director's "capacity for reading the book of nature" (*TF*, 302), they refer to the very same visual sensitivity displayed in Hessel's concept of flanerie as "the art of reading the street," or in Börne's understanding of his walks through the streets of Paris in terms of the act of "leafing through an unfolding book and reading in it." According to Kracauer's definition of filmic direction, the film artist and the modern city-stroller can be described as having the "traits of an imaginative reader or an explorer prodded by insatiable curiosity."

Kracauer's theory of film can be read as an implicit aesthetics of the flaneur, while many Weimar texts of flanerie can be seen as theories of an unfixed and infinite film of reality running in the streets of Berlin. A poetics of the flaneur will finally come down to a cinematography that transcends all plot structures except for those of walking and seeing. It can "do without traditional literary action" and can "completely disregard the story."[84] This aesthetics takes its subjects, objects, themes, and structures "directly from the matter of living reality," discovering them "in the simply visible, in visual being."[85] Beyond any specific "subject matter," the aesthetics of the flaneuristic text manifests itself in "the direct perception of the concrete achievement of a thing in its actuality" (*TF*, 296), in the perception of the visible phenomena of any given reality. "The essential material of 'aesthetic apprehension,' " Kracauer explains, "is the physical world, including all that it may suggest to us. We cannot hope to embrace reality unless we penetrate its lowest layers" (*TF*, 298), open-

ing them up to perception. It is this aesthetics of modernity—an aesthetics grounded in its particular metropolis—which inspires a generation of big-city strollers and observers, poets and flaneurs, from Baudelaire's Paris to Kracauer's Berlin. This filmic reality is reflected in its most striking terms in the *Kino-Debatte*, as a reflection upon a reality whose modern cinematic quality spirits these writing spectators away through their associations "into the lumber room of [their] private selves" (*TF*, 56). It is through this diverse reality that Hessel passes like a flaneur in a "junk store of happiness,"[86] a reality whose magic unfolds for Hugo von Hofmannsthal as a "replacement for dreams,"[87] as a "chest of miraculous bric-a-brac which opens itself up: the cinema."[88]

Friedrich Seidenstücker, "Amateurfotografin" (Amateur Photographer).
Courtesy of Bildarchiv Preussischer Kulturbesitz.

Flanerie, or The Redemption of Visual Reality

TRACING the perception of flanerie in terms of related modern phenomena, we have noted that flanerie can be understood as a precursor, a kind of prehistory to a theory of film. The flaneuristic character is replicated in the photographic and filmic approaches with which the camera views the world and that resonate in many early theories of film. The cinema's "miraculous bric-a-brac" has much in common with the treasures that the explorations of flanerie find in the streets. Expanding flanerie through wider excursions into the related fields of psychoanalysis, sociology, and tourism, we can now focus closer attention on the specific relations between film and flanerie as mediums of modern perception. We can now, that is, take another look at Kracauer's theory of film, which is above all distinguished by its very material, photographic, and filmic qualities. Evoking an equation between the film-maker's camera and the eyes of flanerie, Kracauer's theory of film demonstrates far-reaching affinities between these two modes of vision.[1] As the subtitle to his *Theory of Film* suggests, Kracauer's theory is defined in terms of the continuities and analogies that link it to the Weimar *Kino-Debatte*: a "Redemption of Physical Reality" implies the underlying sensitivities that sustain both this theory of film and the experiences that the flaneur derives from the street.

The flaneuristic writings that both film and the flaneur formulate in their recording of images, Kracauer says, can "be defined as a medium particularly equipped to promote the redemption of physical reality" (*TF*, 300). Formulating a theory of film that seems to paraphrase a theory of flanerie, Kracauer claims that these texts and their "imagery permits us, for the first time, to take away with us the objects and occurrences that comprise the flow of material life." The immediate perceptions and subsequent writings of flanerie can be understood more broadly as a nontechnological manifestation of "the movie camera's exploration and examination of our reality,"[2] a phenomenon that prefigures the work of the cinema's technical apparatus. The camera assumes functions similar to those of flanerie. It seeks, for example—in Kracauer's words—to "record visible phenomena for their own sake" (*TF*, x). From the angle of Dziga Vertov's different, but nevertheless related—especially in its orientation toward exterior reality—theory of film, the camera pursues a "sensory exploration of the world."[3] In very literal ways, the cinema introduces the technological fulfillment of an earlier flaneuristic means of relating to the world. The flaneur's perspective that steps out to explore the world in fact inserts itself into modernity "through film [by] the use of the camera," and in

so doing, likens the eyes of the flaneur to a living version of the "kino-eye." Rendering himself as susceptible to his surroundings as to a walking film-stock, he wishes to become an almost transparent and quasi-invisible medium of the perceptible world. As a moving screen that absorbs and reflects the process of seeing with great intensity, the flaneur moves in ways that are very similar to how Kracauer views the movies: "In keeping with its recording obligations, film renders the world in motion" (*TF*, 158). The flaneur is moved by a similar obsession with the visible, he is driven to fulfill his "recording obligations" by becoming a kind of camera. His art of taking a walk introduces an aesthetics of movement that, more than any other artistic form, reveals an affinity with the long, extended tracking shots of a camera whose movement approaches and embraces the visual emanations of the exterior world.

The flaneur's gaze pursues this open access to the visibilities of reality. He exhibits a potentially infinite curiosity and a transparent sensitivity for every phenomenon of reality. Resembling the slow movement of a camera, the flaneur's text seeks to leave the materials of his perception as intact as possible so that his prose will be able to register and render reality within a spectrum of nuances and details. In other words, the texts of flanerie pursue a "redemption of physical reality" within the limits of its own medium—recalling the ways in which Kracauer theorizes the proceedings of a truly "filmic" camera. Kracauer in fact describes something like an ethics of flanerie: "On the other hand, this reporting job is done with unconcealed compassion for the people depicted: the camera dwells on them tenderly; they are not meant to stand for anything but themselves."[4] In his effort to redeem exterior reality, the flaneur defines himself as a medium that registers the appearance of objects and transports them, through writing, into a text that is attentive to both visual detail and optical specificity. Even if impressions pass through the subjective apparatus of his mind and its senses, the objective of the flaneur's moves coincides with the camera's quest. "As I see it," one of the Lumières' cameramen says, "the cinema is the dynamism of life. . . . All that asserts itself through movement depends on it. Its lens opens on the world."[5] While the objective of the movie camera follows the world like the eyes of the flaneur, the objects of modernity provide its focus. Christopher Isherwood's striking paraphrase of this position collapses the technological manifestation of scopophilia into a complete identification with his own body, with his spectator position in the streets: "I am a camera with its shutter open, quite passive, recording, not thinking. . . . Some day, all this will have to be developed, carefully printed, fixed."[6] Aragon's *Le Paysan de Paris* reveals a similar awareness of the filmic components of surrealistic flanerie when, focusing his perceptive lens on other passersby, he writes: "I see them move by as if I was one of those slow-motion cameras filming the gracious unfolding of plants."[7]

In directing himself toward the multiplicity of the modern city, the flaneur becomes an eye that defines its relation to modernity in visual terms: "With their eyes, people hear. . . . They now only receive the world through their

eyes."[8] The flaneur's subjectivity is "all eye," while his flanerie plays an ongoing "eyefilm" of perception in his own mind. His process of seeing simulates "closely the immense square flickering [*flirrende*] eye"[9] of the camera, thereby linking his flanerie to the technical reproduction of the images he pursues. The reception and production of these images responds to Balázs's definition of the observing perspective in his theory of film: "The camera has my eyes,"[10] he writes, describing the filmic spectator, who is already legible in the flaneur's disposition, and directing the flaneur's eyes to his all-encompassing, ever-present visual perspective. As Balázs notes, his eyes are inside the camera. Eager to roam the realms of exterior reality as if it presented the interiors of a moving film strip, the flaneur looks with eyes that transform him into a camera that produces a street film of the visible world. Identifying the observer's eyes with those of the camera, the very illusion constitutive of film—"to be standing amidst the action, within the depicted space"[11]—becomes apparent in a reality that is central to the medium of flanerie, an experience that resembles the continuous, infinite, only slightly edited film of perception. A means of registering perpetual perception, the flaneur is a cinematographic apparatus in human form, "which can be focused on the material appearances as and how they move all around and past us."[12] Moving amidst the "material appearances" that surround him, he asserts his presence in the streets as a witness of modernity, thereby prefiguring the function of Kracauer's camera: "Here as elsewhere, the role of the camera is that of an independent, if secret, witness" (*TF*, 236).

I want to suggest, then, that Kracauer reinscribes the history of flanerie into his theory of film. He aligns the view of the camera with both that of the flaneur and that of his related personifications, the collector and chiffonier. "Filmic" texts, he says, always "offer the camera ample opportunity to satisfy its inborn curiosity and function as a rag-picker" (*TF*, 54). Insofar as collecting discarded and rejected materials is suspect in both, the moving camera and the flaneur seek to enter "a forbidden realm. . . . The supreme virtue of the camera consists precisely in acting the voyeur" (*TF*, 44). A voyeuristic collector of the visual fragments and nuances of modernity, the camera in this theory of film can be identified with the eyes of the flaneur.[13] The flaneur prefigures the literary predecessor of an imaginary spectator to come, the perceiving and receiving medium of the "photographer as a 'camera-eye' " (*TF*, 14). Noting that the flaneur functions as a kind of camera, we can turn our attention to some of the principles that underlie both film and flanerie.[14]

URBAN DIRECTOR

While the beginnings of the filmic medium have been traced to urban spectatorship, the precise links between the editorial principles of the new medium and the writings of flanerie remain to be illuminated. Following Knut Hicke-

thier's suggestion that "the city determines the models for the patterns of action and representation characteristic of filmic perception and filmic narratives,"[15] we can define the flaneur as an urban figure who functions as the director of his own perception, a visual mind that structures collected materials through his descriptive choices. Even as he edits his writing, the flaneur shows himself to be a reserved and deliberately restrained director, one who refrains from making cuts and intrusions, one whose eyes are guided by the incessant flow and life of reality, a director whose principle is to facilitate the attention he extends to his objects. This visual susceptibility follows the same principle that Walter Serner postulates for scopophilia and the cinema in the *Kino-Debatte*: "[Cinema] throws the backdrops out the window, leans over to the street, and takes pictures. So it gives to the eye what is the eye's."[16] Advancing in the street, the flaneur resembles the figure whom Kracauer celebrates as "the most creative film director [whose] creativity manifests itself in letting nature in and penetrating it" (*TF*, 40).

If flanerie names the principle of an ongoing photographic or filmic perception, it is not surprising that a theory of film formulates its creative subject in apparent analogies to the sensitivity displayed by flanerie. In terms that closely resemble the flaneur's reading of the street, Balázs defines the filmic director as one who "reads the visual score of plurivocal [*vielstimmig*] life."[17] This shared analogy of reading resonates throughout Kracauer's theory as he attributes "such art as goes into films [to] their creators' capacity to read the book of nature. The film artist has traits of an imaginative reader, or an explorer prompted by insatiable curiosity" (*TF*, x). This passage, describing the director in the theory of film, takes the same rhetorical turn that in Kracauer's Weimar writings describes the textual metaphors of flanerie. This turn belongs to the movement that allows Hessel, Benjamin, and their contemporaries to approach the streets of modernity as texts.[18] The filmic direction of these texts can be read in a reality that is oriented toward the eyes of the director, another—if technologically endowed—manifestation of the flaneur, a "man of visual culture," who transforms his optical disposition into professional specialization.[19] Like the flaneur before him, the director learns to "think in optical ways,"[20] even as he accommodates this orientation to the service of commercial purposes or otherwise codified forms of seeing through a technology that fixes this vision by means of an apparatus.

According to Kracauer, the director's sensitivities are linked closely to those of the moving and flexible cameraman, rather than to a director who functions within the constructions of dominant cinema, within artificial spaces and manipulated realities whose main aim is to maximize profits for the film industry. Offering an alternative to this model, Kracauer understands the "filmic" director's visual interests in terms that resemble the stroll of flanerie that seeks to "get the most out of physical reality" (*TF*, 180). Kracauer finds this approach personified above all in Aragon's surrealist flaneur, who derives "a certain

satisfaction from detecting, in the given material, forms and movements which seemed to be completely unreal."[21] A kind of detective, the flaneur becomes an exemplary reader of modernity who learns "to establish affinities among the most minute signs and to combine them."[22] The director's semiotic perspective here corresponds to the flaneur's perception: what transforms them from mere visual cameras into authors of their own texts is a latently melancholic sensitivity and appreciation for the transitory optical nature of images. The sense of the finitude of these sensations moves these modern observers to convey their awareness of the volatility of images in an attempt to preserve and redeem them in their texts, texts that focus on the moving poetry to be found in the streets: "What touches one so much who walks through the streets, one who has eyes, nerves, and a heart. The poet who will have to lead us here with his camera is a lyricist who takes down optical notes and sketches."[23]

What distinguishes the collector of texts and director of images as a receptive sensorium of modernity from a merely passive visual consumer, is an intense impulse to maintain the enjoyment and duration of these fleeting images, and to do so in a way that reflects his optical preference and point of view: "The ubiquitous formative principle originates with the subject."[24] In an effort to preserve a fleeting perception, the director proceeds in consonance with the forms and movements of flanerie.[25] Balázs even describes him as a movable perspective in pursuit of reality: "The director . . . has the camera wander while he is moving alongside the objects [in order to capture] them."[26] He engages, even indulges, in panoramic travelling shots that in their linear procession attempt to track the very succession of images in reality. The eye of the observer focuses on "the physiognomy of things," as Balázs says in *Der Film*. It captures a sequence of phenomena "in the camera's continuous movement."[27] Corresponding to the eyes of the flaneur, this process exhibits the perspective of a director who rearranges the subjectivity of his own perception in the continuum of a filmic text. His choices and arrangements of found and perceived objects manifest the creative moment that shapes the writing of flanerie into a "directing" of images: "Therefore it is the frame and the point of view [*Blickwinkel*] which give things their shape. . . . He does not reproduce his images, he produces them. This is his, the director's 'way of seeing,' his artistic creation."[28] As an observer who invokes his own disappearance in a fiction of invisibility—standing behind a screen provided by the images he perceives—the flaneur undergoes a process similar to the one that Balázs associates with the secret perspective of the most subjective of films. He writes:

> They have no plot (story), but a central figure, a hero: A hero who is invisible because it is he who sees with the film eye [*Filmauge*]. Everything, however, that he sees, expresses his self, his subjectivity, however unconstructed the reality may appear. Because it characterizes and reflects his self, [it confirms] that he is the one who saw this very reality and received it, and no one else.[29]

What Balázs describes here as one of the "most significant, richest, and 'most filmic' branches of a future poetry of film,"[30] aligns itself closely with the aesthetics pursued by the flaneur who seems to "abandon himself to the objective impressions, without searching for connections between them. And yet it is he himself who is the connection! His subjectivity is the constructive principle."[31] Defining his writing as a form of editing, the flaneur chooses to imprint his signature in invisible yet indelible ways on the visual material before him, thereby suggesting that his personality "will only become visible in his way of seeing."[32] He is a director, "just 'the man with the camera.' He himself is not to be seen. But everything that he sees shows him. . . . Without intending to conduct anything to an end or even think to an end, the poet surrenders himself to the simultaneous impressions of the world."[33] An aimless sensitivity opening its lens toward the fragments of perception that come its way, this filmic perception can be traced back to the many flaneurs and urban spectators who preceded it.[34] Balázs's *Der Geist des Films* links these instances of flaneuristic viewing to their continuation in the cinematographic principle that is already afoot in the ways Dziga Vertov seeks to capture public spaces in his film *The Man with the Camera* (1927). Vertov's view of the "kino-eye," a point of urban observation in modernity, is shared by the watching and writing flaneur, based on an aesthetics of flanerie as well as on a theory of film-making:

> I am kino-eye. I am a builder. . . . In bringing together shots of walls and details, I've managed to arrange them in an order that is pleasing. . . . I am kino-eye, I am a mechanical eye. I, a machine, show you the world as only I can see it. Now and forever, I free myself from human immobility, I am in constant motion, I draw near, then away from objects.[35]

Despite his differences from the technical aspects of film-making, the flaneur moves through the streets according to very similar impulses and structures, separated from the filmic process only by an absence of the technological apparatus. The flaneur represents nothing if not another "cinema-eye man," or as Vertov suggests, a "kinok" of modernity.[36] If "Kino-eye opens the eyes, clears the vision," it is because its primary aim is "the decoding of life as it is."[37] Vertov here describes an act of visual reading that is intrinsic to both flanerie and theories of the new medium succeeding it. As Vertov notes, "Within the chaos of movements, running past, away, running into, and colliding—the eye, all by itself, enters life. A day of visual impressions has passed. How is one to construct the impressions of the day into an effective whole, a visual study?"[38] As the "eye" gathers an image of modernity from the "impressions of the day," Vertov not only speaks of the director's "I" as assembling the images of his film. Vertov's director, the man with the camera in the public sphere, is in fact a flaneur, a man with his eyes directed on the phenomena of the streets. Like the man with the camera, the flaneur is "continually swamped by the furious city traffic. The rushing, hurrying human crowd surges 'round

him at every turn."[39] In terms of this shared perspective, the difference between the flaneur and other pedestrians who are less receptive to their surroundings can be recast as the difference between a passive passerby and an active director who shapes his observations into the reflections of his flexible, if technically fixated, flanerie. As Vertov writes: "The man with the camera must give up his usual immobility. He must exert his powers of observation, quickness, and agility to the utmost in order to keep pace with life's fleeting phenomena."[40]

In accordance with Vertov's vision of an all-encompassing, open and democratic access to the making of film, the perambulatory disposition of flanerie is characterized by an apposite ambulatory technique, displaying the mobility and improvisational quality required for producing a flaneuristic film. Vertov's film-making "kino-eyes" are unencumbered travellers, comparable to the city stroller: ideally, they come equipped with "1. quick means of transport, 2. more sensitive film, 3. small, lightweight, hand-held cameras."[41] Vertov reduces the technological mediation of this perception to its minute necessities, thereby freeing the traveller in search of fleeting images to assume the flexibility, transparency, and openness characteristic of the flaneur in his encounters with the exterior world of modernity. Exceeding the ideological perspective of Vertov's director, the impulse of these "kinoks" is "to organize the film pieces wrested from life into . . . an essence of 'I see.' "[42] The perception of "kino-eyes" follows the same lines that the flaneur pursues in his texts or the director in Balázs's eyes: "The director only photographs *reality* . . . but he edits any kind of sense [*Sinn*]."[43] This "sense" comes to the flaneur as he writes and reflects on his impressions. The desire that compels him to walk seeks nothing more nor less than to render the differentiated nuances of his perception, to reflect his subjectivity in the mirror of an exterior screen, the surface of writing on which he projects his film of reality.

MOVING SPECTATOR

If the flaneur sees with camera-like eyes, his desire to redeem these images in a text recalls the directing choices of the new medium. Beyond these constituents of the filmic process, the flaneur's reception of visual reality bears affinities to the cinematic spectator. Oscillating between states of consciousness and distraction, the spectatorship of the street stroller and the moviegoer alike reveals "spells of trance-like absorption" that alternate with moments when the spectator is "quite naturally eager to try to draw the balance of what he experiences under the impact of the sense impressions that close in on him" (*TF*, 171ff). Such moments of trance and reverie form the unconscious background on which reflections of flanerie project themselves. The flaneur attempts to "draw the balance" of these shifting states of mind when he fixes the fleeting fragments of perception into the lasting images of his text, translating their

Augenblicke into the more permanent inscription of his writing. In seeking to decipher these images, or at least to redeem some of their vanishing traces from impending oblivion, the director's activities meet the spectator's receptivity as these sensations are transformed into a script—or film—of flanerie. Immersed in the material of everyday life, the flaneur finds himself transported to the complex psychosensory susceptibility that takes possession of the spectator facing a screen. These shared experiences are evoked in Kracauer's extended description of the disposition. He writes:

> The isolated individual's longings [in the cinema] recall the nineteenth-century *flâneur* . . . in his susceptibility to the transient real-life phenomena that crowd the screen . . . it is their flux which affects him most strongly. Along with the fragmentary happenings incidental to them, these happenings—taxi cabs, buildings, passers-by, inanimate objects, faces—presumably stimulate his senses and provide him with stuff for dreaming. (*TF*, 170)

Linking the flaneur to the moviegoer, Kracauer's *Theory of Film* would suggest that these two figures share more than just a "little in common."[44] Films that are "filmic" in Kracauer's sense exhibit the phenomena of exterior reality with a visual sensitivity and receptivity similar to the one that characterizes the view of the flaneur.[45] The flaneur becomes the name of a form of vision and perspective that prefigures the positions of the camera and its recording functions. He is also linked to the director who, like him, collects and assembles the infinite number of images that he receives. This persona further represents a spectator who responds to this film of reality as it is projected on the mind of the flaneur. Classical theories of film in the Weimar period explore the affinities between the flaneur in the city and the spectator in the cinema. Considering the effects of new technologies, these theorists return rhetorically to processes of seeing that are familiar to them from the exterior spaces of modernity, processes that are now projected on the interior screens of movie houses. "The spectator can, so to speak, feel out the space with his eyes,"[46] Balázs says of a spectatorship that is played out in films both inside and outside the cinema. An equally ambulatory reception of a chain of images strikes Kracauer as constitutive of the moment of cinematic vision: "Struck by the reality character of the resultant images, the spectator cannot help reacting to them as he would to the material aspects of nature in the raw which these photographic images reproduce" (*TF*, 158). Reacting to these "material aspects," the flaneur perceives the events in the street as a film that is projected on his mind. Modern life becomes a sequence of perception that runs through his mind as a potentially infinite film of reality in all of its variations and unforeseeable diversity. Viewing phenomena on the screen or in the street, neither the flaneur of the city nor the spectator of film can ever quite exhaust the "objects he contemplates. There is no end to his wanderings" (*TF*, 165). Kracauer's rhetoric links this figure of "wandering" to the process of seeing,

emphasizing the intricate affinities that link the phenomenon of flanerie to cinematic spectatorship. The figure of a "wandering" viewer is associated with the subjectivity of flanerie that engages his spectatorship in excursions through the images of his society.

Kracauer's theory of film is predicated on the common ground shared by these two versions of specular positions. Arguing against those theatrical, heavily-staged and plotted films that do not move the medium closer to the world,[47] he suggests that the spectator's primary aim is that of "being free to get immersed in the images" (*TF*, 91)—in other words, the same principle of movement that flanerie takes to the streets. According to him, this immersion into images would transcend a tightly focused, controlled observation of naturalistic facts. Instead, it would correspond to a transitional state of consciousness that oscillates within related realms of spectatorship amongst various states of regression, dream, hypnosis, intoxication, and eroticism. We could say that the continuum of flanerie ranges across these unconscious paths, from Hessel's associations of childhood fairy tales to the walking reveries of the adult flaneur, from states of intoxication experienced by the image-drinkers of surrealism to Kracauer's hypnotic attachment to the traumatic and phantasmatic phenomena of the street to both regressive and aggressive eroticizations of the city in modernity. Such kaleidoscopic forms of experience are induced by the same incessant succession of images that also define varieties of cinematic spectatorship. From their earliest speculations, theories of film have always reflected (on) this "dream character of cinema drama."[48] Both the flaneur and the spectator are dreamers and observers, who fuse into the subjectivity of their perception the images of reality projected on the surfaces of the mind. As Kracauer would have it, "the moviegoer watches the images on the screen in a dream-like state. So he can be supposed to apprehend physical reality in its concreteness" (*TF*, 303). His reverie, approaching reality in the dream-like manner of the flaneur, is at once concrete and imaginary. This relation between cinema and dreams has been noted by many theorists of film and touched on by psychoanalytic approaches to the medium.[49] If "cinematic films" in Kracauer's sense "contain dream-like elements" and may "be said to resemble dreams" (*TF*, 164), it is no accident that one of the "most cinematic" sequences of vision—the perception of reality via flanerie—coincides with the following description of filmic reception: "The spectator . . . meanders, dreamingly, through the maze of its multiple meanings" (*TF*, 165). At the heart of Kracauer's theory of film we can find the pivotal terms of a theory of flanerie that records its "meandering" through the "maze" of the metropolis. Kracauer's spectators enter their observations of the filmic image in terms of what Hessel and Benjamin call the "art of getting lost," an *Irrkunst* that allows one to stray from the paths of prescribed meanings into a dizzying maze of signs, to be driven into distraction by the multiple meanings of modern realities.

In his "Thoughts on an Aesthetics of the Cinema," Lukács offers a perceptive outline of what attracts both the spectator and the flaneur to the imaginary worlds reflected by the surfaces of modernity: "A diverse world originates to which, in the worlds of poetry and of life, the fairy tale and the dream seem to correspond: [it is] the becoming decorative of the unpathetic, ordinary life."[50] The literature of flanerie illustrates this marginal, but very real and material aesthetics with every turn that it takes in the streets, with every gesture it makes toward the everyday life. Entranced by a magical perception of the world, the spectator-as-flaneur seeks access to a more expansive experience of the exterior world in all of its material details. In ways that resemble Hessel's reveries as a young man of the city, "the moviegoer again becomes a child in the sense that he magically rules the world by dint of dreams which overgrow stubborn reality" (*TF*, 171). With an attentiveness to the world of textures and objects that is less constrained by rational purposes and dominant conventions, the child's focused gaze upon the materiality of things comes into play, once again bringing to life the magic and mystery of images along with that "other power: that of dreams." As Hofmannsthal notes, the moviegoers "once were children, and they were powerful beings then."[51] The power of this gaze returns in the visual practices of the flaneur and the spectator. Experiencing the film of the street, the flaneur finds a "replacement for the dreams" of his childhood in the ones he experiences in the cinema: "the child . . . in every human . . . is here set free and becomes the master of the spectator's psyche."[52]

Considering that these passages resonate throughout the theories and reflections of the Weimar *Kino-Debatte*, we can suggest that the flaneur's writings not only reveal the unconscious reveries that reality sets into motion, but they also enter very distinctly into contemporary theories of film. Arising from the secret realms of the unconscious, the flaneur's evocation of the child's magical experience calls forth a hypnotic fascination that temporarily suspends the adult's consciousness and understanding of the world as purpose and intention. Rather than follow a set of linear trajectories or prescriptions for action, the flaneur-spectator abandons himself to the seduction of suggestive physical images. This abandonment to the absolute presence and experience of "space and temporality" names the formative moment in both cinema and flanerie, linking the "hypnosis of spectators"[53] to an altered state of expanded consciousness in films of the screen and the street. As Kracauer observes, the streetwalker as well as "the moviegoer is much in the position of a hypnotized person. Spellbound by the luminous rectangle before his eyes . . . he cannot help succumbing to the suggestions that invade the blank of his mind" (*TF*, 160).

Approaching the flaneur's intensified sensitivity from yet another angle, we can note that his general receptivity to the images, structures, and surfaces before him also carries the sensory and sensual indices of an erotic susceptibility. These indices are legible in the excitement that attended both the reception

of the new media and the various debates about the early cinema—both of which were deeply affected by the stimuli and sensations offered in the darkness of the movie houses.[54] A libidinal rhetoric can be read throughout Kracauer's *Theory of Film*. The text is traversed by metaphorical descriptions of an ultimately erotic relay and communion with what was already perceived as the most sensory medium of art. In this respect, Kracauer formulates aesthetic desire in terms of an "aesthetic craving." He registers this desire and craving in the distinctive effects of the "filmic" medium. Kracauer writes, for example, of Wright and Watt's film *Night Mail* (1936) as a film that is directed under the auspices of a "devotion to the hieroglyphs of the train" (*TF*, 203ff). Associating this moving icon of both modernity and film with their libidinal movement, he formulates his theory of film within the context of this latently erotic awareness, this acute openness to every phenomenon of reality.[55] In other words, his sensitivity expresses itself in an emotive rhetoric that figures the gaze as a move that caresses and thereby accentuates the objects of reality. As he notes, "the camera dwells on them tenderly; they are not meant to stand for anything but themselves." This "devotion to the natural world" (*TF*, 204) registers the era's desire for a certain intoxication, expansion, and dissolution of the self beyond its limited rationales and functional fortifications. What the spectators, in Kracauer's view, "really crave is for once to be released from the grip of consciousness, lose their identity in the dark, and let sink in, with their senses ready to absorb them, the images as they happen to follow each other on the screen" (*TF*, 159ff).

Filmic reception therefore can be understood in relation to an erotic receptivity that is moved by the spectator's desire to "lose" his identity in the "dark." This desire is in turn linked to the process of flanerie, that is, to the ongoing seduction of a visual realm that is experienced as a series of images that "follow each other" in linear sequences. The seductive pull of this scopophilia epitomizes the intensity that the flaneur seeks. Leaving behind purposes and intentions, he drifts through the labyrinths of the "secret" city, transporting a trope of unconscious desire that places the viewer where "the movement from the images flows over him," that immerses the spectator in the cinema of the city. This state of receptivity is induced by the presence and plurality of images whose eroticism is suggested by Balázs when he speaks of "the sensory experience of pure existence."[56] This sensuously sensory presence of things calls forth an intoxication that emerges from the sheer awareness of life. As Balázs describes this effusive state, with only seemingly hyperbolic precision: "The visual feeling out of things increases into an intoxication of the highest feeling of life."[57] This intense identification between the filmic image and intoxication quickly leads to tropes of physical inebriation, particularly in Balázs's writings on film, which often associate the abandon of rational control with an excessive "drinking of images." The image for him is a kind of seductive "image poison"[58] that induces a state of mind whose movement recalls the surrealists'

approach to the world: moviegoers and streetwalkers are the very "image-drinkers" that Aragon claims abandon themselves absolutely and indulgently to the images of reality: "This vice called surrealism consists in the immoderate and passionate use of an image-drug, or rather in the uncontrolled conjuration of the image for its own sake."[59]

The passage from Aragon's surrealist manifesto implies a relay among the dynamics of flanerie, addiction, and the reception of filmic images.[60] Surrealism and film represent specific modern gestures that turn toward the image in order to define their new sphere of experience, and to do so in the face of an increasingly anonymous, repetitive "bland emptiness of reality, [an] emptiness [*Öde*] from which alcohol also leads a way out. . . ."[61] This heightened sense of existence is ascribed to the "drug" of the image, to the drug that is the image, even as the rhetoric of its addicts retains an ironic and critical awareness of such excesses. The "passionate" use of this "vice" is regarded as a hedonistic abandonment to the image "for its own sake," an abandonment that threatens the "control" and "moderation" required to organize the masses of modernity.[62] Moreover, the new media of spectatorship, film, and flanerie answer to specific modern discontents: the destruction of experience and a lack of participation is compensated by an intense scopophilia, by a form of spectatorship that "at night . . . satisfies the hunger for images in the cinema."[63] This inordinate and extensive "hunger for life" even takes on the guise of a kind of cannibalism, a "sort of 'hunger for people' " (*TF*, 169). It is the symptom of the increasing melancholy and alienation that define modernity. The individual seeks an antidote to this melancholy and alienation in its subjective "addiction" to images.[64] The ways in which this new obsession fills the void of the melancholy that works as a psychological constant in flanerie are apparent in Hessel's narrative of the young Behrendt who, leaving his house, turns toward flanerie in order to evade suicide.[65]

This generation's ensuing intoxication with the image is experienced most intensely in the cinema and street, which work to provide a welcome suspension of the "emptiness of being"[66] that Hugo von Hofmannsthal suggests haunts the modern melancholic. The flight into flanerie promises access to a sudden mania and excess of stimulation that can deflect this inner depression into an appreciative redemption brought on by phenomena found outside the self.[67] Originating in the alienated individual's introversion, the melancholic gaze displays considerable affinities with the gaze of the disinterested and detached camera, whose lack of emotion renders it "the ideal photographer . . . the opposite of the unseeing lover" (*TF*, 15). Just as photography may be, according to Proust, "the product of complete alienation," flanerie provides access to the world of images that is now available to the modern melancholic. In his preface to the *Theory of Film*, Kracauer declares an "intimate relationship between melancholy and the photographic approach in an attempt to render visible such a state of mind" (*TF*, 17). The affinities between melancholy and photography

predispose the flaneur's identification with the films of reality, a version of which he enacts in his "aimless" strolls and daily "drifting" in a sea of images. Kracauer therefore describes filmic reception as a movement of mental vision that is akin to processes of flanerie: "as [the melancholy character] proceeds, his changing surroundings take shape in the form of numerous juxtaposed shots of house façades, neon lights, stray passers-by, and the like."

If flanerie constitutes (itself as) an ongoing film of the realities surrounding the spectator, it is because the mechanisms of this film are projected on the surface of a self that has become empty and devoid of meaning and substance, a state that corresponds to what Freud sees as the melancholic frame of mind: "In mourning," he tells us, "it is the world which has become poor and empty; in melancholia it is the ego itself."[68] This void in modern subjectivity hungers for a way to encounter the world and its plenitude of sensations. Drawing an entire world of exterior reality into the blank of its interior mind, it turns toward the "objectivity" of things and images in order to lend some resonance to the senses of this emptied "subjectivity." Speculating on the relays between the image and the psychic presuppositions of spectatorship, Kracauer suggests that melancholy "favors self-estrangement, which on its part entails identification with all kinds of objects. [The spectator] is likely to lose himself in the incidental configurations of his environment, absorbing them with a disinterested intensity no longer determined by his previous preferences" (*TF*, 17). The flaneur's aimless "susceptibility" and psychological predisposition to assume the "role of a stranger" responds closely to the alienation of established meanings and conventional directions that prevails in modernity. Kracauer goes on to speculate that "like film, the novel aspires to endlessness" since both of them are the forms "of expression of a later age which no longer knows of ultimate meanings" (*TF*, 233). These "forms of expression" come to the surface in the texts of flanerie. Surrounded by what he calls, following Durkheim, "the 'ruins of ancient beliefs' " (*TF*, 288), Kracauer perceives the man of modernity to be "ideologically shelterless," cast out in a subjectivity that is likely to give itself over to "that stream of things and events which, were it flowing through him, would render his existence more exciting and significant" (*TF*, 169).

Facing a fundamental "disintegration of beliefs and cultural traditions," an entire landscape of presumably meaningful constructions in ruins, the sensory surfaces of these structures in decay become the very touchstones of a new "modern mythology,"[69] one that the flaneur experiences and defines in his ambulatory philosophy. Kracauer observes in his sensory theory of the filmic medium that the rationalization and technologization of modernity have led to, as Kaes has called it, "the sensory deprivation of wide classes of society."[70] As alienation in labor corresponds to the isolation of an urban anonymity, this estrangement from existing purposes calls for a detached but attentive perception of these structures. An author of the Weimar *Kino-Debatte* observes this shift of subjectivity in many bourgeois biographies of his time: "Man, who

still only feels himself in fragmentary ways, has the drive" to gain a wider perspective on [*überblicken*] the other fragments of this modern "existence" [*Daseins*].[71] In the absence of a meaningful integration with reality, the pursuit of experience for its own sake increasingly defines the flaneur's effort to overcome this melancholic crisis of meaning. The instability of meaning in modern life induces a state of acute alertness and attention that is only increased by the gaze of skepsis, speculation and suspicion. Working to alleviate the alienation of its times, the scopophilia that informs both flanerie and film serves to satiate an underlying "hunger for experience" with the inebriation of the image. As Kaes suggests: "Cinema as a substitute for reality seemed to increase in importance to the degree that the alienation from that reality was growing."[72]

As we have seen, Kracauer's view of flanerie forms one of the most significant steps in this process, an attempt to address the craving for experience and the hunger for images through a perception of the sensory surfaces of reality. As Kracauer notes, "only in deliberately scrutinizing, and thus estranging, the room" (*TF*, 55) can modern subjectivity enter these formative spaces with a gaze whose detachment reflects its alienated situation. Seeking to "alienate our environment in exposing it," Kracauer tells us, this gaze of modernity participates in a process that captures its multiplicity in its images.[73] Working to alienate, that is, to defamiliarize—and thereby make both remarkable and memorable—seemingly familiar phenomena, the visual media work to refamiliarize our experience with some of its forgotten materials and visual features. They provide a "redemption of physical reality" that serves as an antidote against the alienation that governs the systematic acceptance of the rationales and functions of abstract structures.[74] Balázs speculatively formulates the subversive potential of visual experience in a way that is consistent with the manner in which images are received in film and flanerie. He writes: "Film is the art of seeing. It is therefore the art of concretization. Film resists . . . the murderous abstraction which in the spirit of capitalism has reduced the things to commodities [and] prices."[75]

As a process that is predicated on such "concretization," that explicitly seeks to reduce the "abstraction" of modern society, flanerie emerges as an "art of seeing" whose "inherent tendency therefore presses for uncovering and unmasking."[76] The primary aim of the flaneur's spectatorship is the reception and perception of sensations in their sensory qualities. The focus of this "redemption of physical reality" is defined in terms of a perception that, as Kracauer suggests, would not be organized "around an ideological center toward which all its patterns of meaning converge" (*TF*, 221). At once sensory and acutely sensitive, materially suggestive and evocative, the act of perception experienced in the media of film and flanerie liberates its spectators from what Kracauer also calls the "abstractness" (*TF*, 296) of modernity. This process of liberation corresponds neither to regressive detours nor nostalgic returns but to avenues that visit and revisit for visual consideration a multitude of stimuli,

images, and objects from the streets of modernity. For these theorists of film and flanerie are neither part of a teleological movement nor an escape from political realities, neither a program of observation nor a method aiming at a naturalistic representation of the world. Rather, as Kracauer views it, they are part of an encompassing "approach to the world, a mode of human existence" (*TF*, xi). According to Kracauer's theory of film, this way of seeing—a way of seeing to which flanerie belongs—consists in a passionate effort to redeem the infinite phenomena of reality, to preserve their presence permanently within the act of perception. What flanerie projects into the mind as a film of reality is nothing less than what Hofmannsthal has called a "replacement for dreams" in the era of modernity. In cinema and flanerie there is still a way for "humans [to enter] into an immediate relationship [to] life,"[77] even if, paradoxically, it is through a cinematic simulation of reception that would be more immediate than its more or less mediated images. In accordance with the speed of his own pace and reception, the spectator casts a gaze toward these images that is free to observe and reflect the visual "life essence"[78] of modernity.

FILM THEORY AND THE FEMALE FLANEUR

These tendencies to experience the world as a "chest of miraculous bric-a-brac, [as] the cinema," both reveals and conceals a number of points that have thus far remained unattended. The following passages may illuminate this constellation further, offering as they do a preview to a gendered, but not gender-exclusive reflection on flanerie. The theoretical positions of Yvette Biro's *Profane Mythology* will serve as the first step toward a discussion of the status of women flaneurs in the public sphere.[79] This female perspective of a theory of film focuses—like Kracauer—on the multitude of impressions and experience of stimuli that also describe the ongoing process in the flaneur's mind.[80] Biro in particular registers the excessive "curiosity," the "hunger for experience" that characterizes the flaneur's cinematic quest. Distinguishing the stimuli to be received and recorded, the camera and the flaneur alike engage in selective processes that seek to stay in close contact with their materials.[81] Linked to the elements of the filmic process that Biro highlights, flaneuristic sensitivity signals a quasi-erotic receptivity that facilitates a democratic transparency as it also serves as the condition for a filmic redemption of reality. Biro links this intense sensitivity to the materiality of things, to a materiality that moves both the camera and the flaneur to an ultimately erotic regard for exterior reality.

Touching the world with his eyes in a detached but always attentive gesture, Kracauer, in the rhetoric of his *Theory of Film*, remains faithful to this passionate engagement with the sensations of the world. Biro returns to these sentiments, suggesting again that the medium tenderly touches and outlines reality even as "the film neither judges nor moralizes" (*PM*, 20). Recalling Hessel's

demand that we "judge less" and "describe more," Biro's insistence on a non-judgmental way of proceeding prepares the way for an engaged appreciation of whatever sensations the world holds for us and encourages our intense desire to experience its images. This sense of wonder translates into a sensory amazement that allows the redemption and transformation of seemingly mundane and marginal aspects. Biro suggests that these transformative powers are the medium's primary experience: "In the cinema the most profane human activities ... appear as extraordinary and comprehensive experiences" (*PM*, 80). The redemptive inclination of the medium touches the surface of things with an attentive gaze and passionate susceptibility that engages the very existence and materiality of visual structures. As Biro emphasizes, the cinema opens those "wide open spaces" of experience in order to allow for perceptions and dispositions that are "charged with strong eroticism" (*PM*, 83). This eroticism is woven through the writings of film's most dedicated theorists and practitioners. Suggesting that the medium is always "touching the skin of things" (*PM*, 132), for example, Antonin Artaud touches on the tangible materialities that underlie film's capacity to unfold its observations with presence and precision. Long takes and extended tracking shots help the eye and the mind explore structures and materials in accordance with the movement of the camera, a movement that lingers patiently on the sensations it encounters, staging in metonymical contiguity an ultimately erotic means of approaching surfaces and appreciating textures.

In so doing, film approaches an elevated state of experience. It enables a celebration of images by an enraptured viewer who opens his eyes to these "profane illuminations" in a nuanced and attentive light. This eroticism of filmic viewing is closely related to a field that Biro charts among the trajectories of film, a realm whose political implications may at first appear to be removed from this eroticized sphere. The film allows the spectator to see the world in an altered state and with new eyes. In this state, Biro notes, "everything appears to bear a new, unusual stamp," citing one of Brecht's early observations on the medium. These modes of sensory susceptibility, this changed presence of mind, suggest film's revolutionary, even utopian potential. The profoundly democratic nature of filmic experience and its concomitant phenomena therefore gives way to new perspectives. Arts that come from the streets in both a literal and material sense, film and flanerie privilege a space that is accessible to everyone in the public sphere.[82] A contingent metaphor for the passage through filmic spaces, the street shares the democratic propensities of a medium of which Biro claims, "everything seems to be on an equal level of importance, making the film [and flanerie] a most beautiful example of metonymic writing" (*PM*, 100). This mode of writing valorizes as it links equally all the phenomena it encounters and describes. It enacts an ultimately democratic approach, as Biro understands it, "in which the debris of life, disdained and discarded objects, demanded a place on the palette" (*PM*, 56).

Film and flanerie bring these ephemeral elements to the fore, and in so doing, encourage an ultimately revolutionary means of seeing within their respective media.[83] The process that imprints both filmic and written texts with images therefore names an impulse to record, and a desire to "make lasting what is ephemeral, to preserve in material form what passes on in time" (*PM*, 7). The acute sensory presence of this present simultaneously represents the democratic propensities and material qualities of its objects.[84] This process of "metonymic writing" links the structures of walking and writing to those of seeing and recording, giving way to a succession of images in the cinematic chain of a text.

The affinities between film and flanerie include modes of modernity that share a field of vision—the city, the public sphere, "the realm of the everyday." Writers and directors approximate everyday life as a series of images and render it in an imprint of ink or in traces of cinematic chemicals, thereby capturing "an imprint of something that has already happened" (*PM*, 7). The medium of photography—with its extensions in film and flanerie—"becomes a metaphor for all kinds of recordings," Biro observes. Film and flanerie are driven "to make lasting what is ephemeral, to preserve in material form what passes on in time."[85] The films that most inspire this impulse—and theory—of the cinema invoke an intensely sensory experience which characterizes the filmmaker or flaneur-writer, who is now "defined by the way she, in her own way, assimilates the outside world" (*PM*, 64). For example, Biro discusses Agnes Varda's *Cleo From Five to Seven*, a film that presents a woman director's recording of a woman flaneur's experience in the early evening of the city, a narrative premise and time of day that directly evokes the strolls and subjectivities of flanerie.[86] The modes of reading and writing that these female flaneurs—protagonist, director, and theorist alike—pursue in reality follow an aesthetics of film that extends the perspectives possible for women in the street and on the screen.[87] Revealing a flexible, sensitive, highly impressionable and impressionistic style, they inscribe the very details, images, and constellations of exteriority onto the screen of their texts.[88] Biro recognizes in their "invisible and reserved articulation"[89] what she calls "the most particularly poetic method of the film" (*PM*, 85), a poetry that leads each medium to delineate its respective visual discoveries "by situating its elements in each other's 'neighborhood.' " The pursuit of experience structures the process of flanerie and this poetics of the cinema: the wanderings of the director-flaneur seek out a succession of sights situated in visual "neighborhoods," locations in their own material right, embedded in particular metonymic "vicinities," a series of images in which one vision and impression is successively followed by another.

Flanerie redeems this succession of images by inscribing it into its texts, translating the passage of visual impressions from perception into the linearity of language. In other words, the camera replicates the very process in which the writer's pen goes over her flaneuristic perceptions, lingering over certain

impressions, forgetting or omitting others, condensing time in the moment of writing.[90] With their close relays to life and its experiential materials, the writings of film and flanerie are more about the process of perception than about anything else. Their "exceptionally patient biding of time" (*PM*, 88) displays a perseverence that insists on vision as the condition of experience in general.[91] As Biro observes, the camera of this kind of cinema "photographs what is *not* worth noting." In so doing, it moves like the flaneur who revisits images that are usually not—or not to be—seen, who retrieves from the inner life of the exterior world a kaleidoscope of secrets that become transparent through the everyday surfaces of modernity. We could say that film and flanerie each mediate an unspoken plenitude of perception and intensity of experience. They memorialize unseen impressions and overlooked constellations in modernity, images that in turn subvert superficial and stereotypical views of the public sphere. They introduce us to an art of the visual and the sensory. This is why, in its visual experience as well as in its projected "redemption" of the physical sphere, flanerie is a philosophy of modernity, one that many theorists of film implicitly relate to their medium's infinitely open film of perception. In his *Theory of Film*, Kracauer speaks of this flaneuristic sense of film in a manner that emphasizes both the transitory quality of phenomena as well as the sensory impulse to redeem them. He expresses an intense respect for the profane mythology that both film and flanerie seek to experience: "Snatched from transient life, [these images] not only challenge the spectator to penetrate their secret but, perhaps even more insistently, request him to preserve them as the irreplaceable images they are" (*TF*, 257).

Part Four

FEMALE FLANERIE

Walter Ruttmann, scenes from *Berlin. Die Sinfonie der Großstadt* (Berlin, the Symphony of the City). Courtesy of J. Dudley Andrew.

Women on the Screens and Streets of Modernity:
In Search of the Female Flaneur

FOLLOWING the course of modernity in the nineteenth and twentieth centuries involves tracing the footsteps of the flaneur as he strolls the streets of Paris, appears in Baudelaire's metropolitan poems, and structures Benjamin's perspective in his Parisian arcades. Both a product of modernity and its seismograph, he represents the man of the streets. He is at once a dreamer, a historian, and an artist of modernity, a character, a reader, and an author who transforms his observations into literary and latently filmic texts. Surrounded by visual stimuli and relying on the encompassing power of his perception, the flaneur moves freely in the streets, intent on pursuing and maximizing his singular experience of reality. What is of interest to me here is that, within the domains of literature, culture, and public life, this unbounded, unrestricted pursuit of perception has been mainly ascribed to men. It is no accident, for example, that Heine and Börne, in *Briefe aus Berlin* and *Schilderungen aus Paris* respectively, take their point of departure from their own physical and tangible presence as men in the city, evoking and facilitating their flaneuristic reflections by observing a contemporary public in the streets. Such unabashed and unadulterated pleasure in the sights, views, and images of the street seems reserved for the experience of male spectators.

Moving through public spaces emerges as a uniquely gendered practice, (almost) exclusively associated with male authors and protagonists. If the art of taking a walk takes many shapes throughout the nineteenth and twentieth centuries, these excursions and experiments are reserved for male perception and authorship. Every one of these flaneurs shares a fascination with images as icons of a modern mythology and an intoxication with the light and structures of the city. Every one of them, however, can indulge this experience of the street only by first freely roaming, unimpeded and unintimidated, as a *male* spectator moving in a space reserved for the eyes of *male* pedestrians. In their intense pursuit of subjectivity and perception, these flaneurs and their gazes are neither restricted by insecurity, convention, modesty, anxiety, or assault, nor by restrictions erected through the controlling or commodifying presence of an other. The possibility of a female flanerie, then, would seem to be absent from the cities of modernity. When Benjamin announces "the return of the flaneur" in 1929, he fails to acknowledge his awareness of the numerous women whom he passes every day in the streets of Berlin and Paris.[1] Kracauer

also moves through his reflections in *Straßen in Berlin und anderswo* without acknowledging that the women he encounters in these public spaces contribute to the *Denkbilder* of his society.[2] In formulating the aesthetic project memorialized in his *Spazieren in Berlin,* Hessel explicitly cautions against walking with women, claiming that they represent a potentially distractive influence on the flaneur's solitary wanderings.[3] This conspicuous absence within male culture moves me, as a female observer and critic, to search for the traces of an alternate form of flanerie, one that might eventually inscribe the presence and potential of a female flaneur in the history of perception. The following speculations on this absence seek to conjure an appearance, to assist us in reconsidering female scopophilia in moving images, and to theorize about the presence of women in public spaces, the female spectator, and a gendered definition of "modernity." In so doing, I hope to sketch a concept of female flanerie that may in turn help reshape the way we think about the spaces of modernity.

WALKING WOMEN

The female flaneur has been an absent figure in the public sphere of modernity, in its media and texts, and in its literatures and cities. From the very first step she takes, her experience is marginal, limited, and circumscribed. This is why female flanerie has no more been considered than its expression in language—and in a concept of its own—has been sayable. In its German usage, the term *"Flaneuse"* suggests what is "typically" female, is associated with "necessarily" menial occupations such as those of the *Friseuse* [female hairdresser] or *Masseuse* [female massage worker], the latter two carrying contingent suggestive and discriminatory connotations. Since the term *flaneuse* comes with this dubious baggage, since it invites unwanted, unwarranted associations, I will try to circumvent it wherever possible. Even so, finding another name for the "female flaneur" or "woman walker," as Meaghan Morris has suggested, has not yet worked to inscribe her presence into the texts or language of flanerie.[4] The female flaneur has not been noted as an image that the canonical authors of flanerie would expect to encounter in the streets, nor as a concept that would give the female flaneur a figure and a term of her own. In the texts, theories, and versions of flanerie mentioned above, we do not and cannot expect to encounter a "flaneuse" in the street.

The question of the presence and representation of women in the streets, however, is neither an academic nor an accidental and marginal one. On the contrary, it suggests a pivotal constellation that may help articulate questions concerning prevailing structures of power and domination in Western society as a direct function of the—gendered—distribution of leisure, time, and status,

that is to say, of the economic, psychological, and physical autonomy and self-assurance of that society's subjects. Since the nineteenth century, flanerie has not only been the privilege of a bourgeois, educated, white, and affluent middle-class but also, above all, has remained a luxury of male society. While their male contemporaries discovered the space of the city as an experience of urban spaces, constituted by ever new and changing stimuli—approaching it with innovative technologies of perception, such as the media of photography and film—women's voices articulate the conditions of a different relation to modernity. These women struggle against the very secluded position that excludes them from the options reserved for men. Rather than celebrate their indulgence in multiple scopic possibilities, women have long wished for admission to the coveted realms of the spectacle, a right of way into the new spaces of flanerie and toward an experience of the images of modernity. Only when chaperoned by companions, disguised in men's clothes, or covered by other means of subterfuge, was this entrance even partially and tentatively possible, as a trial and exception. George Sand's efforts to overcome these obstacles give vivid evidence of the difficulties and prohibitions facing women of her era. Sand realized that she could never fully approach and appreciate the outside world as long as she remained a woman who, in habit and behavior, adhered to contemporary conventions of femininity. Instead, she entered the world as a female flaneur in disguise, functionally outfitted for that purpose in male clothes, in pants and boots. She immediately revelled in the first moments of this escape from the constrictions of a culturally constructed "femininity" that until now had controlled and restricted her every attire and attitude:

> With those little iron-shod heels, I was solid on the pavement. I flew from one end of Paris to another. It seemed to me that I could go around the world. And then, my clothes feared nothing. I ran out in every kind of weather, I came home at every sort of hour, I sat in the pit at the theatre. No one paid attention to me, and no one guessed at my disguise. . . . No one knew me, no one looked at me, no one found fault with me; I was an atom lost in that immense crowd.[5]

The fiction of male identity—constructed here through its exterior trappings—grants Sand the temporary entrance into a realm of considerable, if relative, freedom, opening up a seemingly unlimited, previously utopian mobility, the promise of omnipresent adventure. The realities of many more women's lives during this period, however, were to remain determined and limited by rather different material pressures and psychological factors. This tendency is evident in the public spaces of the nineteenth century and can be traced in its texts. Jules Michelet, for example, testifies in his treatise *La Femme* (1858–60) to the myriad of spatial impediments and obstacles to women's liberty and mobility:

> How many irritations for the single woman! She can hardly ever go out in the evening; she would be taken for a prostitute. There are a thousand places where

only men are to be seen and if she needs to go there on business, the men are amazed, and laugh like fools. For example, should she find herself delayed at the other end of Paris and hungry, she will not dare to enter into a restaurant. She would constitute an event; she would be a spectacle: All eyes would be constantly fixed on her, and she would overhear uncomplimentary and bold conjectures.[6]

Many of these obstacles would remain in the way of women long into the twentieth century. In texts and films from Weimar Germany, idle women are depicted and regarded as prostitutes, and even feminists in the 1970s still hesitate to enter nocturnal streets and restaurants on their own.[7] While the nominal official presence of women in public seemed to increase gradually, it was only with the end of the nineteenth century that the—bourgeois—woman was permitted by society's conventions to walk its streets freely. As Anne Friedberg notes in her search for the origins of female flanerie: "The female *flâneur* was not possible until a woman could wander the city on her own, a freedom linked to the privilege of shopping alone. . . . It was not until the closing decades of the century that the department store became a safe haven for unchaperoned women. . . . The great stores may have been the *flâneur*'s last coup, but they were the *flâneuse*'s first."[8] However, the territories of such preliminary and rudimentary forms of "flanerie"—the preoccupied strolling and shopping of a female consumer—have to be regarded, in view of the vast terrain of existing city spaces, as decidedly circumscribed and distinctly derivative. Limited excursions of shopping in a prescribed ghetto of consumption amount to little more than second-hand distraction, never approximating the flaneur's wide-ranging mode of perception, a mode of seeing unimpeded by aims, purposes, and schedules. The conflation of shopping and strolling noted by Friedberg necessarily relativizes what initially appears as a first instance of the "empowered gaze of the *flaneuse*."[9] Reduced in its potential to the purposefully limited and capitalistically promoted licence of shopping, the early "department store flaneuses" who "roam" the interiors of capitalist consumption represent little more than a bourgeois variant of domesticized "flanerie." They replicate forms of female presence that proletarian women had long since presented in the streets before them. Women workers and housewives had always already entered the streets without ever becoming *flaneuses* in their own right. Instead, the street presented itself to them as a space of transition en route to functional purposes: they would enter the street to shop rather than to "go" shopping, to run errands rather than jog their imagination, to pick up their children without experiencing free-floating impressions, to make their way straight to the workplace.

The public presence of these working women is commonly bound by functions that do not allow for the flaneur's desire to "get lost" or "lose himself" in the spectacle of the street. Beyond the immediate sphere of their duties,

proletarian women, like agrarian wives, in effect rather live "outside" the city, regardless of where they actually work; they are limited to households that remain preindustrial and thereby restrictive in relation to the play of their imagination. To compensate for such confinement, women project all their endeavors into their domestic interiors and become—unwillingly—complicitous with their exclusion from exteriority as well as from new directions of technology, production, and perception.[10] This confinement excludes women from being exposed to the shocks and images of the street and prevents them from developing any immediate sensory relationship to the phenomena of modernity as they are being registered in the street. Other less domestic manifestations of female presence in the street—such as the figures of the prostitute or the bag lady—only further underline the disempowered status of female subjects in the public sphere. The absence of a female flaneur results from a social distribution of power that prescribes the exclusion of women from public presence.[11] Because of the precarious presence of women in the street, the question "To whom do the streets 'belong'?" pertains more to women than to men. Whether the streets belong to the leisured or the working class of society, to its dandies or demonstrators, pedestrians or flaneurs, the free and unimpeded movement of women undergoes additional peril. The street has never "belonged" to women. They cannot walk it freely without also experiencing public judgments or conventions that dictate their images, effectively rendering them objects of the gaze. If women have been considered absent or "invisible," it is partially because they have been removed from the street.[12]

A few critics, however, have taken steps to redress this assumed absence of the female flaneur, finding a tentative presence of women in the street. The feminist art historian Griselda Pollock, for example, scrutinizes the social and historical circumstances of female lives that condition their exclusion from flanerie. She has encouraged us to modify our prevailing understanding that "there *is* not and *could not be* a female flaneuse"[13] into the more cautious observation that there was not supposed to be a female flaneur, and that not many women managed or dared to exceed this prevailing prohibition. Pollock elaborates on the specific restrictions to which the status, gaze, and image of women was subjected in the public sphere: "They did not have the right to look, to stare, scrutinize or watch."[14] While women were positioned as objects and images that passively received the active male gaze, their desire for the freedom of movement can still be read in numerous women's texts of the nineteenth century, writings by adventurous female travellers and explorers who were willing to risk the pursuit of a socially sanctioned scopophilia.[15] Pollock cites Marie Bashkirtseff's efforts to live in nineteenth-century Paris on her own terms. Her vivid description of the struggles that her desire for independence encountered indeed typifies the restrictive circumstances of the society in which she lived as a woman: "What I long for is the freedom of

going about alone, of coming and going . . . of stopping and looking at the
artistic shops . . . that's what I long for; and that's the freedom without which
one cannot become a real artist. Do you imagine that I get much good from
what I see, chaperoned as I am, and when, in order to go to the Louvre, I
must wait for my carriage, my lady companion, my family?"[16] Taking her
investigation one step further, Pollock virtually maps the very real participation
of women onto the spaces of modernity. She revisits the work of female artists
who were present and at work as painters who happened to be women in the
same locations that circumscribe the formative places of Impressionism: "The
key markers in this mythic territory are leisure, consumption, the spectacle and
money. And we can reconstruct . . . a map of impressionist territory which
stretches from the new boulevards via Gare St. Lazare out on the suburban train
to La Grenouillère, Bougival or Argenteuil."[17] The mere presence of women in
the same urban spaces previously occupied only by men creates impression-
able minds and transforms women artists such as Berthe Morrisot and Mary
Cassatt into Baudelairean "painters of modern life."

While the woman stroller is as evidently present on metropolitan pavements
as her male contemporaries, she requires an additional measure of physical
and psychological confidence: the courage to step out, to face the threat of
assault or being taken as a prostitute, in short, to endure the risk of being
transformed into an object. Despite the real material limitations on women's
access to the street, their very presence in public spaces indicates their desire
and determination to experience the city on their own. The precarious status
of this quest—however unchronicled and unacknowledged its struggles have
been in our cultural memory—can be framed by the following two statements,
made by women living a century apart. On January 2, 1879, Bashkirtseff notes
in her diary her experiences with the streets of Paris: "What I long for is the
freedom . . . of walking about old streets at night."[18] More than a century later,
the *Oxford Mail* on November 9, 1979, announces that the state of things for
women in the street has not changed: "Any woman walking alone after dark
invites trouble."[19] Considering the relation between women and public space,
feminist sociology has suggested that there is a "basic asymmetry" in the gen-
dered distribution of physical and psychological power. This asymmetry re-
sults in unequal and inimical constellations that render women the more likely
victims of rape, assault, intimidation, and other forms of harrassment. Such
latent and manifest factors must, as Shirley Ardener declares, necessarily have
"a bearing on how women use space . . . and must be considered when the
question of women's use of space is discussed."[20] Women's specific use of
space has historically been marked by anxieties and limitations that make them
go about their daily matters in a more cautious fashion than men. Restricted
to the home, limited to functional forays into the public, forced to forego the
lure of aimless strolling, women are unable to indulge their full fascination
with the metropolis, especially at night, when any excursion in the city may

mean, beyond hidden revelations in the street, the more manifest danger of attack. This fundamental anxiety is inscribed into women's experience of public spaces and remains a scarcely changing constant, a continuing "containment of women"[21] that curtails their access to the street. The concomitant politics of a "women's movement" must be understood in its extended literal implications, lifting the term "movement" from the status of mere metaphor to a factor that must be taken seriously in its immediate materiality.[22] When Adrienne Rich investigates the factors that determine the dominant socialization of women in patriarchal societies, the material conditions of appearance and movement largely determine women's diminished existence. She asserts that the prescription of female movement is exercised as a pivotal measure by societies that have always, in one form or another, attempted to restrict women's rights in order to contain them within secluded and subdued positions:

> Characteristics of male power include the power of men. . . to confine [women] physically and prevent their movement (by means of rape as terrorism, keeping women off the streets; purdah; foot-binding, atrophying a woman's athletic capabilities; haute couture, "feminine" dress codes; the veil; sexual harrassment on the streets).[23]

These physical and material obstacles are reinforced by means of a psychological containment that often reveals itself in internalized forms of (self-)control. It works to impede the mobility of women, to restrict their gaze, to censure their public presence, and to stylize their images into displays. Gertrud Koch describes the status of female images as the "desired objects of male voyeurism" and suggests that the subjects behind these objects "had to hide their own desires behind their veils, the bars on their boudoir windows, their expensive and time-consuming make-up rituals."[24] While the history of this inequality in the distribution of power prevails, these relations between subjects that look and objects that are looked at, between the spectator's subjectivity and a woman's status as image and object, have come to be gendered and are not easily reciprocal nor reversible. Confronted with a social environment in which they cannot be present as undisturbed observers, as they themselves are made the "natural" objects of observation, women are excluded at once from public presence and spectatorship.[25] This constellation suggests that the absence of female flanerie results not from any individual lack or incapacity but from the crucial blind spot of a society that exposes the limits and conventions imposed on women's lives.[26] While the most obvious restrictions on women have been removed in order to integrate them into the domain of specific business functions, to adjust their traditional roles in terms of a changing economy, their status as an overdetermined image carries these same socially restrictive and restricting expectations into the present.[27] Men still habitually "check out" and evaluate women's images, in a casual yet consistent cultural ritual that continues to make women's presence in public spaces a precarious and volatile one.

Despite women's formal equality and democratic rights, the uninhibited and unobserved presence of a female person in the streets is not a self-evident right. Spaces that are unequivocally free and safe to female movement have yet to open up psychologically. The phenomenon of female flanerie remains an exception.

The female flaneur still encounters a degree of scrutiny, attention, evaluation, judgment, prejudice, suspicion, and harrassment that her male predecessors and contemporaries do not. Even a self-confident flaneur and feminist in contemporary Berlin continues to be self-conscious in the streets as she is forced to delineate her experience of the city in terms of various strategies for survival: "Cities are no longer forbidden spaces. . . . But in the streets, we continue to move strategically, always alerted to having to justify our presence. We learn self-assertion, we practice . . . the purposeful walk, which is to demonstrate that we are protected and bound: at least bound by an agenda, on our way to a secure location, to a job, to a clearly defined aim—and that we are not just loitering around."[28] Pollock reinforces this point when she notes: "The spaces of femininity still regulate women's lives—from running the gauntlet of intrusive looks by men on the streets to surviving deadly sexual assaults. In rape trials, women on the street are assumed to be 'asking for it.' "[29] The realities of women's public lives require that they navigate an obstacle course between their theoretically assured rights and the practical liberties that they can really hope to assume. Their movements in the street remain restricted and organized by "invisible fences,"[30] contained by imaginary yet socially sanctioned boundaries that redistrict their "social maps," even after the most "concrete" restrictions of female roles have been removed.[31] Even acutely aware and critical female subjects have been unable significantly to change the terms on which their images are perceived in the street, the codes and judgments of a culture that perceives them as objects. As long as a woman's movement in the street requires more self-determination and self-confidence than a man's, female flanerie cannot really come into its own.

NEW WOMEN IN THE CITY

Within this context, the period of Weimar Germany enabled a crucial reformulation of a feminist consciousness at the same time that it registered the obstacles that women continue to encounter in the streets to this day. Weimar Germany witnessed an avant-garde women's movement in Berlin faced with the patriarchal relics of Wilhelminian society. This confrontation of the prevailing status quo with a new and liberated women's movement yielded an open moment of modernity, a dynamics that is apt to illuminate the very contradictions that both orient and impede the movement of women. As Patrice Petro has

pointed out, the growing visibility of Weimar women in the public sphere and in male domains of labor after the turn of the twentieth century was met with defensive reactions and exclusionary measures on the part of official organs seeking to regulate women's access to, and participation in, social spaces. As late as 1908, "German law prohibited women from attending public meetings or joining political organizations."[32] Such official sanctions went hand in hand with artistic and intellectual discourses that, while otherwise critical of existing ideologies, maintained their traditional blind spots toward women's public existence.

Benjamin's scrutiny of historical and cultural phenomena, for example, continues to proceed in a way that decidedly overlooks female flaneurs in the streets.[33] As perceptive and innovative as his reflections are in their approach to the shifting modernities of the nineteenth and twentieth centuries, he consistently ignores one of the major formative factors in the public sphere of those times: "His apparently gender-neutral concept of 'the masses' . . . elides any discussion of female subjectivity."[34] And this even though the era of Weimar modernity and its theoretical debates offered the spectacle of an increased female presence in the streets as well as rapid changes in gendered patterns of employment. This open window for the entry of women into the public sphere is illuminated in a series of reflections from the memoirs of author and psychoanalyst Charlotte Wolff, a contemporary of both Weimar Germany and our time. In the following passage, she reflects on the changing and contradictory conditions of the Weimar Republic, a time when traditional opinions of women's roles began to clash with women's own expectations for their lives. For the first time, a gendered nonsynchronicity arises in society about the ways in which to define women's roles: "Who were we and all those other young women of the twenties who seemed to know so well what we wanted? We had no need to be helped to freedom from male domination. We were *free*, nearly forty years before the Women's Liberation Movement started in America. We never thought of being second-class citizens."[35] Wolff belongs to what she herself recognizes as an "international avant-garde" of privileged, educated, bourgeois women. She not only frequented the circles of Berlin intellectuals and artists but also introduced Benjamin to Hessel and strolled the streets of Berlin as a female flaneur along with her male contemporaries.[36] Yet even women who did not partake in Weimar's theoretical debates became increasingly visible in the metropolis: they gained mobility and independence through their work outside the house; riding cars, taxis, and subways, they determined their own paths.

Moreover, women in Weimar were now addressed specifically as privileged audiences for the new media of photojournalism and film.[37] Weimar Germany and its metropolitan capital became the sites of a spectacle in which both the consumption and production of the female image reached a heightened pres-

ence, engendering a new stage in the critical reevaluation of the female image. I wish to read this decisive turn in relation to one of the pivotal artefacts of Weimar society, and to do so in order to describe this transformation of the female image from the point of view of a flaneuristic culture. Images of progressive Weimar women are already captured in the most progressive medium of their times, the moving pictures of early cinema. Cinema in fact offers us, after centuries of male flanerie, some of the first signs of the female flaneur, suggesting the many ways in which she is already present in the scenes and sites of the metropolis, even if she has been overlooked. A unique document of modern scopophilia, recording the city of modernity with the most advanced medium of its times, will provide us with a promising point of departure in our search for the ostensibly absent female flaneur.[38]

Walter Ruttmann's *Berlin. The Symphony of the City* (1927), a city film from the times of the Weimar *Kino-Debatte*, shows an era passionately engaged in, and defined by, the cinema and its new discourses.[39] While Ruttmann's metropolitan symphony is not a production of "feminist" modernism, it does present multiple images of a "new" woman on the screens and streets of modernity, illuminating the multifaceted presence of women in modern spaces.[40] One scene in particular provides a striking commentary on the question of the female flaneur, highlighting the predicaments that the woman-as-streetwalker may encounter: a woman who literally "walks" the boulevards of Berlin and turns a street corner in the *Symphony of the City* focuses her gaze on a man through a shopping window. Her assumption of an active gaze provides a critical turning point for the urban woman as spectator. Her behavior can be regarded as one of the first visually recorded manifestations of the long-absent female flaneur. In previous criticism of the film by male critics, this woman walker has commonly been considered as a professional walker, a woman who goes after her business as a "streetwalker." In 1947, Kracauer describes these street scenes of the film and comes to the following conclusion: "The many prostitutes among the passersby also indicate that society has lost its balance."[41] By 1982, William Uricchio's analysis of these scenes has not advanced much: "After several shots whose common element involves streetwalkers as a subject, a specific mating instance is presented. A prostitute and potential customer pass one another on the street."[42] Juxtaposing these two accounts with a recent description of this same scene by a female critic, we can observe a case of gendered spectatorship. While Uricchio repeats Kracauer's account of the scene as a scene of prostitution, Sabine Hake sees a different action taking place: "The camera almost seems omnipresent . . . following several young women on the streets by themselves: one as she is being picked up . . . another as she waits impatiently at a corner, and yet another as she window shops on elegant Kurfürstendamm."[43] The striking discrepancies in these accounts ask us to take another look at the female image in Ruttmann's film.[44]

A new reading of this metropolitan text might indeed discover a literal female streetwalker, a new figure of subjectivity free of professional purposes other than her own processes of walking, seeing, and potentially recording these actions: a *femme flaneur*. As the critical reception of the female image in *The Symphony of the City* reveals, however, any woman walking the streets on her own, even in the presumably emancipatory age of Weimar Germany, has first to justify, assume, and establish her stance of flanerie.[45] When a woman signals the flaneur's aimless and purposeless drifting along the streets, she risks being perceived as a "streetwalker,"[46] as the object of a male gaze. One of the earliest scenes of the film sets the stage for this mise-en-scène of female images. After the camera establishes the metropolis in spatial terms—trains, tracks, and telephone poles—it continues its sequence of abstract, architectural, and inanimate shots by panning forward and around a corner, past a shoemaker's store (a prime site of production for the film's ensuing fetishism), and comes to rest on the first "human" figures singled out by the camera, a group of women models behind a window. Each mannequin is frozen in a static pose, exhibiting its attire, a single slip that barely covers its puppet body. It is rather apparent from this scene what the intended object on display is: the item of apparel attracts the gaze less to this showcase than to the overall assemblage of female figures. The next shot hints at a partial consequence of this display—the image-status of female existence—as it cuts to the stark picture of water running under a bridge, a bridgepost erected as the marker of future death, a proleptic image of the drowning suicide that comes as a woman's self-destructive act at the dramatic center of the film.

The Symphony of the City revisits similar locations in many instances, focusing on window shots and the display of women's bodies as images. One of these scenes presents a frontal view of the mannequins' plastic surfaces on which we see, inscribed in mirrored reflections on the women's motionless bodies, the store signs that signal ownership. These artificial and simulated female bodies are clearly defined, through the reflection of light, as properties to be displayed and as circulating commodities on the market.[47] However, their own gaze does not seem to be present in this scene, as their complete figures and faces have no part in this picture. While the women are all parts, they also remain impartial and quasi-resistant to their display as an image. In what seems merely a nod at a fashion pose, they ironically raise their twisted plastic hands. A man is seen strolling by the display. Perhaps a flaneur, with the sufficient leisure and visual desire to pause in front of the window, he contemplates the display for a moment, considers it, dismisses it, and walks on. Similar scenes follow this prototypical situation of the public display and evaluation of women's images. On the runway of a fashion show—presenting the small-scale model of an artificial "street"—women circulate within the confines of their modelled and modelling walk, a form of movement that sells

women's bodies and images. This fashion scene is preceded by the film's most desperate act, a woman's suicidal jump from a bridge, which takes place at precisely the same location as the previous exhibition scene with its fore-shadowing water shot.

A narrative of women's lives is suggested that seems to connect their exis-tence in the city to the ways in which their images are exhibited and exploited in it. The film pursues an implicit logic from the first scenes with women as models, instruments, and coat hangers of capitalism, images on display as well as commodities for sale, to the crucial cluster of street scenes where a leisurely strolling woman is perceived as nothing but a marketable image that presum-ably substitutes for her body and persona. The woman in the street is, in social and cultural terms, mostly an image, a commodity trying to sell herself. Look-ing at the scene more closely, however, we discover that this presumed pres-ence of prostitutes instead reveals a multitude of individual women walkers. Indeed, any scrutiny that is more attentive to the presence of women finds that these scenes are not (at) all sites of prostitution but are instead inhabited by at least four distinct female figures. The first of these women is introduced as she looks out over the street, seemingly surveying the scene. She is shown in profile with a grey hat that leaves an open space next to her view for the spectator's own gaze to take in the long shot of a street scene surrounding her figure. Her striking image is but a glimpse of a potential female flaneur who would scrutinize the city, as the symphony cuts from her gaze immediately to that of yet another "other," the image of a black man surrounded by a small group of pedestrians.[48]

Along with this sequence of visual "suspects" on the Weimar scene, the camera proceeds to capture the image of another woman who walks by slowly, wearing a different hat with a band. She is already in the company of a man when she appears on the scene, with no markers of a commercial transaction or solicitation defining their association. Independently of her two predecessors in the street, a third woman strolls by on the far edge of the sidewalk. She sports a white hat and a curious gaze, which she directs with admitted interest upon her fellow pedestrians in the crowd. No other signals allow us to define her specular intensity as either professional or aimless flanerie, leisure or prostitu-tion. A fourth woman in a black hat completes this sequence. Her swaying walk has continuously elicited clichés from male spectators to whom her sensual flexibility has suggested nothing if not the "coquettish," self-advertising stroll that they associate with prostitutes. This female image is the instant suspect who turns the corner and gazes back at a male pedestrian, using the 90-degree-angle through the shopping window as much as a reflective mirror as a window, a transparent surface of specularity. Her interested gaze is commonly inter-preted as so provocative that it presumably causes the man to retrace his steps around the corner to join her. Yet, if we review the scene more closely, without immediately assuming that the woman with the active gaze is a prostitute, we

find the woman with the black hat walking off by herself. It is perhaps even a different man who subsequently walks by with another woman at the other side of the window, a couple that, viewed through the lens of convention, is composed of a prostitute and her client. In its images, however, the scene suggests a new presence of women in the street, requiring an attentive analysis to reveal an instance that confounds rather than confirms preconceived notions of women who walk and look in the streets.

Upon closer inspection, *Berlin. The Symphony of the City* represents many facets of the status of women in the modern city. Their walking down the street opens a space for the female flaneur, develops the improbable and *unheimliche* presence of a woman in the street as a more complex spectacle and presence than conventions would have us expect. In this film, women shop, stroll, go to work, sit in cafés, and observe the crowd. However, even these manifest images of public women continue to be contained by male interpretations. Considering women in public places as professional "streetwalkers" only replicates and prescribes the clichéd images of women who walk in the street, women who participate in the public spectacle. The previously limited roles of women in the streets, circumscribed en route to department stores and work-places, for purposes of shopping and working only, are juxtaposed and directly related to an interpretation that collapses a variety of filmic figures into that of the prostitute, a mere commodity. By way of selling herself, the figure represents an inverted function of both "shopping" and "working," the two accepted female activities in the public sphere. From the nineteenth century to Benjamin and his contemporaries (the spectators and participants of this "symphony of the city"), the prostitute represents the only conceivable form of female presence in the street. The ensuing typification of this figure into a veritable allegory of the city, into the female counterpart of the flaneur, is nothing if not the inscription of a male fantasy upon a female type who—a "streetwalker" out of need, not by leisure—does not frequent the streets to share her subjective experience with the male pedestrian but is defined by the very immediate objectification and commodification of her own body.

Unlike the male flaneur and his gaze, the prostitute is not his female equivalent but rather the image and object of this gaze. Not free to drift along the streets, she is driven into and down the streets by pressing economic motives. She does not pursue her own sensory experience but rather seeks to divest herself of this very experience by gainful means. "[That] the image of the whore [is] the most significant female image in the *Passagen-Werk*"[49] remains a blind spot in the enlightening perception of a long line of male critics and flaneurs.[50] As the prostitute in general is neither flaneuse nor nymphomaniac, and she does not have the streets at her disposal any more than she commands the use of her own body,[51] she does not represent the new image of a self-determined female subject of the streets any more than the shopping flaneuse who has been mobilized by bourgeois consumption, or the bag lady who has

been expelled into the streets and consumed by the system. Within the public dimension of female lives, these women form nothing if not the cynically distorted female images of consumption and flanerie in an age of capitalist and sexist exploitation.[52] In the scene succeeding the one with the strolling woman, a number of women are presented: perfected models strutting the runways, bourgeois ladies decorating the sidewalks, and female tableaux displayed at café tables, captured in the moment of restoring their made-up façades. These exhibited images illustrate the extent to which even in the presumably liberated age of the 1920s, "the spaces of femininity are defined by a different organization of the look."[53] Gertrud Koch describes the dynamics that contain women's own images as well as their access to the images of others: "The aim of the sanction against going alone to pubs, etc., is to remove women from the voyeuristic gaze of men, whereas the implicit cinema prohibition denies the voyeuristic gaze to woman herself." While *The Symphony of the City* does not present images of female moviegoers, the film's presentation of walking female spectators offers a specular process that approximates the "spectatrix's" filmic viewing.[54] In strolling, this *femme flaneur* fixes her gaze on the other pedestrians and takes in the spectacle of the street through the frame of a shop window. Despite this woman's singular courage, however, the prevailing scopic dynamics remain fanned out against the female pedestrian in the street, as the critical reception of this figure and her "provocative" behavior has shown.

The precarious status of the female flaneur expresses an epistemological condition of female existence within the gendered dynamics of the gaze that Koch elucidates: "Being looked at, I become the object of the other who casts his judgment at me with his glance. Every woman knows this situation, which Sartre describes as an ontological one: the domination through the appraising gaze that degrades into an object the one looked at, and subordinates her."[55] From the perspective of women, Sartre's "ontology" describes a male epistemological position rather than an "objective" philosophical one. This view of the world marks its own blindness quite strikingly when Sartre exemplifies his definition of the "other" via his perception of a woman in the street: "Cette femme que je vois venir vers moi [et autres] sont pour moi des objets, cela n'est pas douteux. (This woman I see coming toward me [and others] are without any doubt objects for me)."[56] No less doubtful, however, is the consequence that many women who are faced with such massive scrutiny and daily objectification—and not only through a male philosopher's gaze—find themselves lacking the self-evident confidence that is traditionally exercised by their male contemporaries. Women's scopophilia, along with the potential for female flanerie, has become subjected to so many historical restrictions that they may avoid the public sphere altogether, not willing or capable of exposing themselves to the dominant gaze of daily evaluation. A potential female flaneur may disassociate herself from an exterior world that is largely

defined by the male gaze and withdraw into domestic interiors, assuming her culturally sanctioned presence as a companion of men instead of pursuing a flanerie of her own.[57]

The female flaneur's desire for her own exploration of the world ends where it encounters its limits in male pedestrians whose phantasies assault, annoy, and evaluate her in the street. The socially prescribed status of woman as an image formulates an epistemological position defined by powers that overshadow her potential as an observer. Prevailing definitions of modernity reveal their gendered bias if we consider the related issues of the gaze and the case of the missing flaneuse. It is no accident a recent feminist critic would explicitly name the sense of ominous discontent that Georg Simmel had described in the early years of this century for the interiors of public transportation.[58] As Ulrike Scholvin explains, the cause of this modern anxiety lies, more than in the experience of mere anonymity as such, in a realization that is known to every woman about the extent to which a person's image and appearance is exposed to a ceaseless barrage of visual judgments within a narrow space: "It is probably less anxiety-provoking to see oneself than to realize in the eye of the other that one is being seen by him."[59] This anxiety, most commonly experienced by women, prevails even in the absence of a male gaze: a woman's image continues to be a specular object to other women who have themselves internalized the criteria of society's evaluation.

The predicament in which women find themselves becomes apparent in *The Symphony of the City*'s shop window scenes. In these scenes, women appear only in display cases—as window dolls. On constant display, they exist as both objects of male desire and as objects of the internalized gaze of women in competition. Wherever women go and look, they find their image viewed by a (self-)critical gaze that subordinates and subjects their image value to permanent specular assessment. As Buck-Morss explains: "[Women] make themselves objects. Even with no one looking, and even without a display case, viewing oneself as constantly being viewed inhibits freedom."[60] The female shoppers and strollers gazing into the windows of the *Symphony of the City* demonstrate how a potential flaneuse may come to direct her gaze on herself, and on herself as an image, as a construction that stands in competition with that of the other female images that surround her reflection in the window. A woman's gaze consequently loses its autonomy in relation to an exterior world that is informed by the image value of her appearance. The filmic image of the male flaneur, reflected in the glass and superimposed on the female androids in the window, reveals the destination of the shopping flaneuses who pursue the perfection of their own images in terms of the criteria of the male gaze. While department store strollers and window-shoppers are predominantly women, they have not assumed the purpose-free gaze of the flaneur. Shopping malls likewise have become centers of female self-consciousness rather than self-

confidence, their spaces filled with normative images of a femininity that constrict the flaneur's roaming scopophilia.[61]

Ruttmann's film emphasizes this predicament in scenes that have women gazing into the display windows of apparel stores. The women facing these shop windows find their real reflections in this mirror in competition with, that is, compared and judged in relation to, the "ideal" appearances of mannequins that are arranged and displayed in the shop windows. Subjected to this exchange of values, the woman as buyer before the window is at once rendered an object of the gaze emitted by the sellers, as well as by the other shoppers, of images. A competitive exchange of the gaze prevails whereby its female participants evaluate the other woman's image in the context of the store's images, commodities, and ambience, in comparison and competition with her own value as an image. A woman's gaze into the shop window reveals her own disappearance: her image is refracted into infinite reflections of her object status before her gaze ever has a chance of meeting the exterior world. In this way, the potential for female flanerie is fractured into infinite refractions of commodity mirrorings. The only way out of this labyrinth, this mirror cabinet of mutually reflecting images and values, lies in a woman's decision to pursue her flanerie despite the odds and obstacles, in order to redeem the exterior world in her own terms. The existing laws of competition and comparison that underlie the specular laws of the market provoke the refusal, as one feminist critic has put it, "to disintegrate under the [controlling] gaze of the other."[62] A woman's utopian gaze may transcend her own image only if she becomes an active spectator in her own right, "if she succeeds in holding her ground before this gaze as the subject of a self-confidence against which the *other* freezes into the object." This act of perception, with its implicit reversal of an existing objectification, is a first step toward resisting woman's exclusive status as an image, toward a space in which her own gaze can open onto an exterior world of new sights and views.

This space has already been prefigured in another realm, the scopophilia of the cinema. The film's window through which the stroller sees her own objectification—and beyond if she dares—is replicated in the frame of a camera, but a camera whose images project an entire world. The cinema releases the female spectator from her exclusion from the world and also her reduction to a passive image. The sites of female flanerie have been inscribed into the filmic medium from its earliest times. In its exploration of the images of physical reality, cinema focuses on the prevailing constructions of power and the gaze. In doing so, it opens unclaimed territory by enabling an institutionalized act of perception in which even a woman is free to participate. The spectatrix in the movie theater is therefore a kind of prototype of the female flaneur, a moving spectator in the streets. Early cinema can be seen as one of the first public places in which this new freedom of the gaze was available to, and exercised by, women who had long been excluded from scopic pleasure. Un-

like the spaces of mainly stationary, limited visual pleasure that had tradition-
ally been accessible to women—the housewife's gaze through the windows of
her interior, the shopper's gaze into the interiors of the department store—even
the camera's mediated eye grants the female spectator a relatively uncontrol-
lable gaze by rendering the reality of its moving pictures. As Horkheimer and
Adorno would have it: "In spite of the films which are intended to complete
her integration, the housewife finds in the darkness of the movie theater a place
of refuge where she can sit for a few hours with nobody watching, just as she
used to look out of the window when there were still homes and rest in the
evening."[63]

In the cinema's enclosed and privileged realms—spaces devoted to the ac-
tivity of looking—female scopophilia finds one of its first hideaways. Conse-
quently, women are initially prohibited from going to the cinema, especially
when, as Koch points out, they "go alone."[64] The particular lure of the cinema's
closed interiors, in combination with the promise of increased scopic stimuli,
exerts an irresistible fascination for the female spectator who has been largely
excluded from the streets. The darkened space of the cinema removes her from
the gaze of others, while at the same time allowing her own gaze unrestricted,
extended access to all the shocks and impressions of modernity, approximat-
ing and even exceeding the experience of the street. This onset of the cinema
finally gives women the right to indulge their scopic desires. As Heide Schlüp-
mann notes: "The cinema finally accepted women as social and cultural beings
outside their familial ties."[65] While the move of women toward the liberating
movies encountered significant initial resistance, women nevertheless em-
braced the new medium as a catalyst that gave them their first legitimate access
to spectacle and perception: "While the bourgeois theater-goer continued to
reject [the movies], his wife already spent her free time in the cinema. For
women, the cinema as a rule meant the only pleasure they would enjoy outside
the house on their own, and at the same time also more than entertainment;
they brought into the cinema the claim, not delivered by the theater, 'to see
themselves.' "[66]

The contested participation of women in the *Symphony of the City* coincides
with the popular arrival of cinema in the 1920s, a time when women entered
a world of images that had long been denied to them in the streets. With their
new gaze at the world on the screens, they found themselves in the city, in the
public sphere of Weimar Germany. That women embraced the city's spectacles
through the medium of moving images reveals the extent of their desire for
the perception and redemption of the images of reality. Via the form of flanerie
that it presents its spectators, the cinema transmitted images of exterior reality
to women, allowing them to begin to relate to the world as unimpeded, invisi-
ble, and respectable flaneurs in their own right. On the screens and streets of
modernity, the arrival of female flanerie extends and responds to prevailing
questions about the female spectator. With spectatorship serving as an analogy

and apparent synonym for flanerie, with urban streets a realm intrinsically related to scopophilia on the screens, the female flaneur is a prototype for gendered cinematic spectatorship. Acknowledging female flanerie in the street—and hence extending our understanding of female spectatorship in general—may help to delineate more precisely the contemporary debates over female spectators facing the screen.

If the flaneur pursues what is akin to a cinematic gaze, he is at once a spectator, a camera, with his mind as a medium of recording, and a director who writes and edits images in a text of what he has seen. The eventual appearance of an ostensibly absent female flaneur in the *Symphony of the City* is therefore able to confirm female spectatorship. In order to answer a central question of feminist film theory—"why women go to men's films"—it is helpful to acknowledge that there have long been female flaneurs in modern spaces, women who actively seek their own specularity in response to public spaces and images. To establish such a genuine protofilmic disposition in the streets would go far to demonstrate women's scopophilia, a specular desire that exceeds and predates a woman's becoming subject to the codified images of prevailing forms of the dominant cinema. The film of the street is not merely the medium of "men's films." To be able to speak of a female flaneur would offer the new figure of a resistant gaze, an alternative approach and a subject position that stand in opposition to women's traditional status as an image on the screens and in the streets. The figure of the female flaneur goes beyond the cultural construction of woman as an image wherein she exists primarily to be looked at, offered as a visual commodity to the consuming male spectator.[67] This figure may also help to reformulate theories of spectatorship that organize the gaze entirely along gender lines, that posit an active male spectator who seems in control of female images.

Recognizing a female flaneur would enable women to trace an active gaze of their own to a preexisting tradition of female spectatorship in the public sphere, to an already actively looking female figure who can return the gaze directed to her. At first sight, the conventional assumptions of "woman as image, man as bearer of the look" seem to dominate the specular scene of the city and its "Symphony," with women walking the streets in order to be looked at and checked out by the male gaze.[68] Within this context, the discovery of a female flaneur would help to inscribe a model of resistance for women, one that would establish wide possibilities and open new spaces for their own gaze. The female flaneur would provide an antidote, a new approach and paradigm that would serve to destabilize the dominance of the male gaze and counter it with another gaze. After a long history of male flanerie and the privileged spectatorial position it involves vis-à-vis the image, we should wish to extend and elaborate all theories of women's spectatorship and visual authorship, whether they involve the perception of modernity in the cinema or the city, on

the screen or in the street. In registering the potential flanerie of woman walk-ers and bearers of the gaze, we mean to introduce a perspective into the cultural construction of women's images that grants women authorship of their images. It is time to reconsider the concept of the image in relation to the female subject as a flaneur.

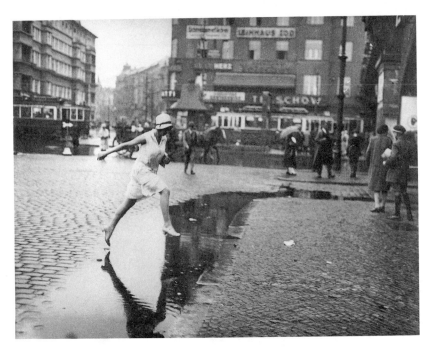

Friedrich Seidenstücker, "Pfützenspringerin" (Puddle Jumper). Courtesy of Bildarchiv Preussischer Kulturbesitz.

Weimar Women, Walkers, Writers:
Irmgard Keun and Charlotte Wolff

THE PRESENCE of female flanerie can be registered further in the traces it has left in female walkers and authors whose literary media reflect images found beyond those displayed on the screens of metropolitan films. These texts belong to a hidden history of literary writings on the city, documents of female creativity that suggest the beginnings of female flanerie.[1] Looking anew at women writers of the Weimar Republic, we can discover texts that are organized around women who walk and write the streets of Berlin. These texts provide innumerable instances of female perception by observant women who walk the streets and assume their (only recently assured) rights to full participation in the political sphere and its public spaces. Like male flaneurs, these women drift along the metropolitan streets of their time, and with their own eyes study the images of the society within which they move, within which they are seen, and in which they see.

These female flaneurs appeared in consonance with, but were not confined to, the phenomenon of the "New Woman" in Weimar culture.[2] The proclaimed liberation of women also involved developments that, formulating new restrictions and expectations for women, proved to be only partially liberating. We can recognize contributions to the "women's movement," however, in the writings and flaneries of Weimar women. Among these documents are the novels of Irmgard Keun and the memoirs of Charlotte Wolff, long-overlooked texts that call out to be included in our history of flanerie and given the close consideration and intense attention they deserve.

NEW WOMAN'S FLANERIE

A highly regarded writer in Weimar Germany, Irmgard Keun has only recently reclaimed some measure of the considerable attention and notoriety that readers and critics bestowed on her during the Weimar Republic, as an eminent author of a series of contemporary novels of the city and the closing years of Weimar modernity.[3] Keun's writings serve to record the many facets and realities of metropolitan women in the 1920s, locating her female experience of the city in an impassioned and innovative narrative voice.[4] The very distinct experience that she ascribes to her protagonists has at times been described

according to a vague, dehistorized myth of the "New Woman" in Weimar Germany, a myth that emerged particularly after its cultural specificity had first been erased through the Nazi suppression of women.[5] Now we may consider her as an author who can be perceived, and not only in her own time, as an acute and vivid sensitivity, a female chronicler and critic of the material and social realities of women in her society.[6]

In particular, Keun's novel *Gilgi—eine von uns* (Gilgi—One of Us) functions as a kind of manifesto for women of her era, providing a novelistic focus for the experience and discussion of the "new" woman in Weimar culture.[7] In ironic, even provocative contrast to her text's given title, the female protagonist of the novel indeed appears not to speak as "one of us," not to represent the average woman of her time.[8] This new protagonist transcends both the traditional expectations of Wilhelminian femininity in the domestic sphere and newer, yet also normative notions of women who aligned themselves with a certain modernity that still belonged to a world defined by men in political and private relations. Situating "Gilgi" within contemporary political disputes over the role of women, Keun presents a disrespectful, unorthodox protagonist who proves to be provocative on all sides of the political spectrum. She is considered a politically irresponsible outsider and a modernist renegade who works against socialist and feminist causes as well as against conservative politics and ideologies. A female anti-hero for Weimar Germany, Gilgi strays from the prevailing assumptions of femininity and the place of women, and thereby defies society's prescribed positions.[9]

The novel traces the experiences of Gilgi, a twenty-one-year-old office worker who comes of age in the Rhineland provinces, but who is nevertheless in the vanguard of the Weimar Republic's "New Woman."[10] Gilgi seeks to revise her position as a daughter, woman, and office worker, first emancipating herself from her adoptive parents, then freeing herself from a harrassing employer, the monotony of her small-town existence, and her typically female menial job. But the economic realities of Weimar Germany impede her self-realization as much as do her emotional dilemmas with a series of male adventurers. Keun suggests that a woman's quest for freedom and independence still continues along the path of economic detours and emotional derailments. A woman of her time, Gilgi chooses to take on the male persona of a *Straßen-junge*—that is, of a tough and fearless character who inhabits the streets—whose name, like his very existence, is linked inextricably to the public domain. The new woman becomes a cultural protagonist who manages a *sachlich* matter-of-factness that is generally only associated with modern men. Gilgi's declared credo is, in her own words, that the modern woman needs "an ice-cold *Sachlichkeit*. One needs a strong touch of street-boyishness as self-protection."[11] Paradoxically, this effort to define her own independence, in her own terms and beyond definitions provided to her by men, still pressures her to adopt certain male roles. Nonetheless, she expands the available repertoire of

feminine roles by inserting herself into public spaces and situations which offer her a whole kaleidoscope of possibilities for self-definition—including a traditionally male position such as the *Straßenjunge*, which enables her to participate in a form of flanerie that she begins to inscribe within this text of her life.

These new images of the new woman correspond to the visual aesthetics of her time and an implicitly female version of the Weimar *Kino-Debatte*. Keun immerses Gilgi in the life of the street and describes her intense fascination with fashion and appearances in the public sphere, a fascination that is intensified further by her dedicated "reading" of images and journals. As the contemporary *Kino-Debatte* suggests, the practice of such visual readings leads to a new kind of literacy (an ability to interpret pictorial illustrations, for example), produces a new means of approaching reality, and anticipates an extended notion of the text that precedes filmic seeing.[12] The protagonist of Keun's next novel, *Das kunstseidene Mädchen* (The Artificial-Silk Girl), in fact defines her perception in terms of an art of writing that works "like a film."[13] Her mode of narration not only simulates a process of perception and recording but also produces for her the images of this cinematic sphere.[14] The pursuit of socially defined visual effects, a desire for the luminosity and lights of coming attractions, becomes the guiding motive of this biographical quest: "I want to become a luster [*ein Glanz will ich werden*]."[15] The literally shining character of this novel—her name is Doris—frequently repeats Keun's avowed credo, to such an extent that she stylizes it into a Leitmotiv of the light that attends this quest for a new female identity. Keun here gives us the formative images of a female "Bildungsroman" in the age of cinematic enlightenment.[16] In ironic consonance with the gendered distribution of leisure and space that prevailed well into and beyond the 1920s, however, Keun still attributes more experiences of flanerie to the dominant male character in her text.

Already in *Gilgi—eine von uns*, Keun projects her impulse to roam the city, free of conflicting obligations and considerations, onto her male character, Martin Bruck, using him as a figure that enables her to "bridge" the presumed lack of female flanerie.[17] An adventurer and drifter, Bruck eventually joins the no less adventuresome Gilgi in a narration that emphasizes the romantic interests between these two inhabitants of the street. Bruck has abandoned the sedentary life of the bourgeoisie for that of an economic outcast, an aimless and carefree writer, a bohemian who leaves this already liberated existence for the even less defined and less constricted project of viewing the world.[18] As Keun's male persona finds himself in the streets of the city, his desire becomes that of the flaneur. She writes, in the ongoing present of a flaneuristic narration: "Without a plan, Bruck roams through the streets. Messy weather . . . blackish, slippery wet pavement. A displeased blinking, the neon signs on the Hohenzollernring through the fog. Urban's Restaurant—Café Wien" (*G*, 81). This configuration of street names and lights, neon signs and urban locales, conjures

an aesthetics of "asphalt and light,"[19] an atmosphere of impressions that, filtered through the flaneur's perception, help form the scriptural character of the modern city. In a significantly nuanced manner, the male figure's text presents itself as a document that records his observations from the perspective of a female flaneur and author, one who shapes the narrative according to her own scopic impulse. Turning a corner, for example, the male representative of Keun's flanerie encounters the more pedestrian but no less flaneuristic observations of women's everyday lives:

> Martin turns into Ehrenstraße. Dorado of housewives. Shop next to shop. Butcher stores charmingly illuminate their aptly arranged displays. . . . Between bloody shreds of meat worry pale little bunches of narcissuses. Woolly, little rabbits stare reproachfully with dead glazed eyes. . . . Ladies with shopping nets push greedily past the display windows for booty like Sioux Indians on the warpath. Pale, neglected women drag filthy children after them, tattered unemployed try in vain to smell themselves well-fed by the warm haze of tempting bread stores. (*G*, 82)

By focusing its "female" gaze on an array of details in this "dorado of housewives"—with its specular displays of flowers, groceries, and fabrics—the text presents commodities whose cheaper, more accessible, more easily perishable, yet also more immediately consumable variations are still uncontainable in their multiplicity. The shift from metropolitan Berlin to a more provincial town would only seem to narrow the array of objects to be perceived. Instead, it sharpens the focus on more minute description and multiple details.[20] The trajectory of even this restricted form of flanerie still evokes the characteristic itineraries of its movement—stores and streets. Fastening his gaze on other, nearly paradoxical "attractions"—grocery stores, displayed rabbits, disheveled women—the flaneur exhibits a degree of scopophilia beyond the glamorous phenomena of metropolitan boulevards. In other words, the sights that Keun's male persona collects are structured according to the paths of shopping housewives not strolling dandys, unemployed women not leisured men. But these small-town, small-scale perambulations evoke a degree of surrealism—viewing the shockingly banal window decorations and arrangements—that recalls the storefronts of Parisian arcades that Aragon visits in order to shop exclusively for images and impressions. Even the ostensible limitations of Keun's gaze lead toward a form of flanerie that is less impeded than it is attuned to the imminent and minute paradoxes of the streets.

Under the oppressive social and economic conditions of a dreary, provincial Germany, the move toward a more serene stance of flanerie that could afford to be unaffected by these circumstances would be at best to participate in an inconsistent luxury. Keun's fictional observer therefore turns Hessel's insight into the culturally conditioned inability of his contemporaries to loiter into a remark with a critical edge that anchors it in the acute reality of her times: "It seems as if in this country, idleness cannot be a pleasure but rather turns

into anguish" (*G*, 83). This inability to linger, to dwell in the streets, and to observe the public sphere from a detached position, is linked—on a collective as well as individual level—to an inability to see that will soon assume catastrophic dimensions in the Nazi state. Keun describes the degree to which economic conditions reinforce a national disposition that was already working to restrict strolls without purpose. Keun's passage here echoes Kracauer's comments in "Kino in der Münzstraße"[21] on the unemployed of Weimar Germany loitering outside one of its picture palaces, a crowd at once excluded from, and oblivious to, scopophilia and the pleasures of the visible. That a female writer formulates this inaccessibility to flanerie also recalls the tenuous status of female flanerie in Weimar Germany, the continuing obstacles that her project faces throughout the twentieth century despite the declared fascination and demonstrated affinities that so many women had with this disposition.[22] A female flanerie that remains elusive even to the contemporary women who pursue it speaks from its paradoxical rejection through Gilgi, who—in opposition to Bruck—defies the male flaneur's perspective that remains unavailable to her: ". . . really, that's boring to me, to walk around so aimlessly, I very much like to walk long distances on foot but I have to go somewhere."[23] Although her feigned indifference, based on anxiety and boredom, remains ambivalent, it nevertheless betrays the traces of a disposition that ultimately will encourage women to engage the exterior world through this antidote to their previous deprivation.[24]

As the pursuit of a text in the process of seeing, of a text that is perceived in walking and recorded in writing, flanerie defines the impulse to record the world that structures Keun's work. Her subsequent novel, *Das kunstseidene Mädchen*, goes so far as to present a female flaneur as the protagonist, a character who goes on extended excursions into the exterior world of the city. This Doris bears the label of a figure fashioned from "artificial silk." A potentially superficial, decidedly surface-oriented "girl" of the 1920s, she is also a figure who represents an "artistic" and particularly receptive "silky" sensitivity.[25] Keun's "artificial-silk girl" becomes a medium of perception through which a woman can mirror her reality in the city, a material personification that transports the physicality of her surroundings and thereby transmits a female flaneur's observations of modernity.[26] Both the novel and the girl focus on the big city that encircles ever larger metropolitan spaces, gradually articulating the conditions for a female flaneur's increasingly assured monologue of perception. While the novel's first chapter presents images of a "medium-size city"—"Part I: End of Summer, and the Medium City"—it serves only as a point of departure for the female character's next step, "Part II: Late Fall, and the Big City," which significantly revolves around metropolitan Berlin.[27] Propelled from an average town to the most expansive urban space of her time, Doris identifies her new location as a place that allows her to unfold the perspective of a modern flaneur. Her writing follows an overriding sense of

optics in order to record her and the city's life in the form of a visual text, a project that she declares to be one of the first principles of her narrative and considers in emphatically cinematic terms: "I want to write like film, for so is my life and it will be even more so."[28]

Doris is defined both by this optics and through her visual text: in the many urban situations in which she finds herself—walking on foot, riding by taxi, catching the subway—she remains acutely aware of the specular angle of all the appearances that come her way. This also includes her own status as an image, by acutely recording a femininity that the female flaneur herself influences and shapes into a literature of her own: "And when I later read it," she says about these texts on her walking, "everything is like cinema—I see myself in images."[29] Considering images as her privileged modes of reflection, Keun's female flaneur follows the current debates on the optics of her time that appear in the Weimar *Kino-Debatte*, especially in discussions over the functions of illustration and illumination, about the way this period "reflects" itself "in images."[30] Keun's female vagabond—herself both spectacle and spectator—continues to stylize herself as a visual object. However, she herself exhibits a measure of control over her appearance, regarding herself as a contemporary female equivalent to the dandy. She is capable of mobilizing and cultivating what she calls "the right gaze"—a contemporary presence of mind that is able to assess any current situation in its most opportune light. In consonance with her time, this "New Woman" as a new flaneur on the streets of the "New Objectivity" asserts her freedom within a commodified society by "attributing high value to the right experience" (*KM*, 19). The "values" that are attributed to this "experience," however, sacrifice economic value to an immersion in aesthetics, resplendent with sensory perception and steeped in sensual awareness. As both woman and flaneur, Doris experiences the dynamics of the male gaze, yet seeks to overcome the limitations that traditionally have trapped women in the street.[31]

Her imaginary is shaped by, and focused on, the perception of a world of reflections in neon and lights, whose modern images in their most recent and brightest emanations correspond to cinematic plays of light. The highly luminous sphere of this novel evokes the mise-en-scène of a world that conforms to the light effects of the cinema's *Lichtspiele*, the most recent realm of visual illusions. Witnessing the literally shining path of an emerging star, Doris declares her ambition in life: "I want to become such a luster [*Glanz*]. I will become a luster and whatever I do then is right. [I will] simply be drunk—nothing can happen to me anymore in loss and contempt, for I am a luster" (*KM*, 45). A personification of the female flaneur in the city, the luminous and illuminated "Doris" finds herself in the ambivalent position of being both the subject and the object of a gaze. Her existence as one more "golden" emanation of the bright lights of modernity merges with the exterior attractions of the metropolitan sphere: she emits images and visual effects while retaining her

observing perspective. While a woman cannot entirely escape her subjection to the image, this figure still resolves to become an agent of perception herself, beyond the veneer of her appearance—a luster of lights that transmits her own visual desires and sees with her own eyes.

Doris's view of her social and visual status is highlighted by a sense of excessive illumination—*ein Glanz*—an idiosyncratic, frequently reiterated term that betrays the character's shining illusions and abandonment to visual appearances. This vision of light informs its own aesthetics and ethics—"what I then do is right"—and thereby names the illuminating light at the heart of society's exterior spheres. The figure's materialistic access to its time moves in synchronicity with the principles of modernity and rhetorically betrays the effects of its light, tempo, and images. The primary site of these experiences is the "big city," synonymous with a Berlin where Doris concludes the first, more tranquil chapter of her life and text and initiates a faster pace of presence and narration: "My life races like a six-day-race [*Sechstagerennen*]" (*KM*, 56). The anticipation of tempo and intensity is projected upon this one privileged destination: "Tonight I will flee. To Berlin. There one submerges" (*KM*, 58). Tropes of unconscious desire signal the transgression of boundaries wherein one could consciously perceive this new reality, a place where one is submerged in a flood of images and impressions. This correspondence between vision and an acceleration of perception hints at an intensification of experience in Keun's text that recalls the rhetorical traces of surrealism and points toward projects of an optical avantgarde.[32] Her arrival in the city opens the female flaneur's eyes to the sensations of modernity, reshaping the novel into a text that explicitly records a woman's experience with the metropolis: "I am in Berlin."[33] Her character begins to take acute note of the time and details of a place that she perceives as a symphony of speed and light, an intense sense of reality that transcends previous forms and metaphors of comprehension. The following passage is characteristic of the rhetorical exteriors of this text with its focus on decor and exterior decoration, its eye for the ornaments and effects of light in physical reality: "Berlin lowered itself on me like a comforter-blanket with fiery flowers. The West is fashionable, elegant, stylish, with high-voltage light. . . . We have here quite excessive light advertisements. All around me was a glittering" (*KM*, 67). Doris displays the keen eye of a physiologist who describes the Berlin West's capitalist excesses in its visible features.[34] She casts her own, previously domesticized gaze on the details furnishing these metaphors—comforters, flowers, elegance. Drawing on a presumably "feminine" sphere of interior ornaments, she short-circuits these gendered clichés in an electrifying way, with tropes from a sphere that is strategically opposed to these conventions. Recycling elements of femininity and linking them to the ways of the so-called "New Woman" of the 1920s, Keun's text describes moments of liberation and visual emancipation that exceed both the presumably "progressive" or "conservative" traits of her character.[35]

The means of liberating not only women's roles in society but also the voices with which they record these new moves can be situated in a new language. Keun's text explores rhetorical niches of innovation, circuitous approaches to new meanings that are exemplified by her fractured syntax and the hyphenated rhythm of her language. Within the very pace of her language, Keun reveals herself to be an eminent flaneur at the edge of surrealist perception, a drinker of images whose intoxication is translated into her syntax and into a cinematic style that is legible throughout her narration. Her unique, often parodistic introduction of a "feminine," almost breathless style of notation, along with its increased preference for the nuances of fabrics and shades, matters and materials, light and design, diversify the attention that motivates this female flaneur's desire to record the public sphere in its most recent manifestations, anchoring her visual perception within the perspective of a modern working-class woman. Instrumental to her flexible, mobile disposition are the city's most recent means of rapid public transit, among them the Berlin subway, which is still partially under construction in the 1920s of the "artificial-silk girl." These modes of modern transit introduce a form of moving in the city that intensifies its sensations and transports the spectator into a realm of accelerated perception. The velocity that her novel's persona undergoes relativizes, as it multiplies, the impact of impressions on her perceptual apparatus, with technologies maximizing the effects of light, the effectivity and speed of its movement. As a modern flaneur, Keun's narrator adapts her presence of mind to the particular tempo of her times:

> There is a subway that is like a lit coffin on rails—below the earth and musty, and one is being crushed. I ride in it. It is very interesting and goes fast. . . . There are also autobuses—very high—like observation towers that hasten. I also ride in them sometimes. At home, there were also many streets, but it was as if they were related to each other. Here are even many more streets and so many that they do not know each other. It is a fabulous city. (*KM*, 68)

Doris reports this series of fragmented effects in a fractured rhythm that is a direct notation of perception which brings together the many facets of metropolitan experience in all of their multiple contradictions. The initial unease generated by the newest medium of transportation can be read in its metaphoric extensions: the anticipation of terminal accidents, the subway buried as "a coffin on rails" below the ground, unearthing the passenger, whose position becomes "crushed" beyond recognition. Even the seemingly familiar autobuses, a means of collective transportation ever since the nineteenth century, have been elevated—"very high"—beyond previous points of reference, hypostasized into extreme and highly detached "towers" of observation which traverse the city and carry a new and mechanically mobilized flaneur.

This mobilization of perception in the metropolis brings its own relativizations along with its new revelations: with both the subway and the new su-

perhigh buses hastening at speeds never seen before, the spectator's attention on a focused picture of the city becomes diffused, fragmented, and fractured, taking on the qualities associated with cinematic cuts. Changing the circumstances but not the intensity of the flaneur's perception, these transformations are played out in a diffusion of physiological forms, interpretative processes that are now mapped on less coherent, more alienating surfaces. The anonymity that Simmel sees in the increased and intensified "mental life" of the metropolis appears in the very topography of Keun's words: there are "so many" streets "that they do not know each other." Even as previous physiologies are confounded, their fictional potential is compounded further by an intensification of perception that exceeds any known reality. "It is a fabulous city," observes Keun's female flaneur, describing her reaction to a city that thrives on the multiplication of its stories and streets, facts and fictions. As a newer flaneur, a physiologist *avant la lettre*, this female protagonist reflects on the differing "character" of diverse streets and sights, recording her revelations with the visual metaphors we have associated with the texts of flanerie—the phenomena of light and images in movement. Flanerie precedes the technology of the filmic apparatus even as its intensity of vision is related intrinsically to a filmic perspective: both perspectives revel in a writing of light, in the movement of the streets. These features are revisited by the female flaneur who considers her biography and narrative to be texts that run "like a film."[36] The flaneuristic character of her text comes to the fore in a passage at the center of her novel entitled *Late Fall, and the Big City*. This particular "fall," a belated but no less absolute abandon to the original sensations of the city, arrives in a seasonal paradox that situates Doris in an anticyclical, nonconventional appreciation of her new surroundings: "But to me, it is a Spring, Berlin to me is an Easter that coincides with Christmas, where everything is full of a shimmering bustle. . . . I love Berlin with an anxiety in my knees and do not know what to eat tomorrow but I don't care—I sit at [Café] Josty's on the Potsdamer Platz. . . . I have always walked on Leipziger Platz and Potsdamer" (*KM*, 95).

That this female flaneur—this woman only recently released from domestic exclusion—distinguishes her reactions to the city from preceding modes of experience reveals a lingering sense of anxiety and trepidation. For the female flaneur, this experience of modernity also describes a process of intensification that reconciles forms of collectively sanctioned, celebratory rites of passage—"Spring, Easter, Christmas"—with a new degree of intensity that exceeds previous cultural determinants. Doris's individual celebration of the everyday is characterized by a principle of simultaneity that exhibits the tempo and acceleration of modern developments as well as the simulation and fictionality ascribed to a future age.[37] The totality of her involvement leads to an overload of perception in which "everything is full" in the world that surrounds the female flaneur. This complete involvement does not exempt her own body as

it moves through an experience that takes possession of her very senses and self. Indeed, parts of this body are affected materially and viewed literally as a kind of medium whereby her sensations are transmitted physically by way of "an anxiety in [her] knees" which, accompanying her walking, is associated with, and indexical of, the female flaneur's presence in the streets. We could even say that her awareness of the darker anxieties lying behind the shining lights of the city, the entrapments of hunger, her vulnerability to the weather, her unemployment and homelessness, gives to this female flaneur far more shocking insights into her tenuous physical presence in the street. Her precarious public position literally speaking through her body, the female flaneur becomes implicated as a material and social witness to urban experiences that put the physicality of her own body on the line.

BLOND CINEMA

A series of episodes in particular illustrate the means whereby this disenfranchised, marginalized subject of modernity unfolds her unique visual talents and displays her potential for a truly stellar performance of flanerie. Doris describes the constellation that motivates her role as visual witness: "And at the bottom of our house lives one Mr. Brenner, he cannot see anything anymore and no stores and checkered lights and modern advertising [*Reklame*] and nothing. For he has lost his eyes in the war" (*KM*, 95). "Mr. Brenner's" name defines him as a catalyst to the "burning" sensations of his age: his eyes have been burnt by the sudden, unforeseeable explosions unleashed in the "blitz" of World War I, whose jarring illuminations continue to haunt the contemporaries of the Weimar Republic. Without a vision of their own, this generation becomes the impressionable screen on which to project the increasing visual desires of a coming generation. In his fervent wish to see, Brenner calls on the female protagonist to provide him with "eyes," to give her vision, through narration, to a man whose perception is supplanted by a female gaze and its text. This unique premise establishes a pretense for female perception that forms the narrative point of departure for Keun's female protagonist. Mobilizing an array of talents that belong to flanerie, Doris thereby radicalizes what Hessel understood to be the distinctly democratic process of a flanerie that could and should be accessible to everyone. Within the narrative of her vicarious flanerie, her visual disposition defines itself as a social movement in the service of others.

Keun creates a public position for her female spectator, a narrated screen on which she projects and records images for her implied audience: "I collect seeing for him. I look at all the streets and restaurants [*Lokale*] and people and lanterns. And then I make a note of my seeing and bring it with me to him" (*KM*, 96). While the female flaneur thus literalizes Benjamin's notion of flan-

erie as a process of "collecting"—she "takes note" of reality by taking notes in the street—she also reinterprets this orientation as a social and shared cultural practice. Doris's innovative use of flanerie records a series of observations in the street that extend over more than twenty consecutive pages, devoting more than one half of an entire chapter to the urban sphere. Such significant, substantial passages of flanerie are motivated primarily by a woman's effort to record her city, but are also related to her wish to render these impressions to an other, to her audience and reader. This dimension of the flaneur's narrative can be read in the actions and words of the female protagonist: "And so I live in Berlin first for myself, and then for Brenner."[38] Along the way, she confronts traditional male phantasies of the city in order to become the bearer of every and any minute detail that she encounters in order, as she puts it, to "bring" Brenner, and her reader, even more of "the Berlin that lies in my lap" (*KM*, 100). This and other evocative metaphors testify to the immediately tactile quality of Doris's observations. Presenting herself as a sensory apparatus, a creative medium that enables an imaginary access to the public sphere, her flaneuristic metaphors register many different forms of female presence in the street. Reporting to Brenner, Doris reports to a traditional male audience that is nearly oblivious to her flanerie, that seeks to confine her rather than acknowledge her as a perceiving subject with her own perspective in the streets.[39] Yet Doris insists on her own attentive focus on the city, retrieving images from the boulevards and bringing them home to her listener—and reader—rendering the metropolitan experience in great detail:

> "I was—on Kurfürstendamm." "What did you see?" And there I just must have seen many colors: "I saw—men on corners selling a perfume, and no coat and fresh face and grey cap—and posters with naked pink girls—no one looking" . . . "What did you see?" "I saw—a man with a poster around his neck: 'I take any job'—and 'any' three times underlined in red." (*KM*, 101)

The kaleidoscope of impressions in the eye of the female flaneur reflects a range of phenomena more socially shocking and visually disturbing than have been seen and observed before.[40] A witness of her time, the female flaneur embodies marginal facets of life in the street often overlooked by other, more comfortable, mostly male flaneurs whose positions traditionally have been less exposed, less on the edge of their societies. The woman in the street focuses on the diverse and ephemeral particles of a reality that passes her eye and comes in direct contact with her body: impoverished crowds, unemployed vendors, the sale of female images and other cheap resources, processes that are particularly jarring to her in their visualization of the capitalist principles at work against her in this society. The female flaneur's visual record becomes most revelatory as it fuses these nearly imperceptible yet significant details from a dispossessed social reality with the shining light effects that always have been the flaneur's obsession and privilege. Doris's description of an un-

employed man in the street with a poster around his neck, for example, seamlessly joins her view of an urban landscape immersed in color and light: "He rolled [a coin] on the pavement which has a shine because of the signs of cinemas and bars. And the poster was white with black on it. And many newspapers and many colors and the tempo pink-purple and night editions with red line and a yellow cross-cut—" (*KM*, 101).

The female flaneur's semiotic focus on the signs of the city and the cinema structures her text and infuses her prose with a quasi-filmic quality. Her gaze falls on the rolling coin with a shine that is reflected by other commercial signs, an *Augenblick* composed of one continuous movement in light. This split second of cinematic vision is joined by a series of other views of adjacent signs. The cumulative sequence of these visual notations comes to replicate the sphere of linear production from which they are gathered: posters, newspapers, night editions of the press. The rapture that results from the rapid pace of these textual productions is mediated by the social questions that they raise and transport as phenomena of modernity. While the female flaneur perceives the grim realities of contemporary Berlin, she also perceives them through the frenzied media of the visible, the escalating pace of stimuli, and the rapid succession of images. As she works to record these stimuli and images for Brenner—the *Brennpunkt* toward which her observations are directed—the memory of these shocks is imprinted in her mind, re-created by her visual imagination, and formulated in a language that the blind spectator elicits with his questions. In a heuristic dialogue, these visual impressions are conjured and exchanged. They are represented before the inner eyes of a reading and listening audience that views an ever-frantic projection of images on the imaginary screen of their minds:

> "And people are rushing . . . And sometimes bars and a great light high above the ground of the Kupferberg Champagne [neon sign]." "What else do you see, what else do you see?" "I see—whisked lights, there are bulbs closely together—women have little veils and hair intentionally blown into their faces. That is the modern hairdo—namely: gust of wind [*Windstoßfrisur*] and shimmer in the eyes—and they are a black theater or a blond cinema. Cinemas are after all predominantly [*ja doch hauptsächlich*] blond—and I rush along there . . . the air is cold and hot lights—I see, I see—my eyes expect something immense—I am hungry for something wonderful and also for a steak." (*KM*, 102)

Concluding this breathless monologue of perception, the female flaneur displays an *Erfahrungshunger* of insatiable desires, detailing the woman's experiences of a female *passante* who—long since departed from Baudelaire's figure of male projection—has access to the streets of Berlin. In an age of lights, movies, and tempo, this female flaneur's perceptive eye renders everything as though it were always there for her, and does so with an acceleration that mirrors the pace of the city in a multiplying modernity. Delineating and driven

by the manifold shocks and stimuli of metropolitan streets, the character sees her own appearance as one image among others. She recognizes her subjugation to a gaze that dominates the street: " 'What else do you see, what else do you see?' 'I see—*myself* in mirrors of windows, and then I find myself pretty, and then I look at the men, and they also look—and black coats and dark blue and in the face much contempt—that is so distinguished—and see—.' "[41] Brenner's desire to receive these insights encourages the female flaneur to move beyond the feuilletonistic detachment of previous flaneurs. This "what else" signals a gendered nature of the spectacle, the presence of a woman whose gaze makes a difference in these public spaces. Nevertheless, the flaneuse explicitly recognizes herself to be among the images on display in the streets. If Doris can say "I see—myself," it is because she views the public sphere as a space for spectacle, a mise-en-scène of presences and surfaces that, reflected in "mirrors of windows," returns her gaze as well as her image.

This process of spectatorial evaluation is magnified in reverse in the case of the woman who gazes upon men who also look back at her. These male spectators do not remain neutral images for the female flaneur. Describing her visual experiences, the female flaneur becomes a flexible and mobile presence within an exchange of the gaze that stages a play of visual desire. Against the potentially colonizing move of the gaze that men direct toward her, this female flaneur exhibits a voluntaristic, effective persistence that gives a considerable degree of power to her own gaze. However, her frequent references to her experiences in the street as experiences of the contempt that her environment directs toward her suggests that her assumption of a more liberated gaze does not exempt her from being evaluated within the dynamics of power, status, and the activity of looking that characterizes the modern city. This dynamics is literalized as soon as Doris engages the company of an older, wealthier, and more established man. Taking advantage of his status, she is able to cruise the streets more easily and extensively. She drifts in a fiction of leisure and luxury that, borrowed from her male sponsor, enables her to indulge in a vicarious command of free movement, giving her access to transportation. She describes her new mode of leisurely movement with a seamless editing that suggests the dominant role of distraction in modernity: "I made myself a dream and drove in a taxi one hundred-hour-long hour after the other all the time [*eine hundertstundenlange Stunde hintereinander immerzu*]—all alone and through long Berlin streets. There I was a film and a newsreel [*Wochenschau*]."[42]

If her new mobility is predicated on a man's affluence, her overdetermined rhetoric of independence—"I made myself a dream"—suggests that her solitary volition is only a desperate fiction that is lived through under restrictive circumstances. Her existence can never be "purely" aesthetic or "purpose-free." Revealing the considerable influence of social status and issues of gender, the "artificial-silk girl" experiences antagonism toward her public persona. She comes to understand these visual judgments as part of a system of "distinc-

tion" and power. But this does not stop this female flaneur. She continues her work of perception—"and sees." The process of perception proves to be addictive in its capacity to give her access to reality. If the above passage outlines her limited status as a commodity and image in the street, it also strikingly emphasizes her insistence, in a state of dream-like determination, on the destination that she sees as the end of her itinerary. Her frequent references to "film" and "newsreels" indicate the contemporary points of departure from which she stakes out some of the pivotal ways of mediating the world of modernity. Ironically, even the tenuous volition of her movement serves to increase the enjoyment of her transitory independence, escalating the pleasure of a movement that lets her drift along the streets on her own. She elevates this solitude to a principle that frees her of the pressures exerted on her by the approach of harrassing men. In contrast to her male mentor, who finances her taxi rides, these men are less tempting customers who expect to buy her company for less than the price of a single cab fare:

> For once I really wanted to taxi. . . . And today I did ride the taxi alone like rich people—so leaned back and the gaze of my eye out the window—always on the corners cigar stores—and cinemas—the Congress dances—Lillian Harvey, she is blond—bread shops—and house numbers with light and without—and rails—yellow streetcars passed past me, the people inside knew I am a luster . . . blue lights, red lights, many million lights—display windows—clothes—but no models—other cars sometimes go faster—. (*KM*, 127)

The passage suggests the heterogenous collage of a woman's image and gaze. Both commodity and consumer, she tells us that her view of the world and her self is shaped by both personal perception and public culture. She casts a semiotic gaze on seemingly trivial sights, on the debris of the everyday and the ephemeral signs of modernity—house numbers, even unlit ones, bread shops and corner cigar stores—with as much fascination as she might direct toward the luminaries of movie stardom. Displaying her obsession with film, lights, stimuli, and visual pleasure in general, her gaze collects commodities—cars, clothes, and displays—even as it tries to redeem the optics of their images by resisting the rules of capitalist prescription as much as it can—following, as Doris puts it, "no models." The female flaneur perceives the capitalist venues and avenues of her city in every conceivable way—both in the sense of obeying their laws and in making them transparent by critically surveying their visual spectacle.

 The closing images of her sequence, however, illustrate the limits that nonetheless restrict this acceleration of movement and increase of light, this excess of wealth and the illusion of leisure, limits that belong to her position within society. While the material excesses of this society may crystallize into an abundance of luster, the artificial-silk girl's position remains contingent on the distribution of material properties and social power, in which she participates

vicariously through her association with men. When her bourgeois sponsor returns to his lawful wife, the flaneuse's borrowed liberties come to a moralist close. Abruptly cut off from the supplies of money, mobility, shelter, and status from which she derived her public freedoms, Doris is returned to her previous sphere, to a more static position: "And so I have just slept one night in winter in the Tiergarten on a bench. Certainly no one can understand this who hasn't experienced it" (*KM*, 139). The voice of a homeless woman in the street finally comes to speak in this text of flanerie, literalizing the degree to which her experience of the street is linked inextricably to her social and psychological states. Her changing flaneuristic text reflects her shifting approaches to the city. When she has access to sources of capitalist affluence, her syntax is infused with an intoxicating frenzy of phrases and an oblivious consumption of impressions. When she is displaced from this inflationary imaginary involvement, she no longer commands the attractions of the Weimar capital but is reduced to the "lack-luster" experience of sleeping on the margins of the street.

The female flaneur no longer finds her home in the public sphere. She is instead homeless, dispossessed from her leisured impressions to the lesser possessions of a bag lady. Now a figure without a privileged point of departure, she can only understand exterior stimuli as imminent threats. She is left to occupy literally nothing if not the utopian "no-man's-land" of her possible presence and return. The final scenes of Doris's excursions through the Weimar sphere introduce her to the full impact of this public dislocation, of this homelessness that exposes her to the street. Her "hunger for experience" is redefined in terms of a very real hunger that is experienced in its most urgent, acute, and oppressive form. Her predilection for flanerie has led the woman walker from prostitution to privilege to poverty, to marginal spaces of observation that not only grant her the critical edge of an outsider's perspective but also lead to some of the more lucid insights into Weimar society. The female flaneur comes to experience her own version of the state of waiting that Kracauer ascribes to "Die Wartenden," society's homeless intellectuals. The woman of the streets is beset by a similar sense of restlessness and aimlessness that is nevertheless inscribed within a different kind of flanerie: "I go around with my suitcase and do not know what I want and where. In the waiting room of the Zoo [Station] I spend a lot of time" (*KM*, 143). That she "spends a lot of time" in a state of waiting without action means, by default and necessity, that she has time to register and reflect her sensory surroundings. The female flaneur's precarious search for a space that she could call her own presents an arduous trajectory dictated by the material necessities of finding yet another site that would be free of charges, accessible by foot, and conducive to an overall sense of shelter, warmth, and security. The bag lady's approach to the streets leaves little leeway for even the most involuntary moments of a flanerie that would be privileged enough to engage its own subjectivity. At every step of her odyssey, the former "artificial-silk girl" comes into contact with the harsher textures of the reality

of Weimar Germany, introducing the reader to the more undesirable, darker sides of the metropolis, which are often bypassed or sidestepped by traditional flaneurs: the real spaces and living conditions of whores, the homeless, and the unemployed, to name only a few of the many marginalized others struggling for survival in the public eye. The principle of prostitution remains in plain view as a determining aspect of this society, present everywhere and at any moment:

> But everywhere in the evenings stand whores—on the Alex so many, so many—on Kurfürstendamm and Joachimsthaler and at the Friedrichbahnhof and everywhere. And don't always look as such, they take such an undecided pace—it's just not always the face that makes a whore—I look into my mirror—that is a way of walking as if your heart has fallen asleep. (*KM*, 144)

Previous eras of flanerie had been quicker to ascribe a woman's undecided pace to her professional loitering, more readily associating the walk and movement of women with prostitution. However, the very slow and tentative pace, the seemingly aimless and suggestible stroll that is performed here by women, had always distinguished the flanerie of male protagonists. Keun's female flaneur now points to the ambivalence of these distinctions, suggesting that the element of flanerie or prostitution at the heart of this movement is one of the paradigms of modernity. As the female modernist comes to render the streets of Berlin, she understands them to be populated by a prostituted populace, that is, by a populace whose principle of prostitution is not limited to women.

On the other hand, she also sees pedestrians whose only alternative is to walk slowly in order to preserve some measure of strength for their immediate survival. They do not have the luxury of walking slowly in order to increase the pleasure they might derive from the sights before them: "And there are old ones with matches and shoe laces—many, many, many—in the street all over whores, young men, and very starved voices" (*KM*, 176). In letting these many diverse voices express themselves in her text, Keun offers her female flaneur a more varied texture and differentiated context within which to perceive the city of Berlin. In the course of her life in the streets, the "artificial-silk girl" observes a variety of realities, matters, and fabrics, weaving together views of the city that range from the oblique vantage point of a petit-bourgeois housewife to the more exposed angles of a homeless woman who faces a host of adverse elements without any kind of social or existential shelter. Keun shows that her character's perceptions of the street undergo significant changes in accordance with the varying pressures, purposes, and routines to which she is subjected and which are exerted by various forces in the interior realms and exterior spheres of the city.[43] The housewife's point of view, for example, is organized around her role as a purposeful shopper, a mode of existence that suggests another distinct, albeit limited form of "flanerie." This domestic iden-

tity yields a more immediately material perspective that directs her attention toward a separate set of values in the objects and commodities she observes:

> And then I do my walks in the street for shopping . . . tangerines, oranges, and cooking apples—toothpaste in the street—a blue post office with such mailboxes—25 pennies these four bananas, 25 pennies the true canaries . . . buy, young woman, young woman—such a street has something about it that makes you feel pregnant. If we would walk together there once. But that is only mornings. Such a street is only mornings—and there is much life, there are people. (*KM*, 198ff)

This scene reflects its own "pregnancy" in multiple ways, not the least of which is its dispersion of the flaneur's perception into a number of minute observations about the commercial microcosm of capitalism. The overall commodification of this modern sphere defines the status of the woman who observes it, a mobile perspective that faces the scene's pregnant possibilities with a critical and, in every sense, shocked presence of mind. Along with their critical potential, these images coalesce in jarring constellations that conjure their own aesthetic attractions, configurations that are beset by the surrealist impact of the all-too-evident but all-the-more incongruous stimuli of the everyday—for example, "toothpaste in the street" and just "25 pennies the true canaries." Coming across such *objets trouvés* of minute, overlooked pedestrian moments, the female flaneur-turned-housewife concurs that "such a street has something about it that makes you feel pregnant." While capitalism impregnates all that it touches, the female sensitivity facing this scene both collaborates as a consumer and counteracts these consumerist tendencies by wresting her own meaning from it. Her process of observation brings to fruition many of the pregnant possibilities present in the scenes and images that she collects on her daily walks. The stimuli she encounters seduce her into giving birth to a new perception of the city, a perception engendered by a female perspective that brings to the world another, if long unacknowledged, brainchild of Weimar modernity.

Keun's character speaks of a female view of modernity whose final destination is the pursuit of a woman's own ways of walking and seeing, of a kind of surrealism of the street that may be everyday but not pedestrian. In consonance with the realities of her time, this flaneur also witnesses the disillusioned end of her attempted ventures, leading her to an insight into the limitations of these new liberties, and her realization of the ultimate destination of Weimar loitering evokes the economic and political twilight of a democratic state: "And people who walk in the mornings in blue air are almost all unemployed, they all have nothing." A shopkeeper, by the listless name of "Schlappweißer," supports this perspective by summarizing the political panorama and major malaise of Weimar society in a sweeping but succinct statement: "That life on the street, whatever you see, that is nothing but *one* unemployment" (*KM*, 200). While these streets display a culture in disarray characterized by unem-

ployment, its very crisis serves as the catalyst that enables women to enter into these public spaces and to leave behind their domestic constrictions. In its own circuitous and contradictory ways, one of the first significant texts of female flanerie in Weimar Berlin arrives with an avalanche of striking impressions which are themselves finally struck down by the material and social realities that prevail over what would be an innovative and open perception of exterior phenomena. Gilgi finally withdraws from these streets of the big city because, as she puts it, it is "so hard outside, you see." In her concluding comments, Keun lets the drifting narrator come to a halt in her resigned yet acutely resonant orientation in Weimar society, conveying a sense of realities that have multiplied, differentiated, and expanded prevailing notions of male flanerie. Throughout her text, this impressive and impressionable female flaneur not only arrives at significant conclusions, but also offers a conclusive document of a feminist avant-garde as it ventures into the streets of Berlin.

RETROSPECTIVE FLANERIE

In a final excursus into Weimar flanerie, I wish to consider a lesser-known but by no means lesser figure, Charlotte Wolff. Wolff is especially important because she can be situated at the intersection of the beginnings of female flanerie and its continuing incapacities. A contemporary of Weimar flaneurs and a catalyst to women's movement in every sense, Wolff provides us with another significant emanation of the female flanerie of her time. She had been a student in and of Berlin, forced to emigrate to Paris, as were so many Jewish intellectuals of her generation; she went on to practice medicine and psychoanalysis in London. Her writings range from early poetic expressions to pioneering feminist studies in analytical theory, bisexuality, and hand reading, to late autobiographical writings that commemorate the course of a woman's life in the twentieth century. Many of Wolff's memories not only return to roam a territory that we have charted from Hessel to Keun, but also complement these writings with her often taciturn and tentative take on the secret dimensions of female flanerie.

Even though she is not often remembered as a Weimar intellectual and theorist in her own right, Wolff was a prominent participant in the circles of Berlin writers, artists and thinkers of her time. She emerges as a seminal figure, as the friend who would introduce Hessel to Benjamin in the environs of the used toy-and-book-stores in Danzig, the very urban treasure troves that would later find their way into both men's writings in the trope of a *Kramladen des Glücks*. Wolff lives the bohemian life of contemporary intellectuals and, along with Hessel's later wife, the Paris journalist Helen Hessel, roams the city of the 1920s and early 30s, frequenting the bars and dance halls of Weimar Berlin. Finally, Wolff later returns to Berlin as an old woman: one of the first flaneurs,

she is also one of the last to continue her ongoing ambulatory sensitivity. The text she writes about this passage of time, about her passage through cities, exemplifies both the potential and perseverence of female flanerie as well as the prevailing pressures that continue to stand in its way.[44] In the early 1920s, even before the forms of flanerie in which Keun's characters engage the streets, this self-confident, female Weimar flaneur leaves her traces in the city's topography. A young member of the metropolitan avant-garde, a philosopher and poet in her own right, Wolff shares the urban experience of flanerie in a particularly significant era of Berlin, taking part in the singular yet everyday practice of modernity.

Her memoirs, entitled *Hindsight*, document a form of retrospective flanerie in which Wolff revisits her former haunts in the city that she used to know as Weimar Berlin. She returns with the perspective of a familiar tourist to the then divided city, literally assuming what Hessel describes as the "first gaze" of flanerie. Naming her autobiography after a process of viewing—"hindsight"—she focuses our attention on the very elements of vision, reflection, and retrospection that she refers to as the significant elements of her flanerie. In many ways, Wolff's autobiography represents a hidden history of the female flaneur, an investigation of lost possibilities as well as an attempt to regain this gaze, at least retrospectively, by revisiting the imaginary city of her previous experience. In the spring of 1974, having been driven into exile by the Nazis, forced to leave her city in the closing years of Weimar culture, she returns home to revisit Berlin by invitation of the lesbian group "L. 74." On her arrival, she reconciles the reflections of a parting flaneur with the first impressions of the returning tourist who rediscovers haunts that are paradoxically both familiar and alien. She writes: "Berlin had been a chimera ever since 23 May 1933, when I stood at the Bahnhof Zoologischer Garten, waiting for the train to take me to Paris. It never entered my mind that one day the chimera might turn into a pleasant dream. But it was a long time before that came to pass."[45]

The once intangible chimera again becomes an appreciable apparition of sensory experience, whose renewed reality and materiality reappear before an impressionable mind that now encounters the traces that were left in her perceptive and acute memory. The female flaneur who frequents the city, not only in the company of Benjamin and Hessel but with many of the intellectual flaneurs of Weimar Berlin, cannot entirely forget the intensity of her experience. In *Hindsight*, Wolff reconstructs her perspective from a stance of retrospection and recognition that moves with the same spirit of tenacity that allowed her to pursue her perception in the first place. The city which had become alien to her during the Nazi transformation of the German capital once again opens onto a topography that gives way to a form of flanerie. Wolff's hopes on her return reconfirm this trajectory: "And I wanted to see Berlin on my own, making careful notes of discoveries of things I had known and those which were new" (*H*, 278). Wolff's ongoing project is therefore to find and

follow the traces that were left as invisible texts imprinted in the suggestive sites and signs of exteriority. She continues to pursue this project and, despite its enforced interruption in Nazi Berlin, it turns out that she had never abandoned it entirely.

Like the flaneurs described in Benjamin's theories, like Wolff's contemporaries in Weimar Germany, the returning female flaneur goes about "like a sleepwalker" whose "dazed feeling" (*H*, 279) seizes her. Participating in the archetypal dream-state of flanerie, she abandons herself to what she calls a "trance-like fatigue" (*H*, 280), a still insatiable exhaustion that earlier flaneurs had described as a spell that overcomes the urban walker on his—and now her—wanderings through the modern city.[46] Reiterating the perspective that Hessel announces on his "sightseeing tour" of the stories and history of Berlin, Wolff likewise sets out in order "to find points of orientation to link the present with the past" (*H*, 261). The female flaneur again seeks to anchor her presence in the city with what she calls her "sense of place," a sensory awareness that approximates the sensing of places that Benjamin has in mind when he speaks of the "haptic sense of a tile"—*Tastbewußtsein einer Fliese*—and of the other tactile territories that attend the distinctive sensitivity and experience of flanerie.[47] Wolff's retrospective tour of the city in *Hindsight* presents the process of a female flanerie in which the time shared with her friends in the 1920s is conjured again, as a reel of sensations that unwinds in her head, a film of the city that has been preserved but not rescreened until the 1970s.[48] To consider the crucial publication history of Wolff's text, an important record of memories that she writes first in English, can help us illuminate the history of female flanerie in German letters. If we consider the intense impact that modern optics and the visual rediscovery of her city hold for Wolff's writings, we may well be alarmed to find the majority of her flaneuristic passages missing from the edited German translation of her text.[49] This process appears to be more symptomatic than accidental. Wolff's experience of the city, the gaze through the eyes of a female flaneur, is considered to be of so little interest to a reading public that this gaze and experience have been erased almost entirely, and without comment, from the original version of this text. If these passages of female flanerie are regarded as nothing but redundant detours in her narrative, their erasure not only effaces them from her text but also from an important literary tradition.

Missing without a trace are Wolff's reflections on the bygone era of a Weimar Berlin that she holds up as a critical mirror in which to view the new perspectives of a divided city. To the returning eyewitness of the 1920s, both Nollendorff- and Wittenbergplatz appear as if they "had been stripped of [their] former identity and only the name[s] had remained" (*H*, 272). In the perspective of a female flaneur who was part of a lively intellectual and cultural scene, Schöneberg "had become an alien district." She finds strange buildings imposed on familiar sites: the "Café Krantzler [*sic*] occupied the place of the

legendary Café des Westens. Its proportions and interior architecture were of a different world, stripped of the bohemian charm of the past" (*H*, 261). Such observations of a changing Berlin would not appear to be erasable from a text that traces the effective destruction and affective loss of a city, that constructs a mental passage from the present to the past. It is difficult to imagine how aimless strolls in the streets could be insignificant to the biography and literature of a woman who invests the city with her sensory experience in ways that go beyond the clichéd usage of a metaphor: "The new Berlin did not help me to find again the town I had once known like the palm of my hand."[50] All of these signs of Wolff's flanerie are eliminated from the German edition of *Hindsight*. Removed from her text is the singular perception that not only constitutes the female flaneur's relation to reality but also indicates her experiences of a city, culture, and society in terms of the everyday practices of both her past and present.

To consider the importance of these passages—not to speak of their elimination—we need only imagine similar omissions from Benjamin's reflections in his *Denkbilder*, from Hessel's perambulations in *Spazieren in Berlin*, or from Kracauer's wide-ranging, far-reaching texts on cities and streets. Wolff not only shares and inhabits the same spaces and spheres of these thinkers and theorists, but the process of flanerie that belongs to the trajectory of her life is similar to that of the flaneurs who precede her text. This becomes even more evident in her many physiological and sociological reflections, for example on the environs around the Wannsee (*H*, 268ff), an aquatic mirror whose changing reflective surfaces she considers in depth and in great detail. She considers the shifting topography and diminished tempo of her city in the age of the Berlin Wall, a structure that restricts movement and experience by installing division and stagnation, that increases car traffic and thereby adds to the congestion and blurring of images that characterize the site.[51] Wolff's observations in general reveal an acute and continuous sense of place, an ever-insistent and alert reflection of urban environs. One of her most evocative scenes appears as if conjured through the chimeric quote of a scene from Hessel's *Heimliches Berlin* that relates his characters' romantic strolls on the Landwehrkanal. Wolff writes: "We didn't enter the house at once, but stood in silence at the river bordered by willows. It reflected the houses and willows on the other side. The softness of the trees, with their long and slender branches enveloping the trunks like a soft dress, made us feel slightly melancholic" (*H*, 307). As a kind of snapshot taken by the returning *flâneuse*, this scene of urban remembrance is indispensible to her text in its resonant atmosphere and latent melancholy. But even this pivotal scene of mourning and recognition is erased without a trace from the German version of this text of a female flaneur.

Nevertheless, Wolff displays her stance of flanerie throughout her writings: she shares the city stroller's intense predilection for movement and lights, for the textures and colors of public spaces that can be seen in the fleeting moments

she seeks to read, redeem, and preserve in her text. Visions of light—with its many subtle changes and shades—still exert a "hypnotic effect" on this spectator who, like all the flaneurs before her, exhibits an increased sensitivity for the *Lichtspiele* of exterior reality. The enticing spectacle of the city moves her to such distraction that it nearly incapacitates her and prevents her from concluding her observations: "One couldn't take one's eyes off the display," she says. Addicted to public spaces in every possible way, she describes an epistemological process that relies on an intense reception of the phenomena of exterior reality. In one sequence, Wolff tells of her "first 'discoveries' while on the walk to the Café Moehring. I looked at the houses in Uhlandstrasse, carefully sifting the old from the new, and I went as far as to enter one of the most promising old buildings. One could hardly open the heavy front door, symbol of the protective power of capitalism" (*H*, 282). As this example shows, the female flaneur approaches the material reality of her city in a highly immediate and sensory way. Seeking haptic access to the scene before her, she rhetorically extends the feeling of the door's weight against her hand, one of the many sensory devices and epistemological instruments of Wolff's later work in graphology. With all her senses, she comprehends these realities and perceptions as *Denkbilder* that bear the material weight of capitalist society. Again and again, Wolff's text follows the flaneur's impetus, compelled by the sights and structures of sites to pursue their history—as she puts it, she "needed to look at what had remained" (*H*, 300).

Reflecting on the origins of this impulse, she considers the ways in which these visual impressions converge with emotional landscapes and urban histories: "I had a sound purpose in my tour of recognition: to make sure how I felt seeing the museum pieces of yesterdays still preserved in the new streamlined Berlin." As this "tentative exploration of Berlin" (*H*, 281) presents the final destination of her biography, this female visitor from a bygone time of flanerie is again driven to register the multiple perspectives of urban spaces, the changing but nevertheless familiar places which she perceives with a renewed "first gaze." We can discern how Wolff's autobiographical writings begin to declare these images the primary concern of her narrative, of a text that revisits Berlin and, in so doing, offers an account of one of the female flaneurs who arrives in the city to assert her presence. The entire text of her female flanerie stands as an answer to her rhetorical question "Why was I drawn to wander along these streets?" (*H*, 300). That the very passages of her text that may define her as a female flaneur are missing from the German version of these writings indicates the implicit and decided discomfort that her ambitious movement produces in a society that regards her close, critical gaze as either a trivial marginality or a disconcerting threat. Charlotte Wolff is among the first women to simply, but decidedly, "take" the liberty of a female flanerie.[52] As one of the first female flaneurs, she gains access to a city that is no longer "closed" to her, that is no longer the alien territory that women had experienced for such

a long time.[53] On her return to the city, the older female flaneur finally finds herself in the position to acknowledge her intense desire for this experience, and to ascertain her ongoing presence in the public sphere.[54] As a flaneur, Wolff arrives in the city and extends her perspective further, observing that "Berlin opened itself up to me more and more" (*H*, 291). Even if the text of this female flaneur is not yet apparent in German literature and culture, and even if Wolff's "radical claim to a representation of her reality and perception as a woman" have long been "threatening to the male principle"[55] that defines itself in its aesthetics, she still insists on pursuing her freedom of movement and vision. As a female flaneur, Wolff returns in order to establish her experience and perception in original ways:

> This time I had found new ground under my feet. . . . I had been impressed by Berlin's new splendours, and seen some of my old haunts. I had explored town and people with a zest that I had not thought myself capable of a year or two ago. . . . Berlin had again become a place on my emotional map. (*H*, 308)

The texts that we have considered—those of Keun, Wolff, and other flaneurs—articulate the utopia of movement and perception that may finally begin to establish the "new ground" of a female aesthetics and politics of the public sphere. As female flanerie begins to find its place, to claim its stakes in the tradition of German culture and its Weimar metropolis, a literature of female flanerie may also, after more than a century, finally situate itself in the topography of public space.

Notes

Chapter 1
Walking Texts

1. Fournel, *Ce qu'on voit dans les rues de Paris*, 262. This passage is presented under a programmatic heading that seems to be aware of the theoretical implications of its aesthetic movement: "L'art de la flânerie."

2. The precursor of another way of walking in the city was still preoccupied with preindustrial concerns related to his wandering, such as the question of shoes, canes and coats, the perils of English weather, and obstacles, as seen in "How to walk clean by Day" and the "Danger of crossing a Square by Night." These considerations preceded the development of the modern city and the age of its industrial lighting. In an account of the material conditions in which walking takes place and the literary shape that it assumes in stylized, conventional poetic forms, John Gay's "Trivia; or, The Art of Walking the Streets of London," presents the document of walking as an overcoming of obstacles rather than as the more free-floating search for sensations which it becomes in the flaneries of the following century. Gay, *Poetry and Prose,* vol. 1, 134.

3. In an important recent study on the dynamics of vision throughout the nineteenth century, the gaze mobilized toward a scopophilia that would encompass all of the phenomena of modernity—that is, flanerie—surprisingly is represented only by its relative absence and brief mention with regard to Benjamin's theories; cf. Jonathan Crary, *Techniques of the Observer: On Vision and Modernity in the Nineteenth Century,* 21.

4. Fournel, *Ce qu'on voit*, 263.

5. The phenomenon of flanerie had all but disappeared in the scene of cultural discussion and as a practice after the end of Weimar Germany. Until the mid-1980s, even a compendium of alternative cultural figures and scenes as comprehensive as Helmut Kreuzer's *Die Bohème* never explicitly names the flaneur, though his study circumscribes the very spaces of urban bohemia and dandy culture that this figure also inhabits. An equally encyclopedic study on the classical capital of flanerie, Pierre Citron's *La Poésie de Paris dans la littérature française de Rousseau à Baudelaire*, does not address the flaneur on its own terms, even though the individual authors quoted throughout Citron's compendium frequently refer to the flaneur as an eminent figure of Parisian city life. A minor renaissance of the figure has occurred in the last decade along with a redefinition of culture and a renewed interest in urban discourses. The first comprehensive survey of flanerie in the tradition of German literature can be found in Eckhardt Köhn's *Straßenrausch. Flanerie und kleine Form.* Köhn includes a large number of authors and their texts since the early nineteenth century under the auspices of a *kleine Form*, the short prose piece that he considers to be the characteristic expression for this mode of perception. While this assumption describes certain fleeting aspects of the flaneur's modernist approach to writing, it necessarily overlooks many of the ambulatory qualities to be found in big-city novels by Döblin, Gurk, and others, and does not consider flanerie as a fundamental principle of collection (as in such fragmentary projects of modernity as Benjamin's *Passagen-Werk*), or the extent to which passages of

flanerie form an integral part of the perception of everyday life in Franz Hessel's novels of the flaneur.

In a more general context, Dana Brand's *The Spectator and the City in Nineteenth-Century American Literature* traces structures of flanerie in texts from the Anglo-American tradition. For a consideration of the relation between flanerie and other forms of realist narratives, cf. John Rignall, *Realist Fiction and the Strolling Spectator.* Keith Tester's *The Flaneur* is a wide-ranging collection of essays that pursues some of the most important sociological implications of the figure of the flaneur. These resonances are pursued further in a recent collection on visual culture as a critical cultural process, particularly in an essay by Chris Jenks, "Watching your Step: The History and Practice of the *Flâneur.*" Some of the most productive approaches to the flaneur have come from female readers and writers who presumably have experienced their exclusion from the sphere of flanerie. This is the argument of an early essay by Janet Wolff, "The Invisible Flaneuse: Women and the Literature of Modernity." Wolff's thesis has been more closely defined by Deborah Epstein Nord's work in the context of British women's literature; see her "The Urban Peripatetic: Spectator, Streetwalker, Woman Writer"; also cf. Judith Walkowitz's study of urbanity, *City of Dreadful Delights.* From the perspective of film theory and the postmodern in twentieth-century culture, Anne Friedberg's *Window Shopping. Cinema and the Postmodern* has unfolded a wide-ranging scenario that includes female scopophilia and the cinematic gaze. Guiliana Bruno has also reflected on female strollers and streetwalkers in relation to Elvira Nartori's Neapolitan films in her *Streetwalking on a Ruined Map. Cultural Theory and the City Films of Elvira Nartori.*

6. Fournel, *Ce qu'on voit,* 268.

7. For the notions and terms that inform the *Denkbild* as a genre, see Eberhard Wilhelm Schulz, "Zum Wort 'Denkbild,' " as well as Heinz Schlaffer's essay "Denkbilder: Eine kleine Prosaform zwischen Dichtung und Gesellschaftstheorie."

8. Also cf. Meaghan Morris's innovation of another programmatic term, the "woman walker," in "Things to Do With Shopping Centres."

9. See, for example, Herbert Günther, *Deutsche Dichter erleben Paris.* The first city of European modernity creates the movement of flanerie along with equally novel steps to formulate its literary expression in the genre of the "city tableaux." Mercier maps one of the first documents of this way of writing the experience of the city in his literary flanerie, *Tableau de Paris* (1781). Cf. also Karlheinz Stierle, "Baudelaires 'Tableaux Parisiens' und die Tradition des 'Tableau de Paris.' "

10. Kleist, Letter of 4 May 1801, *Briefe 1793–1804,* 175.

11. Also cf. Helmut J. Schneider, "The Staging of the Gaze. Aesthetic Illusion and the Scene of Nature in the Eighteenth-Century."

12. Kleist, *Briefe 1793–1804,* 40.

13. As an eminent example for the didactic functions of a process of simultaneous strolling and talking in the eighteenth century, see Lessing's illuminating dialogue of Enlightenment, "Ernst und Falk. Gespräche für Freimaurer."

14. Kleist, Letter of 23 September 1800, *Briefe 1793–1804,* 107.

15. Kleist, Letter of 27 October 1801, *Briefe 1793–1804,* 222.

16. See Michael Geisler's detailed account of the beginnings of journalistic reporting particularly from and about Paris, *Die literarische Reportage in Deutschland. Möglichkeiten und Grenzen eines operativen Genres,* 177–205.

17. Ludolf Wienbarg, quoted in Geisler, *Literarische Reportage*, 178.

18. Karl Gutzkow, quoted in Geisler, *Literarische Reportage*, 179.

19. Both quoted in Geisler, *Literarische Reportage*, 208ff.

20. Quoted in Geisler, *Literarische Reportage*, 210ff.

21. He looks upon its spaces and writes (about) the city as a flaneur; cf. Geisler, *Die literarische Reportage*: "Börne tritt darin als Flaneur auf, der . . . versucht, diese Beobachtungen in ihrer sozialen Signifikanz zu deuten," 181.

22. Cf. Geisler, *Literarische Reportage*, 182ff.

23. Börne, "Schilderungen aus Berlin," 30. Speaking of the *Mittel* employed to attract the gaze points at once to the economic functions of these "means" as well as to the emerging technological and visual "media" of their commercial strategies.

24. Heine, "Briefe aus Berlin"; cf. also Anke Gleber, "Briefe aus Berlin: Heinrich Heine und eine Ästhetik der Moderne."

25. Börne, "Schilderungen aus Berlin," 34. Emphasis in original.

26. Benjamin, *Gesammelte Schriften*, vol. 4, eds. Tiedemann and Schweppenhäuser, 32. For a discussion of other aspects in Benjamin's notion of "reading," cf. Karlheinz Stierle, "Walter Benjamin und die Erfahrung des Lesens."

27. Geisler, *Literarische Reportage*, 185.

28. Benjamin includes similar observations on a visual disposition that finds its way into the protofilmic "medium" of the *Blätterbücher* in his *Berliner Kindheit um Neunzehnhundert*, evidence of the pivotal material significance that he ascribes to these early inventions of visual reproducibility. It is no accident that he uses the same words for the process of "browsing" or "flipping" through a series of accumulating images that also appear in Börne's text; see Benjamin: "Sie flitzen rasch vorbei wie jene *Blätter* der straff gebundenen Büchlein, die einmal Vorläufer unserer Kinematographen waren." Emphasis mine. Benjamin, *Gesammelte Schriften*, vol.4, bk. 1, ed. Rexroth.

29. Benjamin's friend Hessel will define his flanerie in almost identical terms a century later, as a literal performance and production of a reading, "eine Art Lektüre der Straße." See "Berlins Boulevard," in *Ein Flaneur in Berlin*, 145.

30. Eckhardt Köhn situates the physiologies predominantly among those literary forms that trivialize the genre of the more established "tableaux-de-Paris." Cf. *Straßenrausch*, 50ff. Also cf. Hans-Rüdiger van Biesbrock, *Die literarische Mode der Physiologien in Frankreich (1840–1842)*.

31. E.T.A Hoffmann, *Der Sandmann. Das öde Haus. Nachtstücke.*

32. Benjamin initiates this new reading of Hoffmann's tales with his observations in "On Some Motifs in Baudelaire," 173ff. Also cf. the incisive formulation in his notes for "Pariser Passagen I": "Des Vetters Eckfenster das Testament des Flaneurs." *Passagen-Werk*, vol. 2, 1036. For subsequent views on the visual angle of Hoffmann's tales, cf. Helmut Lethen, "Eckfenster der Moderne. Wahrnehmungsexperimente bei Musil und E.T.A. Hoffmann," Heinz Brüggemann, "Das eingeschlossene Frauenbild oder Die Automate im Fenster—Figurationen des Wahrnehmungsbegehrens. E.T.A. Hoffmann, *Der Sandmann* und *Das öde Haus*," Günter Oesterle, "E.T.A. Hoffmann: Des Vetters Eckfenster. Zur Historisierung ästhetischer Wahrnehmung oder Der kalkulierte romantische Rückgriff auf Sehmuster der Aufklärung," as well as Thomas Kleinspehn's comments in his *Der flüchtige Blick. Sehen und Identität in der Kultur der Neuzeit*, 242ff.

33. *VE*, 621.

34. Emphasis mine.

35. Even the politically inclined observer experiences the anonymity of modern reality most pronouncedly in a variation on the symptomatic experience of shock, personified in the shape of an unknown "passing woman" in the street, defined by Benjamin from Baudelaire's sonnet "A une passante." Dronke relates the incident of an anonymous woman in the city addressing him as an intimate friend: "Ihr blickt überrascht auf . . . und die schöne Unbekannte schlägt errötend über ihren Irrtum . . . die Augen nieder." *B*, 10.

36. This historical angle in combination with his acute sociological awareness and political perspective renders Dronke's text the document of a rather more sophisticated flanerie than Köhn would have it; see Köhn, *Straßenrausch*, 81.

37. Benjamin will return to this characteristic constellation in his essay on "Das Leben der Studenten."

38. *B*, 38. Also cf., in the twentieth century, Otto Ernst Sutter, "Berlin als Fremdenstadt." Similar observations by Bloch and Kracauer on forms of "distraction" in the streets of Berlin—see, for example, "Cult of Distraction" and "Die Angestellten"—can be seen as precursors to other marginal cultures and experiences in West Berlin of the 1970s and 80s.

39. *B*, 23. Dronke goes on to criticize constellations of the contemporary capitalism of his society in specific detail, yet with an eye for its visual fascination.

40. *B*, 25. Emphasis mine.

41. Cf. Peter Jukes's collection of urban texts whose very title bears witness to this strong appeal of the city, *A Shout in the Street. An Excursion into the Modern City.*

42. Baudelaire, "A une passante." Cf. Eva-Maria Knapp, "Baudelaire: A une passante," and Elissa Marder, "Flat Death: Snapshots of History."

43. Among many participants in the process of awakening, Baudelaire also emphasizes that these streets are populated by strolling "dandys à face glabre."

44. Inspired by Poe's tale *The Man in the Crowd*, in 1858 Raabe writes his own exemplary excursion into the life of the city and its crowds, *Einer aus der Menge* (One from the Crowd). Situating both this text and Raabe's novel of the *Sperlingsgasse* within structures of perception characteristic for modernity, cf. Susanne Hauser, *Der Blick auf die Stadt. Semiotische Untersuchungen zur literarischen Wahrnehmung bis 1910.*

45. For relations between the city and the literature of modernity in general, see for example, Burton Pike, *The Image of the City in Modern Literature*; for the context of German literature, cf. Karl Riha, *Die Beschreibung der "Großen Stadt." Zur Entstehung des Großstadtmotivs in der deutschen Literatur (ca. 1750–1850)*, Meckseper and Schraut's collection, *Die Stadt in der Literatur*; and Andreas Freisfeld, *Das Leiden an der Stadt. Spuren der Verstädterung in deutschen Romanen des 20. Jahrhunderts.*

46. Klotz, *Die erzählte Stadt. Ein Sujet als Herausforderung des Romans von Lesage bis Döblin*, 172.

47. For a few eminent examples of how a perception of everyday reality may translate into film, see Wim Wenders's *Der Stand der Dinge* (1982), *Chambre 666* (1982), or *Notebook on Cities and Clothes* (1991), as only some among the more visually inflected theoretical reflections recorded by a filmic flaneur.

48. A pivotal text of the city, the location of Raabe's book has over time become a

mythical location in Berlin's literary topography; see, for example, Hessel's mention of this specific lane—"Spreegasse heißt es und ist Raabes Sperlingsgasse"—in his literary walks through a historic Berlin. See "Rundfahrt," in *Ein Flaneur in Berlin*, 65.

49. Edouard Dujardin, *Les Lauriers sont coupés*. Specific references to Dujardin's text follow the German translation, *Die Lorbeerbäume sind geschnitten*.

50. With its highly detailed and deliberately slow representation of a stream of images and perceptions in the protagonist's eye and their projections into his mind, Dujardin's texts become an important inspiration for modernist narratives, in particular Joyce's "stream-of-consciousness" technique, an inspiration that Joyce himself acknowledges. Cf. Dujardin's subsequent theoretical reflections in *Le monologue intérieur. Son apparition, ses origines, sa place dans l'oeuvre de James Joyce*.

51. Prefiguring Hessel's texts of the city comes an early treatise on urban aesthetics by the Berlin architect, city planner, and city stroller August Endell, entitled *Die Schönheit der großen Stadt* (1908), which focuses explicitly on what he perceives to be the entirely unprecedented beauty in urban modernity, as well as another text of Endell's, *Zauberland des Sichtbaren*. Also cf. Lothar Müller, "The Beauty of the Metropolis. Toward an Aesthetic Urbanism in Turn-of-the-Century Berlin."

52. Cf. the terms of this *Kino-Debatte* and its texts in Anton Kaes, *Kino-Debatte. Texte zum Verhältnis von Literatur und Film, 1909–1929*.

Chapter 2
The City of Modernity

1. Among many important inquiries into the relation of modernity to the city, see the writings of Lewis Mumford, in particular *The City in History. Its Origins, Its Transformations, and Its Prospects*, as well as Marshall Berman, *All That is Solid Melts into Air. The Experience of Modernity*.

2. Cf. an anthology of texts relating to various positions on modernity, Gerd Stein's typological collection *Dandy—Snob—Flaneur. Dekadenz und Exzentrik: Kulturfiguren und Sozialcharactere des 19. und 20. Jahrhunderts*.

3. As an introduction to Simmel's thought, see David Frisby, *Georg Simmel*.

4. For an informative study that relates the general context of these writings to the reception of Simmel's thought in Weimar Germany, cf. Frisby, *The Alienated Mind. The Sociology of Knowledge in Germany 1918–1933*. For readings of Simmel with respect to flanerie, also see Frisby's *Sociological Impressionism. A Reassessment of Georg Simmel's Social Theory*, in particular his chapter on "A Sociological *Flaneur*?" 68–101.

5. M, 325. Emphasis mine. What has been translated as the "emotional" life really refers to the life of and perception of sensory stimuli in the actual modern reality of the cities. Also cf. Frisby's "Social Space, the City and the Metropolis."

6. Kleist, *Briefe 1793–1804*, 212.

7. Benjamin quotes a definition of "shock" in accordance with observations by Freud, who seeks to "understand the nature of these traumatic shocks 'on the basis of their breaking through the protective shield against stimuli.' " "On Some Motifs in Baudelaire," *Illuminations*, 161.

8. Benjamin, *Passagen-Werk*, 538.

9. The ambivalence of his existence and a shifting sense of allegiance characterize the ways in which the flaneur can be shown to participate in many differing aspects and types of modernity from Simmel's theories. A close reading of his essay on the metropolis can therefore also serve to name the flaneur as a more multifaceted existence than a recent "postmodern" reclassification of Simmel would suggest. Cf. Deena Weinstein and Michael Weinstein, "Georg Simmel. Sociological flaneur bricoleur." Indeed, the authors' definition of *bricolage* would, in light of Benjamin's and Kracauer's Weimar theories, read as a possible approximation of flanerie: "The stock of the *bricoleur* . . . does not allow for a single and consistent totalization. . . . The individual must cobble together whatever meaning can be wrested from the irreducible and irreconcilable fragments of reality" (68ff).

10. Kleist, *Briefe 1793–1804*, 189.

11. Despite the increasing sense of fascination with the modern city, simultaneous antipathy to the anonymity of the crowds provides one of the foundations for Friedrich Engels's political indictment of capitalist modernity, in *Die Lage der arbeitenden Klassen in England:* "Diese kolossale Centralisation . . . hat die Kraft dieser dritthalb Millionen verhundertfacht. . . . Schon das Straßengewühl hat etwas Widerliches, etwas, wogegen sich die menschliche Natur empört."

12. *M*, 329. Emphasis mine.

13. Cf. these aspects as opposing tendencies, as Simmel describes them in detail in *M*, 330. Also see Laura Boella, "Visibilité et surface. Le possible et l'inconnu dans le concept de forme de Georg Simmel."

14. *M*, 334.

15. *M*, 336.

16. *M*, 336. The precise wording in Simmel's original emphasizes the visual components of this social differentiation, calling it a "Sichherausheben und dadurch *Bemerklich*werden." Emphasis mine.

17. Bruce Mazlish observes that Baudelaire is among the first to articulate this "merging [of] the dandy with the flaneur." See "The flaneur: from spectator to representation." (50).

18. Simmel, "Exkurs über die Soziologie der Sinne," in *Soziologie. Untersuchungen über die Formen der Vergesellschaftung*, 483–93.

19. Simmel, *Soziologie*, 477.

20. Simmel, *Soziologie*, 486.

21. Simmel, *Soziologie*, 486. For this as well as the following translations from Simmel's *Soziologie*, I am indebted to Frisby, *The Alienated Mind*, 78. It is certainly no accident that Simmel's original language here makes use of the word *Verkehr*, a term for "relationship" which in German also signifies "traffic."

22. Simmel, *Soziologie*, 486. Cf. Frisby, 78.

23. Cf. Frisby's term in *Sociological Impressionism*, 68ff.

24. Simmel, *Soziologie*, 488.

25. Cf. a similar notion of "shock" as a pivotal moment in the experience of modernity in Benjamin's writings, particularly in those analyzing the new media. This is most pronounced in the essay "Das Kunstwerk im Zeitalter seiner technischen Reproduzierbarkeit."

26. Simmel, *Soziologie*, 489.

27. The following discussion is indebted to two illuminating studies in nineteenth-century cultural history, Wolfgang Schivelbusch's *Disenchanted Night. The Industrialisation of Light in the Nineteenth Century*, and Christoph Asendorf's *Batterien der Lebenskraft. Zur Geschichte der Dinge und ihrer Wahrnehmung im 19. Jahrhundert.*

28. Schivelbusch, *Disenchanted Night*, 96.

29. In *Disenchanted Night*, Schivelbusch cites a large number of particularly nuanced instances of this shifting perception of light qualities, such as the differences between the experience of gaslight and electrical light, or the first notion of a "flood of light" in the nineteenth century; cf. pages 60ff and 114ff.

30. Schivelbusch, *Disenchanted Night*, 61.

31. Dujardin, *Die Lorbeerbäume sind geschnitten*, 33.

32. Dujardin, *Lorbeerbäume*, 84ff.

33. For further passages on modernity and the cinematic character of Dujardin's text, see, for example, Stefan Buck, *Edouard Dujardin als Repräsentant des Fin de siècle*, in particular his remarks on "Die Modernität von *Les Lauriers sont coupés*" and "Die Konzeption eines erzählten Films," 104–8.

34. Dujardin, *Lorbeerbäume*, 111.

35. Dujardin, *Lorbeerbäume*, 87. Emphasis mine.

36. Dujardin, *Lorbeerbäume*, 37.

37. Schivelbusch, *Disenchanted Night*, 150; cf. also his similar arguments on pages 91ff.

38. Cf. Benjamin, "The Paris of the Second Empire in Baudelaire," 37.

39. Schivelbusch, *Disenchanted Night*, 149.

40. Schivelbusch, *Disenchanted Night*, 145. Cf. also the illustration (1870) from the same time, which shows starkly the social implications of these harsher contrasts between light and shadows under the more accentuated lighting conditions.

41. Gross, "Space, Time and Modern Culture," 69.

42. Cf. Aragon, *Le Paysan de Paris. Pariser Landleben*; see in particular the passage of text that literally winds its way through the "Passage de l'Opéra," 17–131.

43. Schivelbusch, *Disenchanted Night*, 146.

44. See Viktoria Schmidt-Linsenhoff, "Plakate 1880–1914," in *Plakate 1880–1914.*

45. Weill, *The Poster. A Worldwide Survey and History*, 100.

46. The new figure of the advertising executive becomes a projection screen for modern subjectivity in texts from the capital of Weimar Germany; see, for example, Erich Kästner, *Fabian. Die Geschichte eines Moralisten* (1931). Also cf. Wolf Zucker, "Kunst und Reklame. Zum Weltreklamekongress in Berlin."

47. Kurt Wettengl, "Geschäftswerbung," in Schmidt-Linsenhoff, *Plakate 1880–1914*, 399. Cf. also the critical consideration of visual stylization that occurs even in product names and advertising copies analyzed semiotically by Umberto Eco, *Einführung in die Semiotik.*

48. See Schivelbusch's comments on the panoramic gaze of perception over "commodity landscapes" in the department store, a gaze that he links to conventions of seeing first engendered by the "railway journey." *The Railway Journey. The Industrialization of Time and Space in the Nineteenth Century*, 192.

49. Wettengl, "Geschäftswerbung," in Schmidt-Linsenhoff, *Plakate 1880–1914*, 403.

50. *Das moderne Plakat*, 108; quoted in Schmidt-Linsenhoff, "Plakate 1880–1914," 8.

51. *Jugendstil* slogans for an art of the poster, as quoted by Schmidt-Linsenhoff, "Plakate 1880–1914," 8.

52. Cf. Denscher's *Tagebuch der Straße. Geschichte in Plakaten*, quoted in Schmidt-Linsenhoff, "Plakate 1880–1914," 11.

53. Schmidt-Linsenhoff, "Plakate 1880–1914," 14ff.

54. Also see in this context, for example, Mary Louise Pratt, *Imperial Eyes. Travel Writing and Transculturation*.

55. Schmidt-Linsenhoff, "Optische Illusionen," in *Plakate 1880–1914*, 269.

56. Schivelbusch, *Railway Journey*, 160.

57. Gross, "Space, Time and Modern Culture," 65.

58. As a new mode of transportation, railroad travel therefore causes what Schivelbusch calls a "reaction of perceptive powers" that is first registered as a "loss" of perception in its former ways. Schivelbusch, *Railway Journey*, 37. The German original of this study places more emphasis on the moment of loss in perception, characterizing it as a "Wirklichkeitsverlust der Wahrnehmung." *Geschichte der Eisenbahnreise*, 38.

59. Schivelbusch, *Railway Journey*, 55.

60. Schivelbusch, *Railway Journey*, 59.

61. Schivelbusch, *Railway Journey*, 60.

62. Schivelbusch, *Railway Journey*, 63. The original wording emphasizes the ways in which this new medium of "resurrection" is always already a "technologically institutionalized" one; cf. *Geschichte der Eisenbahnreise*, 61.

63. As Schivelbusch quotes John Ruskin on the experience of these early moderns, "all travelling becomes dull in exact proportion to its rapidity." *Railway Journey*, 58.

64. Sternberger, *Panorama oder Ansichten vom 19. Jahrhundert*, 50.

65. Schivelbusch, *Railway Journey*, 48.

66. See, for example, such visual categories as *Gegebenheit, Formlosigkeit, Intensivierung, Farbigkeit, Flüchtigkeit*, and *Nuancenkult*, which Richard Hamann and Jost Hermand delineate as indicative of impressionist approaches to reality. *Impressionismus*, 206–370.

67. Schivelbusch, *Railway Journey*, 191.

68. See the details of this argumentation in Schivelbusch, *Railway Journey*, 184ff.

69. Cf. Alexandre Dumas, Arsène Houssaye, Paul de Musset, et al., *Paris et les parisiens au XIX siècle*, quoted in Schivelbusch, *Railway Journey*, 186.

70. Cf. John Rignall, "Benjamin's *Flaneur* and the Problem of Realism," 112–21.

71. See Benjamin's essay on Hessel's flanerie, "Die Wiederkehr des Flaneurs."

Chapter 3
Passages of Flanerie

1. Cf. Siegfried Kracauer, "Die Wartenden" and "Kult der Zerstreuung," in *Das Ornament der Masse. Essays*, and "Die Angestellten. Aus dem neuesten Deutschland," in *Schriften 1*, 205–304. The essays of *Ornament der Masse* are now available in translation by Thomas Y. Levin as *The Mass Ornament. Weimar Essays* (Cambridge: Harvard University Press, 1995).

2. Kracauer, "The Biography as an Art Form of the New Bourgeoisie," in *Mass Ornament*, 101–5.

3. Kracauer, *Mass Ornament*, 102.

4. Simmel, Soziologie.

5. See Ernst Bloch, *Erbschaft dieser Zeit*, 62. "Simultaneous" is used here as an analogue to Bloch's term *Ungleichzeitigkeit* [non-simultaneity] from the same cultural context.

6. Kracauer, "Angestellten," 215. For the theoretical implications of Kracauer's sociological essays on these figures of a "white-collar culture," cf. Michael Hofmann, "Kritische Öffentlichkeit als Erkenntnisprozeß. Zu Siegfried Kracauers Essays über *Die Angestellten* in der *Frankfurter Zeitung*," 87–104; also, Eckhardt Köhn, "Konstruktion und Reportage. Anmerkungen zum literaturtheoretischen Hintergrund von Kracauers Untersuchung 'Die Angestellten'."

7. Kracauer, "Angestellten," 230.

8. Kracauer, "Cult of Distraction," in *Mass Ornament*, 325.

9. Cf. Heide Schlüpmann's article on Kracauer's perception of the movie-going audiences in Weimar Germany, "Der Gang ins Kino—ein Ausgang aus selbstverschuldeter Unmündigkeit. Zum Begriff des Publikums in Kracauers Essayistik der Zwanziger Jahre," Frisby, in *Siegfried Kracauer. Neue Interpretationen*, 267–84.

10. Kracauer's orginal wording emphasizes the very process of "looking" by placing structural and visual primacy upon the crowd: "*Die vier Millionen* Berlins sind nicht zu übersehen." Emphasis mine.

11. Kracauer, "Boredom," in *Mass Ornament*, 332. Emphasis in original. In the original, the two next-to-last sentences continue as one ongoing structure of thought, attributing an absolute quality to these images—"so besteht außer ihrer Unbeständigkeit nichts. . ." Emphasis mine. "Boredom" as a privileged form of access to the phenomena of the nineteenth century also figures in convolute "D" of Benjamin's *Passagen-Werk*, entitled "Die Langeweile, ewige Wiederkehr" (Boredom, Eternal Return). See *Das Passagen-Werk*, vol. 1, 156–78.

12. For the cinematic refractions of this *Zerstreuungssucht*, see also Schlüpmann, "Der Gang ins Kino," in Frisby, *Siegfried Kracauer*, 274ff, as well as Miriam Hansen, "Decentric Perspectives: Kracauer's Early Writings on Film and Mass Culture."

13. Bloch, *Erbschaft dieser Zeit*, 36. Emphasis mine. Note his characteristic wording of a passage concerning public manifestations of new forms of cultural signification—"Auf der Straße *wird wahr*"—as well as the way he continues this passage of reflection: "Wie *geht sichs müßig* auch hier." My emphases.

14. Bloch, *Erbschaft dieser Zeit*, 368.

15. Benjamin, "Wiederkehr des Flaneurs."

16. Kracauer, "Langeweile," 99. Cf. also one of the pivotal essays in *Mass Ornament* that links these phenomena of flanerie to the time of Weimar, an essay that appears under significantly similar conditions and the identical title of "Langeweile"; see "Boredom," in *Mass Ornament*, 331–34.

17. A related phenomenon can be seen in the resigned stance of a post-1968 student generation in the FRG and West Berlin; cf. Peter Sloterdijk, *Zur Kritik der zynischen Vernunft. Ein Essay*.

18. Kracauer constructs his own term for this inscription as "ihr *Eingebautsein* in eine bestimmte geistige Situation." Emphasis mine.

19. Kracauer, "Those Who Wait," in *Mass Ornament*, 129–40.

20. Kracauer, *Mass Ornament*, 138.

21. Kracauer, *Mass Ornament*, 139ff.

22. Kracauer, *Detektiv-Roman*, 145.

23. Cf. the terms "redemption" and "reality" as the rhetorical foundation and central perspective of Kracauer's *Theory of Film. The Redemption of Physical Reality.*

24. Kracauer here speaks of Berlin's "picture palaces" as *Kultstätten des Vergnügens*, virtual "shrines to the cultivation of pleasure"; "Cult of Distraction," in *Mass Ornament*, 323.

25. Kracauer, *Detektiv-Roman*, 135. For the status of this text within Kracauer's writings and the sphere of metropolitan anonymity, cf. David Frisby, *"Zwischen den Sphären*. Siegfried Kracauer und der Detektivroman."

26. Kracauer, *Detektiv-Roman*, 129. Kracauer goes on to consider "those who wait" in the hotel lobby or society's other transitory spaces as the "schlechthin Beziehungslosen," connecting the figures of perception in the detective novel to the seemingly aimless observers in the street.

27. Kracauer, *Detektiv-Roman*, 164.

28. Benjamin, "Kleine Geschichte der Photographie," 105. For this context of space and surveillance, cf. also Gertrud Koch, "Cosmos in Film: On the Concept of Space in Walter Benjamin's 'Work of Art' Essay."

29. Among the 26 convolutes of *Das Passagen-Werk*, the figure of the flaneur—"M" and No. 13—forms the symmetrical core and center around which this citational construction is organized. The collector—"H"—precedes the flaneur yet repeats many of his characteristics. For an extended view of the *Passagen-Werk*, see Susan Buck-Morss, *The Dialectics of Seeing. Walter Benjamin and the Arcades Project.* Also cf. Rolf Tiedemann's essay "Dialectics at a Standstill: Approaches to the *Passagen-Werk*."

30. Both "fashion" and "photography," the second and second-to-last entries of the *Passegen-Werk*, respectively, form the conceptual frames for this project of cultural collection, while the convolute on "advertising"—"G"—precedes the one on the collector, and the one on "prostitution"—"O"—is near in sequence to the one on the flaneur. In a later notation, the flaneur appears between two entries that involve related instances of dialectics: Benjamin lists the "dialectics of flanerie" as surrounded by one each for the objects of his scopophilia, the dialectics of "fashion" and the "commodity." See *Das Passagen-Werk*, 1215.

31. For the pivotal position of the collector in modernity and in Benjamin's writings, indeed a position that is intricately linked to the one of the flaneur, see Ackbar Abbas, "Walter Benjamin's Collector. The Fate of Modern Experience."

32. Cf. Johann Friedrich Geist's history of these constructions, *Passagen. Ein Bautyp des 19. Jahrhunderts.*

33. Cf. Benjamin's "The Paris of the Second Empire" and other major essays relating to Baudelaire and the flaneur in *Charles Baudelaire. A Lyric Poet in the Era of High Capitalism.* Also cf. Michael W. Jennings, "Benjamin's Baudelaire," in *Dialectical Images. Walter Benjamin's Theory of Literary Criticism*, 15–41.

34. For a contextualization of the privileged position of the city in Benjamin's work, see Peter Szondi, "Walter Benjamin's City Portraits," Bernd Witte, "Paris—Berlin—Paris. Personal, Literary and Social Experience in Walter Benjamin's Late Works," as well as Gary Smith, "Benjamins Berlin."

35. Benjamin, *Passagen-Werk*, 491.

36. Benjamin, *Passagen-Werk*, 492. In speaking of a *Folge* in the dream visions of the twentieth century, Benjamin emphasizes at once the "consequences" that these images conjure as well as a protofilmic, linear quality to the "series" of images as they unfold. For an analysis of interpretative processes in the *Passagen-Werk*, see James L. Rolleston, "The Politics of Quotation: Walter Benjamin's Arcades Project," *PMLA*.

37. Benjamin, *Passagen-Werk*, 1214. For Benjamin's relation to Aragon and the surrealists, see Margaret Cohen, *Profane Illumination. Walter Benjamin and the Paris of the Surrealist Revolution*, in particular her passages on Benjamin's distance from the surrealist treatment of dream, 174ff.

38. Cf. the respective sections—as "framed" terms—in *Passagen-Werk*, 1215. For a retracing of some of the constellations of flanerie in Benjamin's writings, see Sven Birkerts's essay "Walter Benjamin, Flaneur: A Flanerie," Heiner Weidmann's study *Flanerie, Sammlung, Spiel. Die Erinnerung des 19. Jahrhunderts bei Walter Benjamin*, and Rob Shields's discussion of "Fancy footwork. Walter Benjamin's notes on *flanerie.*"

39. Benjamin, *Passagen-Werk*, 546. Margaret Cohen reads these and similar passages of reverie as evidence of an interest in the surrealists, such as Breton and Aragon, that even surpasses Benjamin's emphasis on Baudelaire; see her *Profane Illumination*, 200–205.

40. Benjamin, *Passagen-Werk*, 524. For a consideration of these material relays and their rhetorical consequences in Benjamin's writings, see Thomas Schestag, "Asphalt," *MLN* 3, no. 106 (1991): in particular, 610–21.

41. The flaneur finds himself to be both the subject of and subjected to his sensory perception of these public spaces.

42. Cf. "The Paris of the Second Empire in Baudelaire," 87. A more literal translation of Benjamin's original wording clearly emphasizes the visual aspects of this process itself: "That of which one knows that one soon will not have it before oneself [that is, *before one's eyes*] any longer, becomes an image." This quasi-photographic or filmic reception of reality as an unfolding of images is an ongoing process in the streets, according to Benjamin: "So wurden *es* [an image] wohl die pariser Straßen. . . ." Emphasis mine. See "Das Paris des Second Empire bei Baudelaire," in *Gesammelte Schriften*, vol. 2, bk. 2, eds. Tiedemann and Schweppenhäuser, 590.

43. Benjamin, "Paris of the Second Empire," 74.

44. Benjamin, "Zentralpark," in *Illuminationen. Ausgewählte Schriften* (Frankfurt/M.: Suhrkamp, 1983), 236.

45. Sigmund Freud, quoted in Benjamin, "On Some Motifs in Baudelaire," 161.

46. The experience bears a marked resemblance to the formulation of a "hunger for experience," an *"Erfahrungshunger,"* that defines the generation of a so-called "New Subjectivity" since the 1970s; cf. Michael Rutschky, *Erfahrungshunger. Ein Essay über die siebziger Jahre.*

47. Benjamin, *Passagen-Werk*, 525.

48. Benjamin, "Paris of the Second Empire," 19. Cf. also, for example, Michael Thompson, *Rubbish Theory. The Creation and Destruction of Value*, and Jonathan Culler, "Junk and Rubbish. A Semiotic Approach."

49. Benjamin, "Paris of the Second Empire," 69. This passage's original rhetoric is more receptive to the celebratory aspects and more evocative of the visual components in this process: "In the flaneur, scopophilia celebrates its triumph."

50. Fournel, *Ce qu'on voit*, 263, as quoted by Benjamin in "The Paris of the Second Empire in Baudelaire," 69.

51. Cf. Irving Wohlfahrt, "Et Cetera? The Historian as Chiffonnier." For these both resistant and poetic qualities of the chiffonnier in Baudelaire, also cf. Karlheinrich Biermann, "Der Rausch des Lumpensammlers und der Alptraum des Bürgers. Historisch-soziologische Interpretation von Baudelaire's *Le Vin des Chiffonniers.*"

52. Benjamin, "Paris of the Second Empire," 37.

53. Benjamin refers to Baudelaire's lines from the *Salon de 1845* on the fashions of his time. "The Paris of the Second Empire in Baudelaire," 76ff.

54. Benjamin quotes Baudelaire's aesthetic and rhetorical ideas on his poems in prose, in terms that transfer easily to a prose of flanerie. "Paris of the Second Empire," 69.

55. It would have to be "musical without rhythm and without rhyme, supple and staccato enough to adapt to the lyrical stirrings of the soul, the undulations of dreams, and the sudden leaps of consciousness." The word appearing here as "staccato" is the translation of a term that Benjamin renders in German as "*spröde*," an adjective that also suggests a certain "resistance" or "resilience" against influences and other manipulations. Benjamin, "Paris of the Second Empire," 69.

56. Benjamin's translation of Baudelaire's French again emphasizes a rhetoric of "home" and "property." According to Benjamin, he says that this prose "wird vor allem von dem *Besitz ergreifen*, der in den Riesenstädten mit dem Geflecht ihrer zahllosen einander durchkreuzenden Beziehungen *zuhause ist*." Emphasis mine. Cf. "Das Paris des Second Empire bei Baudelaire," 572.

57. Cf. the notion of "correspondences" as similar structures of poetic thought in symbolism. See, for example, Anna Balakian, *The Symbolist Movement. A Critical Appraisal*.

58. Benjamin, "Zentralpark," 238.

59. Benjamin, *Passagen-Werk*, 547. In this passage, Benjamin is quoting from a flanerie which "constituait déja un acte essentiellement poétique," in an article by Edmond Jaloux entitled "Le dernier flâneur" [1936].

60. Benjamin, *Passagen-Werk*, 528.

61. Cf. Graeme Nicholson's delineation of these processes in his *Seeing and Reading*.

62. Benjamin, *Passagen-Werk*, 530.

63. Benjamin, "Paris of the Second Empire," 100. In the original wording, Benjamin uses the terms of a literally "prosaic," an urban provenance. Also cf. Karlheinz Stierle, "Figuren der Lesbarkeit: Flaneur, Passage, Omnibus," in his *Der Mythos von Paris. Zeichen und Bewußtsein der Stadt*, 205–20.

64. Benjamin, *Passagen-Werk*, 531. Also cf. Winfried Menninghaus's reading of Benjamin's theory of myth in *Schwellenkunde. Walter Benjamins Passage des Mythos*, 33–43.

65. Benjamin, *Passagen-Werk*, 530.

66. Benjamin, *Passagen-Werk*, 534.

67. Benjamin, "Paris of the Second Empire," 37.

68. Benjamin, *Passagen-Werk*, 533.

69. Benjamin, "Paris of the Second Empire," 37.

70. Benjamin speaks of a "weaving" of this phantasmagoria in "Paris of the Second Empire," 39.

71. Benjamin, "Paris of the Second Empire," 39. Benjamin literalizes the process as an "*ablesen*," thereby rendering the physiological interpretation of these significant characteristics as an explicit process of reading.

72. Benjamin, "On Some Motifs in Baudelaire," 165.

73. Benjamin, *Passagen-Werk*, 540.

74. See "Paris of the Second Empire," 36. Benjamin's categories include further primary functions from the organization of social life, such as *Paris à table* or *Paris marié*, or other evocative spaces, such as *Paris dans l'eau*.

75. Benjamin, "Paris of the Second Empire," 36.

76. Cf. Ann Game, *Undoing the Social. Towards a Deconstructive Sociology*, 197.

77. Benjamin, *Passagen-Werk*, vol. 2, 993.

78. Benjamin, *Passagen-Werk*, 562.

79. Benjamin, *Passagen-Werk*, 537ff.

80. Benjamin, "Zentralpark," 239.

81. Benjamin, "Zentralpark," 239.

82. See also Michael W. Jennings, *Dialectical Images*, 119.

83. Benjamin, "Paris of the Second Empire," 56.

84. Cf. Benjamin's notation: "Die Liebe zur Prostituierten ist die Apotheose der Einfühlung in die Ware." *Passagen-Werk*, 637. For related questions of gender and modernity in Benjamin's work, see Angelika Rauch's essay "The *Trauerspiel* of the Prostituted Body, or Woman as Allegory of Modernity."

85. A mode of gathering the images of modernity, the flaneur's reception of visual stimuli lets the labyrinth of the city appear to be, like prostitution, he says, "rimmed [*gerändert*] with colors." Cf. Benjamin, "Zentralpark," 248.

86. Benjamin, *Passagen-Werk*, 560.

87. Benjamin, "Paris of the Second Empire," 34.

88. *Passagen-Werk*, 559. The ways in which Benjamin oscillates between naming these factors either a social "Grundlage" or its "Legitimierung," respectively, points to quite distinct perspectives on an activity that is not exhausted by its social functions.

89. Benjamin, *Passagen-Werk*, 554.

90. Benjamin, *Passagen-Werk*, 551. He discovers this investigator in classical texts from the new "wilderness" of civilization, such as Alexandre Dumas's *Mohicans de Paris* or Eugène Sue's *Mystères de Paris*. As predecessors of the detective story, these texts seek the enigmatic traces left behind in the newly exoticized or criminalized labyrinths of urbanity.

91. In E. A. Poe's "The Man in the Crowd," the detective's new genre, the mystery novel, also gives rise to one of the first exemplary, literary representations of the flaneur. Cf. Benjamin, *Passagen-Werk*, 554.

92. Benjamin, "Paris of the Second Empire," 47.

93. Benjamin, *Passagen-Werk*, 529.

94. Benjamin, "Zentralpark," 243.

95. Benjamin, "On Some Motifs in Baudelaire," 172. Benjamin's wording in the original presents the connotations of a less elitist and egomaniacal sphere: the presumed "elbow room" rather is an extended "space for play" or "free space" [*Spielraum*], while the flaneur really is not limited to being either a "man" or a "gentleman" but represents any individual "who does not want to miss his privatizing [*Privatisieren*]," that is, any figure in the streets who insists upon perceptions and a perspective of his or her own.

96. Benjamin, *Passagen-Werk*, 535.

97. *Passagen-Werk*, 536.

98. Benjamin, "Zentralpark," in *Illuminationen*, 238.

99. Just as Kracauer and Benjamin describe the 1920s as a period of such transitions, a post-1968 generation of writers and filmmakers experiences a similar phase of stagnation and waiting, according to Peter Sloterdijk, *Zur Kritik der zynischen Vernunft*, and Michael Rutschky, *Erfahrungshunger* and *Wartezeit. Ein Sittenbild*.

100. Benjamin, "On Some Motifs in Baudelaire," 180.

101. Benjamin, "On Some Motifs in Baudelaire," 169.

102. Benjamin, "Paris of the Second Empire," 46.

103. Benjamin, "Paris of the Second Empire," 50.

104. Benjamin, "Zentralpark," in *Illuminationen*, 233.

105. Benjamin, "Paris of the Second Empire," 37.

106. Benjamin, "Paris of the Second Empire," 97. Rob Shields discusses the "savage mohicans" in analogy to the urban adventurers of the city's new "wilderness-like space of adventure." See "Fancy footwork: Walter Benjamin's notes on *flânerie*."

Chapter 4
The Art of Walking

1. Many of Benjamin's writings on flanerie in English are collected in *Charles Baudelaire. A Lyric Poet in the Era of High Capitalism*. A recent critic has indeed remarked upon his discovery of Hessel's writings: "Benjamin differs sharply from Hessel in his filtering of impressions through dialectical analysis, often fascinating but at times seeming forced and contrived." Cf. Neil H. Donahue, "Expressionist Prose. Experiments in a New Spirit," in his *Forms of Disruption. Abstraction in Modern German Prose*, 154.

2. Hessel's life and writings are gradually receiving some attention in recent criticism, including the first literary monograph about motifs of eros and death in Hessel's novels by Jörg Plath, entitled *Liebhaber der Großstadt. Ästhetische Konzeptionen im Werk Franz Hessels*. These "aesthetic conceptions" include categories such as the ones summarized in "chapter 2.2.3.4.: Der Flaneur, der Liebhaber," with specific consideration of "2.2.3.4.1: im Intérieur" and "2.2.3.4.2.: im Extérieur." They do not engage a reading of flanerie as an aesthetics of literary scopophilia and the early manifestation of a protocinematic gaze. Among previous investigations of Hessel's works—along with Benjamin and Kracauer—figures primarily the part of one chapter dedicated to his writings in Eckhardt Köhn's survey of German flanerie, *Straßenrausch*, 153–94. Also cf. Neil H. Donahue, *Forms of Disruption*, 148–60, and Michael Bienert, *Die eingebildete Metropole. Berlin im Feuilleton der Weimarer Republik*, 78–82. Hessel's urban writings have undergone a minor "renaissance" as a result of the celebrations on the occasion of Berlin's 750-year anniversary and the concomitant interest in discourses on the city and flanerie.

3. For many decades after Hessel's death in French exile in 1941, the historiography of German literature perpetuated absence and amnesia concerning this author. The *Deutsches Literatur-Lexikon*, for example, continues to list his date of death as "unknown" even as late as 1949, and the same reference work does not register any of the author's writings between 1924 and 1933. As late as 1969, the *Handbuch der deutschen*

Gegenwartsliteratur does not acknowledge Hessel at all as an author with writings in his own right, footnoting him only in relation to Benjamin and Polgar.

4. I will focus here on certain junctures in the development of the concept of flaneur-as-author that will go beyond the facts of biography, to name some of the pivotal influences that have shaped the particular kind of experience that characterizes these writings. The following account is indebted for its factual information to the editorial and biographical essays provided by Bernd Witte in the new editions of Hessel's novels, background portraits that are based on conversations with Hessel's wife, Helen, and his sons, Ulrich and Stephane. See in particular Witte's biographical notes following Hessel's *Der Kramladen des Glücks*, 245–54, *Heimliches Berlin*, 127–37, and *Alter Mann*, 128–36, as well as his perceptive essay "Auf der Schwelle des Glücks. Franz Hessel," in *Ermunterung zum Genuß*, 229–51. Also illuminating in this context are recollections and reminiscences provided by Hessel's wife and sons, collected in *Letzte Heimkehr nach Paris. Franz Hessel und die Seinen im Exil*, 43–96 and 109–50, as well as details from Hessel's own fragmentary diary, posthumously published in *Juni. Magazin für Kultur und Politik*.

5. Munich also saw Hessel's literary debut as a neoromantic in his collection of poems entitled *Verlorene Gespielen* (Lost Playmates). Indicative of Hessel's preferred attitude of a "gender blind" approach to flanerie's sexual politics, he does not name these figures "Gespiel*innen*," as Köhn quotes this title. The "Gespielen" of one of Hessel's first texts are thereby already not necessarily marked as, and limited to, female figures of diversion. Cf. Köhn, *Straßenrausch*, 153.

6. Cf. Susan Buck-Morss on this cooperation and the spatial origins of Benjamin's *Paris Arcades*, in her *Dialectics of Seeing*, 38ff.

7. See for example, Hessel's first volume of poetry, *Verlorene Gespielen* (1905), the Munich novellas *Laura Wunderl* (1908), the poetry collection *Sieben Dialoge* (1924), the dramatic poem *Die Witwe von Ephesos* (1925), the contemporary stories *Teigwaren leicht gefärbt* (1926), and the anthology *Nachfeier* (1929), all of them diverse, if somewhat epigonal, poetic exercises derived from traditional models of literature.

8. In one of Hessel's journalistic pieces, appearing under the heading of "*Selbstanzeige*" on occasion of the publication of *Spazieren in Berlin*, he announces his book and its aesthetic principles in a way that shows the inclusive nature of his engagement with the city: "Zur Liebhaberei will der Verfasser den Leser verführen, indem er ihn über Straßen und Plätze, durch Schlösser und Fabriken, Gärten und Zimmer, zu Kindern und Erwachsenen begleitet und ihm dabei erzählt, was ihm Mitteilsames von altem und neuem Berlin einfällt." *Das Tagebuch*, 21 (1929): 870.

9. *EG*. This text presents the slightly abridged and altered edition of Hessel's original *Ermunterungen zum Genuß*, his last text to appear in Germany, in 1933.

10. Cf. Fournel, *Ce qu'on voit*, 262ff.

11. For the literary implications of *Neue Sachlichkeit* in Weimar culture, see for example, Horst Denkler, "Sache und Stil: Die Theorie der 'Neuen Sachlichkeit' und ihre Auswirkungen auf Kunst und Dichtung," and Helmut Lethen, *Neue Sachlichkeit. Studien zur Literatur des "Weißen Sozialismus."* Also cf. Jost Hermand, "*Neue Sachlichkeit*: Ideology, Lifestyle, or Artistic Movement," in *Dancing on the Volcano: Essays on the Culture of the Weimar Republic*.

12. See Derrida, *Of Grammatology*.

13. Börne, "Schilderungen aus Paris (1822–1824)," 34.

14. Also cf. contemporary reflections of this central boulevard by Joseph Roth, "Der Kurfürstendamm" (1929), in *Werke*, 854–56, and Hans Siemsen, "Kurfürstendamm am Vormittag."

15. *FB*, 145.

16. Hessel, *EG*, 59.

17. Also see Hessel's reflections on the particular aesthetic openness that allows the flaneur a new or "first" gaze upon presumably familiar surroundings, experienced in revisiting some of the changes that the original location of scopophilia, the "*Rummel-platz*," has undergone on its way to becoming the democratic diversion of a modern amusement park: "Hier im Luna-Park ist das nun alles moderner und in größerem Maß-stab geboten. . . . Luna-Park ist 'für alle' " (*Ein Flaneur in Berlin*, 149).

18. See also, for example, Wilhelm Schnarrenberger, "Schilder als Zeichen."

19. Hessel draws our attention, in particular, to the most recent markers of moder-nity, describing the textuality of this new reality in its "advertisement signs that light up and disappear, wander off and come back again." *FB*, 145. Contextualizing this sensitivity to the variations in (artificial) lighting as a historically and culturally specific discourse, cf. Wolfgang Schivelbusch, *Lichtblicke. Zur Geschichte der künstlichen Hel-ligkeit im 19. Jahrhundert.*

20. See Theodor Fontane, "Unsere lyrische und epische Poesie seit 1848," in *Li-terarische Essays und Studien, vol. 21, bk. 2 of Sämtliche Werke* (Munich: Nymphen-burger, 1963), 7–33.

21. *EG*, 59.

22. According to this great artist of nineteenth-century realism, it was the ethical task of the poet to highlight the benign aspects of modern life, especially in a time that he increasingly views as a vast, fractured "quarry of marble that carries within it the matter of eternity." Fontane, "Unsere lyrische und epische Poesie seit 1848," 12.

23. Cf. Kracauer, "Schreie auf der Straße," "Straße ohne Erinnerung," and "Erinne-rung an eine Pariser Straße," all of them reprinted in *Straßen in Berlin und anders-wo*. "Schreie auf der Straße," in particular, calls attention to the increasing violence and aggression that would take over the streets of Berlin with the end of the Weimar Republic.

24. *FB*, 7. This text presents the unabridged, new edition of Hessel's original collec-tion *Spazieren in Berlin* (1929).

25. Gaston Bachelard situates the genealogy of this tender gaze in the world of childhood and reverie, approximating the "first gaze" in a stance wherein "we relive by dreaming in our memories of childhood . . . precisely the world of the *first time*." See *The Poetics of Reverie. Childhood, Language, and the Cosmos*, 117. Paul de Man operates at a somewhat more deliberate distance by describing a similar innovation of vision characteristic of modern literature: "The human figures that epitomize modernity are defined by experiences such as childhood or convalescence, a freshness of percep-tion that results from a *slate wiped clear*." Emphasis mine. In "Literary History and Literary Modernity," 157. The "first gaze" that Hessel has in mind differs markedly from what appears in other modernist texts, which on the surface seem predicated on a related visual intensity. While the flaneur follows the stream of images in a patient and attendant manner, the pedestrian employs a more aggressive, penetrating gaze, embodying the male gaze of a military modern, as in this example from Jünger's *Der Kampf als inneres Erlebnis*: "Mit der geschärften Witterung des Großstädters *durch-*

schreite ich den Trubel, während das Hirn leicht und *präzise* die Überfülle wechselnder Bilder *zerschrotet*. . . . Ich tauche meine Blicke in die Augen vorübergehender Mädchen; flüchtig und *eindringlich*, und freue mich, wenn sie lächeln *müssen*." Emphases mine. While moving within the same time frame and through similar ground, this very direct, goal-oriented approach demonstrates the difference between the contemplative gaze of the flaneur and the decidedly penetrating gaze of other moderns on foreign streets and battlefields.

26. Gert Ueding, "Im Morgenland der Dinge. Über Franz Hessel," 235.

27. See Benjamin's definition of aura in the essay "The Work of Art in the Age of its Technological Reproduceability," 222.

28. *FB*, 9.

29. A latently disoriented Weimar "time of waiting" [*Wartezeit*] may be comparable here to a later time of disquiet and transit. Cf. Michael Rutschky's essay on a similar disposition in the FRG in the late 1970s, *Wartezeit. Ein Sittenbild.*

30. Kracauer, *Der Detektiv-Roman*, (first in 1922–25). See in this context some of Benjamin's essays on flanerie in *Charles Baudelaire. A Lyric Poet in the Era of High Capitalism.*

31. A similar dislocated and unsettling sense of place in modernity underlies Benjamin's questions on the functions of photography in this time: "But is not every spot of our cities a scene of crime . . . every one of the passersby a criminal [*Täter*]?" "Kleine Geschichte der Photographie," 105.

32. See, for example, one of Benjamin's writings on the flaneur: "The street becomes a dwelling for the flaneur; he is as much at home among the façades of houses as a citizen is in his four walls." "Paris of the Second Empire," 37.

33. For the affinities of Hessel's views to Benjamin's thought, particularly in this instance of the "first gaze," cf. Christiaan L. Hart Nibbrig, "Das déja vu des ersten Blicks. Zu Walter Benjamins *Berliner Kindheit um Neunzehnhundert.*"

34. See, for example, a structure of multiperspectivism as the organizing principle of Nietzsche's writings, as well as the implicit poetic plurality in various other projects of modernity, among them the fragmentation of Benjamin's *Passagen-Werk* and the additive ways in which Bloch's *Das Prinzip Hoffnung* proceeds.

35. *FB*, 74. Emphasis mine.

36. *FB*, 64ff. Hessel's precise fomulation suggests the extent of his influence on Benjamin's thought and rhetoric, such as on the latter's concept of an *Irrkunst*, the "art of getting lost."

37. For a history of the term and genre, cf. Heinz Schlaffer, "Denkbilder: Eine kleine Prosaform zwischen Dichtung und Gesellschaftstheorie," and Eberhard Wilhelm Schulz, "Zum Wort 'Denkbild.' "

38. Hermann Kähler, *Berlin—Asphalt und Licht. Die große Stadt in der Literatur der Weimarer Republik*, 174ff.

39. Kähler reduces the flaneur's "first gaze" to a touristic one, erasing the very dimension of lived experience and personal reminiscence that is also always able to take recourse to the child's own "first gaze" at his familiar city; cf. Kähler's assertion that Hessel presumably "gibt der persönlichen Erinnerung wenig Raum." *Berlin—Asphalt und Licht*, 182.

40. Cf. similar retrospective returns to these sites of shared city experiences by Charlotte Wolff, one of Hessel's and Benjamin's contemporary companions of flanerie, who focuses on some of these same spaces and childhood associations in her *Hindsight*.

41. See Raabe's *Chronik der Sperlingsgasse*, one of the immediate predecessors of Hessel's contemplative strolls in the sphere and atmosphere of an earlier Berlin.

42. Hessel makes use of the occasion to go on an interdisciplinary walk through the history of flanerie on the city's major avenue, involving a multitude of writings and genres that range from historical texts and city calendars, to examples of poetry, songs, and other literature about Berlin.

43. Cf. the original reverie that frames Bachelard's genealogy of this experience, traced to a foundational exchange of the gaze between the child and his world of childhood: "Then ... the dreamer believes that, between him and the world, there is an exchange of looks." He goes on to paraphrase the flaneur's experience of an exchange of the gaze in this moment of a childhood reverie: "It would be necessary to say that everything I look at looks at me." *Poetics of Reverie*, 185.

44. Many theoretical reflections on film pursue a similar aesthetics that emphasizes an attentive gaze and a quasi reversible relationship between the presumed "objects" and "subjects" of this scopophilic exchange, most prominently among them Kracauer's *Theory of Film*, while an animation of the gaze also figures in Béla Balázs's various writings on the cinema.

45. Cf. Weimar authors who pursue a similar sensory approach to theoretical thought, in particular authors such as Bloch, Benjamin, and Kracauer, but also Yvan Goll, Wilhelm Speyer, and many others, among them female authors such as Irmgard Keun, Claire Goll, and Annette Kolb.

46. Hessel, for example, deplores the loss of a "holde Kinderstubenunordnung," the naive quality of an early childhood anarchy to which the adult flaneur ascribes certain intimate charms, "gewisse intime Reize." *FB*, 162.

47. *EG*, 55. Hessel's wording in the original text—"eine merkwürdige *Geschichte*"—evokes both the memorable and the remarkable aspects of both this "history" and its "narrative."

48. Cf. Kähler, *Berlin—Asphalt und Licht*, 175ff. For a critical inquiry of ideological and gender implications of *Neue Sachlichkeit*, cf. Richard W. McCormick, "Private Anxieties/ Public Projections: 'New Objectivity,' Male Subjectivity, and Weimar Cinema."

49. These and the following citations of Kracauer's text are from his "Kino in der Münzstraße," reprinted in *Straßen in Berlin und anderswo*, 69–71.

50. Cf. Kracauer's reflections on "Der Detektiv-Roman" in *Schriften*, 103–204, as well as "The Hotel Lobby," one of the pivotal chapters in *Mass Ornament*, 173–85.

51. Cf. Dean MacCannell's observations on the tendency to exoticize aspects of workaday realities and to experience labor as a quasi-foreign territory: "The tourist's inability to understand what he sees is the product of a structural arrangement that sets him into a touristic relationship with a social object, in this case, *work*." *The Tourist. A New Theory of the Leisure Class*, 68.

52. One might indeed criticize Hessel's approach for a lack of explicit engagement. Yet even these problematic tendencies in his flanerie are a result of his attention to all, even seemingly negligible visual discoveries in the places and spaces of a society that he sees every day. The grounds for at once criticizing and crediting this approach are

based on the same unconditional, aestheticizing gaze that conjures the very insights of his flanerie: the attempt to valorize [*gelten lassen*] everything in a process of seeing without judging, perceiving the multitude of modern phenomena without subjecting them to aesthetically or ideologically preconceived notions.

53. Tucholsky, *Gesammelte Werke. Band III. 1929–1932*, 217.

54. See in particular one of Hessel's various essays on fashion, "Von der Mode," in *FB*, 31–37, and about the outskirts of Berlin, "Über Neukölln nach Britz," *FB*, 192–93.

Chapter 5
Secret Berlin

1. See Hessel, *Der Kramladen des Glücks. Roman.*

2. Cf., for example, Hartmut Vollmer, "Der Flaneur in einer 'quälenden Doppelwelt'—Über den wiederentdeckten Dichter Franz Hessel," 727, and his essay to a new edition of Hessel's works: "In allen Romanen hat Hessel die eigene Biographie verschlüsselt," in *Von den Irrtümern der Liebenden und andere Prosa* (Paderborn: Igel, 1994), 171.

3. The autobiographical nature of this relation between the author and his protagonist is also apparent in the assonances that link their names: "Franz Hessel" and "Gustav Behrendt" are both characterized through an identical sequence of vowels—"a-e-e"—in the final three syllables of their names.

4. Bachelard, *Poetics of Reverie*, 99.

5. Bachelard, *Poetics of Reverie*, 127.

6. The narrator describes this situation as abundant with a plenitude of sensory qualities: "And in gossamery [*duftig*] morning dresses came tall girls. One picked him up, all the way up her dress to her breast, and kissed him and lifted him yet higher. Then he stretched his arm and reached for the string of the sinking balloon. And slowly he pulled the shimmering ball closer." *KG*, 7.

7. Cf. this passage in Hessel's narrative, which emphasizes a dichotomy between verbs of detachment and possession, processes of "stroking" and "grasping" the objects: "Er wollte sie streicheln und griff zu."

8. Bachelard, *Poetics of Reverie*, 102.

9. This and the following passages discussed in this sequence are found in *KG*, 9–11.

10. Constructing an early fascination with ephemeral effects of light and shine, the text reads: "Two dangling [*schwebende*] golden angels" are suspended from above the mother's "canopy," creating an appearance to the child's eyes of a literal "bed-heaven" [*Betthimmel*]. The realm of the mother is alive with animated pleasures and magical charms all over, as "snakes of the great hanging light curled and darted out from the middle of the room over to them." *KG*, 9.

11. Bachelard, *Poetics of Reverie*, 105.

12. Cf. Bachelard's notion of a "solitary childhood, a cosmic childhood," in *Poetics of Reverie*, 105.

13. For this term, with its orientation and foundation of the visual in the sensory experience of early childhood, see Bachelard, *Poetics of Reverie*.

14. Bachelard, *Poetics of Reverie*, 185. He continues to paraphrase Hessel's sense of harmonious reverie, saying that "in an exaltation of the happiness of seeing the beauty of the world, the dreamer believes that, between him and the world, there is an exchange of looks."

15. The narrator notes that the mother's enunciation of the word "beauty" remains "for a long time in his mind connected with the indefinite notion of something extraordinary." *KG*, 12.

16. Cf. arguments in cultural anthropology about the normative functions of, in particular, the antilibidinal, bourgeois chair in the process of civilization: "So entwickelte das Bürgertum eine Leistungsmoral, die das lustvolle Erleben . . . unmöglich machte. Eines der Symbole dieser Leistungsmoral ist der Stuhl, der asketische Stuhl, auf dem man von dem anderen getrennt in der besten Arbeitshaltung sitzt." Cf. Jos van Ussel, "Der Prozeß der Verbürgerlichung," in *Texte zur Sozio-Sexualität*, ed. Helmut Kentler (Opladen: Leske, 1973), 195. Also see related arguments on the world of objects in similar normative processes, in Norbert Elias's study *Über den Prozess der Zivilisation. Soziogenetische und psychogenetische Untersuchungen.*

17. Jacques Derrida, "Kant, the Jew, the German," *Yale French Studies.*

18. Derrida, "Kant, the Jew, the German," 59.

19. For a seminal expression of this *Sprachkrise* and a similar turn toward the world of objects, see Hugo von Hofmannsthal's letter of Lord Chandos, "Ein Brief."

20. Bachelard, *Poetics of Reverie*, 107.

21. This and the following passages are from *KG*, 22ff. Bourgeois education enforces a division of pleasures and purposes that lacks any appeal for the child and future flaneur.

22. While both Hofmannsthal's Chandos and Hessel's character turn toward the world of objects in its visual and material qualities, the flaneur never entirely retreats from the world of language into silence; see, in contrast, Hofmannsthal, "Ein Brief."

23. *KG*, 85. For a discussion of this presumably aimless, aesthetic turn toward the images, along with dance, pantomime, and film one of the contemporary ways "out" of the presumptive *Sprachkrise* of their time, cf. David Bathrick, "Der ungleichzeitige Modernist: Béla Balázs in Berlin," 32ff.

24. On the origins of this bourgeois melancholy and its characteristic spaces in society, cf. Wolf Lepenies, *Melancholie und Gesellschaft*, here in particular "Räume der Langeweile und Melancholie," 115–71, with its passages on the melancholic functions of interior spaces and the related differentiation between "*homme intérieur*" and "*homme extérieur.*"

25. Cf. Peter Handke, *Die linkshändige Frau*; see, for example, the distinct passages that characterize this character, for example on pages 35 and 126.

26. *KG*, 87. The pursuit of exterior realities as an antidote to the melancholy and monotony of modernity is part of an early, life-embracing topos of flanerie: "The *Physiologie du Flâneur* proclaims the *flâneur* 'the only happy man on earth,' adducing as proof that no one has ever heard of a *flâneur* who committed suicide." Quoted in Priscilla Parkhurst Ferguson, "The *flâneur* on and off the streets of Paris," 29.

27. Particularly aspects of the night life of reality attract the emerging flaneur's attention, while ensuing studies of the street and its attractions remain a formative aspect of this life and the novels that reflect it.

28. Its presumed purposelessness and aimlessness predominantly shape this approach to the world. In part this exile from life may also be considered Gustav Behrendt's answer to his perception of an "otherness" in himself that the young boy learns to register in terms of his "Jewishness."

29. The narrow alley leading "downward" figures as a psychoanalytic trope that traces an intricate path into earlier levels of this psyche's formation in childhood.

30. Cf. in this context also Egon Erwin Kisch's journalistic observation, "Typen der Straße," 511.

31. Wolff is one of the earliest contemporaries to realize that Hessel's novels "have not only nostalgic charm, but are documents of the city's cultural history." Cf. her memoir *Hindsight*, 70ff.

32. The narrator insists on distantiating Behrendt's peculiar lack of desire from other approaches to life: "Marianne, however, had discovered a large colorful tropical butterfly on the wall. She was happy in the store." *KG*, 224.

33. "'Is not happiness, the realm of heavens like an assortment of all kinds of commodities [*Kram von allerlei Ware*]?' Gustav said, and thought of the store in Basel" (*KG*, 225). On another occasion, Hessel reveals this reflection of commodities to be an entirely visual pleasure in the pursuit of images that does not strive for the possession of actual objects and values. In his Weimar essay "Genieße froh, was du nicht hast," *Das Tagebuch* (1922), he asserts the potentially critical (also political) dimensions of this utopian (also erotic) nonpossessiveness in speaking of the customers of stores and movies: "und während die *unglückliche besitzende Klasse* heraus- und hineinschiebt und -stößt, bin ich glücklich"—in the very act of looking. Emphasis mine.

34. Gustav learns to appreciate visual variants and aesthetic appearances, with their multiple potentialities, to any more defining, if limiting, erotic or other action. Similar tropes of assortment and variety return in what he considers as a "*Gemischtwarenhandlung*" (*KG*, 225), a window display of visual pleasures that confront again his mixed reactions to "the colorful everything [*Allerlei*]" (*KG*, 240), the incongruous pluralities of modern commodities inside their bourgeois interiors.

35. See *KG*, 238. Cf. Lauren Rabinowitz's investigation of fairgrounds and related spheres of early visual pleasures, "Temptations of Pleasure: Nickelodeon, Amusement Parks, and the Sights of Female Sexuality."

36. The phrase reiterates the literal presence and visual existence of the phenomena upon which Gustav directs his gaze: "You look at your lover from the side and are pleased that she *is there*" (*KG*, 241). Emphasis mine.

37. In a similar way, he confesses to loving Martha even "more than ever, now, that she is gone" (*KG*, 72), imagining that at this far remove he could "have her closeness, much more, than before at her feet" (*KG*, 79). The rhetoric of this visual fascination in its detachment reveals the mutual indebtedness of Hessel's specularity to Benjamin's notion of "aura." Cf. "Das Kunstwerk im Zeitalter seiner technischen Reproduzierbarkeit."

38. The contemplative stance also leads to moments of acute awkwardness toward others present in what the flaneur considers as narrative tableaux rather than occasions for action, such as one suggestive scene that shows Gustav alone with Marianne. While she losens her hair for him, he does not act upon a conventional interpretation of this signal but continues to gaze at her image and admire its beauty in silence. In turn he alienates the very real woman of this narrative, a woman who not only contributes her

image but also a subjectivity that includes desires of her own. The protagonist's reluctance is explicitly addressed in Marianne's embarrassment, "since," as the narrator ventriloquizes her sense of alienation, "he did do nothing but look." *KG*, 206.

39. Cf. Klaus Theweleit, *Männerphantasien* (Reinbek: Rowohlt, 1980), in particular the introductory chapter, 11–234.

40. The assumptions underlying his reception of women as "objects" of admiration is not their reduction to an "image as object" but rather a function of the flaneur's extended, infinitely inclusive respect for the entirety of all "images" of the world. See in contrast to this approach the one that Ulrike Scholvin discusses in her reading of Jünger's modernist wartime texts, such as his "Ermannung." *Döblins Metropolen. Über reale und imaginäre Städte und die Travestie der Wünsche*, 146–51.

41. This mutual dynamics is appearent in the writings of Franziska von Reventlow, Hessel's friend in the Munich *bohème* and model for the character of Gerda in *Der Kramladen des Glücks*, a woman who shares as a writer and flaneur his preference for "this beautiful plurality of life." Reventlow, *Von Paul zu Pedro. Herrn Dames Aufzeichnungen. Zwei Romane*, 19ff. Hessel appears in Reventlow's memoirs and amouresks, inspired by his presence, not as a character averse to eroticism in particular but as a figure shy of commiting himself to any kind of explicit action.

42. See Hessel, *Pariser Romanze. Papiere eines Verschollenen.*

43. The text assembles an international kaleidoscope of notes and memories from a prewar urban utopia, which presents a cross section of individuals from varied nations as united, for example, at the coffee tables of the Café Closerie des Lilas. *PR*, 19ff.

44. Cf. Freud's citation from Grabbe's "Herzog von Gothland" in "Civilization and its Discontents."

45. *PR*, 96. Genia Schulz notes a similar, fatal irony in the accident that kills Rolf Dieter Brinkmann in the streets of London, imposing a sudden closure to the flaneur's distracted trance. See "Traum und Aufklärung. Die Stadtbilder Siegfried Kracauers."

46. Cf., for example, Marc Angenot, "Roman et ideologie: *Les Mystères de Paris*."

47. One could relate Hessel's childlike gaze and steps retracing his childhood to the later filmic expeditions by Wim Wenders into the cities, which also serve to reconsider the spaces of Berlin. Cf. Peter Buchka, *Augen kann man nicht kaufen. Wim Wenders und seine Filme*, 25–68.

48. The androgynous "Gaston girl" is modeled after Helen Hessel not only in appearance but also in her sense of independence. See, for example, Man Ray's photograph of her nearly streamlined body parting the ocean, her hair resembling a metallic helmet, as well as passages in which Charlotte Wolff describes her Parisian friend of that time. *Augenblicke verändern uns mehr als die Zeit. Eine Autobiographie*, 111.

49. The text is narrated from the temporal distance of a postwar perspective, as the reminiscence of a Parisian romance that did not come to pass due to the shocks of World War I, a war descending too suddenly upon the bourgeois, bohemian city of an earlier, more cosmopolitan Europe.

50. Cf. Jean-Pierre Roché's writings about these circles and times in his own Parisian novel, *Jules et Jim*. Also see Manfred Flügge's "true story" of the erotic triangle linking both Roché and Hessel to Helen Grund, later Hessel, in *Gesprungene Liebe. Die wahre Geschichte zu "Jules und Jim."*

51. *PR*, 126. The narrator's phrase "An diesem Tage lasen sie nicht weiter" reads as a citation and ironic appropriation of Dante's "Purgatorio."

52. Cf. formative scenes in *Der Kramladen des Glücks*, where a sequence of seemingly lifeless figures evokes the flaneur's early gaze, ranging from the plaster statues in the mother's room to the marble statues first encountered in a museum excursion. *KG*, 10 and 85.

53. Cf. Derrida, "Kant, the Jew, the German."

54. Cf. Wolff, *Augenblicke*, 111. All these scenes of Hessel's spaces as well as the passages to follow are found in *PR*, 11–17.

55. For the description of similar narrative situations in literary modernism, see Paul de Man, *Allegories of Reading*.

56. *PR*, 11. Hessel's rhetoric in this passage explicitly replicates Benjamin's term "Jetztzeit," even typographically acknowledging the very act of citation in his own text.

57. Virilio, *War and Cinema. The Logistics of Perception.* Also cf. his relating the experience of seeing to that of flight, in paraphrasing Nam June Paik's phrase: "Cinema isn't I see, it's I fly," 11–30.

58. *PR*, 41. Cf. Hessel's significant variation on the term, and terms, of the *Denkbild*, by emphasizing his regard for the plurality of the many "thoughts" [*Gedanken-*] that enter into the presumed totality of "thought" [*Denk-*] in the image of reflection.

59. In Hessel's specific case, this problematic tendency does not repeat the aggressive objectivization of woman as city that Patrice Petro analyzes, for example, in "Discourse on Sexuality in Early German Film Theory." Hessel's text does not pursue the imposition of this object character upon women but treats them with the same regard that he extends to himself or any other object.

60. Cf., for example, Ernst Jünger's piercing strolls in cities and on battlefields in this context. In contrast to this modern persona, the flaneur does not pursue a flanerie of what Derrida terms "hard eyes permanently open to a nature that he is to dominate, to rape if necessary, by fixing it in front of himself." Derrida, "The Principle of Reason: The University in the Eyes of Its Pupils," 10. Bachelard formulates a similar detachment for the dream state that has been shown to be formative of a state of flanerie: "But the world dreamer does not regard the world as an object; the aggressiveness of the *penetrating* look is of no concern to him." *Poetics of Reverie*, 185. Emphasis in original.

61. Hessel, *Heimliches Berlin*.

62. After following both the retrospective principle of a childhood narrative and fragmentary structure of an epistolary novel, *Heimliches Berlin* is the first of Hessel's novels that situates an ostensibly closed, coherent plot entirely within the present.

63. The figure is—as are the ones in *Pariser Romanze*—surrounded by a circle of other characters, thereby also rendering his rival and companion Clemens less a—nonexistent—antagonist but rather a fatherly friend and mentor.

64. See, for example, Benjamin, *Berliner Kindheit um Neunzehnhundert*, 236–304.

65. As a personification of the displacement inherent not only in the housing conditions of the time, the Weimar "Schlafgänger" introduces an itinerant tenant who commands a dwelling only for the purposes of sleeping, while spending his days entirely in the street. Cf. *Berlin, Berlin. Die Ausstellung zur Geschichte der Stadt, Katalog*, 309.

66. Cf. similar passages characteristic of the literature of dandyism, for example, in Wilfried Ihrig's study *Literarische Avantgarde und Dandysmus. Eine Studie zur Prosa von Carl Einstein bis Oswald Wiener.* The dandy observes these facets of fashion

and considerations of his own visual appearance as a daily ritual in *Les Lauriers sont coupés*.

67. While the function of female figures here repeats to some extent the familiar conflation of women and the city, the women in Hessel's novel figure less as accessoires to a male-oriented action than—as do all his characters—as reflecting mirrors for all the attractions of an urban existence. Cf. Sigrid Weigel, "Die Städte sind weiblich und nur dem Sieger hold," in *Triumph und Scheitern in der Metropole. Zur Rolle der Weiblichkeit in der Geschichte Berlins.* Wendelin's suggested departure confronts the urban flaneur with an imposition that would erase his visual existence: "To leave the big city! Never again to see on long streets in the light of lanterns the street pavement before the long steps of the friends. . ." *HB*, 9.

68. Cf. Ueding, "Im Morgenland der Dinge," 230. Wendelin's very name encrypts the changing, fluctuating nature of the urban street: both "wenden" and "wandeln" figure as slightly archaic synonyms of "change," "wandeln" as synonymous to "walking;" also cf. the virtual semantic identities between "Wendelin" and the related term for "a stroll"—"Wandeling"—in Flemish.

69. As a precursor to this extraordinary, ubiquitous professor of many aesthetic disciplines and new philosophical insights figures the "kleine Kunstprofessor"—called by his friends "Dappertutto," i.e., "everywhere"—in Hessel's earlier cycle of novellas, *Von den Irrtümern der Liebenden. Eine Nachtwache* (1922).

70. Cf. Kracauer's essay on latent intellectual and social dispositions in Weimar culture, "Those Who Wait," in *Mass Ornament*, 129–40.

71. Derrida, "Mochlos; or, the Conflict of the Faculties," 18. The next quote from the same text, 19.

72. Cf. Hessel's passage as a novelistic enactment of Benjamin's theory of flanerie in "Paris of the Second Empire," 37.

73. Derrida, "Mochlos," 36.

74. Derrida, "Principle of Reason," 6.

75. Clemens's perspective critically discusses the flaneur's own stance of artistic and intellectual observation, going so far as to suggest that this position may present a kind of "romantic quietism" (*HB*, 63). This degree of awareness for the implied problematics of his approach renders Clemens an even more compelling personification of Hessel's theory of flanerie, one that is aware of its own critique and transcends the naive reveries of a quaint private scholar.

76. Derrida, "Mochlos," 18.

77. Derrida describes similar forms of academic engagement in "The Principle of Reason." Clemens offers the discoveries of this nonconformist gaze in an extended "lecture" that forms one of the novel's central passages. Cf. this extended plea for flanerie, *HB*, 96–103. This appeal not only encompasses, in its own circumtuitous, conversational way, the character's individual philosophy of life but at the same time implies the basic principles that move Hessel's flaneurs in general.

78. For Clemens's way of looking, an inscription such as "Professional Choice Unsorted" on a cigar box suggests more than an absurd brand name; it becomes a sign that approximates these bohemians' existential and philosophical state of mind. *HB*, 98.

79. In a different passage, he declares explicitly that he has "decided to enjoy his life." *HB*, 98. A precursor to this inclusive motto of an all-encompassing, yet nonposses-

sive, form of flanerie figures as one of Hessel's early feuilletonistic reflections, itself entitled "Genieße froh, was du nicht hast," *Das Tagebuch* 40, no. 3 (1922). The opening passage of this article is integrated almost verbatim into the version included in *Heimliches Berlin*.

80. Hessel's earlier essay version of "Genieße froh, was du nicht hast," appearing in *Das Tagebuch* 40, no. 3 (1922), during the earlier years of the Weimar Republic, literalizes even further the resistant qualities of this disposition and maxim of flanerie as a critique of capitalist consumption: "Aber nun kann mir die Armut nichts mehr anhaben. Ich genieße."

81. The flaneur asserts an economic independence and autonomy that reads not only as a form of social and political denial but also opens the perspective of a critique of capitalism: "I do not need to enter stores, I am satisfied with windows, displays, the giant still lifes of sausages and grapes, pink salmon, melons and bananas, spread-out fabrics, snaking neckties, smoothing furs, burdening leather-jackets" (*HB*, 98). His passage represents both a critique, inherent in the text, to the rituals of this consumption as well as its rhetorical practice, implicit in spreading out its texts of the objects of commodity culture. He perceives these phenomena as the surfaces of modernity, represents its commodities as a cross section of art and life, and transposes its objects into novelistic "action."

82. This turn toward the minute and marginal phenomena of reality prefigures Kracauer's *Theory of Film* as a declared "redemption of physical reality." Among other phenomena of Weimar reality, the notion of redemption also resonates with a larger sense of futility in modernity, one that prefigures Kracauer's attention for the visual as an implicit move of flanerie.

83. Hessel adapts this semiotic focus early in Weimar modernity when declaring his complete abandon to the fascinations of signs and advertisements, in his manifesto of the aesthetic pleasures of an absolute, noncommercial, visual desire: "Ich lese weiter. Eine Reklame. Was ist erregender als eine Reklame?" "Genieße froh, was du nicht hast."

84. *HB*, 99. This formulation by Hessel's persona Clemens, for example, with its affinities to theories by Bergson and Benjamin, the figure's overall semiotic appreciation of modernity, as well as his theoretical reflections on the intellectual situation of his friends, members of a postwar generation in Weimar Germany, serves to relativize the theses on the presumed "naiveté" and anachronism of Hessel's flaneurs. Cf. Rainer Michael Schaper's statement: " 'Hessel ist Naivist,' ein flanierender Träumer in den Passagen in Berlin und Paris, ohne Theorie-Interesse." *Der gläserne Himmel: Die Passagen des neunzehnten Jahrhunderts als Subjekt der Literatur*, 212.

85. Bergson, *Matter and Memory*, 102–3. The preceding quote is located in that text, 239.

86. Cf. Benjamin's phrase in "Charles Baudelaire. Ein Lyriker im Zeitalter des Hochkapitalismus," 590, to Hessel's—indeed earlier—observation on the pervasive presence of the image. *HB*, 99.

87. During World War II in Budapest Franz Jung formulates a somewhat more sceptical reflection of these aesthetic, if somewhat escapist, qualities of the purposeless gaze: "Sofern es einem gelingt, Zuschauer zu bleiben, ich meine den inneren Zwiespalt vergessen zu machen, gewinnen die Schilderungen . . . einiges an Interesse, an Farbe,

Ironie und—zwielichtiger Moral." *Der Weg nach unten. Aufzeichnungen aus einer großen Zeit*, 402.

88. Cf. Hessel's collection of flaneur essays, *Ermunterungen zum Genuß* (1933), as well as his feuilletonistic impressions of the flight—his *Letzte Heimkehr*—from Nazi Berlin to Paris in 1938.

89. Clemens here formulates one of the foundational dispositions of scopophilia, with its sense of an infinite array of stimuli that fundamentally characterizes the flaneur's view of the world. Cf. Keith Tester's formulation for the perspective of Sartre's flaneur Roquentin: "The world is a pre-existing spectacle which is always and already available to the gaze." "Introduction" to *The Flaneur*, 9.

90. Nancy, "Exscription," Yale French Studies; *On Bataille*, 59.

91. Clemens enumerates a long line of advertising inscriptions, concluding in the rhetorical question: "Is this not the quintessence?" (*HB*, 100), in this way literalizing his essential fascination with images as texts.

92. The material existence of things is among the phenomena which Nancy names as the "reasons to read." Their very presence, the way "*that there is* being . . . is what instigates all possible meanings," that is all possible readings. "Exscription," 64. Emphasis in original.

93. Cf. Nancy on the multiple oscillations of "the name Berlin," from a more recent perspective, yet with a similar emphasis on a site of shrouded meanings; for the both revealing and concealing ruptures within structures of presumed familiarity, cf. Freud's essay on "Das Unheimliche" (1919).

94. Wolfgang Schäche, "Die unsichtbare Stadt," 105.

95. The fragmentary shape of this text allows an extended autonomy of textual segments—included here in the projected novel—that had appeared before as independent essays in their own right. Previous essayistic moments to be worked into this novel of an old man include "Berliner Notizbuch," "Mitgenommen in eine Modenschau," and "Lied von der Arbeitslosigkeit." The strategy of recycling and reconsidering these pieces reveals even Hessel's principles of literary composition to consist of a gradual flanerie over his own landscape of existing and emerging texts.

96. The hidden manuscript of Hessel's last novel, believed to be lost after his death in Southern France, was found among Alfred Polgar's unpublished manuscripts after the latter's death; the fragmentary novel was edited for the first time under the title of *Alter Mann*.

97. Like all of Hessel's protagonists, his very being names this relation to flanerie, each a specific personification among a collection of visual remembrance: "Wächter" watching the images of his *Pariser Romanze*, "Küster" acting as the custodian of his memories in *Alter Mann*, and "Kestner" serving as a container of concealed secrets and meanings of a *Heimliches Berlin*.

98. Asendorf, *Batterien der Lebenskraft*, 38.

99. The name "Doris" returns in several novels by and about Weimar women, including as a telling name for the main protagonist in Keun's *Das kunstseidene Mädchen*. As a significant semantic choice, the name marks both the "golden" age of women's early emancipation in the city and its permeation by a shimmer of irony, always illuminated by the time's fascination with light and shine and the effect of images. Also cf. Christa Jordan, " 'Ein Glanz will ich werden.' Kunstseide und Kultur-

industrie: Irmgard Keun, *Das kunstseidene Mädchen*," in *Zwischen Zerstreuung und Berauschung*, 81–117.

100. See Roland Barthes, *Mythen des Alltags*, and his ongoing semiotic interests in similar sign systems of the everyday, such as *Die Sprache der Mode*.

101. *AM*, 33. Also see many earlier examples of this attention to, and narrative discussion of, wallpapers, ornaments, and other visual materials, in *Pariser Romanze*.

102. Cf. Jeffrey Herf on changes in the public sphere from the 1920s through 30s, in *Reactionary Modernism: Technology, Culture, and Politics in Weimar and the Third Reich*. Despite and to spite changes in systems, the flaneur even as an old man continues to enjoy, valorize, and redeem "in passing" all the signs of advertising and any images of the newest and most recent times.

103. *AM*, 60. Hessel here significantly varies a rhetorical form that has, paradoxically, become almost codified as the *Denkbild*, known primarily from Benjamin's *Denkbilder* and Kracauer's *Straßen in Berlin und anderswo*. Hessel's variations of this essayistic genre and its rhetorical expression points to both his considerable literary influence on Benjamin's writings as well as the ongoing negotiations that originally shape the *Denkbild* in its times. For another important voice in this genre of small-scale modernist storytelling, see Ernst Bloch's writings, and in particular *Spuren*. Cf. Klaus Berghahn's discussion in "A View Through the Red Window: Ernst Bloch's *Spuren*."

104. Gerd Ueding's formulation of the "desperate ground of this mode of existence" points to certain unresolved, inherently unresolvable contradictions in a mode of approaching an increasingly complex reality in a decidedly eclectic way. Ueding, *Die anderen Klassiker*, 239.

Chapter 6
Fragments of Flanerie

1. Nothing has been written about these fragmentary texts so far; they do not even appear in Eckhardt Köhn's listing of Hessel's writings in his study of flanerie, *Straßenrausch*. Some of the texts considered here, in particular the book reviews, were published anonymously or under one of Hessel's known pseudonyms.

2. *MD*. The text includes forty photographs; it is not paginated. The page numberings cited here are according to my own pagination.

3. A wave of contemporary works, along with Hessel's essayistic reflections on Dietrich as a new star, appeared in the same year, using similar language of glowing admiration; cf. Elinor Hughes, *Famous Stars of Filmdom* (Boston: Page, 1931); Jean Lasserre, *La Vie Brulante de Marlene Dietrich* (Paris: Nouvelle Librairie Française, 1931); and Manfred Georg, *Marlene Dietrich* (Berlin: Höger, 1931).

4. *MD*, 1. Emphasis mine. The next quote appears on the following page.

5. The object of obsession herself only appears and is named far into the second paragraph and at the bottom of the first page of this text.

6. The emphasis of Hessel's imaginary construction is on the term "magic," as is evident in the course of this text. He follows this with a related term as he goes on to call Dietrich "einen allgemeinen *Wunschtraum*," a collective dream-wish, which again repeats this emphasis on "dream" and "magic." Emphasis mine.

7. *MD*, 3. Emphasis mine.

8. Cf. *MD*, 5. The passage evokes a decidedly neutralizing and intentionally "chaste" discourse on female sexuality, one that permeates German philosophy as an also tendentially antierotic and misogynist male construction. It finds its way into phrases that continue to haunt Frankfurt School formulations; see, for example, Adorno's dictum on the "false" laughter and "pornography" that is meant as an indictment of *Kulturindustrie*—"Lust jedoch ist *streng*: res severa verum gaudium." Emphasis mine. Max Horkheimer and Theodor W. Adorno, *Dialektik der Aufklärung. Philosophische Fragmente*, 126.

9. Also cf. Hessel's use of similar language in reference to the lost charms of the Berlin Tiergarten area of his childhood in *FB*, 163.

10. Cf. similar concepts of "childhood" in Benjamin's *Berliner Kindheit* und various other essays, such as "Aussicht ins Kinderbuch," "Russische Spielsachen," and "ABC-Bücher vor hundert Jahren," all in *Aussichten*; also see the significant subtext of "redemption" in Kracauer's *Theory of Film*.

11. *MD*, 11. The text has slightly ironic—and certainly misspelled—recourse to problematic contemporary constructions of female sexuality; yet even in doing so, Hessel always foregrounds the dimension of reality and its perception: "getreu ihrer Frauenpflicht, wie Waininger [sic] sie definiert hat: den Mann an die *Wirklichkeit* zu kuppeln." Emphasis mine.

12. For the visual dimensions of Goethe's work, see Gerhart von Graevenitz, *Das Ornament des Blicks. Über die Grundlagen des neuzeitlichen Sehens, die Poetik der Arabeske und Goethes "West-Östlichen Divan"*.

13. Reconstructed posthumously from Hessel's papers, this diary is available only in fragmentary form and appears under the title "Tagebuchnotizen (1928–1932)."

14. Along with his last text, *Letzte Heimkehr nach Paris*, this diary offers some of the final texts and textual relics that have not so far been considered in any of the existing studies of Hessel's writings.

15. Cf. Karin Grund, "Der Tagebuchschreiber. Zu zwei unveröffentlichten Texten Franz Hessels," 35. She also renders the following quote by Helen Hessel, née Grund.

16. Ironically, the only extended text that has now become available by Helen Hessel-Grund herself also concerns her own posthumously published diaries of the years with Hessel and Roché." See Helen Hessel, *Journal d' Helen. Lettres à Henri-Pierre Roché. 1920–1921*.

17. These diary notes will enter into many passages of Hessel's novels and other writings, in only slightly more constructed and stylized ways, as shown by his diary excerpts from 1928–30 and 1932, particularly in relation to his plans for the novel now known as *Alter Mann*.

18. All of the above quotes are taken from Hessel's "Tagebuchnotizen," pp. 37 and 39, dating from the middle to the end of June 1929.

19. Hessel, "Tagebuchnotizen," 39. Emphasis mine. The term that playfully abbreviates the process of "photog[raphy]" is Hessel's own, as are the techniques he and Doris used to distract the intended objects from the gaze of their camera.

20. See also Inka Mülder-Bach, " 'Mancherlei Fremde.' Paris, Berlin und die Extraterritorialität Siegfried Kracauers."

21. The editor chose the title by borrowing the first three words of Hessel's text. The heading *Bloc-Notes* is printed on the cover of the faded, originally violet-colored notebooks into which Hessel enters his notes of a "last return" to Paris.

22. The text contains references to many of the cities in Hessel's novels that have preceded these notations, particularly the primary city of flanerie and location of his *Pariser Romanze*.

23. Cf. Benjamin's pivotal essay on Hessel that bears the closely related title "Die Wiederkehr des Flaneurs" (The Return of the Flaneur), an essay that is, in very similar ways, dedicated to Hessel's practices of flanerie seen as a process of memorializing reality.

24. This instance, in particular, marks the close relation of biography and fiction in texts that the flaneur retrieves from the public spaces of society and translates into the written reflections of his flanerie.

25. Also cf. Martin Jay's writings on exiled members of the Frankfurt School, many of them Hessel's friends and contemporaries; see *Permanent Exiles. Essays on the Intellectual Migration from Germany to America*.

26. Cf. Susan Buck-Morss's observation: "As a dream-image, loitering allows a subversive reading, and it is surely not insignificant that Hitler banned both prostitutes and vagrants from the streets." "The Flaneur, the Sandwichman and the Whore. The Politics of Loitering," 136.

27. See Herf, *Reactionary Modernism*.

28. One might consider the relays that link this new urban figure of a perpetual stroller, along with his impending displacement in fascist and anti-Semitic Germany, to the ancient myth of an "eternally" wandering Jew; cf. "Ahasverus and the Destruction of Judaism," in Paul Lawrence Rose, *German Question/ Jewish Question. Revolutionary Antisemitism from Kant to Wagner*, 23–43.

29. Beginning in 1926, Hessel wrote reviews of both literary and photographic works for the Weimar periodical *Die literarische Welt*.

30. This fascination with and expertise in French literature is also apparent in the project that most closely links Hessel's and Benjamin's literary interests, namely their shared efforts at translating Proust's works into German. Also cf. Hessel, "Bannmeile von Paris."

31. As he notes, "It is like a children's room that has been left in a mess." Recalling his trope of the childlike innocence of a "first gaze," Hessel here casts anew the attractions of anachronisms and relics, of urban facets that come his way in order to be looked at, even if they are "probably outmoded [*überlebt*] which gives them their particular charm." This visual desire pursues impressions that go beyond a *mémoire involontaire* through the past and into the future. The author of this *Bannmeile* is himself "banned," stopped in his strolls, and spellbound by the most minute facets of the city, such as the glimpse of a cracked and weather-beaten window blind whose subtle shock of fading color suggests to him all the anticipation of a theater curtain of history that is about to rise: "The blue-green was so full of the memory of an *I do not yet know* or do not know *anymore. . . .*" Emphasis mine.

32. Hessel, "Aus alten Pariser Gassen."

33. He undertakes this particular flanerie in retracing the—presumably—historical steps taken once by Marguerite of Valois. Also see Hessel, "Ein Garten voll Weltgeschichte," which presents a historical survey that receives its cues by the sights and scenes of this history.

34. Hessel, "Mario von Bucovich: *Berlin*." Also cf. Hessel, "Fred Hildenbrandt: Großes schönes Berlin." The reviewer emphasizes this author's "bright unerring gaze

of a man who is not at home here," an observer whose consistency of vision transcends the tourist's flickering attention. Hildenbrandt's photographic collection in this way approximates what Hessel has described as the "first gaze" and prerequisite of any flanerie.

35. Hessel, "Adolf Behne, Sasha Stone: *Berlin in Bildern.*"

36. Hessel, "Die größte Mietskasernenstadt der Welt."

37. The reviewer finds himself, as he says, becoming "infected" by the "passion to accuse" that he finds in Hegemann's writings. Hessel goes on to declare the utopian potential of this more outspoken critique: "Der große Reiz grollenden Erzählens ist, daß immer mitaufgebaut wird, was einmal wünschenswert gewesen wäre . . . lauter Wunschstädte erstehen."

38. Hessel's rhetoric here defines a distinctly positive turn which defies reactionary notions of *Beschaulichkeit* in the static sense of a false romanticism: "Der beschauliche Leser wird politisiert."

39. In his review of Lou Andreas-Salomé's book on Rilke, for example, he highlights one single photograph and emphasizes the way in which the poet's "gaze . . . hits us." Hessel, "Lou Andreas-Salomé: *Rainer Maria Rilke.*"

40. Hessel, "Arthur Schnitzler: *Flucht in die Finsternis.*"

41. Hessel, "Georg Hermann: *November achtzehn.*"

42. Cf. especially Hessel, "Wilhelm Speyer: *Sommer in Italien,*" and "Julius Meier-Gräfe: *Der Vater.*"

43. Writers such as Gottfried Benn, Lion Feuchtwanger, Annette Kolb, Alfred Polgar, Alfred Döblin, Hermann Hesse, Ernst Toller, and Kurt Pinthus all wrote essays in honor of Hamsun's birthday. See Hessel, "Gruß an Knut Hamsun," front page of *Die literarische Welt*, August 1929. Emphasis mine. Cf. recent titles of what might appear to be a "postmodern" successor to the phenomenon of flanerie, Sten Nadolny and his novels *Netzkarte* and *Die Entdeckung der Langsamkeit.*

44. No mention of this text can be found in either Bernd Witte's or Eckhardt Köhn's accounts of Hessel's works.

45. The text covers more than 23 full pages in the publication context of a separate advertising supplement to the Christmas edition of *Die literarische Welt*, and appears under a title with a baroque construction and attention to detail: "Des deutschen Buches kurioser Tändel-Markt. Wie solches auf der neunzehnhundertdreißiger Weihnachts-wiese von den Herrn Editores sive Verleger selbst feilgeboten und ausgeschrien wird." Hessel creates yet another framing story to the literary genre of the Christmas advertisement supplement in *Die literarische Welt*, a text that has similar commercial intentions, yet is not written in the elaborate stylization of a book-oriented literary flanerie. Cf. "Hier bekommt jeder sein Buch geschenkt. Eine Weihnachtsgeschichte, vier Wochen vor dem Fest zu lesen."

46. Cf. this spatial situation with the privileged position of store scenes and store windows in Hessel's *Der Kramladen des Glücks* as well as with the related spheres of early cinema, which in Hessel's novel still can be found within the confines of the fairground. The screens of this early medium are experienced as quasi display booths of a commercial offering that opens a space of intensely focused scopophilia.

47. Emphasis mine.

48. Describing these *Buchwiesen* customers as a clientele that mainly conducts *Händel* with one another—a singular of belligerent dealings rather than the plural of con-

structive transactions—sets its own self-referential signals for the at once rhetorical and commercial relays with Hessel's own "business" and his business of writing. What Baudelaire would call the modern poet's *Händel*—his struggle and virtual "fencing" for the images and phrases of his modernity—also always concerns and deals with [*handelt von*] the author's *Handel* with the commercial questions that are at stake in his own literary activity.

49. Hessel, "Des deutschen Buches kurioser Tändel-Markt."

50. The term ironically fuses the sphere of the Munich Oktoberfest—"Wies'n," a significant space of life for a former Munich resident—with Hessel's romantically in-spired neologism that betrays a certain arbitrariness of approach—*Wald-, Feld- und Wiesenwanderer.*

51. Cf. Eckhardt Köhn's notion of the particular affinities that a *"kleine Form"* would have with the perceptions and processes of flanerie; see *Straßenrausch.*

52. The fact that the fragments of Hessel's last text, "Alter Mann," were found among Polgar's own posthumous writings provides additional evidence for, and lends further credence to, their close and trusted literary relationship.

53. The idiomatic phrase, in which Hessel also rhetorically performs this continuity, reads "Weiter *im Text.*" Emphasis mine.

54. Following this flaneuristic principle lets him refer, toward the end of his stroll, almost in passing, to the possible "destination" of this flanerie. This reference occurs in relation to a book with the paradoxical title: "Den ewige Jude am Ziel." One of the considerations evoked by this contemporary would involve the ways in which the "art of taking a walk" in Weimar Germany also always was an art of many Jewish-German intellectuals in Berlin, wanderers who would eventually be forced to leave this public sphere and embark on more extended and involuntary "wanderings" into exile.

Chapter 7
A Short Phenomenology of Flanerie

1. Crary, *Techniques of the Observer. On Vision and Modernity in the Nineteenth Century*, 9.

2. Crary, *Techniques of the Observer*, 14.

3. Nietzsche, *The Will to Power. An Attempted Transvaluation of all Values*. New York: Macmillan, 1924.

4. I am indebted here to J. Dudley Andrew's formulation, in the context of a seminar on the status of the image in modernity: "The flaneur is a translator."

5. Crary, *Techniques of the Observer*, 10.

6. MacCannell, *The Tourist. A New Theory of the Leisure Class*, 15.

7. Urry, *The Tourist Gaze. Leisure and Travel in Contemporary Societies*, 138.

8. MacCannell, *Tourist*, 42ff.

9. Sontag, *On Photography*, 55ff.

10. MacCannell perceives this phenomenon as a rare, and rather eccentric, practice that ends with Mark Twain's nineteenth century. The example of Hessel's aimless sight-seer would reveal flanerie's capacity to appreciate the visual pleasures of the tourist sphere. Cf. MacCannell, *Tourist.*

11. Daniel Boorstin draws a similar distinction between the two dispositions of the "traveller" and the "tourist": "The traveller was active; he went strenuously in search . . . of experience. The tourist is passive. He expects . . . everything to be done to him and for him." Boorstin's comment is cited in MacCannell, *Tourist*, 104.

12. MacCannell, *Tourist*, 130ff. He continues his extended definition of flanerie by considering an expansion of the realm of images into a virtual sphere, speaking of the mind as a TV-room.

13. MacCannell, *Tourist*, 13

14. Urry posits the following delineation of spaces in public viewing and walking, such as exhibitions and world fairs: "What people thus do in such a fair is to stroll, to be a flaneur, and what they stroll between are the signs of different cultures. Therefore . . . they are acting as tourists." *The Tourist Gaze*, 153.

15. Urry, *Tourist Gaze*, 13.

16. MacCannell, *The Tourist*, 55.

17. While both the flaneur and the tourist find themselves "gazing upon the signs" of cultures, as Urry notes, flanerie characteristically moves beyond mere consumption toward a creative act of collecting that seeks to reorder, record, and render its materials of perception. See Urry, *Tourist Gaze*, 153.

18. Urry, *Tourist Gaze*, 82.

19. Urry, *Tourist Gaze*, 83.

20. Urry, *Tourist Gaze*, 149.

21. I am indebted to comments by Lauren Rabinowitz and John Peters, whose observations in Dudley Andrew's seminar have informed the following formulations. Also cf. MacCannell's comments on the case of young, unemployed women who frequent these malls and who yet do not turn flaneuses. *Tourist*, 151.

22. *PM*, 70.

23. MacCannell, *Tourist*, 55.

24. Urry, *Tourist Gaze*, 153. The intensity and attention of this gaze and its extended collection of images marks the flaneur's reflection, imparting a decided focus upon the remembrance of the materials and impressions that he gathers.

25. MacCannell, *Tourist*, 57. Rob Shields also emphasizes the tentative, yet intricate, linkage between the observations pursued by the flaneur and the sociologist: "The notion of *flânerie* is essentially a literary gloss: it is uneasily tied to any sociological reality." Cf. his "Fancy footwork: Walter Benjamin's notes on *flânerie*," 62.

26. MacCannell, *Tourist*, 39. MacCannell here thinks of locations charged with specific significance for an early industrialist culture and a literature of critical "Naturalism," such as "the sewers, the morgue, a slaughterhouse." In delineating significant spaces of Weimar culture, one might want to add other locales of an urban visual sphere and its extensions, such as the street, the train station, and the hotel lobby, along with cinemas, cabarets, theaters, pubs, and cafés.

27. *PM*, 3.

28. Michel Foucault, "What is Enlightenment?" 40.

29. *PM*, 54.

30. Emphasis mine. *PM*, 70ff. The relations between forms of reporting in flanerie and sociology also appear in R. Lindner's study *Die Entdeckung der Stadtkultur. Soziologie aus der Erfahrung der Reportage* (Frankfurt/M.: Suhrkamp, 1990).

31. Freud, *Standard Edition of the Complete Psychological Works of Sigmund Freud*, vol. 12, 115–16. For a discussion of the psychoanalytic implications of this analogy of the train, see Laurence A. Rickels, *The Case of California*, 195–99, and Bertram D. Lewin, "The Train Ride: A Study of One of Freud's Figures of Speech."

32. Biro adds the observation that "everywhere in postwar philosophy and the arts [there is an] increased interest in direct phenomena." *PM*, 72ff.

33. *PM*, 133.

34. The extended links of these modernist personae to other positions in modernity are particularly apparent in Weimar writings on the detective, such as Bloch's and Kracauer's. Cf. in particular Siegfried Kracauer, *Detektiv-Roman*.

35. This process also includes the position of the female flaneur, a figure that revisits this visual constellation, linking a possible female relation to modernity with approaches to a female gaze in feminist theories of film.

36. Endell, *Schönheit der großen Stadt*, 55.

37. This inquiry takes its point of departure from a collection of highly suggestive and illuminating texts that in their commonalities and disparity together constitute one of the most important debates on early cinema, texts that were compiled in *Kino-Debatte*. The prehistory of a wide Weimar *Kino-Debatte* is traced in a collection of texts taken largely from filmic reflections in the 1910s, gathered in *Prolog vor dem Film. Nachdenken über ein neues Medium: 1909–1914*, edited by Jörg Schweinitz.

38. Hausenstein, *Eine Stadt, auf nichts gebaut. Wilhelm Hausenstein über Berlin*, 7. Reprint of "Berlin," 1932.

39. Endell, *Schönheit der großen Stadt*, 43.

40. Kracauer, *Theory of Film*, xi.

41. Scenes from Hessel's urban novels seem to be constructed literally along the lines of such a mise-en-scène of light and visual atmosphere. In particular come to mind the long gazes of *Der Kramladen des Glücks* (1913), textures of experience in *Pariser Romanze* (1920), and changes of light as turns of the plot in *Heimliches Berlin* (1927).

42. Schivelbusch, *Lichtblicke*, 209.

43. This phrase by Germaine Dulac, a female director of the early cinema, is cited by Kracauer, *Theory of Film*, 184.

44. Kracauer, *Theory of Film*, 28. Kracauer here comments upon an observation by Georges Sadoul. The link between these new urban *Lichtspiele* and previous forms of shadow-plays is traced by Victor Klemperer in "Das Lichtspiel."

45. Hausenstein, *Eine Stadt, auf nichts gebaut*, 8ff.

46. Brentano, *Wo in Europa ist Berlin? Bilder aus den zwanziger Jahren*, 144.

47. Friedell, "Prolog vor dem Film," 43.

48. Brod, "Kinematographentheater," 39.

49. For other examples in the recording of these scenes, see Carlo Mierendorff's viewing notes in his "Hätte ich das Kino," 142ff.

50. For a survey and commentary of these tendencies, cf. Kaes's introduction to *Kino-Debatte*, 5ff; translated as "Literary Intellectuals and the Cinema: Charting a Controversy (1909–1929)."

51. Hermann Kienzl, "Theater und Kinematograph," in Kaes, *Kino-Debatte*, 6.

52. Lukács, "Gedanken zu einer Ästhetik des Kinos," 114; also cf. Hausenstein, *Eine Stadt, auf nichts gebaut*, 17.

53. Brentano, *Wo in Europa ist Berlin?*, 33.

54. Goll, "Das Kinodram," 136ff.

55. Goll, "Kinodram," 137. In the same context see also Walter Serner, "Kino und Schaulust," 56; and Lukács, "Gedanken zu einer Ästhetik des Kinos," 114.

56. Brentano, *Wo in Europa ist Berlin?*, 97.

57. Lux, "Über den Einfluß des Kinos auf Literatur und Buchhandel," 95.

58. Kaes, introduction, *Kino-Debatte*, 16.

59. Hugo von Hofmannsthal, "Der Ersatz für die Träume," 151.

60. Adolf Behne, "Die Stellung des Publikums zur modernen deutschen Literatur," in Kaes, *Kino-Debatte*, 163.

61. Behne, "Die Stellung des Publikums," 163.

62. See the beginnings of this visual disposition in a 1910 article by an anonymous author, entitled "Neuland für Kinematographentheater," in Kaes, *Kino-Debatte*, 41. Cf. this rhetoric with Hessel's formulation of an aesthetics of flanerie as "a form of reading the street" [*eine Art Lektüre der Straße*]; in "Berlins Boulevard," in *FB*, 145.

63. "Neuland für Kinematographentheater," 41.

64. Behne, "Die Stellung des Publikums," 162.

65. Lukács, "Gedanken," 116.

66. In his "Rückblick auf Chaplin," Benjamin here cites Soupault's remarks on Chaplin as a flaneur. In Kaes, *Kino-Debatte*, 173.

67. Earlier tropes of Weimar flanerie and urban modernity define Kracauer's later *Theory of Film*, in a noticeable return to these perspectives, after the argumentation of his polemical history of Weimar film, *From Caligari to Hitler. A Psychological History of the German Film,* was predicated upon rather more direct implications of a political and psychological critique.

68. Lukács, "Gedanken," 112.

69. Cf. also Kaes, introduction, *Kino-Debatte*, 33ff.

70. *TF*, 34.

71. *TF*, 31.

72. *TF*, 50. Also cf. Knut Hickethier, "Kino Kino," 144.

73. Albert Laffay's definition is cited here in *TF*, 64.

74. Characterized by impressions and observations, episodes and narration in loose association, many texts of Weimar literature can be described as an assemblage of fragmentary writings of perception and its materials.

75. Goll, "Kinodram," 138.

76. Goll, "Kinodram," 138.

77. Kaes, introduction, *Kino-Debatte*, 25.

78. Cf. Aragon's *Paysan de Paris* and André Breton's "Erstes Manifest des Surrealismus." See in particular Aragon's formulation of the narrative principles of the kind of literature he envisions: "This way I have arrived at psychology. . . . A mere chess-game that I am absolutely not interested in." Aragon, *Paysan de Paris. Pariser Landleben*, 87.

79. Cf. Béla Balázs, *Der Film. Werden und Wesen einer neuen Kunst*, 51, as well as Rudolf Arnheim's essay "Neuer Laokoon. Die Verkoppelung der künstlerischen Mittel, untersucht anläßlich des Sprechfilms."

80. Kaemmerling, "Die filmische Schreibweise," 186.

81. Susan Buck-Morss describes the dynamics of this process in the following way: "The process of knowledge moves in the opposite direction. If we as modern subjects

have in fact given up our power of agency, then the first step in regaining it is to acknowledge its loss, and to read our own behavior as an expression of that commodity capitalism which acts through us." "Flaneur," 129. Also cf. her comments, 100.

82. Kaemmerling, "Filmische Schreibweise," 197.

83. Balázs, *Film*, 33.

84. Balázs, *Film*, 142. Also cf. an interview with corresponding views on Wim Wenders's aesthetics of his film-making; *Die Tageszeitung*, 24 October 1986.

85. Balázs, *Film*, 142.

86. See this trope in Hessel's novel *Der Kramladen des Glücks* [1913], a narrative constructed entirely around the notion of an infinite pursuit of visual desire in the everyday offerings of minute moments of happiness.

87. Cf. Hofmannsthal's early formulation of the dream-state of cinema in his suggestive essay, "Der Ersatz für die Träume" (1921), an essay that anticipates psychoanalytic film theory.

88. Hofmannsthal, "Ersatz," 151.

Chapter 8
Flanerie, or The Redemption of Visual Reality

1. See Kracauer, *TF*.

2. Vertov, *Kino-Eye. The Writings of Dziga Vertov*, 48.

3. Vertov, *Kino-Eye*, 14ff.

4. *TF*, 203. Kracauer's writing here turns into a notebook-like assembly of objects and materials.

5. Kracauer here quotes Felix Mesguich, one of the cameramen working with the Lumière brothers. *TF*, 31.

6. Isherwood, *Goodbye to Berlin*, 1.

7. Aragon, *Le Paysan de Paris. Pariser Landleben*, 56.

8. Mierendorff, "Hätte ich das Kino," 141.

9. Mierendorff, "Hätte ich das Kino," 141.

10. Balázs, *Schriften zum Film*, 57.

11. Balázs, *Film*, 41.

12. Julius Hart, "Der Atlantis-Film," 106.

13. Kracauer explains in relation to the images before these eyes: "In a manner of speaking his mind is the seat of the camera generating them." *TF*, 236. Like the spectator in the medium of film, the flaneur sets out like a camera whose gaze seeks to record the spaces of modernity. Cf. Knut Hickethier's description of this process in his "Kino Kino," 146.

14. Anchoring this sense of flanerie in directing a specific, and idiosyncratic, kind of film, I will explore further underlying filmic aspects of flanerie in the kinds of spectatorship it displays and the materials it explores.

15. Hickethier, "Kino Kino," 144.

16. Serner, "Kino und Schaulust," 55.

17. Balázs, *Film*, 48. In the ensuing discussion of Balázs's filmic writings the frequent analogies to, and affinities with, a theory of flanerie and, in particular, Kracauer's writings on film are deliberate and inevitable; cf. David Bathrick's observation: "Die

Phänomenologie Béla Balázs' hat viel mit der von Kracauer und Benjamin gemein-
sam." In "Der ungleichzeitige Modernist," 37.

18. See in particular, Kracauer's essays in *Straßen in Berlin und anderswo.*

19. Balázs, *Film*, 29.

20. Balázs, *Schriften zum Film*, 53.

21. See *TF*, 180.

22. Balázs, quoted by Hickethier in "Kino Kino," 146.

23. Balázs, *Schriften zum Film*, 117.

24. Balázs, *Schriften zum Film*, 124.

25. Kracauer's *Theory of Film* associates throughout the rhetoric of filmic directors
with a mode of perception indicative of flanerie; cf. his citations of formulations by
D.W. Griffith, Vincente Minelli, Federico Fellini, among others.

26. Balázs, *Schriften zum Film*, 124.

27. Balázs, *Film*, 37. For a discussion of the physiognomic dimensions of Balázs's
theory of film, cf. Gertrud Koch, "Béla Balázs: The Physiognomy of Things."

28. Balázs, *Film*, 37.

29. Balázs, *Film*, 147.

30. Balázs, *Film*, 148.

31. Balázs, *Film*, 148.

32. Balázs, *Schriften zum Film*, 118.

33. Balázs, *Schriften zum Film*, 117.

34. Balázs here specifically cites Peter Altenberg, the author and flaneur, in this
context, a link that again points to the relations of his theory of film to a wider practice
of flanerie.

35. Vertov, *Kino-Eye*, 17.

36. Vertov, *Kino-Eye*, 5. Assuming the equivalency of these terms would mean to
momentarily disregard certain aspects of specific ideological intentionality also inher-
ent in Vertov's concepts of filmmaking.

37. Vertov, *Kino-Eye*, 48ff.

38. Vertov, *Kino-Eye*, 18.

39. Vertov, *Kino-Eye*, 286.

40. Vertov, *Kino-Eye*, 287.

41. Vertov, *Kino-Eye*, 74ff. The "kino-eye's" mobile program again corresponds to
contemporary ideas of a highly ambulatory, flexible new film of the European metropo-
lises, informed by a similar time of "Wartezeit" and "Erfahrungshunger" since the
1970s. Cf. Alfred Behrens, "Nachträgliche Wortmeldung," in Prinzler and Rentschler,
Augenzeugen. Hundert Texte neuer deutscher Filmemacher, 228–31.

42. Vertov, *Kino-Eye*, 88.

43. Balázs, *Film*, 149ff. Emphasis in the original.

44. *TF*, 170. Relativizing these phenomena in this specific passage, Kracauer here
cautions against an explicit correlation of film and flanerie by relying on a definition
of the flaneur that is derived from conventional notions of a nineteenth-century type, a
measured, affluent, idle stroller of bygone times. The orientation of Kracauer's own
analyses, however, both in his essays and his *Theory of Film*, amply demonstrate how
the ubiquitous twentieth-century flaneur can no longer be identified exclusively with a
certain class, a restricted speed, or an anachronistic state of mind. Also cf. another of

Kracauer's passages that explicitly refers to the flaneur and places him at the very location of the cinema: "The flaneur is intoxicated with life in the street." *TF*, 72.

45. This definition of the flaneur abstracts his qualities from criteria that were provisionally attached to the nostalgic type with which he has been traditionally associated. Instead, it appears appropriate to extend these considerations to any visual disposition in modernity.

46. Balázs, *Film*, 124.

47. Kracauer here is thinking particularly of films constructed in accordance with the phantastic tradition of Melies; also cf. later articles from a Hollywood context, such as "Those Movies with a Message."

48. Max Bruns, responding to a survey on "Kino und Buchhandel," *Kino-Debatte*, 86. Kurt Pinthus has recourse to a similar phrase, inflected by tropes of Romanticism, when he speaks of the "sanft bewegte träumerische Stimmung" of the movies in his "Quo vadis—Kino?," 75.

49. See primarily Christian Metz, *Le Signifiant Imaginaire: Psychanalyse et Cinéma*.

50. Lukács, "Gedanken," 114ff.

51. Hofmannsthal, "Der Ersatz für die Träume," 150.

52. Lukács, "Gedanken," 116.

53. Walter Hasenclever, "Der Kintopp als Erzieher. Eine Apologie," in Kaes, *Kino-Debatte*, 47.

54. See a number of texts in this erotic subtext of the *Kino-Debatte*, in particular "Kino und Schaulust" by Serner, "Hätte ich das Kino" by Mierendorff, and "Über den Film" by Mann. In considering a latently erotic susceptibility in Kracauer's writings on film, also cf. Helmut Lethen, "Sichtbarkeit. Kracauers Liebeslehre."

55. With regard to this pivotal intersection of visual and mobile modes of impact, cf. Lynne Kirby's article "Male Hysteria and Early Cinema," as well as her dissertation, *The Railroad and the Cinema, 1895–1929*.

56. Balázs, *Schriften zum Film*, 125. Susan Sontag implicitly hints at these relations of filmic reception to an erotic receptivity of the new medium, with her dictum in the closing passages of discussing art and antiart, when she postulates that, instead of a "hermeneutics," we need an "erotics of art." Lethen perceives Kracauer's *Theory of Film* to enact this missing erotics: "Als diese Erotik der Kunst in Kracauers *Theorie des Films* 1960 erschien, nahm sie hierzulande keiner wahr." "Sichtbarkeit. Kracauers Liebeslehre," 228.

57. Balázs, *Film*, 161.

58. Aragon, *Paysan de Paris*, 79.

59. Aragon, *Paysan de Paris*, 78ff.

60. Also cf. contemporary writings on addiction by other latent adherents to flanerie, such as Benjamin's "Haschisch," or Ernst Jünger's *Annäherungen: Drogen und Rausch*. See Avital Ronell, *Crack Wars. Literature, Addiction, Mania*, 33.

61. Hofmannsthal, "Der Ersatz für die Träume," 150.

62. The addictive structure of this attraction to the images again highlights the pivotal relation of flanerie to modernity. On the central position of addiction for modernity, cf. Ronell's speculations in *Crack Wars*, 13.

63. See the anonymous contribution to the *Kino-Debatte*, "Neuland für Kinematographentheater," 41; cf. also similar observations by Serner, "Kino und Schaulust," and Hauptmann, "Über das Kino."

64. The simultaneity of an intensity in imagination and exteriority in the image has affinities with the experience of drugs, an affinity that Ronell emphasizes in relation to Baudelaire's writings: "Drugs are excentric. They are animated by an outside already inside." *Crack Wars*, 29.

65. Freud's analysis of melancholy provides a contemporary correlative to similar psychological predispositions as they are ascribed here to Hessel's character.

66. Hofmannsthal, "Der Ersatz für die Träume," 150.

67. Freud, "Mourning and Melancholy."

68. Freud, "Mourning and Melancholy," 246.

69. Aragon, *Paysan de Paris*, 7–14.

70. Kaes, introduction, *Kino-Debatte*, 8.

71. Mierendorff, "Hätte ich das Kino," 139.

72. Kaes, introduction, *Kino-Debatte*, 24ff.

73. The ambivalence of this approach conjures new media of images as an art form of reality, an aesthetics created by a gaze that observes so closely as to also almost "alienate" the object itself.

74. Cf. Susan Buck-Morss's formulation on the revolutionary potential of this kind of perceptive leisure: "As a dream-image, loitering allows a subversive reading." "Flaneur," 136.

75. Balázs, *Schriften zum Film*, 204. For a discussion of Balázs's Romantic anticapitalism, see David Bathrick, "Der ungleichzeitige Modernist."

76. Balázs, *Schriften zum Film*, 204.

77. Hofmannsthal, "Der Ersatz für die Träume," 152. Cf. Sabine Hake's discussion, who emphasizes some of the more vicarious, problematic aspects of this "replacement" and who sees Hofmannsthal's notion of "*Ersatz*" primarily as a stance of "substitute." *The Cinema's Third Machine. Writing on Film in Germany: 1907–1933*, 100–103.

78. Hofmannsthal, "Der Ersatz für die Träume," 149.

79. Biro, *Profane Mythology*. The text will subsequently be cited as "PM" in parentheses.

80. Concluding an exploration of the filmic aspects formative of flanerie, with the preview of a woman's theory of film and flanerie, we encounter in this theory the precarious status of the woman flaneur, along with first steps toward a phenomenology of film that retraces some of the deliberations we have encountered in the writings of flanerie. Biro's reflections on a "profane mythology" of the cinema always formulate an implicit aesthetics of flanerie, reflections that give way to, and look out on, a definition of flanerie as a semi-filmic subject and object: as a camera, director, and spectator of perception. This perspective aligns itself to Kracauer's latent affinities with aspects of flanerie in his *Theory of Film*.

81. As Biro sees it, the flaneur's perspective as well as the camera's point of view are defined by a perception that "by its very nature, [is] always purposeful and selective." *PM*, 42.

82. Biro postulates that film demonstrates a fundamentally democratic orientation, "a unique position just by belonging to everyone and no one all at the same time" (*PM*, 69). She considers the spaces of flanerie and film to be above all "centers of human contact open and accessible to all."

83. Just as the flaneur shapes his observations into a text of his own, the medium of film does not merely mirror or photograph the world, as Biro observes early in

her discussion; both media always "build and reinterpret reality" (*PM*, 9) in their respective ways. In choosing the images upon which to linger and to regard as constitutive of their texts, the authors of written flaneries—as of those recorded in filmic ways—express their subjectivities through the images that they choose to include in their texts. Flaneur authors are, as Biro notes about a female director with her own approach to physical reality, "defined by the way she, in her own way, assimilates the outside world." *PM*, 64.

84. These affinities are founded, and found, in the ways in which both media approach their experiences as moments in time: just like flanerie and its texts, the medium of film insists on this "freedom to arrange and rearrange its units." *PM*, 116. Both flanerie and film as critical media of modernity engage in what Biro calls the "kind of intellectual activity" that distinguishes the observing critique of a responsive and reflective mind from the passive consumption of preordained designs.

85. Biro perceives both the writings of film and flanerie as derived from, and articulated along, structures of "photography," recorded in either written words or moving images in a way that seeks to "reinterpret reality" in its diverse facets. While this process implies choosing and arranging the elements retrieved via visual impressions in order "to reconstruct [them] in a variety of ways," films like the ones that Kracauer considers as "truely cinematic," as well as the texts of flanerie that Hessel writes, above all strive for a cautious and preliminary rendering of the world, restraining their constructions to "neither judge nor moralize," as Biro says.

86. Dujardin's and Rodenbach's subjects, for example, present eminent examples of these constellations in the nineteenth century.

87. These relays link figures of female subjectivity and their engagement with visual phenomena to flanerie, mediated by films and writings that Biro relates in a theory of film that is itself informed by a distinct sensibility of flanerie. These affinities also allow us to reflect the female spectator from another angle and beyond the restricted spectator position necessarily problematized by Laura Mulvey's seminal essay and consecutive theories of women and film. Transcending gendered limitations and (existing) privileges of access to the world, both male and female writers and directors of both film and flanerie would seek above all to observe and conserve their intense experience of the exterior world in all its sensory realities, pursuing texts that would preserve in perception their "freedom to arrange and rearrange its units." *PM*, 116.

88. The paradigms posited in Biro's text for a writing of film also describe the writings of flanerie: "Experience is no longer stylization but palpable reality, the unavoidable Now." *PM*, 126.

89. In so doing, both film and flanerie proceed by what Biro calls a "language of immediacy," a rhetoric of transmission that seeks to render the fragments of reality retrieved in perception through what she describes as a form of "metonymic writing."

90. In the texts comprised by both film and flanerie, the moment of seeing "is broken down into its elements," a process of fragmentation that is likely to reveal some of the surreal facets and uncanny aspects of the everyday. In cinema, as Biro says of some of her most favored films, "the most banal experience becomes unfamiliar." Cf. *PM*, 86. For a discussion of the uncanny in the everyday structures of exteriority, in particular those of architecture, cf. Anthony Vidler, *The Architectural Uncanny. Essays in the Modern Unhomely.*

91. What appears from the vantage point of more teleologically invested expectations as a "boringly slow advance of action" (*PM*, 90), as Biro says, brings with it a deliberate insistence on reflection and attentive consideration.

Chapter 9
Women on the Screens and Streets of Modernity

1. See Walter Benjamin's essay on his friend Franz Hessel's writings in the Weimar Republic, "Die Wiederkehr des Flaneurs."

2. For an inquiry on implications of gender in Kracauer's and Benjamin's theories, see Patrice Petro, "Perception, Mass Culture, and Distraction: Walter Benjamin and Siegfried Kracauer," *Joyless Streets. Women and Melodramatic Representation in Weimar Germany*, 57–68.

3. A quasi "second return of the flaneur"—to rephrase Benjamin's essay on Hessel, "The Return of the Flaneur"—under the auspices of the New Subjectivity in German literature and film since the 1970s, a movement that is indeed characterized by a radically subjective turn toward the objective reality of exteriority, is also mainly discussed in terms of its male authors and directors.

4. Morris, "Things to Do With Shopping Centres."

5. Sand, quoted in Wolff, "Invisible *Flaneuse*," 148.

6. Quoted in Griselda Pollock, *Vision and Difference. Femininity, Feminism and Histories of Art*, 69.

7. Cf. Verena Stefan, *Häutungen*.

8. Anne Friedberg, "*Les Flaneurs du Mal(l)*: Cinema and the Postmodern Condition," 421. See also Friedberg, "The Gender of the Observer: The Flaneuse," in *Window Shopping*, 32–37.

9. Friedberg, "*Flaneurs du Mal(l)*," 422.

10. Cf. Gertrud Koch, "Von der weiblichen Sinnlichkeit und ihrer Lust und Unlust am Kino. Mutmaßungen über vergangene Freuden und neue Hoffnungen," 116–38, esp. 130.

11. Buck-Morss, "Flaneur," 119. Buck-Morss also touches upon the question of ownership of the street, 114.

12. Cf. Janet Wolff's study on the "impossibility" of female flanerie, "The Invisible *Flaneuse*." As she argues, women might disavow altogether a modernity with its emphasis on the "public world of work, politics and city life," a world that appears to privilege the experience of men. Yet, the challenge to the prevailing "separation of 'public' and 'private' spheres of activity" replicates the exclusion of women from spheres and spaces of modernity that were potentially accessible to women after all. Validating women's interior activities at the expense of their presence in modernity's exteriors does not challenge the perception that women did not, or were not able to, participate in the "public" of male experience. The conclusion that "the solitary and independent life of the flaneur was not open to women" implies a resignation that is not too distinct from the restrictions under critique; statements that the flaneuse "was rendered *impossible* by the sexual divisions of the nineteenth-century" once more exclude women from a significant realm of experience. Perpetuating the thesis of a "missing flaneuse" may too quickly foreclose our attention to instances of female flanerie and narrow the focus of a debate on women's presence in public spaces.

13. Pollock, *Vision*, 71. Emphasis mine.

14. Pollock, *Vision*, 71.

15. Cf. women writers and female travellers of the nineteenth century, especially women travelling to Paris, the city of the 1830 and 1848 revolutions, such as Johanna Schopenhauer, Fanny Lewald, and Emma von Niendorf, among others.

16. Bashkirtseff, quoted in Pollock, *Vision*, 70.

17. Pollock, *Vision*, 52.

18. Quoted in Pollock, *Vision*, 70.

19. Shirley Ardener quotes this piece of contemporary evidence in her sociological study of cultural norms, "Ground Rules and Social Maps for Women: An Introduction." *Women and Space. Ground Rules and Social Maps*, 33. Emphasis by Ardener.

20. Ardener, *Women and Space*, 29. For a history and ethnography of gender harassment in public spaces, cf. Gardner, *Passing By*.

21. Pollock, *Vision*, 63.

22. See also Ardener's statement: "Foot-binding, tight corsetting, hobble skirts, high heels, all effectively impede women's freedom of movement." *Women and Space*, 28.

23. Rich, "Compulsory Heterosexuality and Lesbian Existence," 183–85. In her seminal essay, Rich exposes and defamiliarizes a number of "natural facts" of female existence as socially constructed factors that oppress and literally impede women's movement with crippling consequences. By extension, these material and physical restrictions ultimately result in the "horizontal segregation of women in employment" and the "enforced economic dependence of wives," all aimed at restricting women's movement and reach in an extended and immediate sense.

24. Koch, "Why Women Go to Men's Films," 108ff. To the extent that these factors describe and prescribe women's point of view and access to public space, they are neither "abstract nor exclusively personal, but ideologically and historically construed." Due to their historical seclusion and lack of mobility, women have remained in particular ways within these prescribed "spaces of femininity," rendered the "product of a lived sense of social locatedness, mobility and visibility, in the social relations of seeing and being seen."

25. In a society organized around and dominated by the male gaze, "any presence of women" is and continues to be "sexualized." There is no representation of the female image that is neutral to and removed from issues of gender and power. For these and similar formulations, see a discussion of related arguments in feminist film theory in Stam et al., *New Vocabularies in Film Semiotics. Structuralism, Post-Structuralism and Beyond*, 176.

26. Ulrike Scholvin, a feminist critic in contemporary Berlin, situates this problematic production of the female image by a male gaze that does not reflect the desires or subjectivity of its object, in the following way: "The cities into which we carry our projections in order to lose ourselves in them are blocked with images our wishes have not produced." *Döblins Metropolen*, 8.

27. For one recent investigation, cf. Susan Bordo, *Unbearable Weight. Feminism, Western Culture, and the Body* (Berkeley: University of California Press, 1993), as well as the popular success of Naomi Wolf, *The Beauty Myth. How Images of Beauty are Used Against Women* (New York: Doubleday, 1991). Both of these critical investigations continue an ongoing line of feminist reflections on the normative codings that

govern and concern many aspects of the female image: cf. Wendy Chapkis, *Beauty Secrets. Women and the Politics of Appearance* (Boston: South End, 1986); Robin Tolmach-Lakoff and Raquel Scherr, *Face Value: The Politics of Beauty* (London: Routledge, 1984); Nancy C. Baker, *The Beauty Trap: Exploring Woman's Greatest Obsession* (New York: Franklin Watts, 1984); Lisa Schoenfielder and Barb Wisser, *Shadow on a Tightrope: Writing by Women on Fat Oppression* (Iowa City: Aunt Lute Book Company, 1983); Kim Chenin, *The Obsession: Reflections on the Tyranny of Slenderness* (New York: Harper and Row, 1981); and Susie Orbach, *Fat is a Feminist Issue* (Middlesex: Hamlyn, 1979).

28. Scholvin, *Döblins Metropolen*, 7ff. She goes on to describe her own experience as a woman and flaneur in the 1980s: "We fall into the habit of appraising our environs with quick glances without attracting and holding on to other gazes; we learn to distinguish which places are accessible to us."

29. Pollock, *Vision*, 89.

30. Ardener, *Women and Space*, 12.

31. Susan Buck-Morss, a current critic of this "politics of loitering," speaks for women who have begun to read and uncover these invisible confines of the system, contemporary feminists who may be in a position to declare that "the politics of this close connection between the debasement of women sexually and their presence in public space [is] clear." "Flaneur," 119.

32. Petro, *Joyless Streets*, 69.

33. Rob Shields notes the problematic interrelatedness of the prostitute, as the (only) existing figure of femininity in Benjamin's writings, to the flaneur: "Seeing only the agency of the masculine figure and only the superficiality of the feminine figure leads Benjamin to miss the opportunity to better connect these two archetypical responses to the commodification of social relations." "Fancy footwork," 66.

34. See the entire extent of Petro's critique in *Joyless Streets*, 74.

35. Wolff, *Hindsight*, 106.

36. "Walter [Benjamin] and Franz Hessel, whom I had introduced to each other, became close friends. They collaborated in the translation of Proust and Balzac into German, which strengthened their bond." *Hindsight*, 71.

37. Cf. Petro, "Weimar Photojournalism and the Female Reader," *Joyless Streets*, 79–139.

38. Anne Friedberg suggests a similiar expansion of women's space in rethinking Wolff's deliberations via a new scrutiny of the texts of modernity: "Someone . . . who wants to produce a feminist sociology that would include women's experience should also turn to literary texts by female 'modernists.' " "*Flaneurs du Mal(l),*" 430.

39. Cf. *Kino-Debatte*, 37–175.

40. For two recent explorations of this filmic text with a focus on urban modernity and cinematic space, cf. Wolfgang Natter, "The City as Cinematic Space: Modernism and Place in *Berlin, Symphony of a City,*" and Sabine Hake, "Urban Spectacle in Walter Ruttmann's *Berlin: Symphony of the Big City.*"

41. Kracauer, *From Caligari to Hitler*, 186.

42. Uricchio, "Ruttmann's *Berlin* and the City Film to 1930," 209.

43. Hake, unpublished manuscript, generously provided by the author.

44. Other investigations of the film have also neglected the gendered experience of these streets, instead isolating formal and compositional questions; cf. Matthew

Bernstein, "Visual Style and Spatial Articulations in *Berlin, Symphony of a City* (1927)," Jay Chapman, "Two Aspects of the City: Cavalcanti and Ruttmann;" Jiri Kolaja and Arnold W. Foster, *"Berlin, the Symphony of a City* as a Theme of Visual Rhythm;" and Thomas Kuschel, "Die Darstellung des Menschen und seiner Gesellschaft in den Filmen *Berlin. Die Sinfonie der Großstadt* von Walter Ruttmann und *Vorwärts, Sowjet!* von Dziga Wertow unter Berücksichtigung der künstlerisch-formalen Gestaltungsmittel."

45. Cf. Atina Grossman, "The New Woman and the Rationalization of Sexuality in Weimar Germany," as well as Cornelie Usborne, *The Politics of the Body in Weimar Germany. Women's Reproductive Rights and Duties.*

46. Buck-Morss, "Flaneur," 119.

47. Cf. Luce Irigaray, "Women on the Market," in *This Sex Which is Not One.*

48. Rob Shields points to the relations between the flaneur's scopophilia and "exotic foreigners," the attractions of visuality and otherness. "Fancy footwork," 66.

49. Buck-Morss, "Flaneur," 122 and 119.

50. The absence of a genuine female flaneur typifies the history of male flanerie in its indifference to female experience, especially when prostitution must be considered, as Buck-Morss suggests it was, "the female version of flanerie." "Flaneur," 120.

51. Regarding a specular meditation on related concerns in the filmic medium, see Jean-Luc Godard's *Vivre sa Vie* (1962).

52. Buck-Morss, "Flaneur," 119.

53. Pollock, *Vision*, 84. Koch describes this dynamics between the looker and the objects of his look in the following way: "Woman is subjugated to the dominant gaze before she can even begin to measure herself against man, to measure her gaze against his. All she can do is look demurely at the ground, to strip her expression of all meaning in order to deny and avoid the aggression of his gaze, or to take refuge behind the mask which conceals the gaze." This cultural strategy is especially apparent in the restrictions governing women's entry into privileged spaces of seeing, such as pubs and cinemas, where they must be accompanied by others, mainly men. "Why Women Go to Men's Films," 109.

54. Cf. the special issue of *Camera Obscura. A Journal of Feminism and Film Theory* on the "Spectatrix," edited by Janet Bergstrom and Mary Ann Doane, for reflections on and approaches to the female spectator.

55. Koch, "Von der weiblichen Sinnlichkeit," 125.

56. Sartre, *L'être et le néant. Essai d'ontologie phénoménologique*, 310.

57. Cf. the resignation concluding Stefan's autobiographical account, *Häutungen.*

58. Cf. Simmel, "Die Großstädte und das Geistesleben."

59. Scholvin, *Döblins Metropolen*, 66.

60. Buck-Morss, "Flaneur," 125. Cf. also John Berger, *Ways of Seeing.*

61. "In the shopping mall, the *flâneuse* may have found a space to roam . . . like the *flâneur*, with the privilege of just looking—but what is it she sees?" Friedberg, "Flaneurs du Mal(l)," 429.

62. Scholvin, *Döblins Metropolen*, 66.

63. Horkheimer and Adorno, *Dialectic of Enlightenment*, translated by John Cumming (New York: Herder and Herder, 1972), 139.

64. Koch, "Why Women Go to Men's Films," 108. Attempts at censoring the female gaze follow the logic of restricting women's movement and perception through the

"traditional sanction against unaccompanied women in public meeting-places like pubs, streets, stations, etc. [in order to protect them] as a man's private property from the gaze of other men."

65. Schlüpmann, *Die Unheimlichkeit des Blicks. Das Drama des frühen deutschen Kinos*, 13.

66. Schlüpmann, *Unheimlichkeit des Blicks*, 16.

67. Laura Mulvey's remarks on the gendered construction of dominant cinema apply to the cultural dynamics of public spaces as well: the "socially established interpretation of sexual difference . . . controls images, erotic ways of looking, and spectacle." "Visual Pleasure and Narrative Cinema," 6.

68. Cf. Berger, *Ways of Seeing*, 45–64.

Chapter 10
Weimar Women, Walkers, Writers

1. An increasing number of texts traces the daily, oral histories of women in Berlin as symptomatic of women's presence in the public sphere of modern Germany. Cf., among others, an anthology, *Unter allen Umständen. Frauengeschichte(n) in Berlin*, in particular one essay by Gertrud Pfister, "Abenteuer, Wettkampf und Tanz. Zur Bewegungskultur von Frauen (1890–1933); the collection *Triumph und Scheitern in der Metropole. Zur Rolle der Weiblichkeit in der Geschichte Berlins*, edited by Sigrun Anselm and Barbara Beck; and Petra Zwacka's volume *Ich bin meine eigene Frauenbewegung. Frauen-Ansichten aus der Geschichte einer Großstadt.*

2. For a perceptive analysis of contemporary texts in mass culture, see Gisela von Wysocki, "Der Aufbruch der Frauen: Verordnete Träume, Bubikopf und sachliches Leben. Ein aktueller Streifzug durch SCHERL's Magazin Jhg. 1925." Also cf. a wealth of writings on this context and constellation of history in an anthology of Weimar materials edited by Anton Kaes, Martin Jay, and Edward Dimendberg, *The Weimar Republic Sourcebook*, in particular the section dedicated to "The Rise of the New Woman," 195–219.

3. Kurt Tucholsky's often quoted verdict of "a woman with a sense of humor" is indicative of a widely held appreciation of Keun among her contemporaries; cf. "Auf dem Nachttisch," *Die Weltbühne* 5, no. 28, 1932. Among the critical writings that have contributed to a minor renaissance of Keun's works are studies by Helmut Lethen, *Neue Sachlichkeit 1924–1932;* Erhard Schütz, *Romane der Weimarer Republik*; and Helmut Kreuzer, "Kultur und Gesellschaft in der Weimarer Republik." Some of the most remarkable responses in the recent reception of Keun's writings comes from another author who is not usually situated in close affinity to her modernist predecessors: Elfriede Jelinek's essays "Die Sprache des Kindes: Über die Literatur der Irmgard Keun," and "Weil sie heimlich weinen muß, lacht sie über Zeitgenossen."

4. Despite such achievements, Keun is today only one of the many forgotten voices of her time, voices which, in particular, evoke the presence of women in that period. See Ursula Krechel's rediscovery of Keun in her early consideration of questions of reception and the canon, "Irmgard Keun: Die Zerstörung der kalten Ordnung. Auch ein Versuch über das Vergessen weiblicher Kulturleistungen."

5. On some of the specific historical conditions behind the myth of a "New Woman" in Weimar culture, cf. Renate Bridenthal and Claudia Koonz, "Beyond Kinder, Küche,

Kirche: Weimar Women in Politics and Work;" Hanne Loreck, "Auch Greta Garbo ist einmal Verkäuferin gewesen: Das Kunstprodukt 'Neue Frau' in den Zwanziger Jahren;" as well as Atina Grossmann's work on Weimar women, in particular "Girlkultur or Thoroughly Rationalized Female: A New Woman in Weimar Germany?" and "The New Woman and the Rationalization of Sexuality in Weimar Germany." For an informative study on women in the public sphere of Nazi Germany, see Claudia Koonz, *Mothers in the Fatherland. Women, the Family and Nazi Politics.*

6. Cf. Jelinek's exceptional esteem for, and identification with, Keun's professional and personal choices: "Mit Recht hat sich diese Frau, *eine der ganz bedeutenden deutschen Schriftstellerinnen*, immer wütend dagegen verwahrt, als hauptberufliche Gefährtin bezeichnet zu werden." "Weil sie heimlich weinen muß, lacht sie über Zeitgenossen," 222. Emphasis mine.

7. Keun, *Gilgi—eine von uns*, first published in 1931.

8. See the extended contemporary debate about the implications of this character's politically innovative, yet also provocatively idiosyncratic choices; see Brentano, "Keine von uns. Ein Wort an die Leser des *Vorwärts*," 357ff.

9. One study devoted to Keun and Anna Seghers situates Gilgi primarily as a literary example of the new type of an office girl with an increasingly independent and ambivalent sense of sexual identity; see Irene Lorisika, *Frauendarstellungen bei Irmgard Keun und Anna Seghers*, 126–43. A more recent investigation by Barbara Kosta specifies the incompatible relations between maternity and modernity as the "dark plot" of Keun's novel; see "Unruly Daughters and Modernity: Irmgard Keun's *Gilgi—eine von uns*."

10. Doris Rosenstein's extended monograph on Keun situates the novels *Gilgi—eine von uns* and *Das kunstseidene Mädchen* as examplary literary case studies of the "New Woman," city life, and the Weimar ideology of capitalist success; see *Irmgard Keun. Das Erzählwerk der dreißiger Jahre*, 9–12.

11. *G*, 147. For an introduction to the discussion of Weimar notions of *Sachlichkeit* that translates to a debate on both style and politics in life and literature, see the section on "Neue Sachlichkeit" and its literary manifestations in *Weimarer Republik. Manifeste und Dokumente zur deutschen Literatur 1918–1933*, edited by Anton Kaes (Stuttgart: Metzler, 1983), 319–45, including texts by Egon Erwin Kisch, Johannes R. Becher, Kurt Pinthus, Siegfried Kracauer, and Lion Feuchtwanger, among others.

12. See also the filmic adaptation produced shortly after the publication of Keun's text *Gilgi, eine von uns* (1932), directed by Johannes Meyer, starring Brigitte Helm.

13. First published in 1932; Keun, *KM*, 8.

14. See Volker Klotz, "Forcierte Prosa. Stilbeobachtungen an Bildern und Romanen der Neuen Sachlichkeit," 261.

15. Keun, *KM*, 45. Rosenstein defines this investment in a sense of *"Glanz"* as a prime indicator of the career ideology and star status to which the character and her time aspire above all other ambitions; cf. *Irmgard Keun*, 94.

16. The incessant repetition of this phrase, composed entirely of shine and *"Glanz,"* repeated in only slight variations four times on the very first page alone, a repetition that returns in many of the passages throughout the text of *Das kunstseidene Mädchen*, points to the significance of writings of light and neon as the focus of many texts of her age.

17. Jelinek also acknowledges the unorthodox ways in which Keun approaches any kind of gendered problematics: "Ich weiß natürlich, daß ihr das heutige Emanzipations-

gerede auf die Nerven geht. . . . Ich kann das verstehen von einer Frau, die immer emanzipiert gewesen ist und das als selbstverständlich betrachtet hat." "Weil sie heimlich weinen muß," 222.

18. This declared impulse of a "restless roaming" is pursued throughout the text, projected upon the male character Martin at an ever accelerating pace; see *G*, 64.

19. Cf. a passage from Paul Boldt's early expressionist poem of the city, "Berliner Abend," with the following sequence of light effects and poetic lines: "Der Asphalt dunkelt und das Gas schmeißt sein / Licht auf ihn. Aus Asphalt und Licht wird Elfenbein." *Die Aktion* 3 (1913).

20. The engagement of Keun's character in an intense state of scopophilia, under any kind of urban situation, shows the encompassing extent of the metropolitan gaze in modernity in both Berlin and the "medium city" of Cologne. In contrast to Rosenstein's argument here, one could state that the visual obsessions of this text transcend many territorial and gendered positions. Cf. Rosenstein, *Irmgard Keun*, 70.

21. Cf. Kracauer, "Kino in der Münzstraße" in *Straßen in Berlin*. Friedrich Kittler also notes a strong relation of Keun's writings to Kracauer's observations on Weimar Germany, linking the social and epistemological space of her "*Romanheldinnen*" to the status of his "*Angestellten*." See *Grammophon Film Typewriter*, 126ff. Christa Jordan details the relations of these female employees to their appearance in Weimar prose; see *Zwischen Zerstreuung und Berauschung*.

22. The author's many female readers themselves convey evidence of their ongoing desire for contemporary reality, as the presence of her text in the public sphere and reading community of her time show. One contemporary critic writes: ". . . und das 'Kunstseidene Mädchen' *läuft* tatsächlich durch alle Straßen—monatelang kann man es in keiner großstädtischen Leihbibliothek bekommen und wenn es in fünf Exemplaren vorhanden ist." Elisabeth Fließ, "Mädchen auf der Suche," in *Die Frau* 40 (1932): 172. Emphasis mine.

23. *G*, 119. In contrast to this statement, the text overall very much describes a sensitivity and appreciation for all aspects of scopophilia, as shown in her observations on conditions of lighting such as the *Bogenlampen*, the exteriors of the city, and the sights of the street scenes during the Cologne *Karneval*.

24. Cf. pivotal theoretical reflections on boredom by Weimar contemporary thought, most pronouncedly Kracauer's essay "Langeweile," in *Das Ornament der Masse*, as well as another, yet less-known essay, about nineteenth-century Paris—a period significant also for Benjamin's projects and projections of modernity—with the identical title "Langeweile," in *Jacques Offenbach und das Paris seiner Zeit*. For an exploration of modernity and the image in the transition spaces between boredom and history, see Petro, "After Shock/ Between Boredom and History."

25. Rosenstein considers this title to be an example of her "humoristisch-komische Erzählleistung." *Irmgard Keun*, 116. However, one might also choose to look at these two notions of "artificial" and "silk," joined in one title, as less a contradiction in terms than another implicit reflection of the state of aesthetics in an age of the articial reproducibility of artistic matters and materials.

26. Kittler observes the ways in which this character is linked to new technologies and modern media (albeit still mapping her text upon a male model and short-circuiting questions of female creativity with prostitution): "Romanheldinnen, die wie Irmgard Keuns *Kunstseidenes Mädchen* von 1932 (*offenbar unter ausgiebiger Kracauer-Benut-*

zung) am Grammophon oder Radio zu Dichterinnen (und in Berlin zu Huren) werden."
Grammophon Film Typewriter, 126. Emphasis mine.

27. For an extended differentiation of the state of these cities, cf. the sections of
Rosenstein's study dedicated to these distinct locations in the novel. *Irmgard Keun*,
60–68.

28. *KM*, 8. Similar female characters appear in Keun's other novels, such as the ex-
ample of "Susanne Moder" in her novel *Nach Mitternacht*, a figure who also expressly
understands herself as a camera. Cf. Michael Ackermann, *Schreiben über Deutschland
im Exil. Irmgard Keun: Nach Mitternacht. Anna Seghers: Das siebte Kreuz*, 29.

29. Kittler comments on this linkage of perception and its newest media: "So exakt
beschreiben Unterhaltungsromane (auch der Keun) ihre medientechnischen Produkti-
onsbedingungen." *Grammophon Film Typewriter*, 127. Also cf. Leo Lensing, "Cinema,
Society, and Literature in Irmgard Keun's 'Das kunstseidene Mädchen.' "

30. Cf. similar visually invested texts of the time from a contemporary context in
the *Kino-Debatte*, among them Lux's reflection on the cinema as a continuation of the
illustrating tendencies of the modern presses, "Über den Einfluß des Kinos," or Goll's
essay on the image-shocks of modernity, "Kinodram."

31. Even though she uses her image of stereotypical femininity in seductive ways,
she seeks to do so without hurting the interests—visual or otherwise—of other women
on the scene. Gilgi's feminist position is circumscribed by the only partially ironic
declaration that she considers herself to be a woman "much too decent and too attuned
to the women's movement" (*KM*, 14) to see herself acting against the interests or at the
expense of other women. Keun's rhetoric of casting her character as being one who is
"auf Frauenbewegung eingestellt" resonates as a woman's evocative revision of Die-
trich's contemporary phrase "Von Kopf bis Fuß auf Liebe eingestellt" in Josef von
Sternberg's *Der blaue Engel*.

32. In *Paysan de Paris*, Aragon presents the surrealist as an "image-drinker," as a
modern artist who seeks to submerge in the images of the city.

33. Ulrike Ottinger invents her own portrait of an obsessive drinker of—among
other substances—images, and projects it into a female existence in the frame of a
similar scene in Berlin; see her film *Bildnis einer Trinkerin* (1979).

34. Rosenstein describes the details and diverse facets of this passage as an attempt
to render the frenzied atmosphere of the city. *Irmgard Keun*, 64.

35. Cf. contemporary controversies in the closing years of the Weimar Republic over
images and roles of women, in society and in the new novel, in particular *Gilgi—eine
von uns*, and Weimar leftist publications such as *Die Linkskurve* and *Die Front*.

36. This equation of life and its medium has relays with the life of an author who
reveals a highly cinematic sensitivity also in the context of her own autobiographical
experience, a life that she considers a "*wilder Wirbel*," that is, a veritable reel of sensa-
tions. See also Gabriele Kreis's comments in her edition of Keun's letters to her lover
Arnold Strauss: "Her novels are a reflex to her biography, her biography is novels
written forth." *Ich lebe in einem wilden Wirbel. Briefe an Arnold Strauss, 1933 bis
1947*, 305.

37. Cf. Jean Baudrillard's postulate of a "reign of the emancipated sign, that all
classes will partake equally of." *Simulations*, 85.

38. *KM*, 99. See particularly pp. 120–27 for details of an understanding of the city as a commodity world creating the mundane and the everyday, a commercial sphere also which produces historically and culturally relevant nuances and constellations.

39. Defined primarily by his marriage to a housewife, a homely woman excluded from the sensory qualities of exteriority, Brenner is invested in his informant's process of seeing in only the most general terms. For a similar instance of mediation and the gendered transmission of the gaze cf. also an—even muted—acknowledgment of the street as a visual scene by the domestic woman in the closing sequence of Karl Grune's film *Die Straße* (1923).

40. Rosenstein considers Doris's seeing for Brenner to be a phase in which her illusion of the city collapses. *Irmgard Keun*, 66. While these reports and observations certainly include many of the more unpleasant particles of reality, they also contribute to an expansion of vision that does not surrender its visual sensitivity or sense of curiosity, as the passages following in the text with their distinctly semiotic turn illustrate.

41. *KM*, 103. Emphasis mine.

42. *KM*, 126. This contemporary identification particularly of the lives of Weimar women with the cinema is apparent also in one of Hessel's figures, Margot of *Nacht-wache*, who admits to dreaming of arcadia while at the same time considering herself "ja wohl ein ziemlich modernes Geschöpf, und in meinem Leben geht es oft zu wie im Kino."

43. Katharina von Ankum reads this phase of the housewife as a latent state of prostitution, and not so much as a transformation of this scopophilia than as its disappearance, as evidence that "Doris ihren anfänglichen Emanzipationsanspruch der realen Erfahrung der modernen Großstadt geopfert hat." " 'Ich liebe Berlin mit einer Angst in den Knien.' Weibliche Stadterfahrung in Irmgard Keuns *Das kunstseidene Mädchen*," 374.

44. As the example of the German edition of Wolff's autobiography shows, a text that has presumably been prepared for a mainstream market, cuts and interventions obliterate in particular those passages that mark the writer's more aimless "transgressions" toward the rambling subjectivity of a female flaneur.

45. *H*, 250.

46. It is only with the passage of time that her "daze of having arrived in Berlin" (*H*, 258) will lift and facilitate a more focused gaze upon the spaces of previous and anticipated walks in the city.

47. The process of her flanerie sets in motion a film of associations that runs in Wolff's mind, an imaginary film composed of the images of reality both past and present, as well as the many sensory impressions and memories she traverses in the urban sphere.

48. *H*, 261.

49. Cf. the German translation of Wolff's text, *Augenblicke verändern uns mehr als die Zeit*.

50. *H*, 268. Upon her return to the divided city, Wolff deplores above all the now prevailing, even more manifest limitations to her freedom of movement. Her emphasis of "reading" this city as a tactile, distinctly physical offering—a "hand"—underlines what is not just a clichéd expression for one of the leading theorists of a physiological study of the hand, a prime sensorium of tactile expression and experience. As a physiol-

ogist and female flaneur, Wolff is also a reader of handlines; cf. her clinical textbooks *The Human Hand*, and in particular, *A Psychology of Gesture*.

51. *H*, 272.

52. Christa Wolf's textual flanerie *Unter den Linden* traces the ways in which female subjectivity demands, among other things, this freedom of reverie within interiors as well as the public sphere, by questioning the persona that she names her "dream censor."

53. Stefan phrases her striking formulation of this state of exclusion in a similar way: "die Stadt [war] zu." *Häutungen*, 22.

54. The extent of this empowerment is apparent if we consider the prevailing power over women by harrassing experiences in the public sphere, as another female flaneur from the Berlin of the 1980s reports in detail of her own traumatic personal and theoretical relation to the city; cf. Scholvin, *Döblins Metropolen*.

55. Catherine Silberschmidt, in considering the case of Germaine Dulac and a female aesthetics of film. "Kino das ist Bewegung, Rhythmus, Leben. Germaine Dulac— Filmpionierin der 20er Jahre," 86.

Bibliography

Abbas, Ackbar. "Walter Benjamin's Collector. The Fate of Modern Experience." In *Modernity and the Text: Revisions of German Modernism*, edited by Andreas Huyssen and David Bathrick, 216–40. New York: Columbia University Press, 1989.

Ackermann, Michael. *Schreiben über Deutschland im Exil. Irmgard Keun: Nach Mitternacht. Anna Seghers: Das siebte Kreuz*. Stuttgart: Klett, 1982.

Angenot, Marc. "Roman et ideologie: *Les Mystères de Paris*." *Revue des langues vivantes* 38 (1972): 392–410.

Ankum, Katharina von. "'Ich liebe Berlin mit einer Angst in den Knien.' Weibliche Stadterfahrung in Irmgard Keuns *Das kunstseidene Mädchen*." *German Quarterly* 3, no. 67 (1994): 369–88.

Anselm, Sigrun, and Barbara Beck, eds. *Triumph und Scheitern in der Metropole. Zur Rolle der Weiblichkeit in der Geschichte Berlins*. Berlin: Reimer, 1987.

Aragon, Louis. *Le Paysan de Paris*. Paris: Gallimard, 1966; first ed. 1926.

———. *Le Paysan de Paris. Pariser Landleben*. Translated by Rudolf Wittkopf. Munich: Rogner and Bernhard, 1969.

Ardener, Shirley, ed. *Women and Space. Ground Rules and Social Maps*. London: Oxford University Women's Studies Committee, 1981.

Arnheim, Rudolf. "Neuer Laokoon. Die Verkoppelung der künstlerischen Mittel, untersucht anläßlich des Sprechfilms." In *Kritiken und Aufsätze zum Film*, 81–112. Frankfurt/M.: Fischer, 1979.

Asendorf, Christoph. *Batterien der Lebenskraft. Zur Geschichte der Dinge und ihrer Wahrnehmung im 19. Jahrhundert*. Gießen: Anabas, 1984.

Bachelard, Gaston. *The Poetics of Reverie. Childhood, Language, and the Cosmos*. Translated by Daniel Russell. Boston: Beacon, 1969.

Balakian, Anna. *The Symbolist Movement. A Critical Appraisal*. New York: New York University Press, 1977.

Balázs, Béla. *Der Film. Werden und Wesen einer neuen Kunst*. Vienna: Globus, 1980.

———. *Schriften zum Film*. Vol. 2, *Der Geist des Films: Artikel und Aufsätze 1926–1931*, edited by Wolfgang Gersch. Munich: Hanser, 1984.

Barthes, Roland. *Mythen des Alltags*. Frankfurt/M.: Suhrkamp, 1964.

———. *Die Sprache der Mode*. Frankfurt/M.: Suhrkamp, 1985.

Bathrick, David. "Der ungleichzeitige Modernist: Béla Balázs in Berlin." In *Filmkultur zur Zeit der Weimarer Republik*, edited by Uli Jung and Walter Schatzberg. 26–37. Munich: Saur, 1992.

Baudrillard, Jean. *Simulations*. Translated by Paul Foss et al. New York: Semiotext(e), 1983.

Benjamin, Walter. *Berliner Kindheit um Neunzehnhundert*. In *Gesammelte Schriften*. Vol. 4, bk. 1, edited by Tillman Rexroth. Frankfurt/M.: Suhrkamp, 1983.

———. *Gesammelte Schriften*. Vol. 4. Edited by Rolf Tiedemann and Hermann Schweppenhäuser. Frankfurt/M.: Suhrkamp, 1985.

———. "Kleine Geschichte der Photographie." In *Aussichten. Illustrierte Aufsätze*. Frankfurt/M.: Insel, 1977.

Benjamin, Walter. "Das Leben der Studenten." In *Illuminationen. Ausgewählte Schriften*, 9–20. Frankfurt/M.: Suhrkamp, 1977.

———. "On Some Motifs in Baudelaire." In *Illuminations*, edited by Hannah Arendt, translated by Harry Zohn. New York: Schocken, 1968.

———. "Das Paris des Second Empire bei Baudelaire." In *Gesammelte Schriften*. Vol. 1, bk 2, edited by Rolf Tiedemann and Hermann Schweppenhäuser. Frankfurt/M.: Suhrkamp, 1974.

———. "The Paris of the Second Empire in Baudelaire." In *Charles Baudelaire. A Lyric Poet in the Era of High Capitalism*, translated by Harry Zohn. 9–106. London: Verso, 1983.

———. *Das Passagen-Werk*. 2 vols. Edited by Rolf Tiedemann. Frankfurt/ M.: Suhrkamp, 1983.

———. "Die Wiederkehr des Flaneurs." *Die literarische Welt* 40, no. 5 (1929).

———. "The Work of Art in the Age of its Technological Reproduceability" (translation modified). In *Illuminations*, edited Hannah Arendt, translated by Harry Zohn, 217–51. New York: Schocken, 1968.

Berger, John. *Ways of Seeing*. New York: Penguin, 1977.

Berghahn, Klaus. "A View Through the Red Window: Ernst Bloch's *Spuren*." In *Modernity and the Text: Revisions of German Modernism*, edited by Andreas Huyssen and David Bathrick, 200–15. New York: Columbia University Press, 1989.

Bergson, Henri. *Matter and Memory*. Translated by Nancy Margaret Paul and W. Scott Palmer. New York: Macmillan, 1913.

Bergstrom, Janet, and Mary Ann Doane. *Camera Obscura. A Journal of Feminism and Film Theory*. Special issue, "The Spectatrix," 20–21 (1989).

Berlin, Berlin. Die Ausstellung zur Geschichte der Stadt. Katalog, edited by Gottfried Korff and Reinhard Rürup. Berlin: Nicolai, 1987.

Berman, Marshall. *All That is Solid Melts into Air. The Experience of Modernity*. New York: Simon and Schuster, 1982.

Bernstein, Matthew. "Visual Style and Spatial Articulations in *Berlin, Symphony of a City* (1927)." *Journal of Film and Video* 36, no. 4 (fall 1984): 5–12.

Bienert, Michael. *Die eingebildete Metropole. Berlin im Feuilleton der Weimarer Republik*. Stuttgart: Metzler, 1992.

Biermann, Karlheinrich. "Der Rausch des Lumpensammlers und der Alptraum des Bürgers. Historisch-soziologische Interpretation von Baudelaire's Le Vin des Chiffonniers." *Germanisch-Romanische Monatsschrift* 29 (1979): 311–21.

Biesbrock, Hans-Rüdiger van. *Die literarische Mode der Physiologien in Frankreich (1840–1842)*. Frankfurt/M.: Lang, 1978.

Birkerts, Sven. "Walter Benjamin, Flaneur: A Flanerie." *The Iowa Review* 3–4, no. 13 (1982): 164–79.

Biro, Yvette. *Profane Mythology. The Savage Mind of the Cinema*. Translated by Imre Goldstein. Bloomington: Indiana University Press, 1982.

Bloch, Ernst. *Erbschaft dieser Zeit*. Frankfurt/M.: Suhrkamp, 1985.

Boella, Laura. "Visibilité et surface. Le possible et l'inconnu dans le concept de forme de Georg Simmel." *Information sur les Sciences Sociales* 25, no. 4 (1986): 925–43.

Börne, Ludwig. "Schilderungen aus Berlin." In *Sämtliche Schriften*. Vol. 2, edited by Inge and Peter Rippmann. Dreieich: Melzer, 1977.

Brand, Dana. *The Spectator and the City in Nineteenth-Century American Literature.* Cambridge: Cambridge University Press, 1991.

Brentano, Bernard von. "Keine von uns. Ein Wort an die Leser des *Vorwärts*," in *Weimarer Republik. Manifeste und Dokumente zur deutschen Literatur 1928–1933*, edited by Anton Kaes, 357–58. Stuttgart: Metzler, 1983.

———. *Wo in Europa ist Berlin? Bilder aus den zwanziger Jahren.* Frankfurt/M.: Insel, 1981.

Breton, André. "Erstes Manifest des Surrealismus." In *Surrealismus in Paris. 1919–1939*, 80–117. Leipzig: Reclam, 1986.

Bridenthal, Renate, and Claudia Koonz, "Beyond Kinder, Küche, Kirche: Weimar Women in Politics and Work." In *Liberating Women's History. Theoretical and Critical Essays*, edited by Berenice A. Carroll, 301–29. Urbana: University of Illinois Press, 1976.

Brod, Max. "Kinematographentheater." In Kaes, *Kino-Debatte*, 39–41.

Brüggemann, Heinz. "Das eingeschlossene Frauenbild oder Die Automate im Fenster—Figurationen des Wahrnehmungsbegehrens. E.T.A. Hoffmann, *Der Sandmann* und *Das öde Haus*." In *Das andere Fenster: Einblicke in Häuser und Menschen. Zur Literaturgeschichte einer urbanen Wahrnehmungsform*, 121–52. Frankfurt/M.: Fischer, 1989.

Bruno, Giuliana. *Streetwalking on a Ruined Map. Cultural Theory and the City Films of Elvira Nartori.* Princeton: Princeton University Press, 1993.

Buchka, Peter. *Augen kann man nicht kaufen. Wim Wenders und seine Filme.* Munich: Hanser, 1983 .

Buck, Stefan. *Edouard Dujardin als Repräsentant des Fin de siècle.* Würzburg: Königshausen and Neumann, 1987.

Buck-Morss, Susan. *The Dialectics of Seeing. Walter Benjamin and the Arcades Project.* Cambridge: MIT Press, 1989.

———. "Dream World of Mass Culture. Walter Benjamin's Theory of Modernity and the Dialectics of Seeing." In *Modernity and the Hegemony of Vision*, edited by David Michael Levin, 309–38. Berkeley: University of California Press, 1993.

———. "The Flaneur, the Sandwichman and the Whore. The Politics of Loitering." *New German Critique* 39 (1986): 99–140.

Chapman, Jay. "Two Aspects of the City: Cavalcanti and Ruttmann." In *The Documentary Tradition*, edited by Jay Leyda. New York: Norton, 1971.

Citron, Pierre. *La Poésie de Paris dans la littérature française de Rousseau à Baudelaire.* 2 vols. Paris: Editions des Minuit, 1961.

Clark, T.J. *The Painting of Modern Life. Paris in the Art of Manet and His Followers.* Princeton: Princeton University Press, 1984.

Cohen, Margaret. *Profane Illumination. Walter Benjamin and the Paris of the Surrealist Revolution.* Berkeley: University of California Press, 1993.

Crary, Jonathan. *Techniques of the Observer. On Vision and Modernity in the Nineteenth Century.* Cambridge: MIT Press, 1990.

Culler, Jonathan. "Junk and Rubbish: A Semiotic Approach." *Diacritics* (fall 1985): 2–13.

Denkler, Horst. "Sache und Stil: Die Theorie der 'Neuen Sachlichkeit' und ihre Auswirkungen auf Kunst und Dichtung." *Wirkendes Wort* 18 (1968): 167–85.

Denscher, Bernhard, ed. *Tagebuch der Straße. Geschichte in Plakaten*. Wien: Jugend und Volk, 1981.

Derrida, Jacques. "Mochlos; or, The Conflict of the Faculties." In *Logomachia. The Conflict of the Faculties*, edited by Richard Rand, 3–34. Lincoln: University of Nebraska Press, 1992.

———. *Of Grammatology*. Translated by Gayatri Chakravorty Spivak. Baltimore: Johns Hopkins University Press, 1976.

———. "The Principle of Reason. The University in the Eyes of Its Pupils." *Diacritics* 13, no. 3 (fall 1983).

Donahue, Neil H. *Forms of Disruption. Abstraction in Modern German Prose*. Ann Arbor: University of Michigan Press, 1993.

Dronke, Ernst. *Berlin*. Edited by Rainer Nitsche. Darmstadt: Luchterhand, 1987.

Dujardin, Edouard. *Les Lauriers sont coupés. Suivi de Le monologue intérieur*. Edited by Carmen Licari. Rome: Bulzoni, 1977.

———. *Die Lorbeerbäume sind geschnitten*. Translated by Irene Riesen. Zurich: Haffmans, 1984.

———. *Le monologue intérieur. Son apparition, ses origines, sa place dans l'oeuvre de James Joyce*. Paris: Messein, 1931.

Eco, Umberto. *Einführung in die Semiotik*. Munich: Fink, 1972.

Elias, Norbert. *Über den Prozess der Zivilisation. Soziogenetische und psychogenetische Untersuchungen*. 2 vols. Frankfurt/M.: Suhrkamp, 1980.

Endell, August. *Die Schönheit der großen Stadt*. 1908. Reprint, Berlin: Archibook, 1984.

———. *Zauberland des Sichtbaren*. Berlin: Verlag der Gartenschönheit, 1928.

Engels, Friedrich. *Die Lage der arbeitenden Klassen in England. Nach eigner Anschauung und authentischen Quellen*. Berlin: Dietz, 1974.

Ferguson, Priscilla Parkhurst. "The *flâneur* on and off the streets of Paris." In *The Flaneur*, edited by Keith Tester, 22–42. London: Routledge, 1994.

Flügge, Manfred. *Gesprungene Liebe. Die wahre Geschichte zu "Jules und Jim."* Berlin: Aufbau, 1993.

Fontane, Theodor. "Unsere lyrische und epische Poesie seit 1848." In *Literarische Essays und Studien*. 1. Teil, 7–31. *Sämtliche Werke*. Vol. 21, bk. 2. Munich: Nymphenburger, 1963.

Foucault, Michel. "What is Enlightenment?" In *The Foucault Reader*, edited by Paul Rabinow, 32–50. New York: Pantheon, 1984.

Fournel, Victor. *Ce qu'on voit dans les rues de Paris*. Paris: Adolphe Delahays, 1858.

Freisfeld, Andreas. *Das Leiden an der Stadt. Spuren der Verstädterung in deutschen Romanen des 20. Jahrhunderts*. Cologne: Böhlau, 1982.

Freud, Sigmund. *Standard Edition of the Complete Psychological Works of Sigmund Freud*. Vol. 12. Translated by James Strachey. London: Hogarth, 1957.

———. "Trauer und Melancholie." In *Studienausgabe*. Vol. 3, *Psychologie des Unbewußten*, 193–212. Frankfurt/M.: Fischer, 1975.

Friedberg, Anne. "*Les Flâneurs du Mal(l)*: Cinema and the Postmodern Condition." *PMLA*, 106, no. 3 (May 1991): 421.

———. *Window Shopping. Cinema and the Postmodern*. Berkeley: University of California Press, 1993.

Friedell, Egon. "Prolog vor dem Film." In Kaes, *Kino-Debatte*, 42–47.

Frisby, David. *The Alienated Mind. The Sociology of Knowledge in Germany, 1918–1933*. London: Routledge, 1992.

———. *Georg Simmel*. London: Horwood, 1984.

———. "Social Space, the City and the Metropolis." In *Simmel and Since. Essays in Georg Simmel's Social Theory*, 98–117. London: Routledge, 1992.

———. *Sociological Impressionism. A Reassessment of Georg Simmel's Social Theory*. London: Routledge, 1992.

———. "Zwischen den Sphären. Siegfried Kracauer und der Detektivroman." In *Siegfried Kracauer. Neue Interpretationen*, edited by Michael Kessler and Thomas Y. Levin, 39–58. Tübingen: Stauffenburg, 1990.

Game, Ann. *Undoing the Social. Towards a Deconstructive Sociology*. Toronto: University of Toronto Press, 1991.

Gardner, Carol Brooks. *Passing By. Gender and Public Harassment*. Berkeley: University of California Press, 1995.

Gay, John. "Trivia; or, The Art of Walking the Streets of London." In *Poetry and Prose*. Vol. 1. Oxford: Clarendon Press, 1974.

Geisler, Michael. *Die literarische Reportage in Deutschland. Möglichkeiten und Grenzen eines operativen Genres*. Königstein: Scriptor, 1982.

Geist, Johann Friedrich. *Passagen. Ein Bautyp des 19. Jahrhunderts*. Munich, 1969.

Gelley, Alexander. "City Texts. Representation, Semiology, Urbanism." In *Politics, Theory, and Contemporary Culture*, edited by Mark Poster, 237–60. New York: Columbia University Press.

———. "Thematics and Historical Construction. The Example of Benjamin's *Passagen-Werk*." *Strumenti Critici*, n.s. 4, no. 2 (May 1989): 25–43.

Gleber, Anke. "Briefe aus Berlin. Heinrich Heine und eine Ästhetik der Moderne." *Monatshefte* 82, no. 4 (winter 1990): 452–66.

———. "Die Erfahrung der Moderne in der Stadt. Reiseliteratur der Weimarer Republik." In *Der Reisebericht. Die Entwicklung einer Gattung in der deutschen Literatur*, edited by Peter J. Brenner, 463–89. Frankfurt/M.: Suhrkamp, 1989.

———. "The Secret Cities of Modernity. Topographies of Perception in Georges Rodenbach, Robert Walser and Franz Hessel." In *The Turn of the Century/ Le tournant du siècle. Modernism and Modernity in Literature and the Arts*, edited by Christian Berg, Frank Durieux, and Geert Lernout, 363–79. Berlin: de Gruyter, 1995.

———. "The Woman and the Camera: Walking in Berlin. Observations on Walter Ruttmann, Verena Stefan, and Helke Sander." In *Berlin in Focus. Cultural Transformations in Germany*, edited by Barbara Becker-Cantarino, 105–24. Westport: Praeger, 1996.

Goll, Yvan. "Das Kinodram." In Kaes, *Kino-Debatte*, 136–39.

Graevenitz, Gerhart von. *Das Ornament des Blicks. Über die Grundlagen des neuzeitlichen Sehens, die Poetik der Arabeske und Goethes "West-Östlichen Divan."* Stuttgart: Metzler, 1994.

Gross, David. "Space, Time and Modern Culture." *Telos* 50 (1981–82): 59–78.

Grossman, Atina. "Girlkultur; or, Thoroughly Rationalized Female: A New Woman in Weimar Germany?" In *Women in Culture and Politics. A Century of Change*, edited by Judith Friedlander, 62–80. Bloomington: Indiana University Press, 1986.

———. "The New Woman and the Rationalization of Sexuality in Weimar Germany." In *Powers of Desire. The Politics of Sexuality*, edited by Ann Snitow, Chris-

tine Stansell, and Sharon Thompson, 153–71. New York: Monthly Review Press, 1983.

Grund, Karin. "Der Tagebuchschreiber. Zu zwei unveröffentlichten Texten Franz Hessels." *Juni. Magazin für Kultur und Politik* 1, no. 3 (1989): 35.

Günther, Herbert. *Deutsche Dichter erleben Paris.* Pfullingen: Neske, 1979.

Hake, Sabine. *The Cinema's Third Machine. Writing on Film in Germany, 1907–1933.* Lincoln: University of Nebraska Press, 1993.

——. "Urban Spectacle in Walter Ruttmann's *Berlin: Symphony of the Big City.*" In *Dancing on the Volcano. Essays on the Culture of the Weimar Republic*, edited by Thomas W. Kniesche and Stephen Brockmann, 127–37. Columbia: Camden, 1994.

Hamann, Richard, and Jost Hermand. *Impressionismus.* Berlin: Akademie, 1966.

Handke, Peter. *Die linkshändige Frau.* Frankfurt/Main: Suhrkamp, 1981.

Hansen, Miriam. "Decentric Perspectives. Kracauer's Early Writings on Film and Mass Culture," *New German Critique* 54 (1991): 47–76.

Hart, Julius. "Der Atlantis-Film." In Kaes, *Kino-Debatte*, 104–106.

Hauptmann, Gerhart. "Über das Kino." In Kaes, *Kino-Debatte*, 159–60.

Hausenstein, Wilhelm. *Eine Stadt, auf nichts gebaut. Wilhelm Hausenstein über Berlin.* Berlin: Archibook, 1984.

Hauser, Susanne. *Der Blick auf die Stadt. Semiotische Untersuchungen zur literarischen Wahrnehmung bis 1910.* Berlin: Reimer, 1990.

Heine, Heinrich. "Briefe aus Berlin." In *Sämtliche Schriften.* Vol. 3, *1822–1831*, edited by Günter Häntzschel, 7–68. Frankfurt/M.: Ullstein, 1981.

Herf, Jeffrey. *Reactionary Modernism. Technology, Culture, and Politics in Weimar and the Third Reich.* New York: Cambridge University Press, 1984.

Hermand, Jost. "*Neue Sachlichkeit*: Ideology, Lifestyle, or Artistic Movement." In *Dancing on the Volcano. Essays on the Culture of the Weimar Republic*, edited by Thomas W. Kniesche and Stephen Brockmann, 57–68. Columbia: Camden House, 1994.

Hessel, Franz. "Adolf Behne, Sasha Stone: *Berlin in Bildern.*" *Die literarische Welt* 46, no. 4 (1928).

——. *Alter Mann.* Edited by Bernd Witte. Frankfurt/ M.: Suhrkamp, 1987.

——. "Arthur Schnitzler: *Flucht in die Finsternis.*" *Die literarische Welt* 47, no. 7 (1931).

——. "Aus alten Pariser Gassen." *Die literarische Welt* 48, no. 6 (1930).

——. "Bannmeile von Paris." *Die literarische Welt* 5, no. 5 (1929).

——. "Des deutschen Buches kurioser Tändel-Markt. Wie solches auf der neunzehnhundertdreißiger Weihnachtswiese von den Herrn Editores sive Verleger selbst feilgeboten und ausgeschrien wird." *Die literarische Welt* 49, no. 6 (1930).

——. *Ermunterung zum Genuß. Kleine Prosa.* Edited by Karin Grund and Bernd Witte. Berlin: Brinkmann and Bose, 1981.

——. *Ein Flaneur in Berlin.* 1929 as *Spazieren in Berlin.* Berlin: Das Arsenal, 1984.

——. "Fred Hildenbrandt: *Großes schönes Berlin.*" *Die literarische Welt* 42, no. 4 (1928).

——. "Ein Garten voll Weltgeschichte." *Die literarische Welt* 40, no. 6 (1930).

——. "Georg Hermann: *November achtzehn.*" *Die literarische Welt* 2, no. 7 (1931).

——. "Die größte Mietskasernenstadt der Welt." *Die literarische Welt* 46, no. 6 (1930).

Hessel, Franz. "Gruß an Knut Hamsun." Front page, *Die literarische Welt*. 31, no. 5 (1929).

———. *Heimliches Berlin*. Frankfurt/M.: Suhrkamp, 1982.

———. "Hier bekommt jeder sein Buch geschenkt. Eine Weihnachtsgeschichte, vier Wochen vor dem Fest zu lesen." *Die literarische Welt* 49, no. 8 (1932).

———. "Julius Meier-Gräfe: *Der Vater.*" *Die literarische Welt* 6–7, no. 9 (1933).

———. *Der Kramladen des Glücks. Roman*. Frankfurt/M.: Suhrkamp, 1983.

———. "Letzte Heimkehr." In *Letzte Heimkehr nach Paris. Franz Hessel und die Seinen im Exil*, edited by Manfred Flügge, 7–32. Berlin: Arsenal, 1989.

———. "Lou Andreas-Salomé: *Rainer Maria Rilke.*" *Die literarische Welt* 31, no. 4 (1928).

———. "Mario von Bucovich: *Berlin.*" *Die literarische Welt* 13–14, no. 5 (1929).

———. *Marlene Dietrich*. Berlin: Kindt and Bucher, 1931.

———. *Pariser Romanze. Papiere eines Verschollenen*. Frankfurt/M.: Suhrkamp, 1985.

———. "Tagebuchnotizen (1928–1932)." *Juni. Magazin für Kultur und Politik,* 3 no. 1 (1989): 36–49.

———. *Teigwaren leicht gefärbt*. Berlin: Rowohlt, 1926.

———. *Von den Irrtümern der Liebenden und andere Prosa*. Paderborn: Igel, 1994.

———. "Wilhelm Speyer: *Sommer in Italien.*" *Die literarische Welt* 3, no. 9 (1933).

Hessel, Helen. *Journal d' Helen. Lettres à Henri-Pierre Roché, 1920–1921*. Translated by Antoine Raybaud. Marseille: Dimanche, 1991.

Hickethier, Knut. "Kino Kino." In *Mythos Berlin. Zur Wahrnehmungsgeschichte einer industriellen Metropole*, 143–51. Berlin: Ästhetik und Kommunikation, 1987.

Hoffmann, E.T.A. *Der Sandmann. Das öde Haus. Nachtstücke*. Stuttgart: Reclam, 1969.

Hofmann, Michael. "Kritische Öffentlichkeit als Erkenntnisprozeß. Zu Siegfried Kracauers Essays über *Die Angestellten* in der *Frankfurter Zeitung.*" In *Siegfried Kracauer. Neue Interpretationen*, edited by Michael Kessler and Thomas Y. Levin, 87–104. Tübingen: Stauffenburg, 1990.

Hofmannsthal, Hugo von. "Ein Brief." In *Gesammelte Werke*. Vol. 7, 461–72. Frankfurt/M.: 1979.

———. "Der Ersatz für die Träume." In Kaes, *Kino-Debatte*, 149–52.

Horkheimer, Max, and Theodor W. Adorno. *Dialektik der Aufklärung. Philosophische Fragmente*. Frankfurt/ M.: Fischer, 1971.

Ihrig, Wilfried. *Literarische Avantgarde und Dandysmus. Eine Studie zur Prosa von Carl Einstein bis Oswald Wiener*. Frankfurt/ M.: Athenäum, 1988.

Irigaray, Luce. *This Sex Which is Not One*. Translated by Catherine Porter. Ithaca: Cornell University Press, 1985.

Isherwood, Christopher. *Goodbye to Berlin*. 1939. Reprint, edited by Geoffrey Halston. London: Longman, 1980.

Jay Martin. *Downcast Eyes. The Denigration of Vision in Twentieth-Century French Thought*. Berkeley: University of California Press, 1993.

———. *Permanent Exiles. Essays on the Intellectual Migration from Germany to America*. New York: Columbia University Press, 1985.

———. "Sartre, Merleau-Ponty, and the Search for a New Ontology of Sight." In *Modernity and the Hegemony of Vision*, edited by David Michael Levin, 143–85. Berkeley: University of California Press, 1993.

Jelinek, Elfriede. "Die Sprache des Kindes: Über die Literatur der Irmgard Keun." *Extrablatt* 4, no. 2 (1980): 88–89.

―――. "Weil sie heimlich weinen muß, lacht sie über Zeitgenossen." *Die Horen* 25 (1980): 221–25.

Jenks, Chris. "Watching your Step. The History and Practice of the *Flâneur.*" In *Visual Culture*, edited by Chris Jenks, 142–60. London: Routledge, 1995.

Jennings, Michael W. *Dialectical Images. Walter Benjamin's Theory of Literary Criticism.* Ithaca: Cornell University Press, 1987.

Jordan, Christa. *Zwischen Zerstreuung und Berauschung. Die Angestellten in der Erzählprosa am Ende der Weimarer Republik.* Frankfurt/M.: Lang, 1988.

Jukes, Peter, ed. *A Shout in the Street. An Excursion into the Modern City.* Berkeley: University of California Press, 1990.

Jung, Franz. *Der Weg nach unten. Aufzeichnungen aus einer großen Zeit.* Hamburg: Edition Nautilus, 1961.

Jünger, Ernst. *Annäherungen. Drogen und Rausch.* Stuttgart: Klett, 1970.

―――. *Der Kampf als inneres Erlebnis.* Berlin: Mittler, 1926.

Kaemmerling, Ekkehard. "Die filmische Schreibweise." In *Materialien zu Alfred Döblins Berlin Alexanderplatz*, edited by Matthias Prangel, 185–98. Frankfurt/M.: Suhrkamp, 1975.

Kaes, Anton. "Literary Intellectuals and the Cinema: Charting a Controversy (1909–1929), *New German Critique* 40 (winter 1987): 7–34.

Kaes, Anton, ed. *Kino-Debatte. Texte zum Verhältnis von Literatur und Film, 1909–1929.* Tübingen: Niemeyer, 1978.

Kaes, Anton, Martin Jay, and Edward Dimendberg, eds. *The Weimar Republic Sourcebook.* Berkeley: University of California Press, 1994.

Kähler, Hermann. *Berlin—Asphalt und Licht. Die große Stadt in der Literatur der Weimarer Republik.* Berlin: Das europäische Buch, 1986.

Keun, Irmgard. *Gilgi—eine von uns.* Bergisch Gladbach: Lübbe, 1981.

―――. *Ich lebe in einem wilden Wirbel. Briefe an Arnold Strauss, 1933 bis 1947.* Edited by Gabriele Kreis and Marjory S. Strauss. Düsseldorf: Claassen, 1988.

―――. *Das kunstseidene Mädchen.* Bergisch Gladbach: Lübbe, 1981.

Kirby, Lynne. "Male Hysteria and Early Cinema." *Camera Obscura* 17 (1988): 112–31.

―――. *Parallel Tracks. The Railroad and Silent Cinema.* Durham: Duke University Press, 1996.

―――. "The Railroad and the Cinema, 1895–1929. Technologies, Institutions and Aesthetics." Ph.D. diss., University of California, Los Angeles, 1990.

Kisch, Egon Erwin. "Typen der Straße." In *Gesammelte Werke in Einzelausgaben.* Vol. 2, 510–16. Berlin: Aufbau, 1980.

Kittler, Friedrich. *Grammophon Film Typewriter.* Berlin: Brinkmann and Bose, 1986.

Kleinspehn, Thomas. *Der flüchtige Blick. Sehen und Identität in der Kultur der Neuzeit.* Reinbek: Rowohlt, 1989.

Kleist, Heinrich von. *Briefe 1793–1804.* Vol. 6. Munich: Deutscher Taschenbuch Verlag, 1964.

Klemperer, Viktor. "Das Lichtspiel." In *Prolog vor dem Film. Nachdenken über ein neues Medium, 1909–1914*, edited by Jörg Schweinitz, 170–82. Leipzig: Reclam, 1992.

Klotz, Volker. *Die erzählte Stadt. Ein Sujet als Herausforderung des Romans von Lesage bis Döblin.* Munich: Hanser, 1969.

———. "Forcierte Prosa. Stilbeobachtungen an Bildern und Romanen der Neuen Sachlichkeit." In *Festschrift zum 65. Geburtstag von Josef Kunz,* edited by Rainer Schönhaar, Berlin: 1972.

Knapp, Eva-Maria. "Baudelaire: A une passante." *Germanisch-Romanische Monatsschrift* 24 (1974): 182–92.

Koch, Gertrud. "Béla Balázs. The Physiognomy of Things." *New German Critique* 40 (winter 1987): 167–77.

———. "Cosmos in Film. On the Concept of Space in Walter Benjamin's 'Work of Art' Essay." *Qui parle* 2, no. 5 (1992): 61–72.

———. "Von der weiblichen Sinnlichkeit und ihrer Lust und Unlust am Kino. Mutmaßungen über vergangene Freuden und neue Hoffnungen." In *Überwindung der Sprachlosigkeit,* edited by G. Dietze, 116–38. Darmstadt: Luchterhand, 1979.

———. "Why Women Go to Men's Films." In *Feminist Aesthetics,* edited by Gisela Ecker, translated by Harriet Anderson, 108–19. Boston: Beacon, 1985.

Köhn, Eckhardt. "Konstruktion und Reportage. Anmerkungen zum literaturtheoretischen Hintergrund von Kracauers Untersuchung 'Die Angestellten' (1930)." *Text und Kontext* 2, no. 5 (1977): 107–23.

———. *Straßenrausch. Flanerie und kleine Form: Versuch zur Literaturgeschichte des Flaneurs von 1830–1933.* Berlin: Das Arsenal, 1989.

Kolaja, Jiri, and Arnold W. Foster. "*Berlin, the Symphony of a City* as a Theme of Visual Rhythm." *Journal of Aesthetics and Art Criticism* 23, no. 2 (spring 1965).

Koonz, Claudia. *Mothers in the Fatherland. Women, the Family and Nazi Politics.* New York: St. Martin's Press, 1987.

Kosta, Barbara. "Unruly Daughters and Modernity. Irmgard Keun's *Gilgi-eine von uns.*" *German Quarterly* 3, no. 68 (1995): 271–86.

Kracauer, Siegfried. "Die Angestellten. Aus dem neuesten Deutschland." In *Schriften.* Vol. 1, 205–304. Frankfurt/M.: Suhrkamp, 1971.

———. *Der Detektiv-Roman. Ein philosophischer Traktat.* In *Schriften.* Vol.1, 103–204. Frankfurt/M.: Suhrkamp, 1971.

———. *From Caligari to Hitler. A Psychological History of the German Film.* Princeton: Princeton University Press, 1947.

———. "Langeweile." In *Schriften.* Vol. 8, *Jacques Offenbach und das Paris seiner Zeit.* Frankfurt/M.: Suhrkamp, 1976.

———. *Das Ornament der Masse.* Edited by Karsten Witte. Frankfurt/M.: Suhrkamp, 1977.

———. *Straßen in Berlin und anderswo.* Berlin: Das Arsenal, 1987.

———. *Theory of Film. The Redemption of Physical Reality.* New York: Oxford University Press, 1960.

———. "Those Movies with a Message." *Harper's Magazine* 196 (June 1948): 567–72.

Krechel, Ursula. "Irmgard Keun: die Zerstörung der kalten Ordnung. Auch ein Versuch über das Vergessen weiblicher Kulturleistungen." *Literaturmagazin* 10 (1979): 103–28.

Kreuzer, Helmut. *Die Bohème. Beiträge zu ihrer Beschreibung.* Stuttgart: Metzler, 1968.

Kreuzer, Helmut. "Kultur und Gesellschaft in der Weimarer Republik." In *Text und Kontext. Kultur und Gesellschaft in Deutschland von der Reformation bis zur Gegenwart*, edited by Klaus Bohnen, 130–54. Kopenhagen, 1981.

Kuschel, Thomas. "Die Darstellung des Menschen und seiner Gesellschaft in den Filmen *Berlin. Die Sinfonie der Großstadt* von Walter Ruttmann und *Vorwärts, Sowjet!* von Dziga Wertow unter Berücksichtigung der künstlerisch-formalen Gestaltungsmittel." *Filmwissenschaftliche Mitteilungen* 6, no. 1 (1965).

Lensing, Leo. "Cinema, Society, and Literature in Irmgard Keun's 'Das kunstseidene Mädchen,' " *Germanic Review* 1, no. 60 (1985): 129–34.

Lepenies, Wolf. *Melancholie und Gesellschaft*. Frankfurt/M.: Suhrkamp, 1972.

Lessing, Gotthold Ephraim. *Ernst und Falk. Gespräche für Freymaurer*. Wolfenbüttel: Dieterich, 1778.

Lethen, Helmut. "Eckfenster der Moderne. Wahrnehmungsexperimente bei Musil und E.T.A. Hoffmann." In *Robert Musils "Kakanien"—Subjekt und Geschichte*, edited by Josef Strutz, 195–229. Munich: Fink, 1987.

———. *Neue Sachlichkeit. Studien zur Literatur des "Weißen Sozialismus."* Stuttgart, 1970.

———. "Sichtbarkeit. Kracauers Liebeslehre." In *Siegfried Kracauer. Neue Interpretationen*, edited by Michael Kessler and Thomas Y. Levin, 195–228. Tübingen: Stauffenburg, 1990.

Lewin, Bertram D. "The Train Ride: A Study of One of Freud's Figures of Speech," *Psychoanalytic Quarterly* 49 (1970): 71–89.

Lindner, R. *Die Entdeckung der Stadtkultur. Soziologie aus der Erfahrung der Reportage*. Frankfurt/M.: Suhrkamp, 1990.

Loreck, Hanne. "Auch Greta Garbo ist einmal Verkäuferin gewesen. Das Kunstprodukt 'Neue Frau' in den Zwanziger Jahren." *Frauen Kunst Wissenschaft* 9–10 (1990): 17–26.

Lorisika, Irene. *Frauendarstellungen bei Irmgard Keun und Anna Seghers*. Frankfurt/M.: Haag and Herchen, 1985.

Lukács, Georg. "Gedanken zu einer Ästhetik des Kinos." In Kaes, *Kino-Debatte*, 112–18.

Lux, Joseph August. "Über den Einfluß des Kinos auf Literatur und Buchhandel." In Kaes, *Kino-Debatte*, 93–96.

MacCannell, Dean. *The Tourist. A New Theory of the Leisure Class*. New York: Schocken, 1989.

Man, Paul de. "Literary History and Literary Modernity." In *Blindness and Insight. Essays in the Rhetoric of Contemporary Criticism*. Minneapolis: University of Minnesota Press, 1983.

Mann, Thomas. "Über den Film." In Kaes, *Kino-Debatte*, 164–66.

Marder, Elissa. "Flat Death. Snapshots of History." *Diacritics* 22, no. 3–4 (fall-winter, 1992): 128–44.

Mazlish, Bruce. "The flaneur. From spectator to representation." In *The Flaneur*, edited by Keith Tester, 43–60. London: Routledge, 1994.

McCormick, Richard W. "Private Anxieties/ Public Projections. 'New Objectivity,' Male Subjectivity, and Weimar Cinema." In *Women in German Yearbook* 10, edited by Jeanette Clausen and Sara Friedrichsmeyer, 1–18. Lincoln: University of Nebraska Press, 1994.

Meckseper, Cord, and Elisabeth Schraut, eds. *Die Stadt in der Literatur*. Göttingen: Vandenhoeck and Ruprecht, 1983.

Menninghaus, Winfried. *Schwellenkunde. Walter Benjamins Passage des Mythos*. Frankfurt/M.: Suhrkamp, 1986.

Mercier, Louis Sébastien. *Tableau de Paris*. Paris: Bibliotheque Nationale, 1884.

Metz, Christian. *Le Signifiant Imaginaire. Psychanalyse et Cinéma*. Paris: Union Générale d'Editions, 1977.

Mierendorff, Carlo. "Hätte ich das Kino." In Kaes, *Kino-Debatte*, 139–46.

Morris, Meaghan. "Things to Do With Shopping Centres." Milwaukee Working Papers, no. 1 (fall 1988).

Mülder-Bach, Inka. " 'Mancherlei Fremde.' Paris, Berlin und die Extraterritorialität Siegfried Kracauers," *Juni. Magazin für Kultur und Politik* 3, no.1 (1989): 61–72.

Müller, Lothar. "The Beauty of the Metropolis. Toward an Aesthetic Urbanism in Turn-of-the-Century Berlin." In *Berlin: Culture and Metropolis*, edited by Charles W. Haxthausen and Heidrun Suhr, 37–57. Minneapolis: University of Minnesota Press, 1991.

Mulvey, Laura. "Visual Pleasure and Narrative Cinema." *Screen* 16, no. 3 (autumn 1975): 6–18.

Mumford, Lewis. *The City in History. Its Origins, Its Transformations, and Its Prospects*. New York: Harcourt, Brace and World, 1961.

Natter, Wolfgang. "The City as Cinematic Space: Modernism and Place in *Berlin, Symphony of a City*." In *Place, Power, Situation, and Spectacle. A Geography of Film*, edited by Stuart C. Aitken and Leo E. Zonn, 203–27. Lanham: Rowman and Littlefield, 1994.

Nibbrig, Christiaan L. Hart. "Das déja vu des ersten Blicks. Zu Walter Benjamins *Berliner Kindheit um Neunzehnhundert*." *Deutsche Vierteljahresschrift* 47 (1973): 711–29.

Nicholson, Graeme. *Seeing and Reading*. London: Macmillan, 1983.

Nietzsche, Friedrich. *The Will to Power. An Attempted Transvaluation of all Values*. New York: Macmillan, 1924.

Nord, Deborah Epstein. "The Urban Peripatetic. Spectator, Streetwalker, Woman Writer." *Nineteenth-Century Literature* (1991): 351–75.

———. *Walking the Victorian Streets. Women, Representation and the City*. Ithaca: Cornell University Press, 1995.

Oesterle, Günter. "E.T.A. Hoffmann: Des Vetters Eckfenster. Zur Historisierung ästhetischer Wahrnehmung oder Der kalkulierte romantische Rückgriff auf Sehmuster der Aufklärung." *Der Deutschunterricht* 1, no. 39 (1987): 84–110.

Petro, Patrice. "After Shock/ Between Boredom and History." In *Fugitive Images. From Photography to Video*, edited by Patrice Petro, 265–84. Bloomington: University of Indiana Press, 1995.

———. "Discourse on Sexuality in Early German Film Theory." *New German Critique* 40 (1987): 115–46.

———. *Joyless Streets. Women and Melodramatic Representation in Weimar Germany*. Princeton: Princeton University Press, 1989.

Pfister, Gertrud. "Abenteuer, Wettkampf und Tanz. Zur Bewegungskultur von Frauen (1890–1933). In *Unter allen Umständen. Frauengeschichte(n) in Berlin*, edited by Christiane Eifert and Susanne Rouette, 138–58. Berlin: Rotation, 1986.

Pike, Burton. *The Image of the City in Modern Literature*. Princeton: Princeton University Press, 1981.

Pinthus, Kurt. "Quo vadis—Kino?" in Kaes, *Kino-Debatte*, 72–75.

Plath, Jörg. *Liebhaber der Großstadt. Ästhetische Konzeptionen im Werk Franz Hessels*. Kassel: Igel, 1994.

Pollock, Griselda. *Vision and Difference. Femininity, Feminism and Histories of Art*. London: Routledge, 1988.

Pratt, Mary Louise. *Imperial Eyes. Travel Writing and Transculturation*. London: Routledge, 1992.

Prinzler, Hans Helmut, and Eric Rentschler, eds. *Augenzeugen. Hundert Texte neuer deutscher Filmemacher*. Frankfurt/ M.: Verlag der Autoren, 1988.

Raabe, Wilhelm. *Die Chronik der Sperlingsgasse*. Berlin: Grote'sche Verlagsbuchhandlung, 1908.

Rabinowitz, Lauren. "Temptations of Pleasure. Nickelodeon, Amusement Parks, and the Sights of Female Sexuality." *Camera Obscura* 23 (1990): 71–89.

Rauch, Angelika. "The *Trauerspiel* of the Prostituted Body; or, Woman as Allegory of Modernity." *Cultural Critique* 10 (fall 1988): 77–88.

Reventlow, Franziska zu. *Von Paul zu Pedro. Herrn Dames Aufzeichnungen. Zwei Romane*, edited by Else Reventlow. Frankfurt/M.: Ullstein, 1987.

Rich, Adrienne. "Compulsory Heterosexuality and Lesbian Existence." In *Powers of Desire. The Politics of Sexuality*, edited by Ann Snitow, Christine Stansell, and Sharon Thompson, 177–205. New York: Monthly Review Press, 1983.

Rickels, Laurence A. *The Case of California*. Baltimore: Johns Hopkins University Press, 1991.

Rignall, John. "Benjamin's *Flâneur* and the Problem of Realism." In *The Problems of Modernity. Adorno and Benjamin*, edited by Andrew Benjamin, 112–21. New York: Routledge, 1989.

———. *Realist Fiction and the Strolling Spectator*. London: Routledge, 1992.

Riha, Karl. *Die Beschreibung der "Großen Stadt." Zur Entstehung des Großstadtmotivs in der deutschen Literatur (ca. 1750–1850)*. Bad Homburg: Gehlen, 1970.

Roché, Jean-Pierre. *Jules und Jim*. Translated by Joe Hembus and Walther H. Schünemann. Bremen: Rowohlt, 1964.

Rodenbach, Georges. *Bruges-la-Morte. Roman*. Paris: Flammarion, 1900.

Ronell, Avital. *Crack Wars. Literature, Addiction, Mania*. Lincoln: University of Nebraska Press, 1992.

Rose, Paul Lawrence. *Revolutionary Antisemitism in Germany from Kant to Wagner*. Princeton: Princeton University Press, 1990.

Rosenstein, Doris. *Irmgard Keun: Das Erzählwerk der dreißiger Jahre*. Frankfurt/M.: Lang, 1991.

Rutschky, Michael. *Erfahrungshunger. Ein Essay über die siebziger Jahre*. Frankfurt/ M.: Fischer, 1982.

———. *Wartezeit. Ein Sittenbild*. Cologne: Kiepenheuer, 1983.

Sartre, Jean-Paul. *L'être et le néant. Essai d'ontologie phénoménologique*. Paris: Gallimard, 1957.

Schäche, Wolfgang. "Die unsichtbare Stadt." In *Mythos Berlin. Zur Wahrnehmungsgeschichte einer industriellen Metropole*, 105–17. Berlin: Ästhetik and Kommunikation, 1987.

Schaper, Rainer Michael. *Der gläserne Himmel. Die Passagen des neunzehnten Jahrhunderts als Subjekt der Literatur.* Frankfurt/M.: Athenäum, 1988.

Schivelbusch, Wolfgang. *Disenchanted Night. The Industrialisation of Light in the Nineteenth Century.* Translated by Angela Devies. Oxford: Berg, 1988.

———. *Geschichte der Eisenbahnreise. Zur Industrialisierung von Raum und Zeit im 19. Jahrhundert.* Frankfurt/ M.: Ullstein, 1979.

———. *Lichtblicke. Zur Geschichte der künstlichen Helligkeit im 19. Jahrhundert.* Frankfurt/M.: Fischer, 1986.

———. *The Railway Journey. The Industrialization of Time and Space in the Nineteenth Century.* Berkeley: University of California Press, 1986.

Schlaffer, Heinz. "Denkbilder: Eine kleine Prosaform zwischen Dichtung und Gesellschaftstheorie." In *Poesie und Politik: Zur Situation der Literatur in Deutschland*, edited by Wolfgang Kuttenkeuler, 137–54. Stuttgart: Kohlhammer, 1973.

Schlüpmann, Heide. *Die Unheimlichkeit des Blicks. Das Drama des frühen deutschen Kinos.* Frankfurt: Stroemfeld/ Roter Stern, 1990.

Schmidt-Linsenhoff, Viktoria. "Plakate 1880–1914." In *Plakate 1880–1914. Inventarkatalog der Plakatsammlung des Historischen Museums Frankfurt*, edited by Viktoria Schmidt-Linsenhoff, Kurt Wettengl, and Almut Junker, 8–10. Frankfurt: Historisches Museum, 1986.

Schnarrenberger, Wilhelm. "Schilder als Zeichen." *Die Form* 3 (1928): 362–67.

Schneider, Helmut J. "The Staging of the Gaze. Aesthetic Illusion and the Scene of Nature in the Eighteenth-Century." In *Reflecting Senses: Perceptions and Appearance in Literature, Culture, and the Arts*, edited by Walter Pape and Frederick Burwick. Hawthorne, N.Y.: Walter De Gruyter.

Scholvin, Ulrike. *Döblins Metropolen. Über reale und imaginäre Städte und die Travestie der Wünsche.* Weinheim: Beltz, 1985.

Schütz, Erhard. *Romane der Weimarer Republik.* Munich: Fink, 1986.

Schulz, Eberhard Wilhelm. "Zum Wort 'Denkbild,' " In *Wort und Zeit*, 218–52. Neumünster: Wachholtz, 1968.

Schulz, Genia. "Traum und Aufklärung. Die Stadtbilder Siegfried Kracauers." *Merkur* 36 (1982): 878–88.

Schweinitz, Jörg, ed. *Prolog vor dem Film. Nachdenken über ein neues Medium, 1909–1914.* Leipzig: Reclam, 1992.

Serner, Walter. "Kino und Schaulust." In Kaes, *Kino-Debatte*, 53–58.

Shields, Rob. "Fancy footwork. Walter Benjamin's notes on *flânerie*." In *The Flaneur*, edited by Keith Tester, 61–80. London: Routledge, 1994.

Siemsen, Hans. "Kurfürstendamm am Vormittag." In *Hier schreibt Berlin*, edited by Herbert Günther, 17–20. Berlin: Internationale Bibliothek, 1929.

Silberschmidt, Catherine. "Kino das ist Bewegung, Rhythmus, Leben. Germaine Dulac—Filmpionierin der 20er Jahre." In *Weiblichkeit und Avantgarde*, edited by Inge Stephan and Sigrid Weigel. Berlin: Argument, 1987.

Simmel, Georg. "Die Großstädte und das Geistesleben." In *Die Großstadt. Vorträge und Aufsätze.* Dresden: Jahrbuch der Gehe-Stiftung, 1903.

———. "The Metropolis and Mental Life." In *On Individuality and Social Forms. Selected Writings*, edited by Donald E. Levine. Chicago: University of Chicago Press, 1971.

Simmel, Georg. *Soziologie. Untersuchungen über die Formen der Vergesellschaftung.* Berlin: Duncker and Humblot, 1968.

Sloterdijk, Peter. *Zur Kritik der zynischen Vernunft. Ein Essay.* Frankfurt/M.: Suhrkamp, 1983.

Smith, Gary. "Benjamins Berlin." In *Wissenschaften in Berlin*, edited by Tilmann Buddensieg, 98–102. Berlin: Mann, 1987.

Sontag, Susan. *On Photography.* New York: Dell, 1977.

Sponsel, Jean Louis. *Das moderne Plakat.* Dresden: Kühlmann, 1897.

Stam, Robert, Robert Burgoyne, and Sandy Flitterman-Lewis, eds. *New Vocabularies in Film Semiotics. Structuralism, Post-Structuralism and Beyond.* London: Routledge, 1992.

Stefan, Verena. *Häutungen.* Munich: Frauenoffensive, 1975.

Stein, Gerd. *Dandy—Snob—Flaneur. Dekadenz und Exzentrik: Kulturfiguren und Sozialcharaktere des 19. und 20. Jahrhunderts.* Frankfurt/ M.: Fischer, 1985.

Sternberger, Dolf. *Panorama oder Ansichten vom 19. Jahrhundert.* Hamburg: Claassen, 1955.

Stierle, Karlheinz. "Baudelaires 'Tableaux Parisiens' und die Tradition des 'Tableau de Paris.' " *Poetica* 6 (1974): 285–322.

———. *Der Mythos von Paris. Zeichen und Bewußtsein der Stadt.* Munich: Hanser, 1993.

———. "Walter Benjamin und die Erfahrung des Lesens." *Poetica* 12 (1980): 227–48.

Sutter, Otto Ernst. "Berlin als Fremdenstadt." *Das neue Berlin. Monatshefte für die Probleme der Großstadt* 5, no. 1 (1929): 89–94.

Szondi, Peter. "Walter Benjamin's City Portraits." In *On Walter Benjamin. Critical Essays and Recollections*, edited by Gary Smith, 18–32. Cambridge: MIT Press, 1991.

Tester, Keith, ed. *The Flaneur.* London: Routledge, 1994.

Thompson, Michael. *Rubbish Theory. The Creation and Destruction of Value.* Oxford: Oxford University Press, 1979.

Tiedemann, Rolf. "Dialectics at a Standstill. Approaches to the *Passagen-Werk.*" In *On Walter Benjamin. Critical Essays and Recollections*, edited by Gary Smith, 260–91. Cambridge: MIT Press, 1991.

Tucholsky, Kurt. *Gesammelte Werke.* Vol. 3, *1929–1932.* Reinbek: Rowohlt, 1961.

Ueding, Gert. "Im Morgenland der Dinge. Über Franz Hessel." In *Die anderen Klassiker. Literarische Porträts aus zwei Jahrhunderten.* Munich: Beck, 1986.

Uricchio, William. "Ruttmann's *Berlin* and the City Film to 1930." Ph.D. diss., New York University, 1982.

Urry, John. *The Tourist Gaze. Leisure and Travel in Contemporary Societies.* London: Sage, 1990.

Usborne, Cornelie. *The Politics of the Body in Weimar Germany. Women's Reproductive Rights and Duties.* Ann Arbor: University of Michigan Press, 1993.

Vertov, Dziga. *Kino-Eye. The Writings of Dziga Vertov.* Edited by Annette Michelson. Berkeley: University of California Press, 1984.

Vidler, Anthony. *The Architectural Uncanny. Essays in the Modern Unhomely.* Cambridge: MIT Press, 1992.

Virilio, Paul. *War and Cinema. The Logistics of Perception.* Translated by Patrick Camiller. London: Verso, 1989.

Vollmer, Hartmut. "Der Flaneur in einer 'quälenden Doppelwelt'—Über den wiederentdeckten Dichter Franz Hessel." *Neue Deutsche Hefte* 34, no. 4 (1987).

Walkowitz, Judith. *City of Dreadful Delights.* London: Virago, 1992.

Weidmann, Heiner. *Flanerie, Sammlung, Spiel. Die Erinnerung des 19. Jahrhunderts bei Walter Benjamin.* Munich: Fink, 1992.

Weigel, Sigrid. "'Die Städte sind weiblich und nur dem Sieger hold.' Zur Funktion des Weiblichen in Gründungsmythen und Städtedarstellungen." In *Triumph und Scheitern in der Metropole. Zur Rolle der Weiblichkeit in der Geschichte Berlins,* edited by Sigrun Anselm and Barbara Beck, 207–27. Berlin 1987.

———. "Traum—Stadt—Frau. Zur Weiblichkeit der Städte in der Schrift: Calvino, Benjamin, Paul Nizon, Ginka Steinwachs." In *Die Unwirklichkeit der Städte. Großstadtdarstellungen zwischen Moderne und Postmoderne,* edited by Klaus R. Scherpe, 173–96. Reinbek: Rowohlt, 1988.

Weill, Alain. *The Poster. A Worldwide Survey and History.* Boston: Hall, 1985.

Weinstein, Deena, and Michael Weinstein. *Postmodern(ized) Simmel.* London: Routledge, 1994.

Witte, Bernd. "Paris—Berlin—Paris: Personal, Literary and Social Experience in Walter Benjamin's Late Works." *New German Critique* 39 (fall 1986): 49–60.

Wohlfahrt, Irving. "Et Cetera? The Historian as Chiffonnier." *New German Critique* 39 (fall 1986): 142–68.

Wolf, Christa. *Unter den Linden.* Darmstadt: Luchterhand, 1987.

Wolff, Charlotte. *Augenblicke verändern uns mehr als die Zeit. Eine Autobiographie.* Translated by Michaela Huber. Frankfurt/ M.: Fischer, 1986.

———. *Hindsight.* London: Quartet, 1980.

———. *The Human Hand.* London: Methuen, 1949.

———. *Studies in Hand-Reading.* London: Chatto and Windus, 1936.

Wolff, Janet. "The Invisible Flaneuse. Women and the Literature of Modernity." In *The Problems of Modernity. Adorno and Benjamin,* edited by Andrew Benjamin, 141–56. London: Routledge, 1989.

Wysocki, Gisela von. "Der Aufbruch der Frauen: Verordnete Träume, Bubikopf und sachliches Leben. Ein aktueller Streifzug durch SCHERL's Magazin Jhg. 1925." In *Massenkommunikation* 3. Edited by Dieter Prokop, 295–304. Frankfurt/M.: Suhrkamp, 1977.

Zucker, Wolf. "Kunst und Reklame. Zum Weltreklamekongress in Berlin." *Die literarische Welt* 32, no. 5 (1929).

Zwacka, Petra, ed. *Ich bin meine eigene Frauenbewegung. Frauen-Ansichten aus der Geschichte einer Großstadt.* Berlin: Hentrich, 1991.

Index